𝓚nown for its herbal flavors, rustic dishes, fiery dips, and comforting noodles, the food of northern Thailand is both ancient and ever evolving. Travel province by province, village by village, and home by home to meet chefs, vendors, professors, and home cooks as they share their recipes for Muslim-style *khao soi*, a mild coconut beef curry with boiled and crispy fried noodles, or spiced fish steamed in banana leaves to an almost custard-like texture, or the intense, numbingly spiced meat "salads" called *laap*.

Featuring many recipes never before described in English and snapshots into the historic and cultural forces that have shaped this region's glorious cuisine, this journey may redefine what we think of when we think of Thai food.

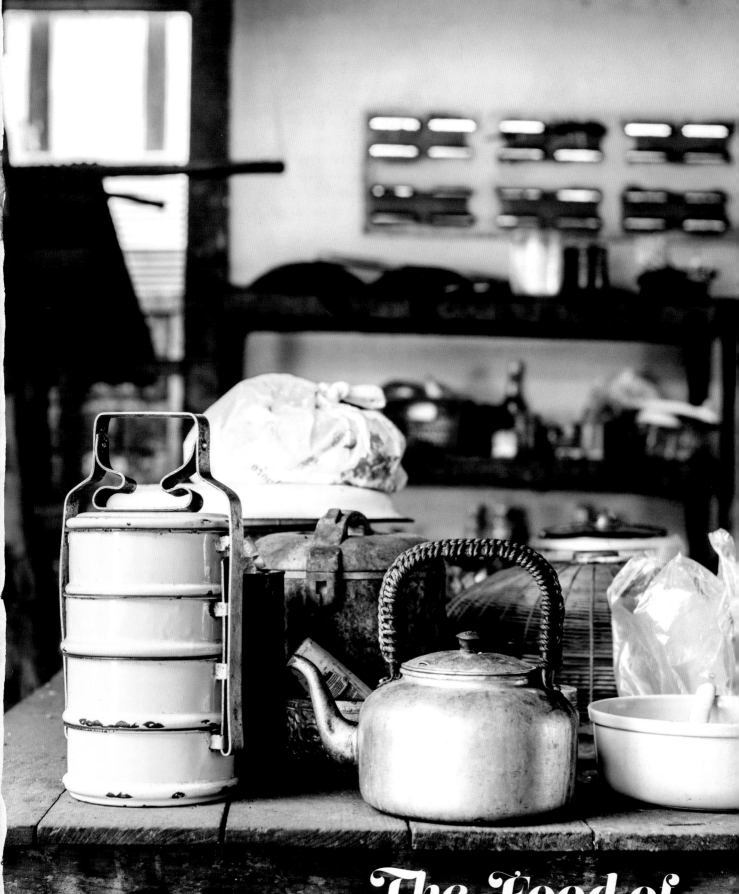

The Food of
Northern Thailand

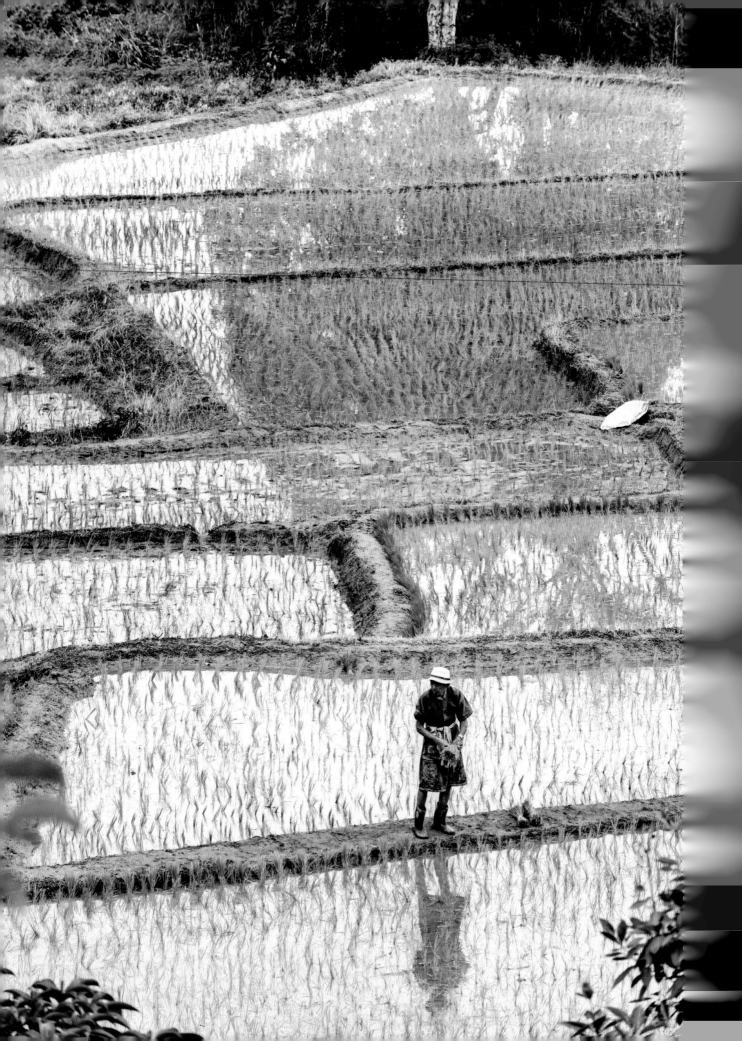

The Food of Northern Thailand

Written and photographed by Austin Bush

Illustrated by Kathy MacLeod

CLARKSON POTTER/PUBLISHERS *New York*

Library of Congress Cataloging-
in-Publication Data has been
applied for.

ISBN 978-0-451-49749-9
Ebook ISBN 978-0-451-49750-5

Printed in China

Book design by Marysarah Quinn
Cover photographs by Austin Bush

10 9 8 7 6 5 4 3 2 1

FIRST EDITION

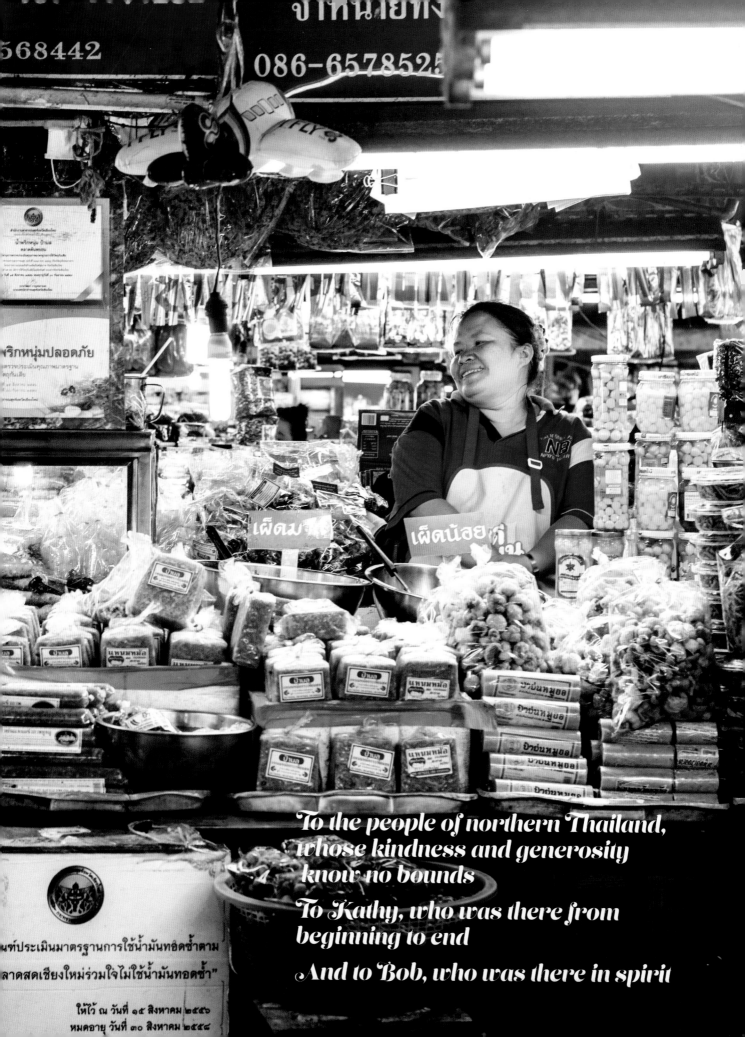

To the people of northern Thailand, whose kindness and generosity know no bounds

To Kathy, who was there from beginning to end

And to Bob, who was there in spirit

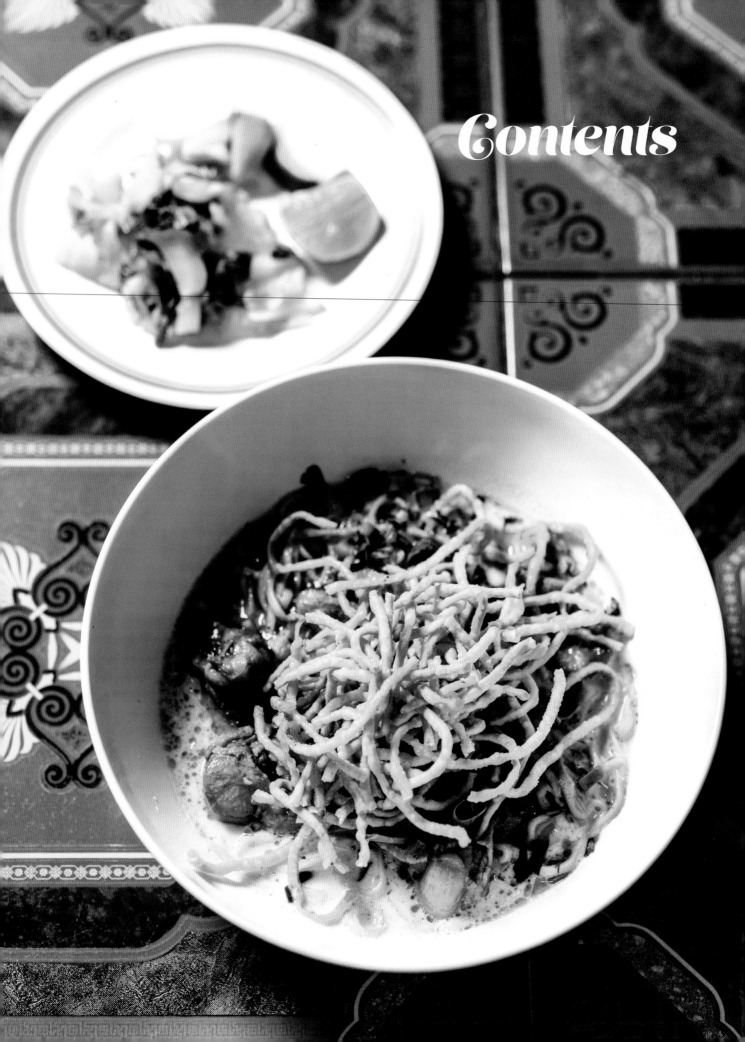

Contents

INTRODUCTION 9

A (VERY) BRIEF HISTORY OF NORTHERN THAILAND 15

THE PEOPLE OF NORTHERN THAILAND 16

THE FOOD AND FLAVORS OF NORTHERN THAILAND 17

COOKING NORTHERN THAI-STYLE 21

NORTHERN THAI COOKING METHODS 24

NORTHERN THAI KITCHEN TOOLS 25

Chiang Mai 27

Chiang Rai 91

Lampang 159

Mae Hong Son 202

Phrae & Nan 268

NORTHERN THAI INGREDIENTS: GUIDE AND GLOSSARY 324

BIBLIOGRAPHY 329

ACKNOWLEDGMENTS 330

INDEX 332

Introduction

’m driving a rental car, navigating the 1,219 curves of northern Thailand's so-called Death Highway. The nickname stems from the challenge the road has presented to car brakes over the years, a fate I'm hoping to avoid while on the way to Um Phang, a tiny village tucked between mountains near the border with Myanmar. I've been to Um Phang a few times before, for both work and pleasure, and know what's waiting for me there: a dish of northern Thai–style *laap*. Combining finely minced beef, sliced offal, herbs, and a fragrant spice mixture that threatens to numb the tongue, it's a world away from the spicy, tart "larb" found in Thai restaurants abroad—or even in Bangkok. Indeed, accompanied by a bamboo basket of steaming sticky rice and a platter of herbs, vegetables, and bitter greens, these are ingredients and flavors that are really only available in Thailand's north. For me, it's the kind of meal that's worth the risky drive.

I've been visiting places like Um Phang since I moved to Thailand in 1999. I originally came to the country on a scholarship at Chiang Mai University, where I learned to speak, read, and write Thai. After I was done studying, I landed a job teaching English. During school breaks I'd travel the country, going to remote places, camera in hand—an effort, I suppose, to wrap my head around the place where I was living. But it didn't take me long to realize that food is almost certainly the best way to learn about Thailand. I was both overwhelmed by and obsessed with Thailand's cuisine, but I also found food a way to improve my language skills, meet people, and learn about the culture. Since then, I've worked as a writer and photographer, having contributed to more than twenty books for the travel publisher Lonely Planet and other publications. I started an acclaimed blog about Thai food, and shot the photos for Andy Ricker's Pok Pok cookbooks.

For most of this time, I've lived in Bangkok, epicenter of the "pad Thais" and green curries that have made Thai food so famous worldwide. Yet it took

traveling outside the capital to learn that Thai food is anything but a single entity. Nearly twenty years of eating in just about every part of the country have taught me that, from region to region, Thailand's flavors, ingredients, cooking methods—even for staples like rice—differ immensely. And it's these uniquely regional dishes—a fish curry at a roadside stall on an island in southern Thailand that was so intensely spicy I was, momentarily, high; an unexpectedly sweet and fragrant salad of raw minced buffalo eaten at the edge of a rice field in Thailand's north; a crunchy, intensely herbal stir-fry of dried cobra served from a shack in central Thailand—that I've found myself most frequently drawn to.

Yet of Thailand's vast spread of regional cuisines and dishes, I find that I keep coming back to those of the country's north. The food of northern Thailand is a world away from the highly refined, royal court– and Chinese-influenced style of cooking associated with Bangkok and central Thailand—the Thai food that most of us are familiar with. It's a cuisine with its own distinct identity, one that is rustic and earthy, meaty and fragrant; one with roots in the Thai repertoire but with branches that extend beyond the country's borders; a cuisine that manages to feel ancient and contemporary, domestic and foreign, all at the same time.

Led to remote destinations in the course of work, I've had the chance not only to eat northern Thai dishes in every province in the region but also to talk with northern Thai home cooks, restaurateurs, and academics. I have photographed rural markets and cooked with locals. I have spent time in libraries, poring over old texts and recipes, and hours in the kitchens of food vendors and housewives. From these experiences, I have assembled a body of knowledge and photographs of a cuisine that few in Bangkok know much about, let alone those in the English-speaking world.

What, then, is northern Thai food? We have the rest of this book to explore that question, but for now, my mind flits to sitting on the floor, cross-legged, at the edge of a short, squat table, plucking sticky rice from a bamboo basket. I

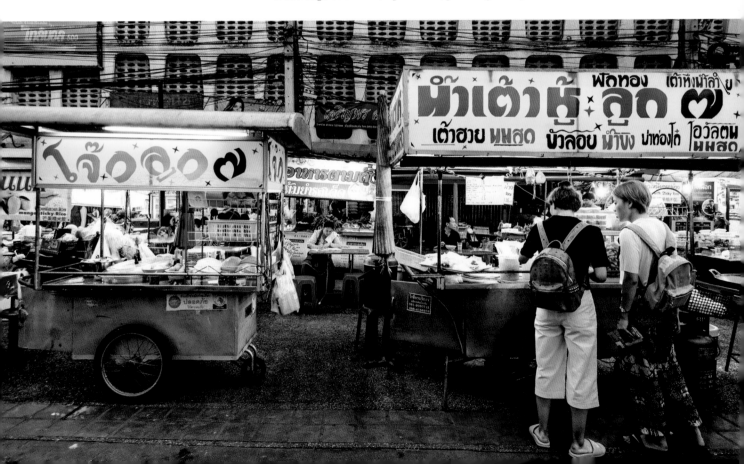

think of rolling that rice into a ball with my fingers and swiping it into dips that are smoky, spicy, and salty. I'm reminded of soups packed with so many herbs that identifying a single one is an almost impossible task. Of hazy grills stacked with mysterious banana leaf packages, coils of sausage, and unidentifiable pork parts. And of home cooks preparing food from muscle memory, not recipes. To me, northern Thai food means dishes made from raw meat that are as delicious as they are intimidating. And noodle soups that are so fundamentally, effortlessly tasty that there's no barrier to entry; they're just plain *good*, no matter what you grew up eating.

Death thwarted, I pull into Um Phang, but only to find that the *laap* shack is gone. Instead, there's a shiny new 7-Eleven—Um Phang's first—by far the brightest and most modern building around, drawing the town's hungry like moths to a flame.

Nearly two decades of documenting food in Thailand have also instilled in me a sense of urgency. The way people eat is changing rapidly and profoundly. Across the country, modernization and increasing wealth are having a huge impact on Thai food. A Western-style diet is becoming the norm, and these days, hot dogs can seem as common as *tom yam*. Likewise, Thailand's local cuisines are becoming increasingly homogenous, and the current generation of cooks is probably the last who will have been direct witness to the full vastness of the country's culinary diversity.

This book is not an encyclopedia of northern Thai food. The recipes included here are not meant to define the cuisine, nor are they exhaustive. Rather, they stem from six provinces in northern Thailand that boast particularly vibrant culinary legacies. Nor is this book meant to be a nostalgic reminiscence of what people used to eat. My hope is that it can serve as a snapshot of the culinary world of northern Thailand as it stands today, of the people, dishes, ingredients, and cooking techniques that form this unique, fascinating, and delicious cuisine.

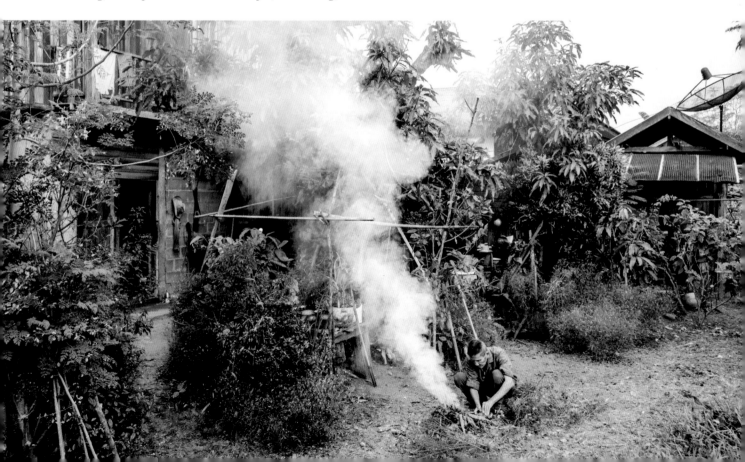

A (Very) Brief History of Northern Thailand

The region known today as northern Thailand is thought to have been first settled by a people called the Lua (or Lawa). Little is known about the Lua, except that their existence was documented by the Mon, the next significant group to settle the area and the first to leave written records. The Mon, thought to have arrived in northern Thailand around the ninth century, founded the region's first kingdom, known as Haripunchai, which was governed from current-day Lamphun.

The Tai (the wider ethnolinguistic group from which the Thai, northern Thai, Lao, Shan, and other related groups stem) most likely originated in Sichuan Province in southern China. Pushed southward by the Mongols, they gradually dispersed and resettled in northern Thailand's fertile river valleys between the twelfth and fourteenth centuries. By the end of the thirteenth century, they had displaced the Mon entirely, in the process having gleaned from them important cultural attributes ranging from Buddhism to a written script.

The Tai united in 1262, forming a kingdom known today as Lan Na (or Lanna), meaning "a million rice fields." Initially based in present-day Chiang Rai, Lan Na expanded rapidly through a series of alliances with neighboring kingdoms and small city-states known as *mueang*. In 1339 the seat of Lan Na was shifted to Chiang Mai, yet northern Thailand's physical geography meant that the various *mueang* often maintained significant autonomy, and the subsequent two centuries were largely defined by disputes between Chiang Mai and the principalities under its control, as well as with the central Thai kingdom of Ayuthaya. Burma, taking advantage of this discord, successfully invaded Lan Na in 1558 and subsequently ruled the kingdom for more than two centuries.

With the help of the Siamese government, Lan Na eventually escaped Burma's grip in 1796, but this came at the cost of its autonomy: in 1882 Lan Na became a vassal state of the Bangkok-based kingdom of Siam. Under Siam, expansionist threats from France led to huge swaths of Lan Na territory being ceded to French Indochina. Likewise, pressure from colonial Britain meant that Lan Na had to give up its lucrative monopoly on the teak trade, eventually granting logging rights to the British and their Burmese subjects.

In 1931, the kingdom of Nan, the last Lan Na holdout, was incorporated into Siam, and a year later, Chiang Mai was officially granted provincial status, signifying the last breath of the Lan Na kingdom as an autonomous entity.

The People of Northern Thailand

The vast majority of the inhabitants of Thailand's north belong to the Tai ethnolinguistic group, from which the Thai, Lao, Shan, and other groups stem. The largest group is, not surprisingly, the northern Thai, who refer to themselves as *khon mueang* (from *khon mueang nuea*, "people of the northern region"), and who probably came from southern China, settling in the region known today as northern Thailand around the twelfth century. Like the Thai in the rest of the country, they're predominately Buddhist, yet they have their own distinct cultural attributes, ranging from architecture to cuisine, and they speak a slow, lilting dialect of Thai (*kam mueang*, "northern words") that can be incomprehensible to those from other parts of the country.

After the *khon mueang*, the largest Tai group in the north is the Shan. Also known as Thai Yai, Tai, or, somewhat pejoratively, Ngiaw, the Shan have historically lived within the borders of present-day Myanmar, but beginning in the mid-nineteenth century they emigrated to Thailand in great numbers to escape conflict. More Shan arrived in northern Thailand's urban centers during the latter part of the nineteenth century, when the British and their Burmese subjects (who included the Shan) were granted logging rights in Thailand. The Shan have had the most significant culinary impact on northern Thailand of any minority group, likely introducing such staples as *khao kan jin* (page 245) and *khanom jiin naam ngiaw* (page 189), among many other dishes.

Another Tai group that has had a palpable impact on the culture of northern Thailand is the Tai Lue. Originally from southern China, the Tai Lue settled in the former northern Thai kingdom of Lan Na during the late eighteenth century. Many were brought to the present-day province of Nan, where their influence can be seen in the architecture, art, and dress, although less so in the province's food.

The Chinese have had a long presence in northern Thailand, beginning with the Jeen Haw, Muslims of Yunnanese-Chinese descent who, as far back as the sixteenth century, plied an important trade route linking Yunnan Province in southwestern China, northern Thailand, and southern Myanmar. Although the Chinese influence on northern cuisine is significantly less than that in central and southern Thailand, the Jeen Haw most likely introduced *khao soi* (see page 30),

today northern Thailand's most famous dish. Subsequent Chinese immigration, starting in the late nineteenth century and largely centered in the cities of Lampang and Chiang Mai, saw the introduction of Chinese ingredients such as soy sauce and noodles, and cooking techniques such as wok-frying, that have since become contemporary Thai standards. The most recent group of Chinese to impact the north's culinary landscape are ex-Kuomintang (Chinese Nationalist Party, also called KMT) fighters who fled China following their defeat by communist forces in 1949. After being booted out of Burma in the early 1960s, they resettled in the more remote and mountainous areas of Chiang Mai, Chiang Rai, and Mae Hong Son Provinces, where they introduced tea agriculture and a repertoire of Yunnanese-Chinese dishes.

Also noteworthy are Thailand's so-called hill tribes, highland-dwelling groups with origins in China and Burma who began to inhabit northern Thailand during the nineteenth century. There are nine officially recognized hill tribes in northern Thailand, from the Akha to the Yao, and although few of their dishes have become part of the standard northern Thai repertoire, they remain responsible for the production of certain crops associated with the north, such as chayote, corn, and even coffee.

The Karen, one of the largest minority groups in the north, is often considered a hill tribe, although many inhabit the same lowland valleys as the Tai. They are closely associated with the production of incendiary *phrik kariang*, "Karen chilies," grown in Mae Hong Son.

The Food and Flavors of Northern Thailand

How does one even begin to encapsulate an entire cuisine? The food of northern Thailand is old: it's dominated by simple dishes like soups and salads, and by ancient cooking methods such as grilling. It's a mix of the indigenous and the imported, a jumble of ingredients from the region and influences that stem from Myanmar to China. It's unabashedly rustic, although perhaps not quite as spicy as one might expect. It loves its vegetables, and, especially nowadays, it also loves its meat.

Compared to those of Thailand's other regional cuisines, northern Thailand's dishes are arguably the least spicy. Unlike the refined, court-influenced style of cooking in Bangkok and central Thailand, there's relatively little effort to include or balance the four flavors of salty, sour, sweet, and spicy in a single dish. Instead, many northern Thai dishes, broadly speaking, push more in just one or two directions, typically emphasizing herbal, bitter, fragrant, and/or meaty flavors. Often, the flavor of a dish comes from one or two herbs, spices, or other ingredients, rather than a complex blend of multiple seasonings.

Unlike in Bangkok and central Thailand, where curry pastes—the base of many Thai curry and soup dishes—are often blends of a complex variety of overtly fragrant herbs and dried spices, most northern Thai dishes are based around a simple combination of chili, shrimp paste, shallots, and garlic, which are sometimes grilled before being pounded into a paste. This cornerstone is the source of the savory, salty flavor that so many northern Thais are fond of.

Seasonings specific to the north include salt (often used in place of the fish sauce so key to central Thai cooking) and *thua nao khaep* disks of dried, fermented soybeans (see page 227) that are sometimes used in place of the central Thai shrimp paste. *Naam puu*, a dark paste that is the result of boiling tiny field crabs with herbs (see page 57), is used in some salads, and many dishes include *plaa raa*, a pungent, salty, unfiltered seasoning made from fermented freshwater fish. Sugar plays a very minor role in the northern Thai kitchen. Likewise with coconut milk, as coconut palms don't thrive in the region, although you will see them occasionally in areas that have been influenced by trade and travel.

Dried spices make regular appearances in the northern Thai kitchen, most notably *makhwaen*, the husk and seed of an evergreen shrub related to Sichuan pepper and prickly ash that's not eaten elsewhere in Thailand. Like its relatives, *makhwaen* provides *laap* (a "salad" of minced, typically uncooked, meat) and many other northern Thai dishes with a floral, citrusy, almost pine-like fragrance and a subtle numbing sensation. Additionally, *phong hang lay*, an Indian-masala-inspired spice blend, is used in a handful of northern Thai dishes. The high floral note of coriander seed appears in some curry pastes, pleasantly astringent turmeric powder features heavily in the Shan-style cuisine of Mae Hong Son, and smoky black cardamom pops up in several dishes of Chinese origin or influence.

Herbs are hugely important in northern Thai cooking, and there are more than forty edible herbs indigenous to the region, many of which are not available outside the area. Some are used as seasonings and some as garnishes, while many leafy, often bitter, astringent, or sweet-tasting herbs feature as optional sides to the region's meaty dishes; you'll find platters of them served alongside, allowing diners to customize each bite with their flavors.

In the past, northern Thai ate large animals only on special occasions, but today, pork has emerged as the most common protein. Every part of the pig is used, from the skin, which is deep-fried into crispy pork rinds, to offal, which is grilled or thinly sliced and included in northern Thai–style *laap*. Beef and water buffalo, meats generally eschewed in central Thailand, are also common in the north, and as in other landlocked parts of Thailand, scrawny-but-flavorful free-range chickens and freshwater fish are ubiquitous and beloved, and are served grilled, steamed, and in soups. Other proteins eaten in northern Thailand include insects and insect eggs, snails, ant eggs, and silkworm larvae.

Yet perhaps the most important and distinctive food item associated with northern Thailand is rice. Like the residents of Isan, Thailand's northeastern region, northern Thais prefer glutinous or sticky rice: short, fat grains of chewy rice that are steamed, not boiled, and eaten by hand, rolled into a small ball and dipped in the various dishes (for more on sticky rice, see page 54).

Given that the north was the first region to be settled by the Tai people, it's not surprising that its cooking techniques remain, in many ways, among the country's oldest and most conservative. Stir-frying—a relatively recent Chinese

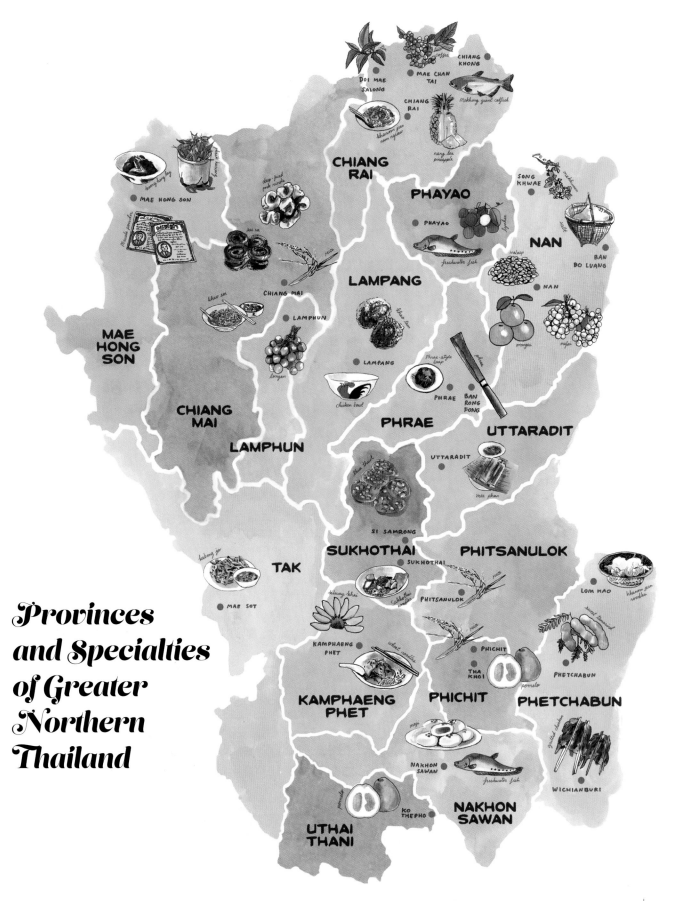

Provinces and Specialties of Greater Northern Thailand

introduction—has made few inroads in northern Thailand, and most traditional dishes are boiled or grilled.

Indeed, the grilling of meat has an almost cultlike following in northern Thailand, and the region's most common type of eating establishment is the grill. Meats, ranging from beef loin to pork teat, are slow-grilled over smoky coals and paired with alcohol. Northern Thailand's grilled dishes are minimally marinated but are served with dips that range in flavor from sweet to spicy. Northern Thai grills also feature more sophisticated items such as *sai ua* (herb-packed pork sausages; page 74) and *jin som mok khai* (deliciously tart, rich banana leaf packages of fermented pork and egg; page 64).

Conversely, the region is also notable for its abundance of raw meat dishes. These range from *laap* to *luu*, a shockingly red "soup" of raw pork blood, both available across the region but particularly associated with the provinces of Phrae and Nan.

In recent decades, deep-frying has emerged as one of the most popular and emblematic methods of cooking in northern Thailand, particularly in Chiang Mai. Thai visitors to the city are practically obligated to bring bags of deep-fried pork rinds back to friends and family, while urban locals cherish late-night meals that couple *naam phrik* (spicy dips or relishes) with deep-fried bites ranging from chicken to pork belly.

Given that the region has a more variable climate than elsewhere in Thailand, preservation also plays an important role in the northern kitchen. This is evident in foods ranging from *jin som* (pork made sour after fermenting for three days; see page 63) to the previously mentioned disks of fermented, dried soybeans that can be kept for weeks—if not months.

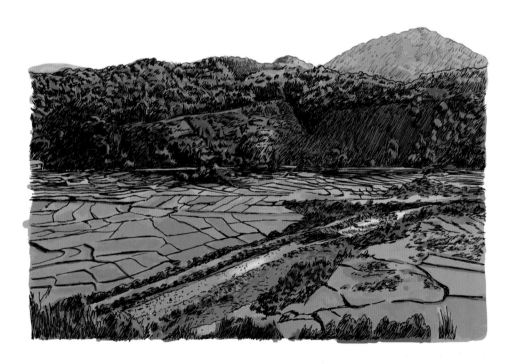

Cooking Northern Thai-Style

This book offers a close look at a regional cuisine. As is the case when delving into any highly specific foreign topic, there can be a steep learning curve: names appear unpronounceable, methods unfamiliar, the end results obscure. In the course of researching this book, I made it my goal to record the way people cook and eat in northern Thailand as accurately as possible. As such, I'm proud to say that I've made no exceptions. Yet, at the same time, I acknowledge that many of these methods, ingredients, and dishes will be unfamiliar to diners in Bangkok, let alone those in, say, Iowa or Belgium. Adding to the difficulty is the fact that the written word isn't always the ideal medium to accurately convey nuanced, sensory experiences such as taste and fragrance. I've made an effort to explain things as clearly as possible, but a bit of experience in Thai cookery will certainly help put things in context. For excellent crash courses in the fundamentals of Thai cuisine, consider reading and cooking a few dishes from *Pok Pok*, by Andy Ricker with JJ Goode; *Simple Thai Food*, by Leela Punyaratabandhu; or *Thai Food* or *Thai Street Food*, both by David Thompson.

Beyond these titles, below are some of the building blocks—both practical and theoretical—that will help you make the most of your experience cooking northern Thai dishes.

COOKING BY SENSE

Northern Thais cook almost exclusively by experience, taste, and intuition. I've been in dozens of northern Thai kitchens, and the only times I've seen measuring cups or scales are in the kitchens of those making sweets (pastry chefs around the world are all alike); I've yet to see a single northern Thai cook from a written recipe. Instead of meticulously measuring ingredients or following instructions, northern Thais cook via meticulously tasting dishes, dipping in and out, and adjusting seasonings to arrive at an intersection of balanced flavors and subjective preference.

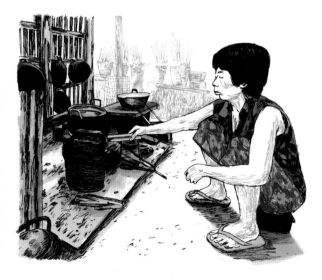

Therein lies the paradox: this a cookbook, and for a cookbook to work consistently, it must include recipes that give precise amounts. But your tomatoes might be sweeter than those available in Chiang Mai, your turmeric powder faded in comparison to the freshly ground stuff available in Mae Hong Son. The only way to bridge this gap is to cook as the northern Thais do and employ your

senses. And by that I mean all of the senses, as in northern Thailand the way a dish looks, smells, and feels can be just as important as how it tastes.

With this in mind, to cook like a northern Thai, it's necessary to become familiar with the following parameters, included here in order of their importance in the northern Thai kitchen:

TASTES

Key in any region is an understanding of the six predominant flavors of Thai cuisine: umami, salty, sour, bitter, spicy, sweet. Yet unlike Bangkok- and central Thai–style cooking, which often strives to include all of these elements in a single dish, in northern Thailand, certain tastes tend to feature more prominently than others.

UMAMI: Judging just by the amount of monosodium glutamate (MSG) that northerners add to their dishes (i.e., too much), the meaty roundness of umami is one of the most cherished flavors of the cuisine. It is present in, if not headlining, just about every dish, from soups to salads. Meaty ingredients and other naturally glutamate-heavy items such as tomatoes or fermented soybeans are also used as sources of this flavor, but nearly all cooks in northern Thailand also use MSG flakes (usually Ajinomoto brand). I leave it to you to decide if you want to use this enhancer in these recipes.

SALTY: Salt simply makes everything taste better, and it features prominently, though not overwhelmingly, in the northern Thai repertoire. Salt, soy-based sauces, and, increasingly these days, fish sauce are the main sources of this flavor.

SOUR: Tart flavors are essential to many northern Thai dishes. Yet unlike elsewhere in Thailand, where sourness typically comes from the addition of acidic liquids such as lime juice, tamarind pulp, or vinegar, in the north it often comes from the inclusion of inherently sour ingredients like tart leaves, tomatoes, or even fermented pork.

BITTER: Feared in the West, bitterness is a beloved flavor in traditional northern Thai cooking, prized perhaps even more than spiciness. In northern Thailand, bitter flavors can come from the addition of an herb or vegetable, or sometimes beef bile.

SPICY: Forget what you have probably heard about Thai food; the food of Thailand's north is not about blowing your ears off with chili. Yes, there's often some heat, typically from the addition of a few fresh or dried chilies, but it's rarely the predominant flavor, instead functioning as a moderately loud part of the background noise.

SWEET: Where savory dishes are concerned, sweet is the least appreciated flavor in northern Thai cooking. Unlike in central Thailand, where dinner will boast a trace (or more) of sweetness, sugar is rarely—if ever—added to dishes in the north. Even northern Thailand's sweet snacks aren't particularly sugary, many getting their sweet flavor from ingredients such as bananas, or emphasizing fragrance as much as sweetness.

AROMAS: In northern Thailand, the way a dish smells can be just as important as—or sometimes even more important than—how it tastes. In the north, aroma generally stems from fresh herbs or dried spices, but it can also mean the (pleasantly) funky odor of fermented fish sauce or soybeans, or a whiff of smoke.

TEXTURES: Mouthfeel is an essential aspect of northern-style cooking, but again, unlike in Bangkok and central Thailand, where dishes are seemingly engineered to include multiple contrasting textures in every bite, northern Thai cooks are generally happy to emphasize one, maybe two, distinct textures in a dish.

Once you're familiar with these characteristics, cooking northern Thai–style becomes—among other things—an effort to achieve a balance of the elements that traditionally define a dish.

HOW TO COOK FROM THESE RECIPES

For an illustrated guide to northern Thai cooking methods and tools, see pages 24–25 and a detailed glossary of ingredients on pages 324–28.

MEASUREMENTS

Unless you already have a firm sense of northern Thai flavors and seasonings, weight is really the only way to communicate exactly how much of a particular ingredient needs to be included in a dish, and a digital scale is by far the most accurate way to measure this. Because the amounts of aromatic ingredients in this book tend to be minute, I've opted to use the metric system as the standard in these recipes and have both recorded and developed them using grams and, where practical, volume measurements like teaspoons and cups. For convenience's sake, I've also included pound and ounce weights, but note that these are rounded conversions from the metric and may sometimes be inconsistent; the recipes will work, but to get as close as possible to the recipes I recorded, I recommend going by the gram measurements. Plus, you should adjust according to how a dish is meant to taste; I've included detailed descriptions of how each dish should taste, smell, and feel to act as a guide.

TASTING

As mentioned previously, northern Thais cook by frequent tasting, which also is how you should approach these recipes. Start with the prescribed amounts and taste the dish several times, adjusting as you go, ideally arriving at an intersection of the flavors described in the recipe and those you personally prefer.

SERVING SIZES AND NORTHERN THAI MEALS

By American standards, the serving sizes in the book may appear small. This is because a dish, unless noted otherwise, is meant to be served Thai-style, that is, as part of a greater meal that includes at least two other items, to be eaten by a group of four people, and almost always served with sticky or long-grained rice.

Northern Thai Cooking Methods

In northern Thailand, there's a variety of cooking methods specific to the region; in particular, this means a variety of ways to cook ingredients over coals, with subtle differences between them.

AEP / แอ็บ A method of cooking in which ingredients are seasoned and wrapped in a banana leaf before being grilled over coals.

AWK / อ็อก A method of cooking in which ingredients—most notably eggs but also fish—are put in an open container made from banana leaf and grilled over relatively hot coals.

HUM / อุ่ม To simmer relatively large pieces of meat until tender.

JAW / จอ To simmer vegetables.

JAAW / จ่าว To season a dish by adding it to a wok with hot crispy garlic and garlic oil.

JII / จี่ To grill relatively large items such as fish, offal, or fresh chilies directly on hot coals, typically before inclusion in another preparation.

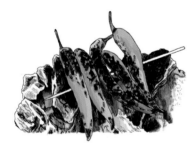

JUEN/KHAEP / จืน/แคบ To deep-fry in oil, which in northern Thailand is generally done at a relatively low temperature.

KHUA / คั่ว To stir-fry in a wok, with oil, but can also refer to frying in a small amount of water, or dry-roasting.

MOK / หมก Grilling relatively small items such as garlic, shallots, or even fermented fish (the latter wrapped in banana leaf) directly on hot coals, typically before including the ingredient in another preparation.

NUENG / นึ่ง To steam; also the verb used to describe how sticky rice, known locally as *khao nueng* ("steamed rice"), is cooked.

OP / อบ To simmer ingredients over low heat in a pot with a closed lid.

PAAM / ป่าม To cook an ingredient—typically egg—with no oil, usually on/in a banana leaf. Sometimes synonymous with *awk*.

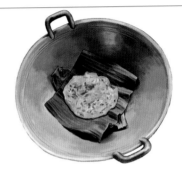

PHING/AEN / ภิ่ง/แอน Slow-grilling over coals, typically in order to prepare ingredients such as dried chilies, dried fish, or dried spices for inclusion in other dishes.

PING / ปิ้ง To grill meat or fish over coals.

Northern Thai Kitchen Tools

When any cooking tool or utensil not standard to the Western kitchen is required in a recipe, I've made a note of it. Those that appear most frequently in the northern Thai kitchen—and are thus worth investing in—include the following:

CLEAVER / *LAAP* KNIFE: If you don't have access to a heavy-bladed Thai-style *laap* knife, you'll need a large cleaver to mince meat finely for *laap* or to chop through bones.

DIGITAL SCALE: One of the most important tools for cooking from this cookbook is, paradoxically, something you'll never, ever find in a northern Thai kitchen. That's because while northern Thai cooks work from memory and a sense honed by years—or decades—of experience, the best way I can think of to communicate this is, in part, to use the most accurate way of measuring ingredients. So, if you don't have one, buy an inexpensive digital scale, and see page 23 for tips on cooking with weight and mass.

ELECTRIC RICE COOKER: This seemingly modern indulgence may clash with the rustic aura of northern Thai cooking, but just about everybody in northern Thailand—even those in remote hill tribe villages—uses one to cook long-grained rice. And there's no need to go fancy: I still use the same cheapo Panasonic model I bought at Talat Ton Phayom in Chiang Mai back in 1999.

GRANITE MORTAR AND PESTLE: In flipping through this book, it will quickly become apparent that many northern Thai dishes are based around curry pastes, which are combinations of herbs, spices, and other ingredients pounded and blended with a granite mortar and pestle. Yes, the northern Thai, especially food vendors who prepare large quantities of food, use electric food processors. And so can you. But the results are, frankly, inferior. And once you take the plunge, I guarantee you'll find that the mortar and pestle is a handy kitchen tool for a number of tasks besides pounding curry pastes, including grinding dried spices, crushing garlic and chilies for stir-fries, and even tenderizing meat. I'd recommend a medium-sized set (with an opening at least six inches in diameter); anything smaller is impractical, and anything bigger packs a heft that will probably discourage frequent use. Some recipes call for a large clay or wooden mortar and pestle set; although not absolutely necessary, its larger size makes it more convenient for making pounded salads. See page 47 for tips on using the mortar and pestle like a northern Thai.

GRILLING BASKET: This hinged, wire-mesh tool serves as a convenient way to grill anything from whole fish to dried chilies over coals.

NOODLE BASKET: If you plan on making any noodle dishes, this tool, a cup-like wire basket attached to the end of a long bamboo handle, will make the task of cooking and straining noodles much easier.

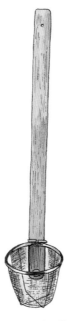

PAPAYA SHREDDER: Similar to a vegetable peeler but with a corrugated blade, this tool makes it easy to shred green papaya into thin strips.

STICKY RICE STEAMING POT AND BASKET: Sticky rice is the staple carb in northern Thailand, and these two inexpensive tools (unrelated to the Thai-style steamer mentioned at right) are the best—and most convenient—way to prepare it. For more on steaming sticky rice, see page 54.

THAI-STYLE CHARCOAL GRILL: This item is not obligatory, and a Western-style barbecue (or even the broiling function of an oven) does a similar job. But for a relatively convenient way to grill, especially one that imparts that desirable smokiness, nothing beats this tool. Look for one that's at least twelve inches in diameter.

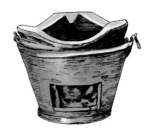

THAI-STYLE STEAMER: This book features several steamed dishes that are made most conveniently if you have a relatively wide steamer (approximately eleven inches in diameter).

WOK: For the vast majority of recipes in this book, a medium wok (approximately twelve inches in diameter) is sufficient; it's what I—and many northern Thai—use at home. To make the most of this tool, be sure to also buy a wok spatula. If you plan on doing a lot of deep-frying or making some of the sweets in this book, then you may also want to consider investing in a larger, heavy-bottomed wok, which does a better job at distributing heat evenly, thus maintaining a more consistent temperature.

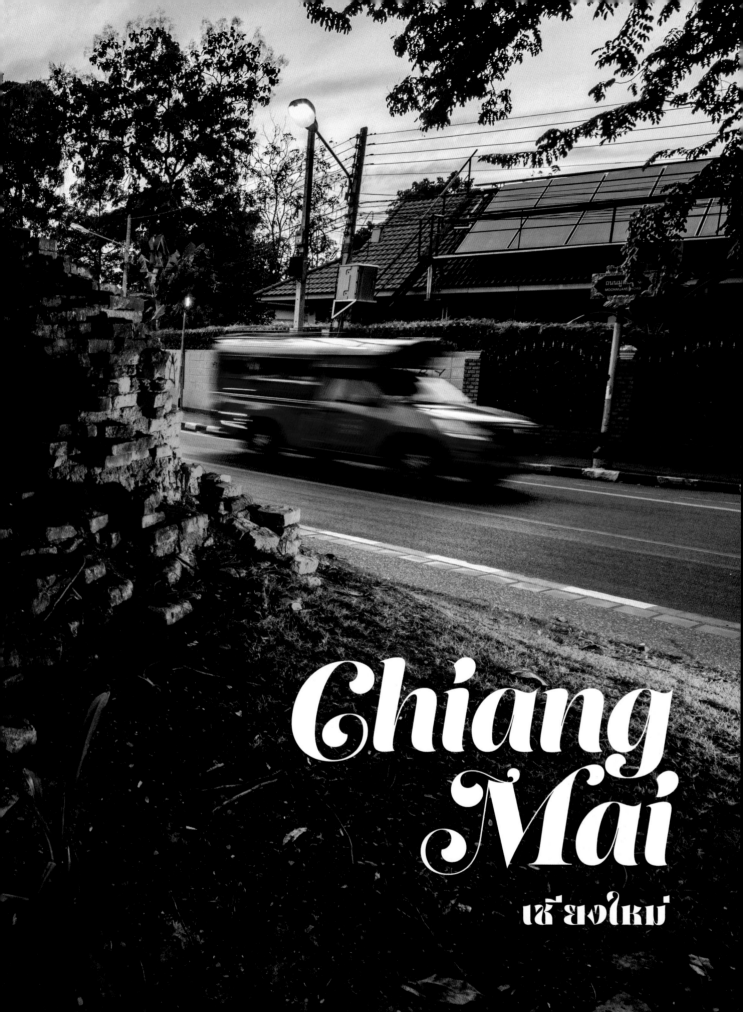

Chiang Mai

เชียงใหม่

Chiang Mai was my introduction to northern Thailand. In 1998, I boarded a bone-rattling, fan-cooled, second-class train north to the city. It was my first visit to Thailand, and I had spent only a couple days in Bangkok at that point, but upon arriving in Chiang Mai, the differences were immediately palpable. The weather was cooler. The pace was slower. The temples looked older. The people seemed friendlier (my neighbor on the train, an old woman, offered me a bag of sticky rice—a sign, perhaps?). Even the food seemed different from what I'd encountered in Bangkok, although I couldn't quite put my finger on it at the time. And coming from Oregon, I appreciated the mountains and greenery. Simply put, it just clicked, and I knew then that Chiang Mai would be a place that I'd be coming back to.

I can only suspect that Mengrai, the first king of the Lan Na kingdom, must have felt the same way. In 1296 he chose Chiang Mai as the new seat of his realm. (*Chiang* was the title given to cities, typically walled, in the Lan Na kingdom that functioned as the home of a king or important prince; *Mai* means "new.") Under Mengrai's rule, Chiang Mai rapidly achieved both political power and wealth, but it can be argued that much of this was also due to its favorable geography. An early chronicle states that the city "turned its back to the hill and faced the water," the hill being the mountain known today as Doi Suthep, and the water, the Ping River. This unique position meant that Chiang Mai had a nearly constant flow of water, with another chronicle stating that the Chiang Mai basin was so fertile that the rice yield for one year could provide sustenance for seven years. The forests that surrounded Chiang Mai were an additional source of food and livelihood, and an early poem states that the city was home to three important markets that sold agricultural products including rice, chilies, betel leaves, betel nut, cotton, and basketry.

As Chiang Mai emerged as an important center of commerce, it drew Shan, Burmese, Chinese, and other traders, eventually earning the nickname "City of Twelve Languages." This mix of outside influences came to shape Chiang Mai's culture, and even today, Burmese-style Buddhist temples, hill tribe residents, and Chinese mosques continue to give the city its uniquely jumbled cosmopolitan character. This diversity also had a huge impact on Chiang Mai's food, and dishes with ostensibly foreign roots, such as *khao soi*, the city's famous curry noodles, took root there, eventually spreading outward and influencing cuisine across northern Thailand.

Since that train ride in 1998, I've been based in Bangkok. Yet over the years, I've visited Chiang Mai frequently, and it strikes me that it has managed to retain its place as northern Thailand's most culturally diverse city; at this point, with foreign investment and immigration, digital nomads and backpackers, the city's languages surely number in multiple dozens. Bangkok- and Western-style life, with its malls and traffic, its fast food and big-city glitz, have arrived and can appear to dominate some corners of the city. But Chiang Mai's moat, ancient walls, and charming Buddhist temples, its ubiquitous restaurants selling *khao soi* (see page 31), open-air stalls serving *khanom jiin naam ngiaw* (a soup of tomatoes and pork ribs served over thin rice noodles; see page 189), late-night haunts specializing in deep-fried dishes, and markets where sticky rice remains the carb of choice continue to give the city its own unique cultural and culinary vibe. This blend of the new and old, local and foreign, is what shaped Chiang Mai from the beginning.

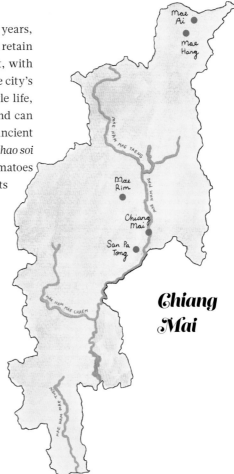

Chiang Mai

The Mystery of Khao Soi

Khao soi, a chicken- or beef-based curry broth made rich with coconut milk, fragrant with a mild dried spice mixture, and bulked out with wheat-and-egg noodles, is without a doubt Chiang Mai's—if not northern Thailand's—most famous food item. Yet the dish, so closely associated with the city, is at the same time both emblematically Chiang Mai and utterly foreign.

Today, most vendors in Chiang Mai attribute *khao soi* to the Jeen Haw, Muslims of Yunnanese-Chinese descent who, as early as the sixteenth century, plied a web of overland trading routes that linked Yunnan, northern Thailand, and Mawlamyine (in present-day Myanmar). In the early twentieth century, some Jeen Haw began to put down roots in Chiang Mai, predominately in the area east of the walled city known now as Ban Ho ("Jeen Haw Village"), or in English as the Night Bazaar. It is approximately during this period that we begin to hear about *khao soi*, a dish that was allegedly sold and eaten exclusively by the Jeen Haw. But just about every long-standing vendor of the dish in Chiang Mai claims that the *khao soi* prepared by their predecessors bears little resemblance to the dish we know today.

Several vendors told me that the original *khao soi* included noodles made from rice, not the current wheat-and-egg variety. Others mentioned that the early version of the dish was topped with minced meat stir-fried with pickled vegetables, not the larger cuts of curried meat that we know today. And nearly everybody agrees that the original *khao soi* did not include coconut milk, a defining element of the contemporary dish.

Why would there be such fundamental differences between the original Jeen Haw–style *khao soi* and the dish served today?

One common theory among contemporary vendors is that coconut milk and dried spices were added to *khao soi* to suit the palates of central Thai, or even those of Chiang Mai's Indian and Burmese communities. Another posits that, while on the caravan trail in Myanmar, the Jeen Haw encountered *ohn-hno hkauk-hswe*— a Burmese dish that's a combination of wheat noodles, a coconut-milk-based broth, chicken, a crispy deep-fried noodle garnish, and sides of lime and sliced shallots—and decided to integrate these elements into their own noodle dish.

I suspect that it's simply a quirk of language. Several of the Jeen Haw caravan routes passed through Myanmar, where the generic word for "noodles" is the Shan term *hkauk-hswe*. Corrupted to *khao soi*, this term would have been roughly understood by northern Thai and could have been applied to just about any noodle-based dish, old or new. Admittedly, given the hazy memories and lack of written records on the topic, this is all speculation. But what's undeniable is that *khao soi* serves as both a concrete and an abstract reminder of the people and cultures that mixed and mingled to shape the cuisine of Chiang Mai.

Khao Soi Yunnan

ข้าวซอยยูนนาน

"ANCIENT" *KHAO SOI*

SERVES 4 TO 6

"The original *khao soi* had no coconut milk—Chinese people don't like it!" says Temsiri Wiyakaew, a vendor of the noodle dish in Chiang Mai and herself of Muslim-Chinese ancestry.

I'm in Temsiri's narrow shophouse restaurant, where she's offered to show me how to make *khao soi Yunnan*, by numerous accounts the precursor to Chiang Mai's famous curry noodle dish and an item generally unavailable in the city's restaurants.

"We usually serve this dish at festivals at Chiang Mai's Ban Ho Mosque," she explains, as she loads a table with the dish's constituent parts. Among these, I spy the elements of *khao soi* that anyone who's eaten the dish in Chiang Mai will recognize: squiggly flat wheat-and-egg noodles; sides of sliced pickled mustard greens, shallots, and lime; a condiment of ground dried chilies simmered in oil. But as she adds pieces of poached chicken, a small bowl of deep-fried peanuts, and a topping of minced chicken stir-fried with pickled mustard greens and dried spices, it becomes clear to me that, although *khao soi yunnan* may not include coconut milk, it's an even more decadent dish.

Temsiri offers me a bowl, and one taste reveals a broth with a punch of umami and a subtle background fragrance of star anise and black cardamom, a topping that seamlessly blends meaty and acidic flavors, not to mention enough delicious sides to form a meal on their own. It's a true feast, and although I'm no closer to discovering how this dish is related to the coconut milk–based *khao soi* that has put Chiang Mai on the culinary map, it doesn't seem to matter so much anymore.

RECIPE CONTINUES

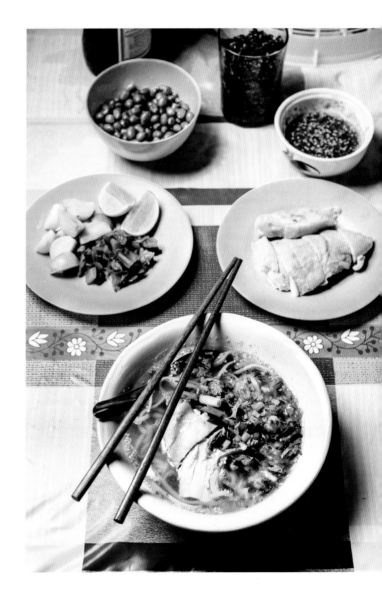

For Chili Powder Fried in Oil
12 large dried chilies (14 grams /
½ ounce total; see page 325)
6 tablespoons vegetable oil

For the Crispy Garlic and Garlic Oil
100 grams / 3½ ounces Thai garlic
(or 20 standard garlic cloves,
peeled; see page 325)
2 cups vegetable oil

For the Deep-Fried Peanuts
200 grams / 7 ounces skin-on raw
peanuts (or use roasted peanuts
and skip the frying step)
vegetable oil, for deep-frying

For the Toasted Sesame Seeds
¼ cup white sesame seeds

For the Dipping Sauce
juice of 2 limes
2 tablespoons black soy sauce
(see page 328)
½ teaspoon table salt
1 tablespoon sesame oil

For the Broth
4 to 6 bone-in, skin-on chicken
thighs (750 grams / 1¾ pounds
total)
1 tablespoon plus 1 teaspoon table salt
2 chicken carcasses (1 kilogram /
2¼ pounds total)
30 grams / 1 ounce ginger, peeled and
sliced
2 stalks lemongrass (50 grams /
1¾ ounces total), exterior tough
layers peeled, green section
discarded, pale section sliced
thinly
6 cilantro roots (13 grams / ½ ounce
total)
1 pandan leaf, tied into a knot (it's
easier to handle this way)
2 black cardamom pods (4 grams
total)
2 whole star anise (3 grams total)
1 tablespoon raw sugarcane sugar
½ teaspoon MSG (optional)

Prepare the chili powder fried in oil: Using a mortar and pestle, coffee grinder, or food processor, grind the chilies to a relatively fine consistency. Heat the vegetable oil and dried chili powder in a wok over medium-low heat. When the oil reaches a low simmer, fry, stirring frequently, until the chili powder is dark and fragrant, but not burned, about 10 minutes. Remove from the heat and let cool. Remove the chili oil mixture to a glass jar and seal tightly; it can be kept in a refrigerator for up to a couple months.

Make the crispy garlic and garlic oil: Pound and grind the garlic in a mortar and pestle until the cloves have a coarse, rough consistency just short of a paste. Heat the garlic and vegetable oil in a wok over medium-low heat. When the oil reaches a gentle simmer, lower the heat to maintain the temperature. Cook, stirring occasionally, until the garlic is fragrant, golden, and flaky, a total of around 30 minutes. Let cool. Transfer to a glass jar and seal tightly; the crispy garlic and garlic oil can be kept in a refrigerator for up to a couple months.

Prepare the deep-fried peanuts: Heat 1½ inches of oil to 250°F in a large wok over medium-low heat. Add the peanuts and fry, stirring occasionally, until slightly darker and fragrant, about 10 minutes. Remove the peanuts with a slotted spoon or spider, and drain on paper towels.

Prepare the toasted sesame seeds: Add the sesame seeds to a wok over low heat. Toast, stirring frequently, until slightly darker in color and fragrant, about 10 minutes. Remove from the heat and cool.

Prepare the dipping sauce: Pound and grind ¼ cup of the fried peanuts to a coarse powder using a mortar and pestle. In a small bowl, stir together the ground peanuts, 3 tablespoons of the chili powder fried in oil, 1 tablespoon of the toasted sesame seeds, 2 tablespoons of lime juice, the black soy sauce, ½ teaspoon salt, the sesame oil, and 2 tablespoons of water.

Taste, adjusting the seasoning if necessary; the dip should taste tart and spicy, salty and nutty (in that order).

Prepare the chicken thighs: The day before cooking, rub the chicken thighs with 1 teaspoon of the salt and allow them to marinate overnight.

Prepare the broth: The next day, bring 2½ quarts of water, the chicken thighs, chicken carcasses, ginger, lemongrass, roots, pandan leaf, black cardamom, star anise, and sugar to a boil in a large stockpot over high heat. Reduce the heat to a simmer. Remove the chicken thighs when they are just cooked through, after about 10 minutes. After 1 hour of simmering, add 1 tablespoon of the salt and the MSG (if using) to the broth and simmer another 30 minutes.

Taste, adjusting seasoning if necessary; the broth should be fragrant from the dried spices and herbs, and slightly salty. Using a cleaver, cut the chicken thighs through the bone into sections about ½ inch wide.

Prepare the topping: While the broth is simmering, crack the black cardamom, discarding the shell. Add the black cardamom seeds to a wok over medium-low heat. Toast, stirring frequently, until slightly dark in color and fragrant, about 10 minutes. Pound and grind the toasted cardamom seeds to a fine powder using a mortar and pestle. Remove and set aside. Repeat with the star anise. Heat the oil in a wok over high heat. Add the ground chicken and fry, stirring frequently, until cooked through, about 5 minutes. Reduce heat to medium, add the pickled vegetables, garlic, black soy sauce, salt, ½ teaspoon ground black cardamom, and ½ teaspoon ground star anise. Fry, stirring frequently, until the flavors have combined, another 5 minutes.

Taste, adjusting the seasoning if necessary; the topping should taste salty, tart, and fragrant from the dried spices and garlic.

Prepare the bowls: Bring at least 6 inches of water to a boil in a large stockpot over high heat. Put 75 grams / 2¾ ounces of noodles in the noodle basket and boil, agitating the basket until the noodles are just tender, about 20 seconds. Drain and add the noodles to a serving bowl. Top the noodles with 1½ cups of the broth, a scant ½ cup of the minced chicken topping, 1 teaspoon of the crispy garlic and garlic oil, 1 heaping teaspoon of the toasted sesame seeds, and a pinch of green onions. Repeat with the remaining ingredients for each bowl.

Serve the bowls with the chicken thighs and the dipping sauce, and the deep-fried peanuts, wedges of lime, shallots, and pickled vegetables.

For Serving

1 black cardamom pod (2 grams)
3 whole star anise (5 grams total)
2 tablespoons vegetable oil
250 grams / 9 ounces minced chicken
250 grams / 9 ounces Yunnanese-style pickled mustard greens (see page 110), chopped finely
3 garlic cloves (15 grams / ½ ounce), peeled and minced
1 tablespoon black soy sauce (see page 328)
½ teaspoon table salt
500 grams / 18 ounces fresh flat wheat-and-egg noodles
4 small green onions (80 grams / 3 ounces total), sliced thinly
3 limes, cut into wedges
100 grams / 3½ ounces shallots, peeled and sliced
200 grams / 7 ounces Yunnanese-style pickled mustard greens, sliced (see page 327)

THAI KITCHEN TOOLS
granite mortar and pestle
medium wok (approximately 12 inches)
large cleaver or *laap* knife
noodle basket

Advance prep: A day or two in advance, make the chili powder fried in oil, the crispy garlic and garlic oil, the deep-fried peanuts, the toasted sesame seeds, and the dipping sauce, and salt the chicken thighs.

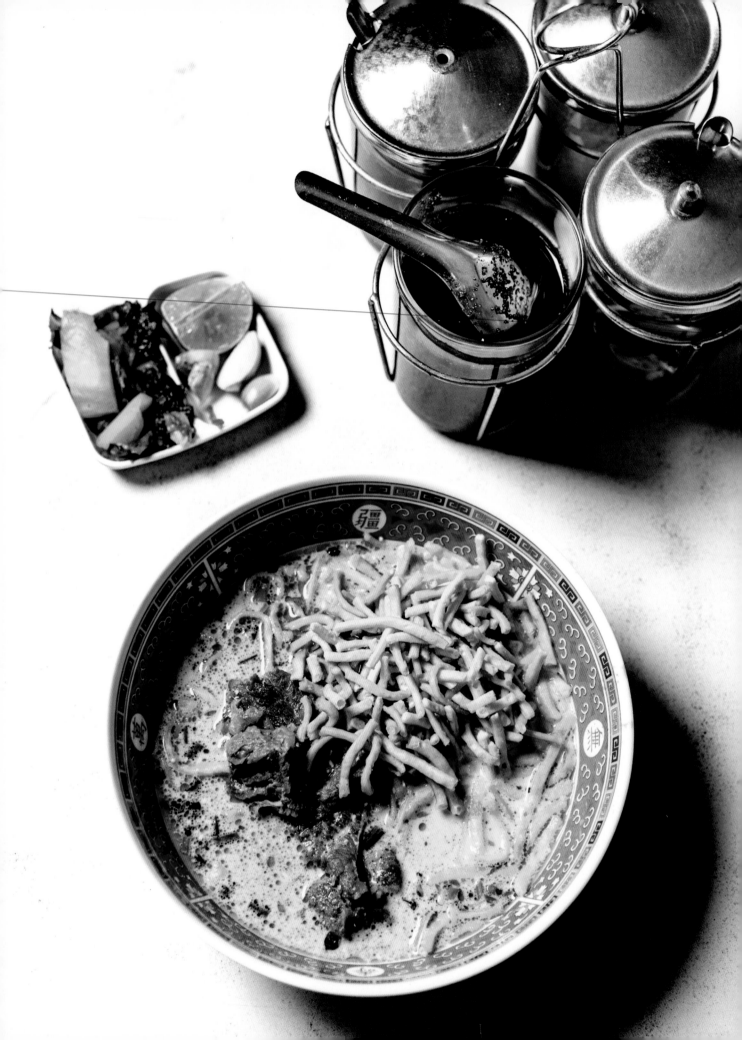

Khao Soi Nuea

ข้าวซอยเนื้อ

MUSLIM-STYLE BEEF *KHAO SOI*

SERVES 4 TO 6

In English, *khao soi* is often referred to as "curry noodles," a descriptor that, for most of us, implies spice. But as served by Chiang Mai's Muslim community—the people who most likely introduced it to the city—the dish is a subtle, some might even say bland, affair.

"Some people put curry powder in their *khao soi*," says Temsiri Wiyakaew, a Chiang Mai–based *khao soi* vendor, her disapproval apparent in her expression. "It smells too strong, I don't like it!"

Yet contemporary Muslim-style *khao soi* essentially begins as a curry, albeit one with relatively little dried spice.

"We make a dry curry with beef and let it simmer for two to three hours," explains Worakan Yuyangthai, the second-generation owner of Khao Soi Prince, a Chiang Mai–based restaurant that's been serving *khao soi* for nearly a half century. He's describing the first step in his family's take on the dish, a rich, thick curry—chicken is also an option—that can be served on its own, over rice. *Khao soi* is notable for including coconut milk in its broth, but when served at Khao Soi Prince and other Muslim restaurants in Chiang Mai, this ingredient is invariably kept separate. "To serve, we combine the curry and coconut milk in the bowl," says Worakan, explaining that this allows the diner to have a say in how rich his or her bowl is, and also prevents any unsold curry from spoiling too quickly.

Khao soi's other distinctive element is its noodles—squiggly shoelaces made from wheat flour and egg that Chiang Mai's best *khao soi* restaurants continue to make in-house. On a previous visit to Khao Soi Prince, I'd watched Worakan work a jerry-rigged pasta maker with the confidence of an Italian grandma, cranking out noodles that were both firm and delicious.

"The noodles are the pride of our restaurant," explains Worakan. "The Jeen Haw made their own noodles, so we do the same."

As is the case elsewhere, a portion of these noodles are deep-fried, serving as a crunchy garnish to the dish, along with a bit of chopped cilantro and green onion. And no bowl of Muslim-style *khao soi* is complete without sides that include slightly sweet, Yunnanese-style pickled mustard greens, sliced shallots, wedges of lime, and a spicy condiment of chili flakes simmered in oil.

The result is a union of disparate elements—a rich, creamy, subtly fragrant broth; tender cubes of slow-cooked beef; a crunchy garnish; and overtly acidic sides—that culminate in one of the country's greatest noodle dishes.

Chiang Mai *khao soi* vendors are notoriously reluctant to reveal their secrets, so the following recipe is a blend of what Temsiri Wiyakaew was kind enough to share with me and elements of the bowls sold at Prince and other Chiang Mai Muslim-run *khao soi* restaurants.

RECIPE CONTINUES

For the Crispy Noodle Garnish

vegetable oil, for deep-frying
80 grams / 3 ounces fresh flat
 wheat-and-egg noodles

For the Curry Paste

10 large dried chilies (16 grams /
 ½ ounce total; see page 325)
2 teaspoons table salt
20 grams / ⅔ ounce ginger, peeled
 and sliced
1 medium onion (200 grams /
 7 ounces), peeled and chopped
80 grams / 3 ounces shallots, peeled
 and sliced
8 garlic cloves (40 grams / 1½ ounces),
 peeled and sliced

For the Curry

2 black cardamom pods (5 grams
 total)
6 whole star anise (6 grams total)
¼ cup vegetable oil
1 tablespoon turmeric powder
35 grams / 1¼ ounces ginger, peeled
 and sliced
800 grams / 1¾ pounds beef
 shank, silver skin trimmed and
 discarded, 1-inch pieces
1 tablespoon black soy sauce
 (see page 328)
1 teaspoon raw sugarcane sugar
½ teaspoon MSG (optional)
1½ cups coconut milk
1½ cups coconut cream (see page 325)
500 grams / 18 ounces fresh flat
 wheat-and-egg noodles

For Serving

1 small bunch cilantro (20 grams /
 ⅔ ounce total), chopped
2 green onions (40 grams / 1½ ounces
 total), chopped
240 grams / 8½ ounces shallots,
 peeled and sliced
300 grams / 10½ ounces Yunnanese-
 style pickled mustard greens,
 sliced (see page 110)
4 limes, cut into wedges
chili powder fried in oil
 (see page 32)
fish sauce

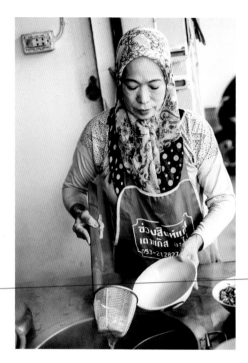
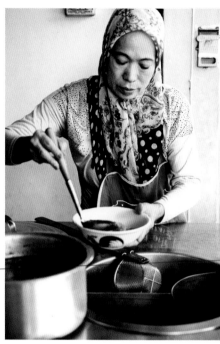

Prepare the crispy noodle garnish: Heat 1½ inches of oil to 325°F in a wok over high heat. (If you don't have a thermometer, the oil is ready when a noodle sizzles instantly in the oil, but it shouldn't be smoking hot.) Carefully place 20 grams / ⅔ ounce of noodles in the oil, deep-frying until crispy but not burnt, about 30 seconds. Remove the noodles with a slotted spoon or spider, and drain on paper towels. Repeat with the remaining noodles. When the noodles are cool, store in an airtight container for up to 2 days.

Prepare the curry paste: Bring the chilies and enough water to cover by an inch or two to a boil in a small saucepan over high heat. Remove the saucepan from the heat and soak the chilies for 15 minutes. Drain, discarding the water, and when cool enough to handle, remove and discard the seeds from the chilies. Using a mortar and pestle, pound and grind the chilies and salt to a coarse paste. Add the ginger; pound and grind to a coarse paste. Add the onions, shallots, and garlic, and pound and grind to a fine paste. (Because of the liquid in these ingredients, this last step is easiest if done in a blender or food processor.)

Prepare the curry: A day or several hours before serving, crack the black cardamom pods, discarding the shells. Add the black cardamom seeds to a wok set over medium-low heat. Toast the seeds, stirring frequently, until they are slightly dark and fragrant, about 10 minutes. Pound and grind the seeds to a fine powder in a mortar and pestle (or use a spice grinder). Repeat with the star anise.

Heat the oil in a large saucepan over medium-low heat. Add the curry paste, 1 tablespoon of the ground black cardamom, 2 teaspoons of ground star

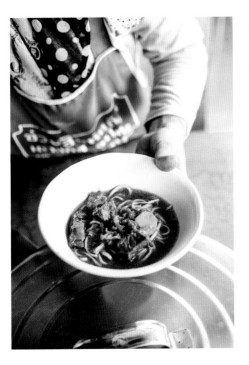
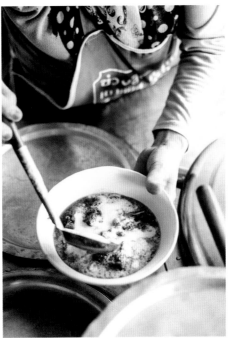
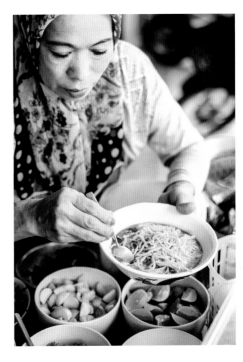

anise, turmeric, and ginger, and fry, stirring occasionally, until the mixture is fragrant and a thin layer of oil has begun to emerge, about 20 minutes. Increase the heat to medium, add the beef, and fry, stirring occasionally, until the beef is just firm, about 5 minutes. Add 1 cup of water, the black soy sauce, sugar, and MSG (if using), and increase the heat to high. Bring to a boil, reduce the heat to a gentle simmer, cover the saucepan, and simmer for 1 hour. Open the lid slightly and simmer until the beef is very tender and a layer oil has risen to the top, another 1 to 1½ hours.

Taste, adjusting the seasoning if necessary; the curry should taste meaty and slightly salty, and it should be fragrant from the dried spices.

Prepare the bowls: Warm up the beef curry, adding a few tablespoons of water, if necessary (the mixture should be thick but somewhat pourable). Bring the coconut milk and coconut cream to a gentle simmer in a small saucepan over medium-low heat.

Bring at least 6 inches of water to a boil in a stockpot over high heat. Put 75 grams / 2¾ ounces of noodles in a noodle basket and boil, agitating the basket until the noodles are just tender, about 20 seconds. Remove the noodles, drain, and add to a serving bowl. Top with a scant ½ cup of the beef curry and a scant ½ cup of the coconut milk mixture. Garnish with the cilantro, green onions, and the crispy fried noodles. Repeat with the remaining ingredients for each bowl.

Serve with the sliced shallots, sliced pickled greens, and limes, as well as the dried chilies fried in oil and fish sauce.

THAI KITCHEN TOOLS
granite mortar and pestle
medium wok (approximately
 12 inches)
noodle basket

Advance prep: A day or two before serving, prepare the crispy noodle garnish, the curry paste, and the chili powder fried in oil.

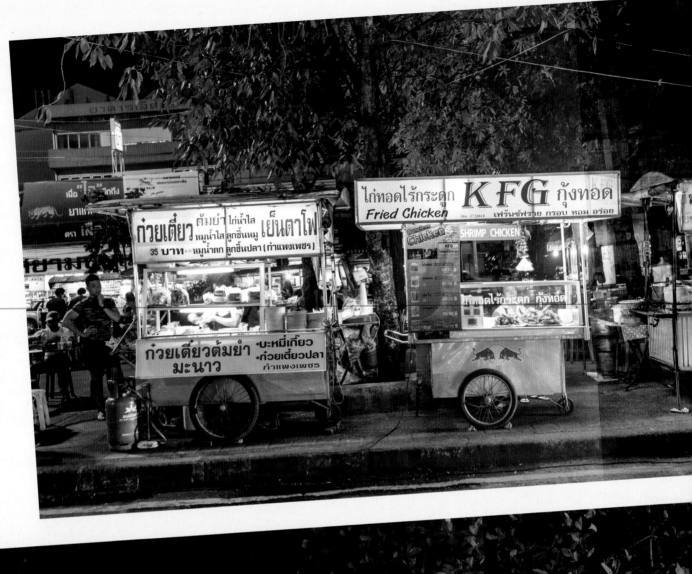

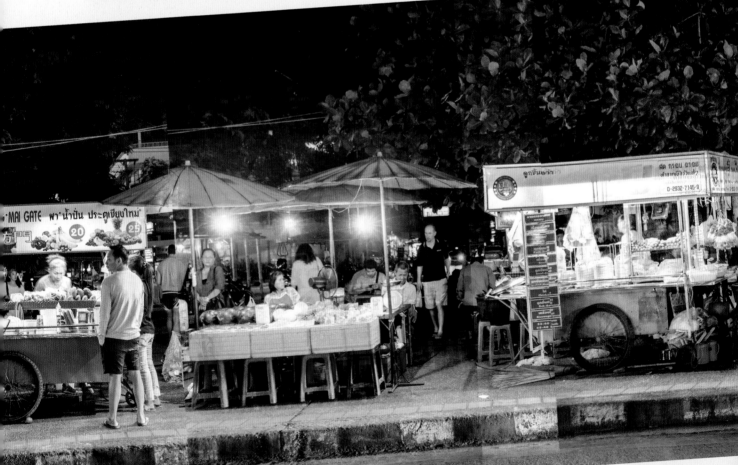

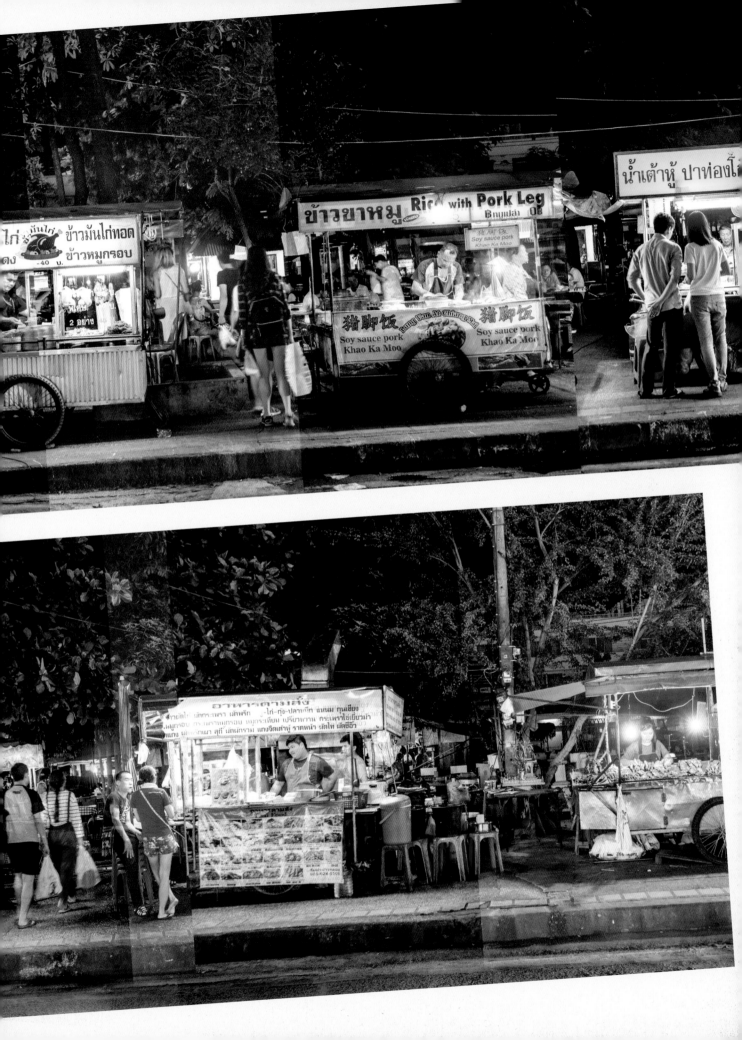

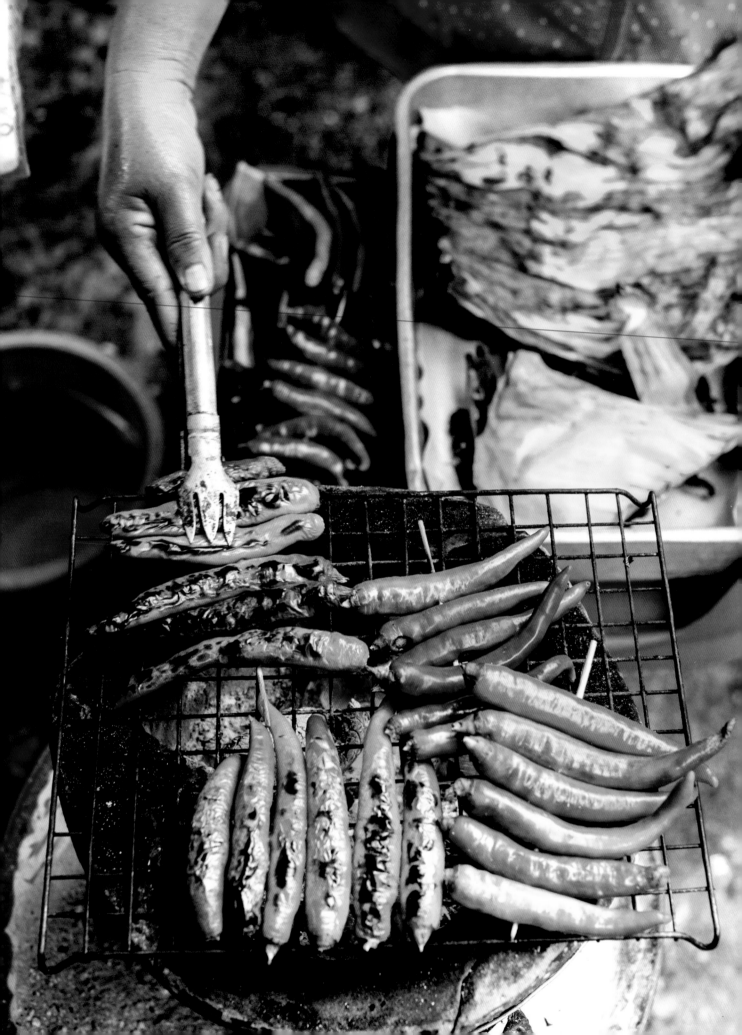

Chili Water

They don't get much press, can appear intimidating and mysterious, and seldom surface on restaurant menus, and their central ingredient hails from a different continent. But *naam phrik*, spicy dips typically made by pounding chilies and other ingredients to a paste with a mortar and pestle, are arguably northern Thailand's most important and beloved food item, claimed by many to be second in importance only to rice.

Chilies are, relatively speaking, a recent introduction to the Thai kitchen. Originally from South America, they were most likely introduced to central Thailand by the Portuguese during the sixteenth century. The new, spicy ingredient eventually made its way into just about every type of dish but landed a starring role in *naam phrik*—literally "chili water."

Fast-forward nearly five centuries, and today *naam phrik* are among the most regionally diverse dishes in Thailand, and a dip served in Chiang Mai could very well be unrecognizable to someone in Bangkok. Even within the north, the dips can take numerous forms, and one book I came across cited 191 different recipes for *naam phrik* in the region. But there are some similarities among northern Thailand's *naam phrik*.

"Most northern Thai *naam phrik* are salty in flavor and dry in consistency," explains Suneemas Noree, a professor of home economics at Chiang Mai University. She goes on to explain to me that northern Thailand's *naam phrik* also don't tend to include sugar, lime juice, shrimp paste, or fish sauce—bold seasonings that are *naam phrik* staples elsewhere in the country. Compared to those others, northern Thailand's dips are relatively mild in flavor, typically lacking tons of chili heat. Also unique is that northern Thailand's *naam phrik* tend to revolve around ingredients that have been cooked—typically grilled—before entering the mortar.

"Traditionally, in the morning, people would light a fire to steam rice and would also grill a few chilies," Suneemas tells me. "When they got back from the fields, if they had any other ingredients, they'd add them to the *naam phrik*."

These days, a dwindling handful of northerners light a fire to cook their rice, but this combination—grilled fresh chilies, garlic, and salt—known as *naam phrik hawm* ("fragrant chili paste"), remains the foundation for many northern Thai–style dips.

Another unique aspect of northern Thailand's *naam phrik* is their seasonality. During the rainy season, tiny fish or tadpoles, netted in waterlogged rice fields, may find their way into the mortar and pestle. Come the cold season, a spicy *naam phrik taa daeng* might be supplemented with hog plum, a fruit at its tart peak during this time of year.

Without exception, northern Thailand's *naam phrik* are eaten with sticky rice, the grains squeezed into bite-sized balls and dipped in the relishes by hand. They're also always accompanied by a spread of vegetables, fruits, and/or herbs, sometimes served raw, sometimes parboiled or steamed. And like the *naam phrik* themselves, these sides are determined by seasonality and availability, and can range from hearty chunks of steamed pumpkin to parboiled greens or astringent-tasting herbs, typically plucked from a nearby garden or field.

Naam Phrik Num

น้ำพริกหนุ่ม

A NORTHERN THAI-STYLE DIP OF GRILLED CHILIES, SHALLOTS, AND GARLIC

SERVES 4

"It should be spicy," offers Areerat Chowkasem, a former restaurant cook, from her home kitchen in Mae Rim, outside of Chiang Mai.

Overt heat is unusual for a northern Thai dish. But *naam phrik num*, a dip revolving around grilled chilies, is the exception to this rule.

The dish consists of little more than northern Thailand's famous slender green chilies—the eponymous *phrik num*—garlic and shallots, grilled over coals until charred, soft, and fragrant, before being pounded with seasonings using a mortar and pestle.

"I don't pound the chili too finely," explains Areerat while gently blending the ingredients with the pestle; *naam phrik num* shouldn't have the consistency of a uniform paste, but rather that of a tangle of pale green, spicy strands.

It's this simplicity—and also that heat—that has made *naam phrik num* the flagship dish of the northern Thai repertoire, beloved by just about everybody and sold at every market—including from souvenir stalls at Chiang Mai International Airport.

Traditionally, the dip is eaten with sticky rice, steamed or parboiled vegetables, and ideally also some deep-fried pork rinds (see page 70). Yet it also functions equally well as a dip for *sai ua* (northern Thai–style sausage; page 74), or, my personal favorite, deep-fried chicken. Similarly, countless variations on *naam phrik num* exist, in which its core elements are supplemented with ingredients ranging from deep-fried pork rinds to grilled fish (see opposite and page 44 for two of these).

Phrik num are unavailable outside of northern Thailand, but Andy Ricker, in his book *Pok Pok*, suggests that mild Anaheim, Hungarian wax, or goat horn chilies, supplemented with spicier serrano chilies, serve as an acceptable substitute. Traditionally, *naam phrik num* is seasoned with little more than salt, but Areerat, somewhat unconventionally, opts for soy sauce; I've gone with a balance of the two. If you want to go completely old-school, you can eliminate this ingredient altogether and season your *naam phrik num* to taste with salt or even *plaa raa*, unfiltered fish sauce.

Using a Thai-style charcoal grill, light the charcoal and allow the coals to reduce to medium heat (approximately 350°F to 450°F, or when you can hold your palm 3 inches above the grilling level for 5 to 7 seconds).

Skewer the chilies, shallots, and garlic separately. When the coals are ready, grill the chilies, shallots, and garlic, turning them occasionally, until fragrant and soft, and their exterior is uniformly charred, around 10 minutes. When cool enough to handle, remove and discard the charred exterior from the chilies, shallots, and garlic.

Pound and grind the shallots and garlic to a coarse paste with a mortar and pestle. Add the chilies and pound and grind just enough to combine; you do not want a uniform, fine paste but rather a tangle of strands. Add the salt and white soy sauce (if using), mixing with a spoon.

Taste, adjusting the seasoning if necessary; the *naam phrik num* should taste spicy and salty, and should be fragrant from the garlic and the grilling.

Remove to a small serving bowl and serve with steamed or parboiled vegetables, deep-fried pork rinds, and sticky rice as part of a northern Thai meal.

For the Dip

500 grams / 18 ounces large fresh chilies (ideally *phrik num*, or a combination of serrano and other milder chilies)

80 grams / 3 ounces shallots, unpeeled

12 garlic cloves, unpeeled (60 grams / 2 ounces total)

1 teaspoon table salt

1 teaspoon white soy sauce (optional) (see page 328)

For Serving

600 grams / 1⅓ pounds of parboiled or steamed vegetables, such as pumpkin, cabbage, long bean, small eggplant, and/or raw vegetables, such as cucumber or Thai eggplant, cut into bite-sized pieces

160 grams / 5½ ounces deep-fried pork rinds (see page 70)

sticky rice (see page 54)

THAI KITCHEN TOOLS

Thai-style charcoal grill or barbecue
metal or bamboo skewers (the latter soaked in water), or a grilling basket

VARIATION:

Naam Phrik Plaa Jii /
น้ำพริกปลาจี่ /

NAAM PHRIK NUM WITH GRILLED FISH

Follow the recipe for *naam phrik num*. After grilling all the ingredients, allow the coals to reduce to low heat (approximately 250°F to 350°F, or when you can hold your palm 3 inches above the grilling level for 8 to 10 seconds). Add 1 small (approximately 300 grams / 10½ ounces) freshwater fish, such as Nile tilapia, to a grilling basket and grill, flipping occasionally until cooked, about 30 minutes. When cooked through and cool enough to handle, remove the flesh, discarding any bones and skin; you should have about 100 grams / 3½ ounces of fish. Add the fish to the mortar, along with shallots, garlic, and an extra ¼ teaspoon of table salt, and proceed with the recipe. Remove to a small serving bowl and serve with steamed or parboiled vegetables (such as chayote, long beans, or small eggplant) cut into bite-sized pieces and sticky rice, as part of a northern Thai meal.

RECIPE CONTINUES

VARIATION:
Naam Phrik Khaep Muu /
น้ำพริกแคบหมู / *NAAM PHRIK NUM*

WITH PORK RINDS

Follow the recipe for *naam phrik num*, adding 80 grams / 3 ounces of deep-fried pork rinds (the type that also have a layer of fat; see page 70) to the mortar with the shallots, garlic, and a few sprigs of chopped cilantro, along with the salt and white soy sauce (if using), and proceed with the recipe. Remove to a small serving bowl and serve with steamed or parboiled vegetables (such as sweet potato, pumpkin, okra, cabbage, and chayote) cut into bite-sized pieces and sticky rice, as part of a northern Thai meal.

1. Naam Phrik Taa Daeng
2. Naam Phrik Plaa Jii
3. Naam Phrik Khaep Muu
4. Naam Phrik Makhuea Som
5. Naam Phrik Awng
6. Naam Phrik Num

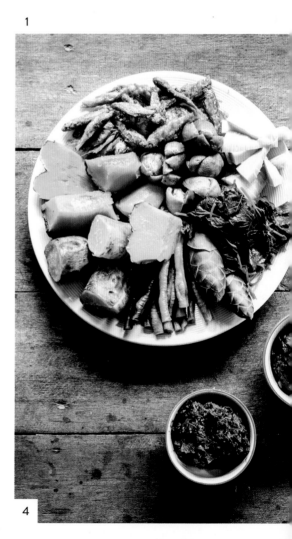

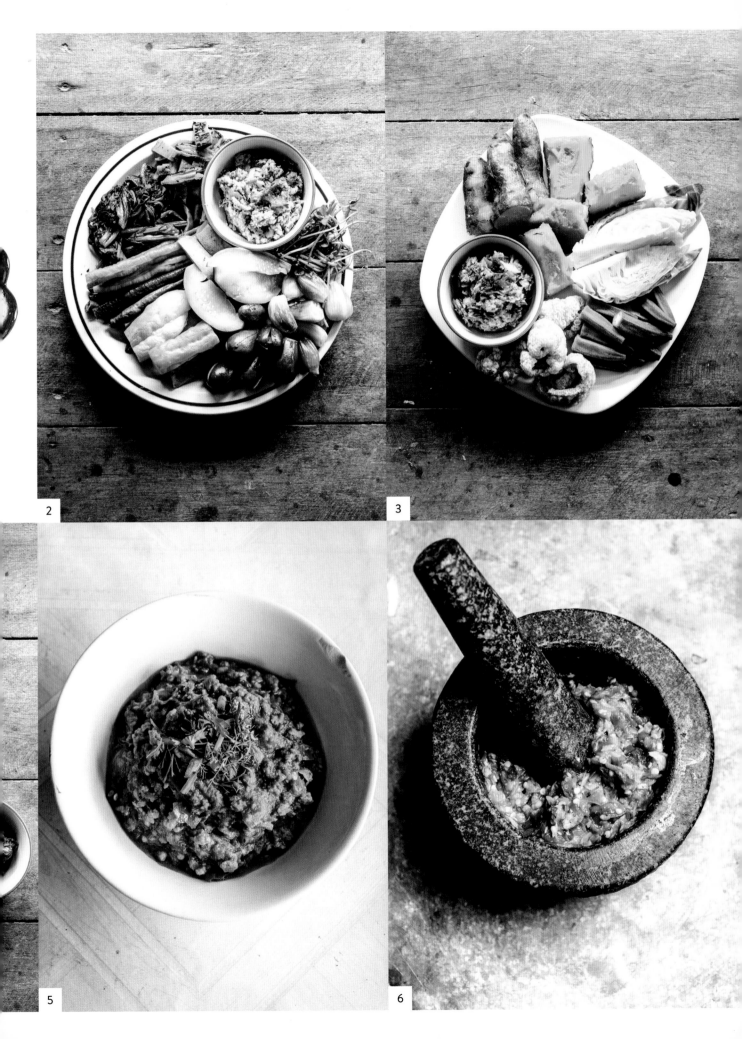

2

3

5

6

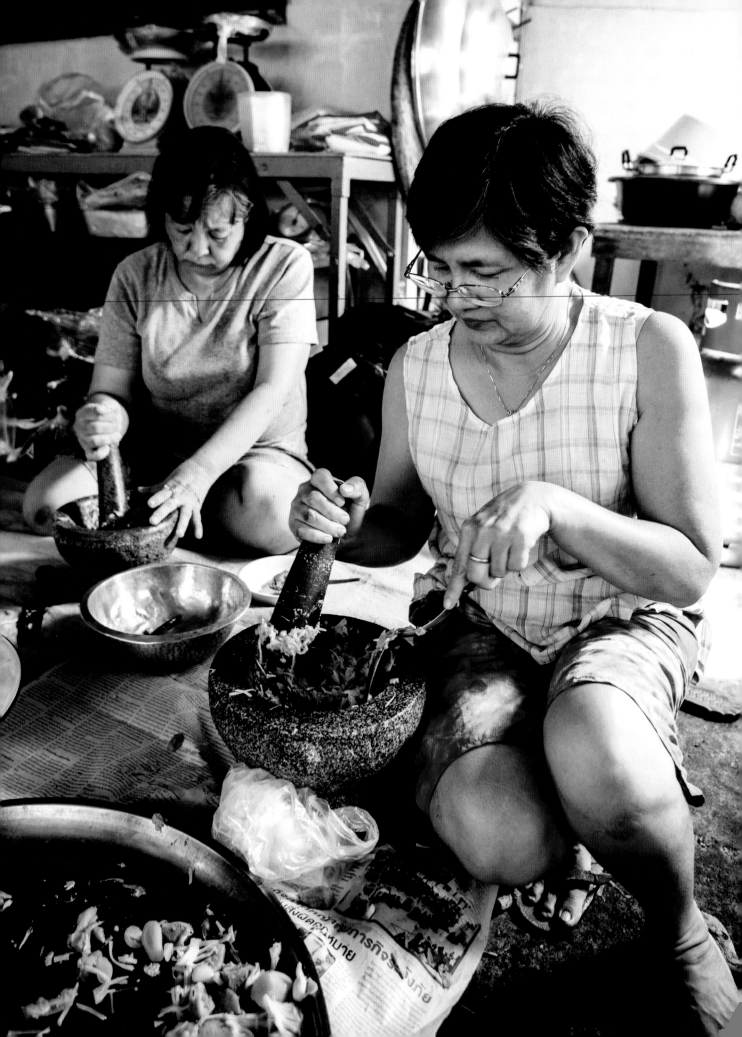

HOW TO *Use a Mortar and Pestle like a Northern Thai*
การตำเหมือนคนเมือง

A granite mortar and pestle set is the most called-for kitchen tool in this book. There's one in every northern Thai home, and it's used for both quick jobs—perhaps to muddle a few chilies and garlic for a stir-fry—and heavier tasks—making fine curry pastes from often coarse and stringy herbs. The larger clay pestles, often used with a wooden mortar, are generally used for pounded salads.

If you want to cook northern Thai food, you'll be using these tools a lot, so below are a few tips—both practical and cultural—for using a mortar and pestle the northern Thai way:

- Relatively dry ingredients—salt, dried chili, galangal, lemongrass—should be pounded first. When these are ground sufficiently, progressively add ingredients that have more moisture—fresh chili, shallots, garlic—culminating with shrimp paste.
- Pound on the side, not the middle, of the mortar, otherwise the ingredients will bounce out or land in your eyes.
- If any spicy curry paste enters your left eye, pouring cool water on your left foot (and vice versa) will cause the pain to go away. (This is the traditional wisdom, and—spoiler alert—it doesn't really work.)
- Historically, in choosing a daughter-in-law, the sound of her pounding was second in importance only to her manners. If a woman's pounding style is regular, it's believed that she's a talented cook; if irregular, it means that she doesn't like going in the kitchen and probably isn't a good cook, and thus not ideal daughter-in-law material.
- When finished with a mortar and pestle set, don't leave the pestle in the mortar—this will bring bad luck!

Naam Phrik Awng

น้ำพริกอ่อง

A NORTHERN THAI-STYLE DIP
OF TOMATOES AND GROUND PORK

SERVES 4

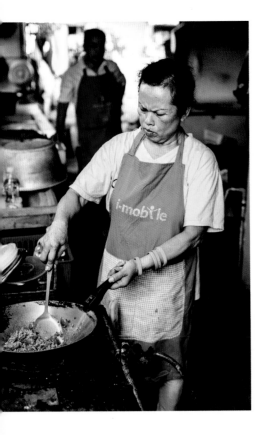

The Thai are eminently adaptable people, and as such their cuisine is perpetually in flux, constantly incorporating new ingredients and techniques. Still, I was surprised when fifty-nine-year-old restaurateur Wanphen Jumpajan, the source of this recipe, chose to toast her dried chilies in the microwave.

"If it's a special occasion, I'll grill the chilies over coals," explains the co-owner of Ton Kham, a decades-old northern Thai restaurant outside of Chiang Mai, "but microwaving is easier—it only takes a few seconds, and there are no coals to deal with!"

Wanphen was in her restaurant's semi-open-air kitchen making *naam phrik awng*, a blend of toasted dried chilies, ground pork, and tart tomatoes, slowly simmered until they merge into a rich, sour, spicy, pleasantly oily dip. She claims that she learned the recipe from her mother, but in the course of watching her cook, it became clear that the microwave was just one of several unconventional techniques.

"I use two types of tomatoes," says the native of Chiang Mai, "cherry tomatoes to add a sour flavor and bigger tomatoes for a sweet flavor."

Likewise, her take on the dish includes, unusually, *plaa raa*, the infamously pungent fermented and unfiltered fish sauce, here rendered mellow and fragrant through slow simmering—a technique called *awng*.

The microwave melted Wanphen's plastic container, tainting the chilies (it's worth mentioning that otherwise they turned out handsomely and uniformly toasted), and in the end, she opted to dry-roast the chilies in a wok. But in going the traditional route, I suspect that little was lost.

Over coals, a stovetop burner, or even in a toaster oven, toast the fermented soybean disk until fragrant, golden, and pockmarked, about 2 minutes. When cool enough to handle, grind to a powder using a mortar and pestle. Set aside.

Add the dried chilies to a wok over medium-low heat. Dry-roast, tossing and stirring occasionally, until fragrant, swollen, and toasted, dark in color but not yet black, approximately 10 minutes. (Alternatively, using a ceramic or glass dish, microwave the chilies for about 2 minutes on medium power, or until dark in color but not yet black.)

Pound and grind the chilies with the mortar and pestle to a coarse powder. Add half of the garlic; pound and grind to a coarse paste. Add the unfiltered fish sauce, and pound and grind to a fine paste. Remove and set aside.

Wipe out the mortar and pestle, and pound and grind the remaining garlic to a coarse paste. Set aside.

Heat the oil in a wok set over medium heat. Add the garlic paste and fry, stirring, until fragrant and starting to color, about 1 minute. Add the chili-garlic paste, cherry tomatoes, medium tomato, and ground pork, and fry, stirring and pushing to crush the tomatoes, until the mixture is relatively amalgamated and the tomatoes are soft, about 10 minutes.

Add 1 cup of water, bring to a boil, and reduce the heat, simmering until reduced slightly, another 5 minutes. Add the fish sauce, MSG (if using), and 2 tablespoons of the reserved dried fermented soybean powder. Simmer until most of the water has evaporated and the mixture is thick but not dry, about 5 minutes.

Taste, adjusting the seasoning if necessary; the *naam phrik awng* should have a balance of savory, tart, spicy, and salty flavors. The unfiltered fish sauce will usually impart enough salty flavor, but additional salt can be added, to taste, if necessary.

Remove to a medium serving bowl, garnish with green onion and cilantro, and serve at room temperature with sticky rice, vegetables, and pork rinds, as part of a northern Thai meal.

For the Dip

1 fermented soybean disk (15 grams / ½ ounce; see page 227)
12 large dried chilies (20 grams / ⅔ ounce total; see page 325)
40 grams / 1½ ounces Thai garlic (or 8 standard garlic cloves, peeled; see page 325)
3 tablespoons unfiltered fish sauce (*plaa raa*; see page 325)
2 tablespoons vegetable oil
25 tart cherry tomatoes (200 grams / 7 ounces total), halved
1 ripe medium tomato (120 grams / 4¼ ounces total), sliced
175 grams / 6 ounces ground pork
1½ teaspoons fish sauce
½ teaspoon MSG (optional)
table salt (optional)

For Serving

1 green onion (20 grams / ⅔ ounce), chopped
a few sprigs cilantro (5 grams), chopped
sticky rice (see page 54)
600 grams / 20 ounces of raw, crunchy vegetables, such as cabbage, long beans, and cucumber, cut into bite-sized pieces
160 grams / 5½ ounces deep-fried pork rinds (see page 70)

THAI KITCHEN TOOLS
granite mortar and pestle
medium wok (approximately 12 inches)

Naam Phrik Taa Daeng

น้ำพริกตาแดง

"RED EYE" CHILI PASTE

SERVES 4 TO 6

Is there a more intimidating dish in northern Thailand than *naam phrik taa daeng*? From its appearance (a shade of dark red that could stem from only one thing: many, many dried chilies) to its suspiciously minute portion size (the dip is sold to-go in bundles barely larger than a marble), everything about *naam phrik taa daeng* seems to scream punishing heat. Even the name—*naam phrik taa daeng*, which translates as "red eye chili paste"—packs a punch.

Yet Sira Prapa, who has been making the dip from a tiny home-based factory outside of Mae Ai, in Chiang Mai Province, for the last five years, wants to set the record straight.

"It shouldn't be too spicy—northern Thai people don't like spicy," explains the soft-spoken cook. "Everything should be balanced."

As such, Sira uses two types of chilies in her *naam phrik taa daeng*, one hot and one relatively mild. And in watching her cook, it became evident to me that she counters the chili heat by adding a variety of meaty, fragrant ingredients, including dried fish, shallots, and, in particular, *plaa raa*, an unfiltered fish sauce or paste.

In its raw state, *plaa raa* is, frankly, downright stinky. But when cooked, its flavor shifts to a strong but pleasant funk—think of a ripe Camembert—that's crucial to the dish. Sira suggests wrapping the *plaa raa* in a banana leaf package and grilling it slowly over coals, a process that both mellows its odor and causes the bones to "melt." If this cooking method isn't convenient, you can simmer the fermented fish, shallots, and garlic in a saucepan until fragrant and the bones have disintegrated.

As indicated by how it's sold, a little bit of *naam phrik taa daeng* goes a long way, and this recipe makes approximately 150 grams / 5¼ ounces (about ¼ cup) of the stuff, more than enough to serve four as part of a larger northern Thai–style meal. The leftovers can be kept in the refrigerator, sealed tightly, for a couple weeks, or can be fried with tart tomatoes as in the variation described opposite.

Using a Thai-style charcoal grill, light the charcoal and allow the coals to reduce to medium heat (approximately 350°F to 450°F, or when you can hold your palm 3 inches above the grilling level for 5 to 7 seconds).

While the coals are reducing, wrap the unfiltered fish sauce, shallots, and garlic in three layers of banana leaf, sealing them so that any liquid can't escape and fastening the package with a toothpick. Grill the banana leaf package and the iridescent shark over coals, turning occasionally, until the contents of the former are fragrant and the solid parts have largely dissolved, and the latter is toasted and fragrant, approximately 15 minutes.

When the iridescent shark is cool enough to handle, flake the flesh, discarding any skin and large bones. Reserve about 25 grams / 1 ounce of fish, keeping the remainder for another use.

Add both the large and the medium dried chilies to a wok over medium-low heat. Toast, tossing and stirring occasionally, until fragrant, swollen, toasted, and darkened but not yet black, 15 to 20 minutes.

Pound and grind the chilies with a mortar and pestle to a coarse powder. Add the fish and pound and grind to coarse powder. Add the contents of the banana leaf and the MSG (if using), and pound and grind to a fine paste.

Taste, adjusting the seasoning if necessary; the *nam phrik taa daeng* should taste spicy, pleasantly fishy, herbal, and salty (in that order) and should have a thick consistency. The *plaa raa* will usually impart enough salty flavor, but additional salt can be added, to taste, if necessary.

Remove *naam phrik taa daeng* to a small serving bowl and serve with vegetables and sticky rice as part of a northern Thai meal.

VARIATION:
Naam Phrik Makhuea Som /
น้ำพริกมะเขือส้ม / "RED EYE" CHILI PASTE

FRIED WITH TOMATOES

Follow the recipe for *naam phrik taa daeng*. Soak a few bamboo skewers in water, skewer 30 tart cherry tomatoes (250 grams / 9 ounces total), and along with the fish, grill over coals until slightly charred and soft. In a mortar, combine 150 grams / 5¼ ounces of the finished *naam phrik taa daeng* and the grilled cherry tomatoes. Pound to a paste. Heat 2 tablespoons of vegetable oil or lard in a small wok or frying pan over low heat. Add the paste and fry until fragrant and combined, 4 to 5 minutes. Taste, adjusting seasoning, if necessary; the *naam phrik makhuea som* should be thick in consistency and slightly tart from the tomatoes. Remove to a small serving bowl and serve with deep-fried tiny fish and/or parboiled or steamed vegetables (such as pumpkin, sweet potato, long bean, or bamboo) and sticky rice as part of a northern Thai meal.

For the Dip

100 grams / 3½ ounces unfiltered fish sauce (*plaa raa*; see page 325)
75 grams / 2¾ ounces shallots, peeled and sliced
6 garlic cloves (30 grams / 1 ounce total), peeled and sliced
4 feet of banana leaf, or as needed
1 small smoked iridescent shark (100 grams / 3½ ounces; see page 326) or other dried, smoked freshwater fish
8 large dried chilies (15 grams / ½ ounce total; see page 325)
10 medium dried chilies (5 grams total; see page 325)
½ teaspoon MSG (optional)
table salt (optional)

For Serving

600 grams / 1¼ pounds of raw, crunchy vegetables, such as cucumber, cabbage, or Thai eggplant, cut into bite-sized pieces
sticky rice (see page 54)

THAI KITCHEN TOOLS
Thai-style charcoal grill or barbecue
medium wok (approximately 12 inches)
granite mortar and pestle

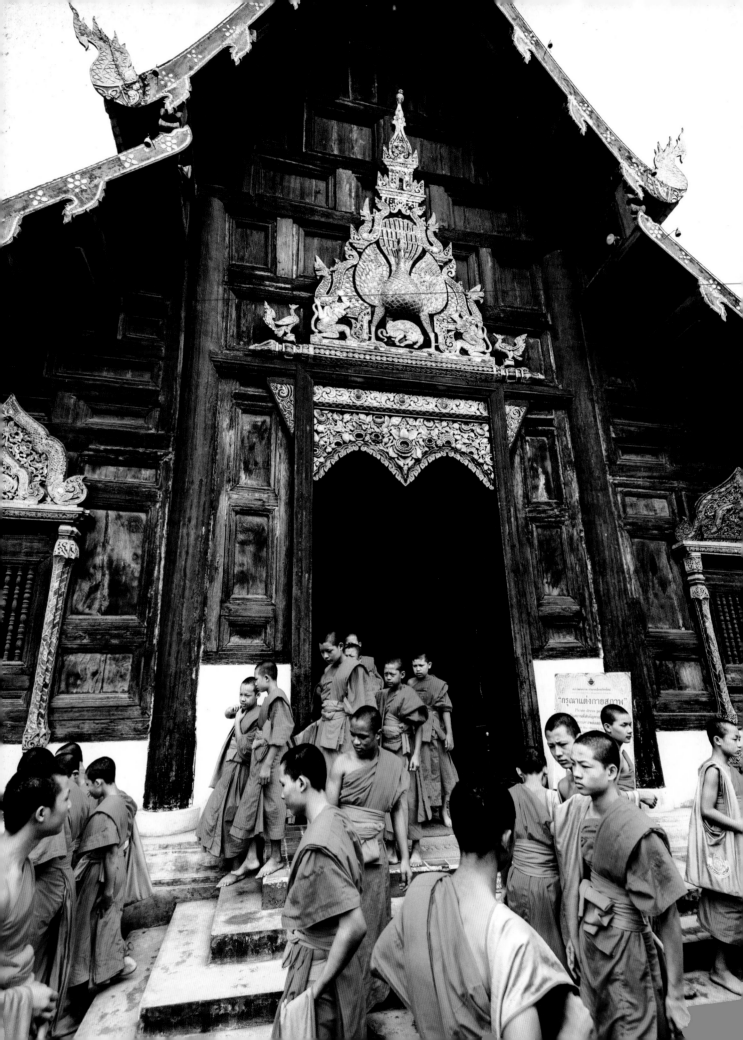

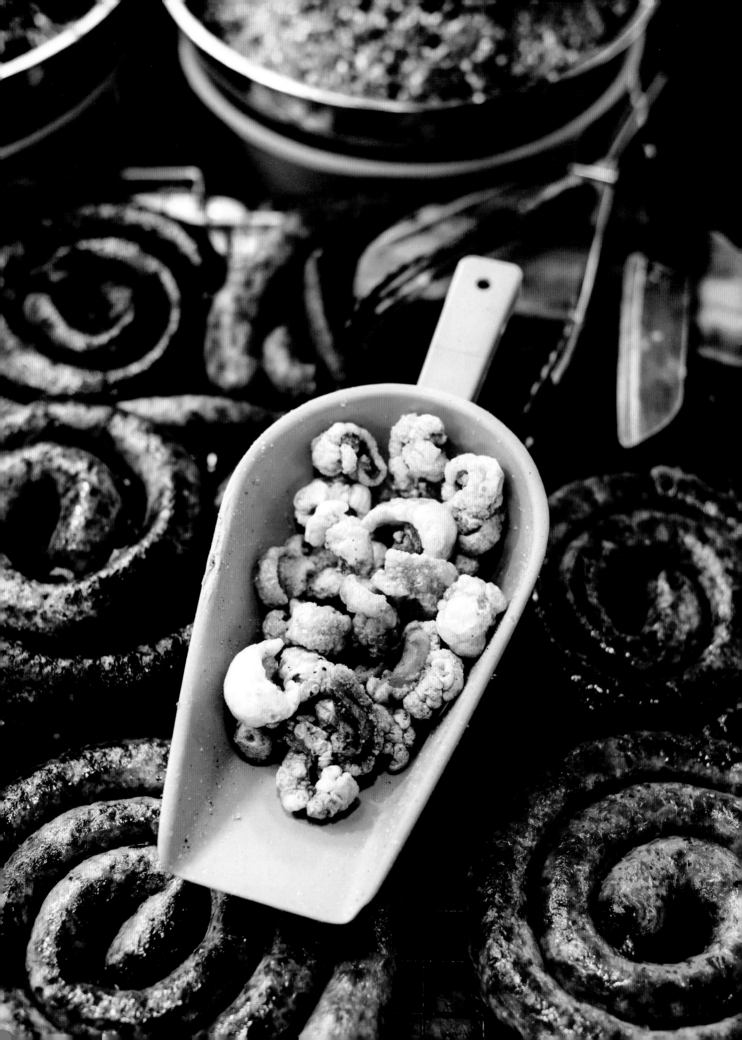

Sticky Rice

In northern Thailand, sticky rice is more than just the carb of preference: it's the embodiment of sustenance. In the local dialect, *kin khao* (literally "consume rice") means "to eat" in the broadest sense, and to eat in northern Thailand invariably means eating sticky rice.

Also known in English as glutinous rice, sticky rice takes the form of short, chubby grains of rice that have a higher starch content than their long-grained counterparts. In most cases, the term *steamed rice* is a misnomer, as long-grained rice is simmered in water. But sticky rice truly is steamed—that is, is elevated over boiling water, the grains making contact only with rising steam (in the northern Thai dialect, sticky rice is known as *khao nueng*, "steamed rice"). Abundant starch causes the cooked grains to stick together, and the rice is eaten by rolling it into a small ball and dipping it by hand into the various dishes.

"Long-grained rice was known as high-class food—*khao jao* [rice of the lords]—while sticky rice was food for normal people," explains Sakul Moolkam, Senior Agronomist Researcher at the Chiang Mai Rice Research Center. To an extent, this division stands today, with the wealthier, more urban central and southern parts of Thailand preferring long-grained rice, while those in rural northern and northeastern Thailand staunchly subsist on sticky rice. Thus it's no exaggeration to state that, in addition to being the culinary staple, sticky rice is also one of the most important cultural signifiers of the north.

Today, the tiny grains continue to define the rhythm of life in northern Thailand. In the more rural corners of the region, the day begins by lighting a fire and steaming sticky rice. Typically, a large quantity of rice is made in the morning, to be eaten at breakfast, lunch, and dinner, kept warm and moist in *klawng khao* (permeable bamboo baskets for storing cooked rice) or, increasingly these days, wrapped loosely in cheese-cloth and held in a plastic cooler. In northern Thailand's past, meals often consisted of little more than a heaping mound of sticky rice and perhaps a chili-based dip or simple soup—bringing home the fact that sticky rice is the primary food and everything else just sides. In an even broader sense, traditional northern Thai life remains dictated by the cycle of planting and harvesting the grains, a process that can span as long as half a year, one prescribed by the seasons and requiring the collaboration of entire villages.

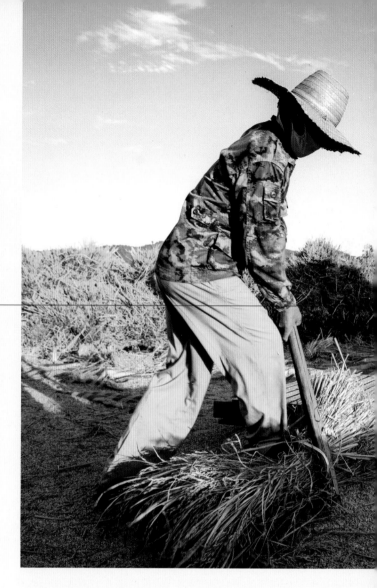

HOW STICKY RICE IS GROWN

In northern Thailand's past, rice was generally harvested once a year, a process that began with the monsoon and ended in the cold season, a period spanning as many as six months, with people and buffaloes undertaking all the work. Today, bioengineering, advances in irrigation, and mechanical tools mean that, in many places, rice can be grown twice a year, in some cases in fewer than 140 days from planting to harvest.

The traditional monsoon-based system of rice growing involves the following steps:

1. In April, following the Thai New Year, farmers start to prepare rice from the previous harvest by sorting and discarding any bad seeds.
2. Come May, when the monsoon rains begin, the fields are flooded and plowed, and a small protected section of each rice field is set aside for sowing the seeds.
3. After about a month, the seedlings are uprooted and transplanted in rows.

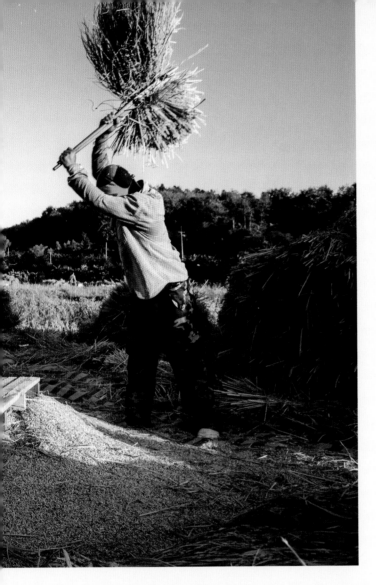

HOW TO STEAM STICKY RICE

To steam sticky rice as most northern Thai do these days, you'll need a *maw nueng*, a distinctly shaped pot, typically made from aluminum, and a *huat*, a conical basket woven from thin strips of bamboo, both generally available at Thai grocery stores in the United States. Four cups of uncooked sticky rice is enough to serve four to six hungry diners.

1. At least 12 hours before you plan to eat the rice, gently wash it in several changes of water until the water runs clear.
2. Soak the sticky rice in plenty of water for at least 8 hours, or overnight.
3. Strain the rice, discarding the water.
4. Put a few inches of water in the pot and place it over high heat. When the water reaches a rolling boil, reduce the heat slightly, pour the strained rice into the bamboo basket, insert the basket in the pot, elevated above the water, and cover the basket with the lid of a saucepan or a damp cloth and steam.
5. After 15 minutes, check the rice to see if it's nearly tender. If so, invert the rice (this is done by flipping the ball-like mass of rice directly in the basket—a feat that requires some practice) and steam for another 5 to 10 minutes, or until the rice is tender and chewy, but not mushy or, alternatively, hard in the center of each grain.
6. Remove the basket from the pot, use a large spoon to stir the rice briefly to allow it to expel excess steam, and put the rice in a bamboo sticky-rice container or a plastic cooler lined with cheesecloth where it can be kept warm and moist; otherwise, when exposed to air, it will quickly grow dry and hard.

4. The seedlings are left to grow for at least four months. The middle part of this period is also when farmers gather edible creatures—crabs, tadpoles, fish—that thrive in the flooded fields.
5. The rice is harvested between October and December. To do this, the stalks of rice are cut, allowed to dry in the sun, then threshed—the process that separates the seeds from the stalks—a process still done by hand in many parts of the north.
6. The grains of rice—husks still intact—are then bundled in bags and dried in granaries for one month.
7. The rice is then milled, the process that removes the husks and the exterior layer of bran, and is finally ready for consumption. Rice from the most recent harvest is known as *khao mai*, "new rice," and has a relatively high moisture content, while rice from the previous year's harvest is known as *khao kao*, "old rice," and has less moisture, thus requiring more water when cooked. After a year, *khao kao* generally becomes too dry and brittle to steam and is ground into rice flour, an important ingredient in Thai sweets.

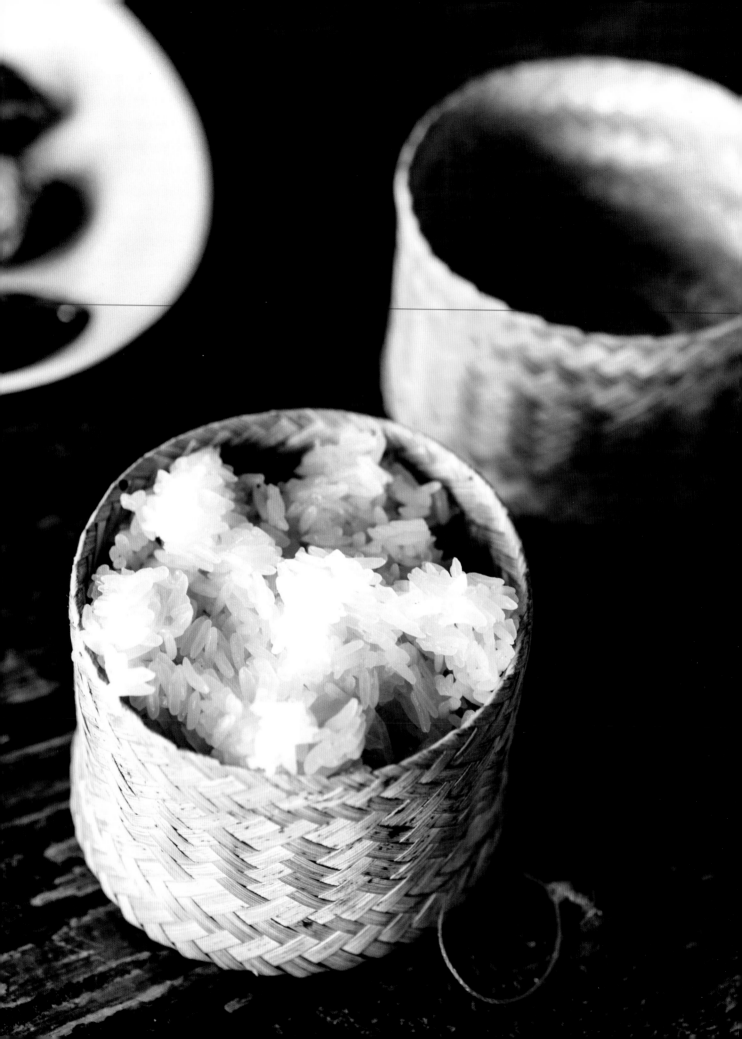

Crab Water

I was drawn by the sight of smoke, but also by the smell—a dark, pungent, earthy funk. It was the middle of the wet season in Mae Jaem, in Chiang Mai Province, and ringing the village were rice fields flooded with water, paradise for *puu naa*, black field crabs that range in size from a quarter to a fist. And in northern Thailand, at the peak of the wet season, this combination of smoke and water could only mean one thing: *naam puu*, literally "crab water." A paste made from freshwater crabs, it's an unusual but beloved condiment.

"*Naam puu* is only made during August and September," says Sriphin Kannika, a farmer in Ban Bon Na, just outside of Mae Jaem, the person responsible for that smoke and funk. It was late morning in mid-August, and she and her neighbors were slowly simmering a muddy liquid in an earthenware pot over a wood fire. She explains that these two months are when the crabs are at their most plentiful, when the water and roots of the rice plants are deep enough to sustain them.

The previous day, Sriphin had bought six pounds of crabs from a local farmer. She ground them to a paste with an electric food processor before combining the paste with a generous amount of water, straining it, and discarding the solids. The crab-infused water was then left to sit overnight ("This makes it more fragrant"); the next morning, it was brought to a boil and, over the course of several hours of simmering, reduced to a dark paste: *naam puu*.

As this process can take all day, I head out to a nearby rice field where some farmers are at work, to see how the crabs are gathered.

"Crabs are getting hard to find these days," explains one farmer, pulling weeds at the edge of a waterlogged and impossibly green rice field. "People use a lot of pesticides, which kills them." After poking around a bit, he's eventually able to find one crab, slightly larger than a silver dollar and clearly reluctant to be taken from its home.

"We make a lot of *naam puu* in Mae Jaem, so much that we sell it elsewhere in northern Thailand," explains Phimpha Kapchai, head of a community-based agriculture initiative in the town.

I'm at her home-based office, where she pulls out two plastic containers of *naam puu*, one made last year and one she's been holding on to for five years. She peels and slices sections of boiled bamboo—another wet-season delicacy—and dips them in the paste.

"It should taste a bit salty," explains Phimpha, when I ask her what qualities one should look for in *naam puu*. "Some people add chili or guava leaves; lemongrass is standard as it helps cover any unpleasant odors."

Indeed, the *naam puu* is salty but also pleasantly bitter—a cherished flavor in northern Thailand—and it's palpably, although not overpoweringly, funky, with a distant herbal fragrance. Phimpha explains that villagers in Mae Jaem are happy to eat the paste on its own, using it as a dip for bamboo or sticky rice, but more often it's combined with chili and garlic in a variety of *naam phrik* (chili-based dips) or used as an essential ingredient in a variety of *tam* (pounded salads).

In the afternoon, I returned to Ban Bon Na, and what was that morning a pot brimming with liquid was now reduced to a dark, thick, pungent puddle. Sriphin stirred the mixture with a bamboo hook to confirm its consistency. "It should be slightly sticky," she explained, as the liquid drizzled from the stick. And so from six pounds of crabs, an abundance of water, and nine hours of simmering, she was rewarded with one scant pound of the rainy season's most obscure delicacy.

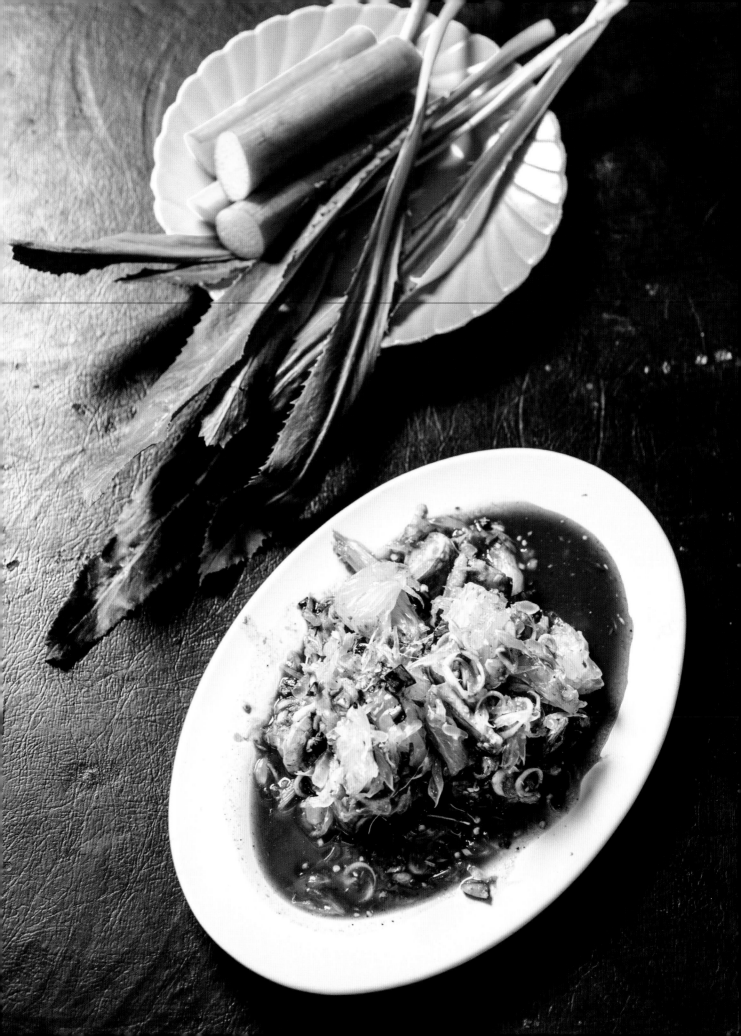

Tam Som Oh

ตำส้มโอ

A POUNDED SALAD OF POMELO AND CRAB PASTE

SERVES 4

Made from segments of pomelo, a large, grapefruit-like citrus fruit, that have been just barely bruised with lemongrass, chili, eggplant, and seasonings including *naam puu* (northern Thai–style crab paste), there's a lot going on in *tam som oh*.

"It should be sour and sweet—from the pomelo and the sugar—and it should be spicy," explained a cook at Laap Kao Cham Chaa, an open-air eatery in Chiang Mai, who didn't want to share her name. "It should be, as they say in central Thailand, *khrop rot*," which means "has all the flavors."

All these flavors are there for a reason.

"The tart pomelo is balanced with sugar," explains the cook, "and lemongrass counters the strong flavor of the crab paste."

And although the tendency at Laap Kao Cham Chaa is to emphasize the sweet, each of these flavors is customizable. Tell the vendor you like spicy, and she'll throw in a couple extra chilies for you. Tell her you don't like unfiltered fish sauce, and she won't include it. It's the epitome of a Thai dish both in that it features a variety of different flavors and that these flavors are also subject to personal preference.

When making this dish, choose a pomelo that is slightly on the tart side, and note that an unpeeled pomelo weighing four pounds will produce approximately two pounds of flesh.

RECIPE CONTINUES

For the Salad

2 tablespoons dried shrimp

1 pomelo (2 kilograms / 4½ pounds)

8 small fresh chilies (5 grams total; see page 324)

4 stalks lemongrass (100 grams / 3½ ounces total), exterior tough layers peeled, green section discarded, pale section sliced thinly

1 tablespoon northern Thai crab paste (*naam puu*; see page 57)

1 tablespoon unfiltered fish sauce (*plaa raa*; see page 325)

1 tablespoon palm sugar

3 Thai eggplants (90 grams / 3 ounces total), halved and sliced thinly

For Serving

100 grams / 3½ ounces of vegetables and herbs, such as napa cabbage, wild betel leaf, and sawtooth cilantro

THAI KITCHEN TOOLS
clay mortar and pestle

Heat the dried shrimp in a small wok or frying pan set over low heat. Dry-roast, stirring occasionally, until fragrant and uniformly toasted, about 5 minutes.

Use a knife to peel the pomelo and discard the thick exterior peel. Then using a combination of knife and hands, remove and discard the white membrane that encases the sections, keeping the segments intact and discarding any seeds. Reserve approximately 400 grams / 14 ounces of fruit.

In a clay mortar, combine the chilies, lemongrass, crab paste, unfiltered fish sauce, and palm sugar. Using the pestle and a large spoon, pound and mix to a coarse paste. Add the dried shrimp and eggplants, pounding and mixing until just bruised and combined. Add the pomelo segments, gently pounding and mixing until just bruised and combined—you do not want a paste or uniform consistency here, but rather a salad with some large chunks of pomelo.

Taste, adjusting the seasoning if necessary; *tam som oh* should taste funky, herbal, spicy, and equally tart and sweet (in that order).

Remove to a serving plate and serve with the vegetable and herb sides and sticky rice as part of a northern Thai meal.

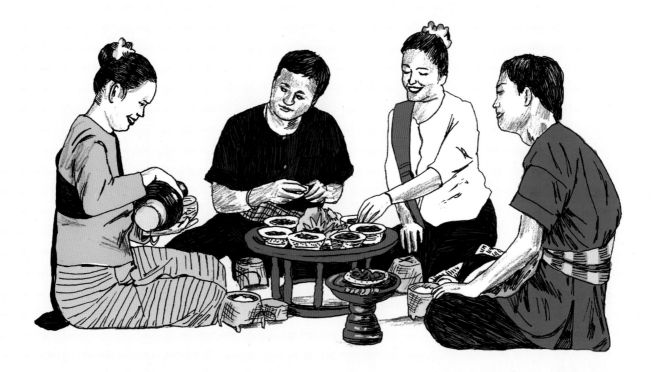

Khan Toke Dinner

ขันโตกดินเนอร์

In the late '90s, on my first visit to Chiang Mai, the students taking part in a cultural exchange program hosted by Chiang Mai University and I were bused to a large hall decked out in northern Thai kitsch, seated at low, round tables, and served local (or, perhaps more accurately, locally inspired) dishes while taking in a northern Thai dance performance. At the time, I knew little about northern Thai culture and food, but the whole thing struck me as slightly off (were prawns really part of the traditional diet of landlocked northern Thai?). It seemed like something of a Disneyfication of northern Thai traditions. Yet for decades, this very experience, known colloquially as *khan toke*, has been touted as a slice of northern Thai culture and has been on the itinerary of just about every tourist who has visited Chiang Mai.

In reality, *khan toke* has a markedly less glamorous meaning, and a backstory that's both old and new.

In the northern Thai dialect, *khan* is the name for a type of small bowl, while *tohk* is a round, low-slung table usually made from wood or rattan. When used together, the words refer to a characteristically northern style of eating from these items while sitting on the floor. In 1953, a prominent citizen of Chiang Mai fused a rather upscale version of this style of dining with live music and dance for private events. Nearly twenty years later, and inspired by Hawaii's Polynesian Cultural Center, a local couple opened the Old Chiangmai Cultural Center, the city's first commercial *khan toke* venue, which remains open to this day.

"It's food that everyone can eat," explains Manaswat Chutima, the third-generation owner of Old Chiangmai, as the *khan toke* venue is known today, of the dishes served there. "We've adapted the recipes so they're not too spicy."

Then, as now, a meal at Old Chiangmai spans seven slightly toned-down versions of northern Thai staples ranging from *naam phrik num* (a dip of grilled chilies) to *kaeng hang lay* (a rich, fragrant pork curry), all served on those low tables during a performance of traditional northern Thai and hill tribe dance. And because so many people have passed through its doors—Old Chiangmai can seat up to 1,400 diners—it can be argued that the restaurant has had an influence on northern Thai cuisine.

"Our versions have actually become the standard of some dishes," suggests Manaswat, describing to me how decades ago the restaurant's first general manager decided to tinker with the *kaeng hang lay* recipe, adding a bit of sugar to appeal to foreign and Bangkok palates. "Now people think that the dish should have a sweet flavor," she adds.

Today there are nearly ten *khan toke* venues in Chiang Mai, a new role for the formerly humble dinner table.

Jin Som and Naem:
Northern Thailand's Sour Meats

For many people, meat that is uncooked, fermented, and sour-tasting is something to avoid rather than to crave. But for a northern Thai, it's one of the most quintessential local dishes. And if you can get past your aversions, it's easy to see why: *jin som* or *naem*, as the dish is known, packs a tart flavor, a distinct meatiness, and an appealing unctuousness. Indeed, a good version can seem almost

decadent, but like many other fermented food items, it has its roots in parsimony and preservation—a way of stretching a precious resource.

Naem and *jin som* are preserved meat items that get their uniquely tart kick from a process called lactic acid fermentation (much like how kimchi and yogurt are produced). To see how this is done, I visit the home-based factory of Bualiaw Phanthong, a native of Chiang Mai and producer of northern Thai–style fermented meats for more than forty years.

Bualiaw and her team of five helpers begin by combining meat—a mix of raw, lean, minced pork and thin strips of boiled pigskin—and steamed sticky rice. The mixture is seasoned with minced garlic, salt, and MSG, and wrapped tightly in banana leaves. The sugars in the sticky rice act as the catalyst, causing the meat to ferment and ultimately turn sour over a period of forty-eight hours.

"Normally we leave *jin som* to ferment for two nights," Bualiaw tells me. "If you like it really sour, you can leave it to ferment for three nights."

I was given a taste, and two nights in Chiang Mai's tropical climate was enough for the mixture to transform into a fragrant (some might say pungent), tart-tasting, sausage-like morsel that has no counterpart I know of in the West.

In northern Thailand, *jin som* is often eaten in its raw form, but it can also be deep-fried or grilled, the latter sometimes supplemented with an egg. *Naem*, the more refined, commercial version of the dish, tends to be leaner, firmer, and more tart in flavor, and is often spiked with a chili or two. It can also be eaten raw, added to soups, or included in stir-fries.

Today, pork is by far the most popular ingredient for *naem* and *jin som*, but according to Bualiaw, "You can make it from pork, beef, or buffalo. The flavor is all the same; they're all sour!"

Jin Som

จิ๊นส้ม

NORTHERN THAI-STYLE FERMENTED PORK

SERVES 4 TO 6

This recipe makes six or seven packets of *jin som*, more than enough for a large meal. You can freeze any remaining *jin som* after they've fermented. As with all fermentation projects, please ensure that all your tools, surfaces, and hands are sanitized before using. The fermented pork will have a sour but delicious scent; if it looks or smells buttery or off, trust your instincts and discard it.

At least 48 hours before you plan to eat the *jin som*, remove any hairs and excess fat or meat from the pork skin, and cut it into strips 2 inches wide. Bring the pork skin and enough water to cover by several inches to a boil in a stockpot over high heat. Reduce the heat to a rapid simmer, cooking until the pork skin is cooked through yet still somewhat firm, about 30 minutes. Strain and add the pork skin to a large bowl and cover with cool water. When cool enough to handle, slice the pork skin as thinly as possible, returning it to the cool water. Gently rub the pork skin in several changes of cool water (this will rid the pork skin of excess collagen, which would otherwise turn the *jin som* into a sticky mass) and drain.

Pound and grind the garlic with a mortar and pestle to a coarse paste.

Put the sticky rice and 2 tablespoons of water in a small bowl. Using your hands, mix and spread the mixture until the grains have separated (this will help the sticky rice distribute evenly throughout the *jin som*).

To a large mixing bowl, add the minced pork, pork skin, garlic, sticky rice, salt, and MSG (if using). Mix and squeeze until thoroughly blended.

Prepare the banana leaves and wrap the *jin som* as described on page 64; you should end up with 6 or 7 packets. Bundle the packets in two layers of plastic bags and leave them in a consistently warm place for 48 hours. (When I tested this dish in Chiang Mai, the temperature fluctuated between 75°F and 90°F; if cooking in locations with cooler temperatures, you may need to put the *jin som* near a consistent source of warmth, such as a heater or even the top of a refrigerator.)

The *jin som* is finished when it has a pleasantly (but not overwhelmingly) sour aroma and a firm, amalgamated texture; it should taste tart, meaty, garlicky, and salty (in that order).

The Northern Thai prefer to eat *jin som* uncooked, but if you like, you can grill or microwave it (in its banana leaf package), or even deep-fry it (unwrapped). Eat with sticky rice as part of a northern Thai meal.

400 grams / 14 ounces pork skin
50 grams / 1¾ ounces Thai garlic (or about 10 standard garlic cloves, peeled; see page 325)
50 grams / 1¾ ounces steamed sticky rice (see page 54)
250 grams / 9 ounces lean ground pork
15 grams / ½ ounce table salt
1 teaspoon MSG (optional)
8 feet of banana leaf, or as needed

THAI KITCHEN TOOLS
granite mortar and pestle

RECIPE CONTINUES

HOW TO *Fold a Banana Leaf for Jin Som*

In this particular banana leaf fold, the goal is to wrap the filling tightly and exclude as much air as possible; otherwise the *jin som* can spoil.

1. Cut the banana leaf into 30 sections, each approximately 10 inches square. Lay one leaf, shiny side facing down, and stack three other leaves on top, alternating the grain and ensuring that the topmost leaf has its shiny side facing up.

2. Put ½ cup of *jin som* in the center of the topmost leaf. With the entire stack of leaves in your left hand, twist the stack so that it's at an oblique angle to your hand.

3. Using your right hand, gather the right-hand point tightly over the *jin som*.

4. Pinching the tip of the right-hand point to keep it in place, fold the left-hand point into one or two narrow creases, and wrap over the *jin som*.

5. Crease the tip of the far end and pull it over the *jin som* tightly, holding it in place with your left thumb.

6. Crease the tip of the near end and pull it over the entire bundle.

7. Wrap the packet tightly, lengthwise, and secure with a rubber band.

VARIATION:

Jin Som Mok Khai /
จิ๊นส้มหมกไข่ / NORTHERN THAI-STYLE

FERMENTED PORK GRILLED WITH EGG

Follow the recipe for *jin som*. On the day of eating, using a Thai-style charcoal grill or barbecue, light the charcoal and allow the coals to reduce to low heat (approximately 250°F to 350°F, or when you can hold your palm 3 inches above the grilling level for 8 to 10 seconds). Unwrap the *jin som* packets, crush the pork with a fork, put the entire opened banana leaf package in a bowl, and crack an egg directly on top of the pork. Rewrap the banana leaf as illustrated in the recipe for *haw nueng kai* (see page 149). Repeat with the remaining *jin som* and additional eggs. Grill the packets, turning occasionally, until the eggs are just set, approximately 30 minutes. Eat at room temperature, with sticky rice, as part of a northern Thai meal.

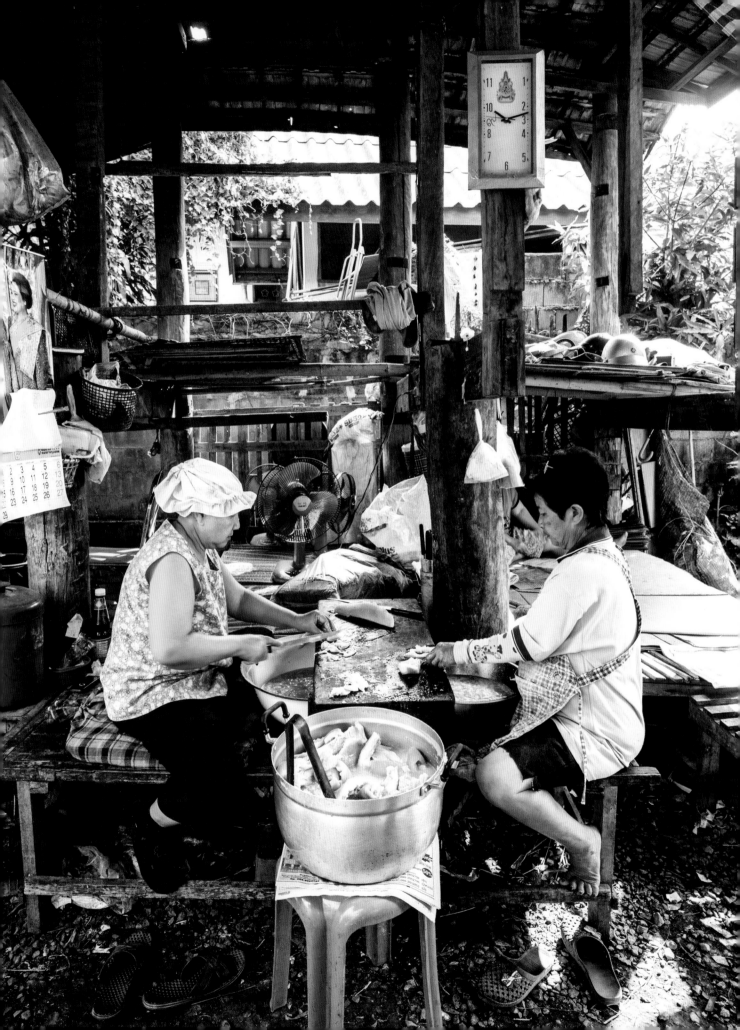

Naem Khua Kap Khai

แหนมคั่วกับไข่

FERMENTED PORK STIR-FRIED WITH EGG

SERVES 4

Aroon (Rai), a decades-old restaurant in Chiang Mai, is where I had my first taste of northern Thai food. Led there in 1998 by Lonely Planet's *Thailand* guidebook (which, incidentally, I would contribute to a decade later), I'm pretty sure I ordered *naam phrik awng*, the classic northern Thai dip of minced pork and tomatoes, and *kaeng hang lay*, a rich curry of pork belly. I'm also pretty sure I was unimpressed. I recall the dishes as being blandly meaty and slightly sweet. Although I knew virtually nothing about northern Thai food at the time, they struck me as approximations.

In the decades since, I've revisited Aroon (Rai) a few times, and it remains a pretty mediocre restaurant. But they do serve an excellent *naem khua kap khai*, fermented pork stir-fried with egg. I suspect that this is because Aroon (Rai) is essentially a Chinese restaurant—one that happens to serve northern Thai dishes.

In the past, the majority of restaurants in northern Thailand were run by Chinese. One of the rare stir-fried dishes in the northern Thai repertoire, *naem khua kap khai* quite possibly stems from this tradition, one of Chinese cooks combining Chinese cooking techniques (stir-frying) and ingredients (onion, pickled garlic) with local ingredients (*naem*). It's an example of fusion with a backstory, one that's worth seeking out.

The owners of Aroon (Rai) weren't interested in being interviewed for this book, so the following is my approximation of their version of the dish.

———

Heat the oil in a wok set over high heat. When very hot, add the *naem* and allow it to sear on one side for about 1 minute. Add the chilies, onion, tomato, pickled garlic, white soy sauce, and salt, and fry, stirring infrequently to sear the vegetables, until the tomatoes are just tender, 3 to 4 minutes. Push the ingredients to one side of wok, and add the eggs, turning the wok to allow the eggs to set in a thin layer. Fry, stirring only occasionally, until the eggs are just set, about 1 minute. Add the green onion, and stir the whole mixture briefly, breaking the omelet that has formed, to combine.

Taste, adjusting the seasoning if necessary; the *naem khua kap khai* should taste tart and salty.

Remove to a serving dish and serve hot, with long-grained or sticky rice, as part of a northern Thai meal.

2 tablespoons vegetable oil

150 grams / 5¼ ounces *naem* (Thai-style fermented pork), 1-inch pieces

2 large fresh red chilies (40 grams / 1½ ounces total; see page 324), ½-inch slices

50 grams/ 1¾ ounces onion, sliced

60 grams / 2 ounces tomato, sliced lengthwise

8 cloves Thai pickled garlic (20 grams / ⅔ ounce total)

½ teaspoon white soy sauce (see page 328)

¼ teaspoon table salt

2 eggs, beaten lightly

1 green onion (20 grams / ⅔ ounce), green part only, 1-inch lengths

THAI KITCHEN TOOLS

medium wok (approximately 12 inches)

Deep-Fried Stuff

You'll smell it before you reach it. Every evening, Chiang Mai's Kamphaeng Din neighborhood becomes shrouded in a cloud of oily smoke, liberally accented with notes of deep-fried pork fat, augmented by a soundtrack of sizzling and splattering and conversations that tend to be a bit on the loud side. The source of all this is a handful of restaurants that specialize in deep-fried meats, eateries legendary and beloved—and infamous—among the residents of Chiang Mai.

The story goes that there was once a pork slaughterhouse located not far from Kamphaeng Din, and attached to it were a couple late-night restaurants selling deep-fried pig parts to off-duty butchers and hungry drinkers staggering home. Today the slaughterhouse is long gone, but over time, the restaurants shifted a few blocks over to the Kamphaeng Din area, carrying on the meaty tradition (one of the restaurants is still referred to as Tup Iit—an onomatopoeia for the thwack and squeal, respectively, that constitute the final sounds before a pig becomes pork).

"We were the first restaurant to sell deep-fried stuff in this area," explains Surachet Trakulneungcharoen, whose parents opened Midnight Fried Chicken, as it's known in English, more than thirty years ago. It's by far the most popular of Kamphaeng Din's oily eateries, boasting long queues even before it opens at 10 p.m. And it's typical of the genre, serving a repertoire of deep-fried items that includes chicken, but also pork belly, four types of pork intestine, stomach, two types of liver, tongue, sausage, sun-dried beef, and even mackerel, all of which are simmered for as long as a half hour in vast woks of oil as dark as the stuff you'd find in the crankcase of a Mack truck. To order, point out your meats from the pile, couple them with your choice of *naam phrik num* (a dip of grilled chilies, garlic, and shallots) or *naam phrik taa daeng* (a dip of dried chilies), a tiny plate of pickled mustard greens and boiled cabbage—the only concession to vegetables in these parts—and a mound of sticky rice, and you're ready to embark upon one of Chiang Mai's most delicious culinary experiences.

The restaurants are open until late, drawing hungry nocturnal locals, the occasional curious tourist, and, of course, a boozy post-drinking crowd. Yet Midnight Fried Chicken remains resolutely dry. "We don't sell any alcohol; we haven't since the beginning," Surachet tells me. "People who eat here have already had enough to drink, and we don't want any problems."

But Chiang Mai's obsession with deep-fried food isn't limited to a single neighborhood or the nighttime. Visit any of the city's markets and you'll encounter stalls selling many of the same deep-fried meats offered at Kamphaeng Din, but especially pork rinds—lots and lots of pork rinds—quite possibly the most Chiang Mai dish of all. Plucked from bubbling lard and piled in immense heaps, still popping and crackling, they're bagged up and bought by locals—sublime when combined with *naam phrik num*—or by tourists as obligatory gifts for friends and family back at home.

When I ask Surachet why people in Chiang Mai are so fanatical about deep-fried foods, he tells me, "It's our local food, it's simple, we've been eating it since we were young," before adding, rather pragmatically, "and deep-frying is faster than grilling."

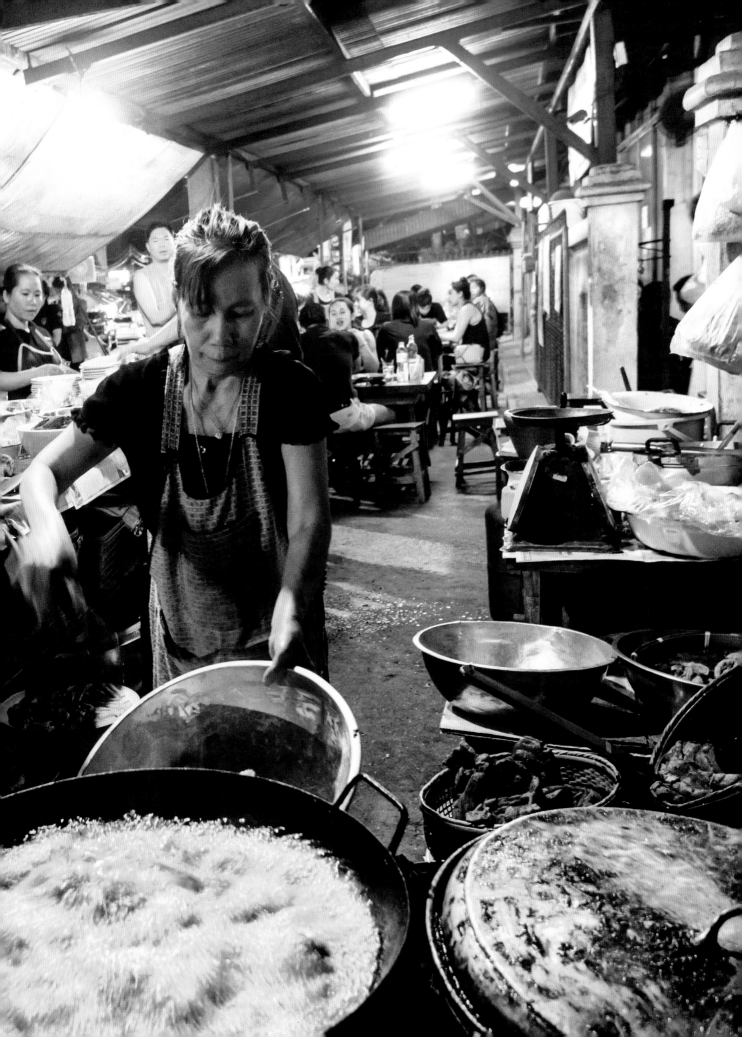

Khaep Muu

แคบหมู

DEEP-FRIED PORK RINDS

SERVES 4 TO 6

In the United States, pork rinds have a pretty bad rep: the epitome of unhealthy indulgence, the flagship snack of the couch-bound and pot-bellied. But cross to northern Thailand and pork rinds carry none of this baggage. Eaten on their own, coupled with spicy *naam phrik* (chili-based dips) or crumbled on top of other dishes as a garnish, they're an almost obligatory element to any local meal.

"I use pork skins that have a layer of fat," explains Khampo Lueatmak, who has been deep-frying pork rinds from her home-based factory outside of the town of Mae Rim for more than a decade. "If there's a little bit of meat left on the skin, it's even tastier!"

As is the preference in much of northern Thailand, Khampo's pork rinds are thick, hearty, and meaty. This comes from that layer of fat and also from the cooking process, which sees the pigskins simmered in oil for as long as two hours, fully rendering the lard and turning the fat and skin dark and crispy. When they've reached this stage, Khampo kicks up the heat, blasting the pork rinds for a couple of minutes, resulting in swollen, golden, crunchy, pock-marked balls of skin and unctuous fat.

You can couple these pork rinds with just about any *naam phrik*, but *naam phrik num* (page 42) is the classic counterpart.

Wash the pork skin in cool water and remove any hairs with tweezers or a razor. Pat the skin dry with paper towels and lay it out to dry in direct sunlight (or in a food dehydrator), skin side up, for a half day, or until slightly dry and stiff.

Using a heavy cleaver, cut the pork skin into strips about 1 inch wide, then into sections about 2 inches long.

Heat the vegetable oil, pork skin, salt, white soy sauce, black soy sauce, and MSG (if using) in a wok over medium heat. Adjust the heat to maintain a gentle simmer and stir occasionally. After 20 minutes the mixture should be slick with rendered lard; after 50 minutes the rendered lard should be approximately at the level of the pork skin; after 1 hour, the pork rinds should be darkening in color and the skin should start to crisp; after 1½ hours, the pork skin should have floated to the top of the oil and will be light brown or orange in color, and the skin side should be crispy with tiny pockmarks. Remove the pork rinds and allow them to drain on paper towels.

Strain the oil, return it to the wok, and heat it over medium-high heat to 400°F. Put a small portion of the pork rinds in the hot oil, stirring frequently; they should float immediately, turn pale, then golden, crispy, and fragrant, a total of about 2 minutes. Remove them from the oil and drain on paper towels. Repeat with the remaining pork rinds.

Serve at room temperature, with sticky rice and *naam phrik*, as part of a northern Thai meal.

1½ kilograms / 3¼ pounds fat-on pork skin
⅓ cup vegetable oil
1 tablespoon table salt
½ teaspoon white soy sauce (see page 328)
½ teaspoon black soy sauce (see page 328)
½ teaspoon MSG (optional)

THAI KITCHEN TOOLS
large cleaver or *laap* knife
large heavy-bottomed wok (19 inches or larger)

The Northern Thai Grill

One of the most frustrating paradoxes in northern Thailand is that, despite how unique and delicious the region's cuisine is, there are relatively few restaurants that serve local food. For locals, eating out can be expensive, and anyway, most folks prefer to cook at home, occasionally supplementing their meal with a bag or two of takeout from the market. But the one exception to this is the grill. If a northern Thai town has only one eatery, it will inevitably be a smoky shack full of dudes, semilegal alcohol, and grilled meat—especially the odd cuts.

You see, in northern Thailand, little—if anything—is wasted. This is especially true when it concerns meat, until recently a rare and precious commodity in the region. Butchering a pig results in fatty sections of skin, undesirable cuts of meat, and miscellanea such as intestines and brains—bits and bobs that, elsewhere, might simply be discarded. In the north, they wind up on the grill.

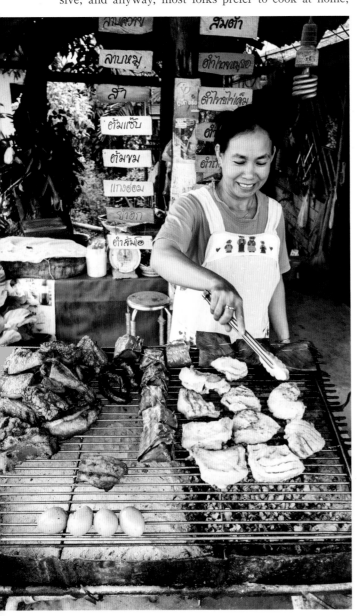

Not only do these odd cuts of meat eventually cross paths with hot coals, but they do so in a way that takes brilliant advantage of each ingredient's specific qualities. Leg, belly, tail, and other cuts that cling to skin are grilled until their exteriors are golden, bubbly, crispy, and virtually indistinguishable from deep-fried meat. Rubbery large intestines and teat (yes, teat) are doused in a strong marinade to temper their overtly porky odor before being grilled. Thin gut is stuffed with fatty pork and fragrant herbs in the form of sausages. Unctuous brain is paired with similarly rich pork and egg and grilled in banana leaf packages. Although born out of necessity, this resourcefulness has resulted in what is undoubtedly the most popular type of eatery in northern Thailand.

With an unassuming roadside location, an interior that features dusty, rustic bric-a-brac, and a small but prominent grill, Pannika, the source of the following recipes, is the archetypical northern Thai grill shack. Come 11 a.m., patrons start to pull up directly in front of the grill—engines still running—point to a couple items, pair them with a bag or two of sticky rice, and race off. Others—teachers on lunch break, military types, a family—might eat in, pairing their slices of grilled pork neck with a plate of papaya salad and perhaps a beer. Patrons walk into the kitchen and serve themselves. Staff communicate by shouting. It's informal and delicious, hardly a paradox at all.

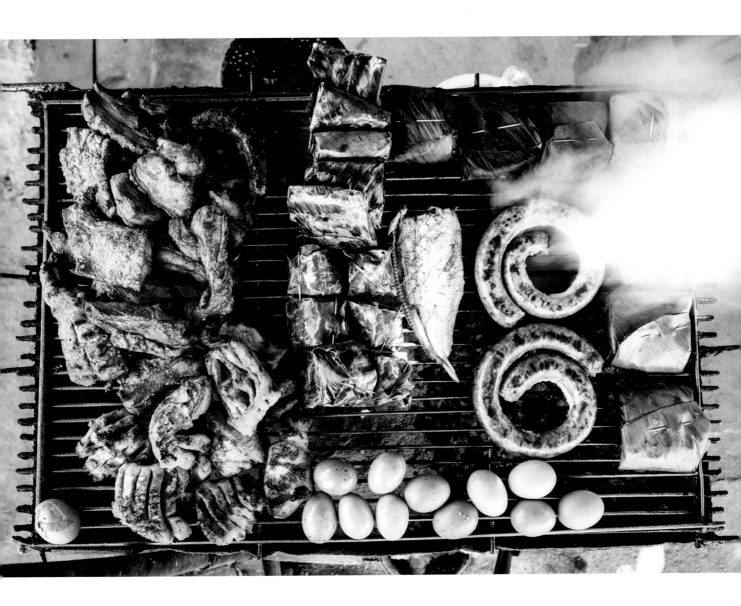

Grilled Favorites

On a typical day, the grill at Pannika, a roadside restaurant in Mae Hang, Chiang Mai Province, includes the following items:

1. Pork leg, neck / *saphok muu, khaang muu* / สะโพกหมู คางหมู
2. Banana leaf packages of fatty pork, brains, and herbs / *aep awng aw* / แอ็บอ่องออ
3. Eggs / *khai ping* / ไข่ปิ้ง
4. Pork teat / *paeng nom yaang* / แป้งนมย่าง
5. Fermented pork / *jin som* / จิ้นส้ม
6. Dried fish / *plaa haeng* / ปลาแห้ง
7. Pork and herb sausage / *sai ua* / ไส้อั่ว

Sai Ua

ไส้อั่ว

NORTHERN THAI-STYLE HERB SAUSAGE

SERVES 4 TO 6

Like New Yorkers and their pizza, northern Thai aren't exactly shy to share their opinions about *sai ua* (literally "stuffed intestines"), sausages packed with fatty pork and aromatic herbs.

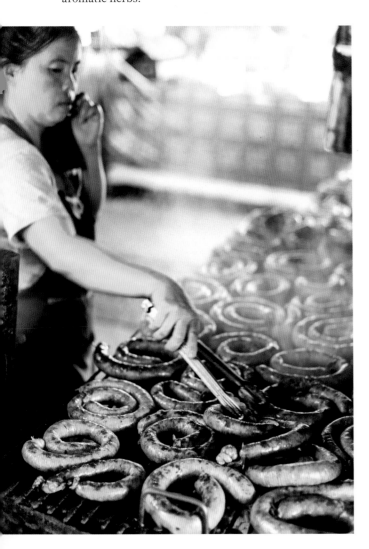

"Some people deep-fry *sai ua*, but it's more fragrant if you grill it," explains Pannika Tanjina, cook/owner of the eponymous roadside restaurant outside of Tha Ton, in rural Chiang Mai Province.

From village to village across northern Thailand, there are subtle twists on the sausage—without a doubt one of the region's most famous dishes—with some versions emphasizing herbs and lean pork, others boasting decadent chunks of fat or dried spices, some versions grilled and others deep-fried.

"*Sai ua* should taste herbal," Pannika tells me. "It should be spicy and salty," she adds, describing her version of the dish, which I also found to have a near-perfect balance of lean pork and fat.

I tend to agree with Pannika about grilling, but if you're cooking at home, it's fine to broil or panfry (or, if so inclined, deep-fry) *sai ua*. Regardless of how you serve it, be sure to ask your butcher to grind the pork coarsely, as the sausage should have a relatively loose, chunky texture. This recipe makes enough *sai ua* for a couple meals, but any uncooked sausage can be frozen for a few months.

Make the curry paste: Pound and grind the salt and chilies with a mortar and pestle to a coarse powder. Add the lemongrass and pound and grind it to a coarse paste. Add the shallots, garlic, and shrimp paste, and pound and grind to a relatively fine paste.

Prepare the sausages: In a large bowl, place the curry paste, pork shoulder, pork belly, kaffir lime leaves, white soy sauce, turmeric powder, and MSG (if using); mix gently to combine. Avoid working the mixture too much; you want it to remain a bit loose, not tight and emulsified.

Fry a tablespoon or so of the mixture briefly in hot oil (or microwave it). Taste and adjust the seasoning if necessary; the *sai ua* should taste herbal, spicy, and meaty (in that order).

Rinse the sausage casings thoroughly in cool water. Take a section around 2 feet long, knot one end, and put the other on a wide-mouthed funnel. Fill the casings by hand; avoid packing them too tightly. When full, tie off the open end and pierce any visible air bubbles with a toothpick or needle. Repeat with the remaining pork mixture and casings.

In a large grill or barbecue, light the charcoal, allow the fire to reduce to coals, spread out the coals, and adjust the grate to 6 to 7 inches above the coals (otherwise the dripping fat will cause flare-ups). When the coals have reached low heat (approximately 250°F to 350°F, or when you can hold your palm 3 inches above the grilling level for 8 to 10 seconds), add as many coils of *sai ua* as fit comfortably and grill, flipping once, until cooked through and browned on the exterior, a total of around 20 minutes. Remove from the heat and cool.

Cut the sausages into sections about 1 inch long and eat with sticky rice—and perhaps *naam phrik num* (page 42)—as part of a northern Thai meal.

For the Curry Paste
½ teaspoon table salt
10 medium dried chilies (5 grams total; see page 325)
4 stalks lemongrass (100 grams/ 3½ ounces total), exterior tough layers peeled, green section discarded, pale section sliced thinly
100 grams / 3½ ounces shallots, peeled and sliced
10 garlic cloves (50 grams / 1¾ ounces), peeled and sliced
2 teaspoons shrimp paste

For the Sausage
500 grams / 1 pound fatty pork shoulder, ground coarsely
500 grams / 1 pound skinless pork belly, ground coarsely
7 kaffir lime leaves, sliced very thinly
1 tablespoon white soy sauce (see page 328)
1 teaspoon turmeric powder
½ teaspoon MSG (optional)
6 feet of prepared natural pork sausage casings, or as needed

THAI KITCHEN TOOLS
granite mortar and pestle

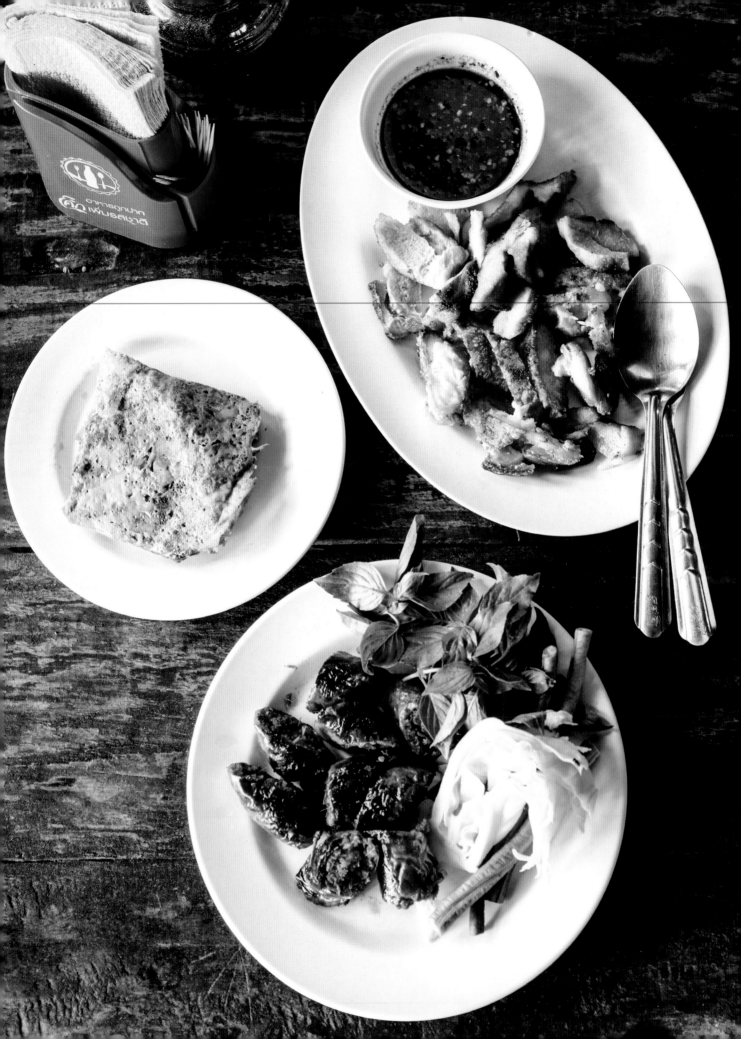

Muu Yaang

หมูย่าง

NORTHERN THAI-STYLE GRILLED PORK

SERVES 4

Neck, leg, chin, belly, tail: why these very specific yet unusual pork parts so regularly end up on the northern Thai grill was a mystery to me until I met Pannika Tanjina.

"We like to use lean meat from the pork leg to make *laap*," explained the restaurateur of the salad of minced meat. "The part with the skin is left over, so we grill it."

There's an unglamorous practicality behind this reasoning, but there's also an element of culinary genius. Cuts such as the exterior of the pork leg include skin, fat, and meat. When grilled, the skin crisps on the outside, the interior layer of fat melts, and the meat becomes tender and juicy. The epitome of this is grilled pork tail, in which the thin skin serves as a crispy shell for the fatty meat inside. (Large intestine and pork teat—two other cuts that frequently feature on the northern Thai grill—are somewhat harder to grasp until you consider that the Thai are big fans of texture.)

Because the marinade for northern Thai-style grilled pork is—by Thai standards—relatively minimal, the dish is typically served with a dipping sauce. The dip at Pannika's restaurant blends tart tamarind and sweet palm sugar, with just enough salt and chili to be heard.

This recipe should be made with a mixture of pork belly (with skin intact), fatty pork neck (with skin), and/or fatty pork leg (with skin). Note that, because these cuts are so fatty, you'll need a US-style barbecue grill (or equivalent) with a grate that's at least six inches above the coals; otherwise the dripping fat will cause flare-ups. And Pannika's marinade, like that of just about anyone else who grills pork in northern Thailand, includes a generous amount of MSG. The ingredient contributes to the dish's red color—slightly less so to its taste—and is entirely optional.

RECIPE CONTINUES

OPPOSITE: From the top—
Muu Yaang,
Aep Awng Aw,
and *Sai Ua.*

For the Dipping Sauce

100 grams / 3½ ounces tamarind pulp
¼ cup vegetable oil
70 grams / 2½ ounces shallots, peeled
 and sliced thinly
⅓ cup palm sugar
1 tablespoon dried chili powder
1 tablespoon table salt
1 teaspoon white soy sauce
 (see page 328)
½ teaspoon MSG (optional)
1 tablespoon crispy garlic and garlic
 oil (see page 32)

For the Grilled Pork

500 grams / 1 pound fatty pork
 (ideally a mixture of belly, neck
 and leg), 6 × 2-inch pieces
1 teaspoon fish sauce
1 teaspoon white soy sauce
 (see page 328)
1 teaspoon MSG (optional)

Prepare the dipping sauce: A few hours before you plan to serve the dish, bring 1½ cups of water to a boil in a small saucepan over medium heat. Remove it from the heat, add the tamarind pulp, and mash with a spoon to combine. Set aside for 15 minutes. Pour the tamarind mixture through a sieve, pushing to extract as much of the liquid as possible. Discard the solids; you should end up with approximately 1 cup of relatively thick tamarind liquid.

Heat the oil in a wok over medium-low heat. Add the sliced shallots and fry, stirring frequently, until golden, crispy, and fragrant, about 20 minutes. Remove the shallots from the oil and drain on a paper towel.

Add the tamarind liquid, ½ cup of water, and the palm sugar to a saucepan over low heat. Simmer until the sugar melts. Add the chili powder, salt, white soy sauce, and MSG (if using), and simmer, stirring occasionally, until reduced slightly (but not yet syrupy in consistency), about 5 minutes. Add the crispy garlic and 1 tablespoon of the crispy shallots, and taste; the dip should taste sweet, tart, spicy, and salty (in that order). Remove the dipping sauce to a small serving bowl.

Prepare the pork: Combine the pork, fish sauce, white soy sauce, and MSG (if using). Marinate for 1 hour.

While the pork is marinating, prepare the grill: In a large grill or barbecue, light the charcoal, allow the fire to reduce to coals, distribute the coals, and adjust the grate to 6 to 7 inches above the coals. When the coals have reached 250°F to 350°F, or when you can hold your palm 3 inches above the grilling level for 8 to 10 seconds, add the pork, skin side down. Grill the pork, flipping once after approximately 20 minutes, until cooked through but still tender, juicy, and slightly crispy on the exterior, a total of approximately 40 minutes.

Slice the pork thinly (ensuring that each slice includes lean meat, fat and skin) and serve with the dipping sauce and sticky rice as part of a northern Thai meal.

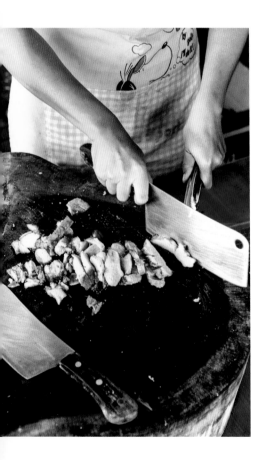

Aep Awng Aw

แอ็บอ่องออ

GRILLED HERBAL PACKETS OF PORK AND BRAINS

SERVES 4 TO 6

Easily the most mysterious northern Thai grilled dish is *aep*, a banana leaf packet concealing an herbal curry paste and, unless you've already been informed, an unknown main ingredient. The latter can be just about anything from tiny freshwater fish to mushrooms, but the most prized—and easily the most decadent—version is *aep awng aw*, which highlights pork brains.

"It's the same recipe as *sai ua*," explains Pannika Tanjina, drawing parallels with the famous northern Thai sausage. "I use the same ingredients, but add egg and pork brains."

Additional divergences include the fact that the *aep* is steamed before it's grilled, a step that, according to Pannika, imparts the pork with an additional layer of subtle fragrance from the banana leaf. Coupled with the egg, these fatty cuts and the almost creamy brains culminate in a dish that is unctuous, smooth, and rich—more curry than sausage.

If you can't—or don't want to—obtain pork brains, it's perfectly acceptable to omit this ingredient (and ½ teaspoon of salt), in which case the packets are known simply as *aep muu*, pork *aep*.

RECIPE CONTINUES

For the Curry Paste

½ teaspoon table salt

5 medium dried chilies (3 grams total; see page 325)

4 stalks lemongrass (100 grams; 3½ ounces total), exterior tough layers peeled, green section discarded, pale section sliced thinly

40 grams / 1½ ounces shallots, peeled and sliced

4 garlic cloves (20 grams / ⅔ ounce), peeled and sliced

1 teaspoon shrimp paste

For the Aep

250 grams / 9 ounces fatty pork shoulder, ground

250 grams / 9 ounces skinless pork belly, ground

3 kaffir lime leaves, sliced very thinly

1 teaspoon white soy sauce (see page 328)

1 teaspoon table salt

¼ teaspoon MSG (optional)

¼ teaspoon turmeric powder

2 eggs

100 grams / 3½ ounces pork brains

6 feet of banana leaf, or as needed, cut into 8 sections: 4 10 inches square and 4 10 inches × 8 inches

THAI KITCHEN TOOLS

granite mortar and pestle
Thai-style steamer

Make the curry paste: With a mortar and pestle, pound and grind the salt and chilies until you have a coarse powder. Add the lemongrass; pound and grind until you have a coarse paste. Add the shallots, garlic, and shrimp paste; pound and grind to a fine paste.

Prepare the aep: Mix together the curry paste, pork shoulder, pork belly, kaffir lime leaves, white soy sauce, salt, MSG (if using), turmeric powder, and eggs. Fry approximately 1 tablespoon of the mixture briefly in oil (or microwave it). Taste, adjusting the seasoning if necessary; the *aep* should taste herbal, salty, spicy, and meaty (in that order).

Prepare the banana leaves and fold in the *aep* as illustrated below; you should end up with 4 or 5 packages.

Place the banana leaf packages in a Thai-style steamer over high heat, and steam for 20 minutes.

While the *aep* are steaming, prepare the grill. In a large grill or barbecue, light the charcoal, allow the fire to reduce to coals, distribute the coals, and adjust the grate to 6 to 7 inches above the coals. When coals have reached 250°F to 350°F, or when you can hold your palm 3 inches above the grilling level for 8 to 10 seconds, add the *aep*. Grill, flipping once, until the exterior of the banana leaf package is slightly charred, about 20 minutes.

Eat warm or at room temperature with sticky rice as part of a northern Thai meal.

HOW TO *Fold a Banana Leaf for Aep*

1. Position one square section at an angle, the shiny side facing down, and top with one smaller section, the grain running at a 45-degree angle to the first leaf, the shiny side facing up. Top with 100 grams / 3½ ounces of the pork mixture and 20 grams / ⅔ ounce of pork brains.

2. Fold the right-hand and left-hand points of the square piece over the pork mixture.

3. Fold the near and far points of the square piece over the top of the pork mixture, pinching the final protruding point to make a neat square packet.

4. Seal the package with one or two toothpicks. Repeat with the remaining banana leaf sections and pork mixture.

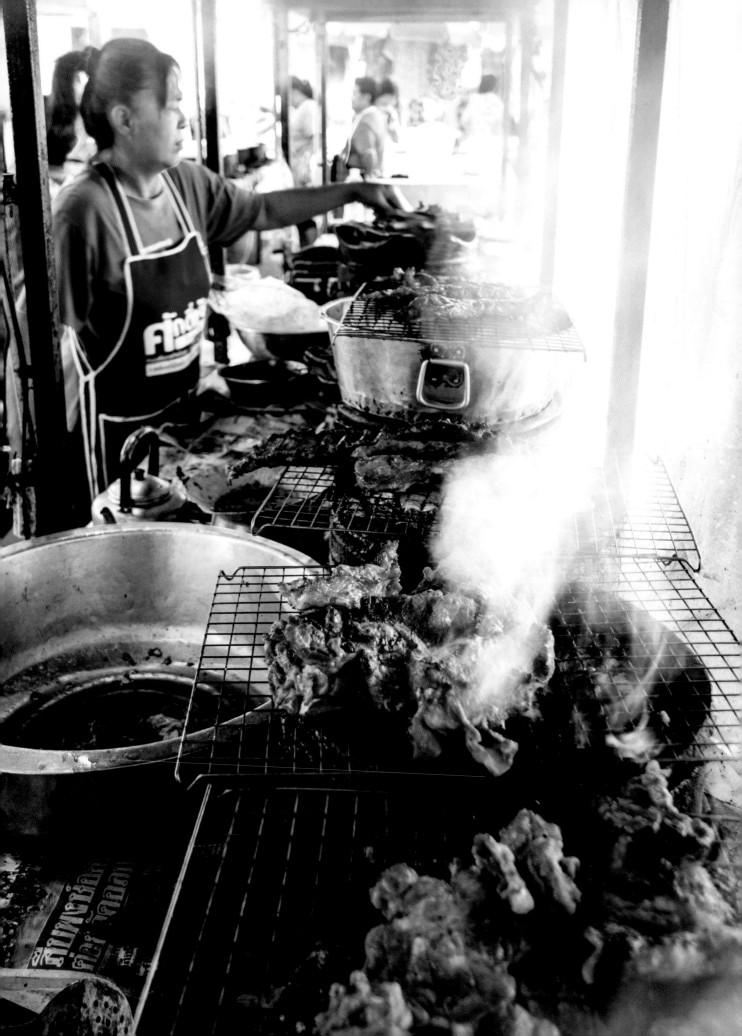

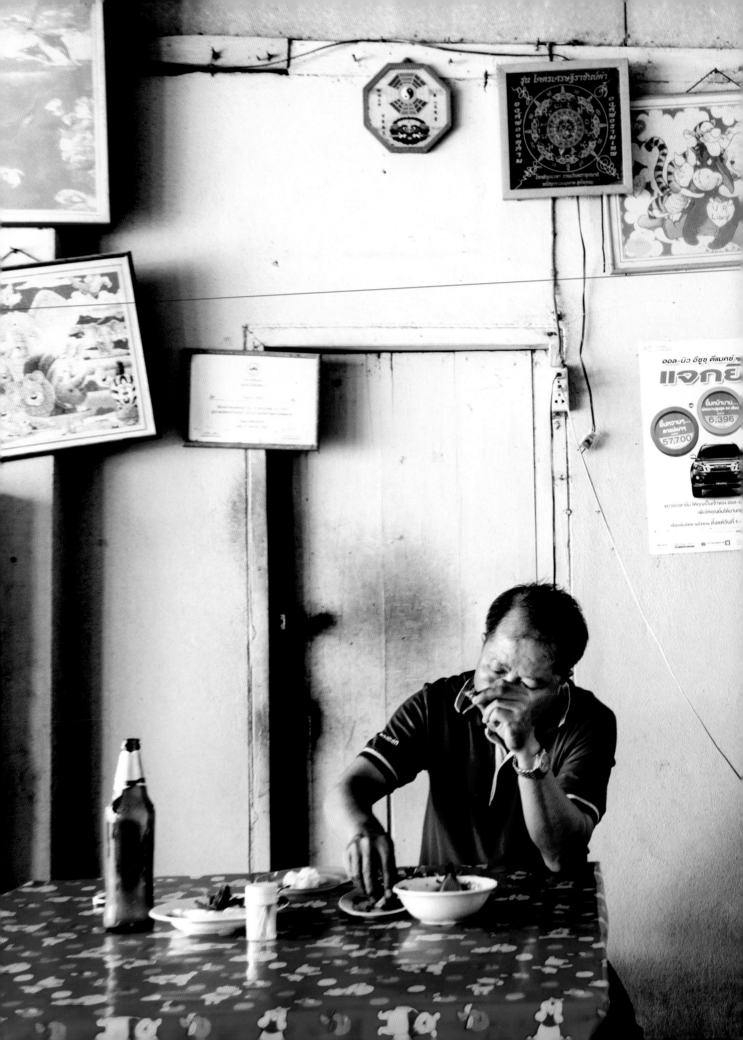

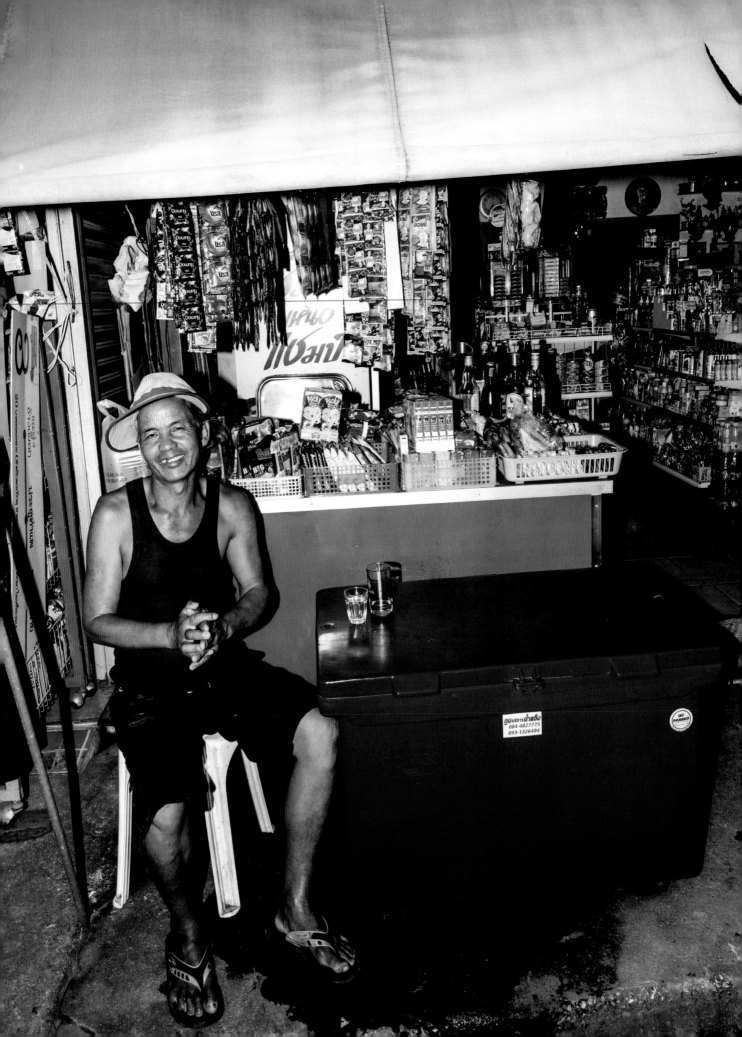

White Booze

Yes, there is a drinking scene in northern Thailand. In the countryside, it typically takes the form of slightly seedy but welcoming, gaudily lit karaoke joints where you can pair your Singha with a spicy dish, a song, and a female "friend." In the city, you'll find sophisticated pubs where your options might include a bottle of Red Label and a live cover band. But for the real northern Thai drinking experience, all you really need to do is head to the corner shop. Whether you're in the city or the country, just around the corner there's invariably a dusty, family-run mini-mart selling everything from dried squid to toothpaste. Beneath unflattering fluorescent lighting, with motorcycles buzzing by and a soundtrack of Thai country music, there's bound to be a fake marble table and a small rack of locally produced bottles of booze. That's the bar.

The Thai are relatively prolific drinkers, yet for many in the north, beer's price tag comes too steep. Instead, many locals opt for *lao khao*, "white alcohol," sticky rice–based booze typically distilled at rural home-based factories. Along with the ersatz marble table (known locally as *maa hin*—"stone horse"), *lao khao* is an obligatory element of the northern Thai corner shop boozing experience. Locals drink the stuff by the *kong*, a small tin cup equivalent to one and a half ounces, or one shot. A *kong* of booze can cost as little as 7 baht (about US$0.20) and is usually paired with some sort of snack: tart fruit dipped in salt or perhaps a bag of deep-fried pork rinds. Feeling antisocial and prefer to drink your *lao khao* at home? The shop owner will be more than happy to pour it in a plastic bag for you—complete with a rubber-band handle and straw.

In many cases, particularly in the countryside, those brown bottles of booze crowding the *maa hin* originated only a short distance away.

"I learned how to make alcohol from my parents when I was sixteen or seventeen," explains Duangporn Heepthong, a sixty-year-old distiller of *lao khao* in Ban Mai, a rural village north of Chiang Mai. "Back then it was illegal to make alcohol at home. We had to hide in the forest to do it!"

These days, with the requisite government permission, private distilling is above board, and with the help of her son, Duangporn makes *lao khao* from her home-based factory. With sacks of rice and empty beer bottles scattered about, I have trouble telling where Duangporn's home ends and the factory begins, but that's because she's responsible for virtually every step of the process, from the cultivation of the sticky rice used to make the booze to the bottling.

Producing *lao khao* the northern Thai way begins by making a starter, dough-like balls of sticky rice flour, spices, herbs, and water that nurture the ambient yeasts and bacteria that transform the sugars in the sticky rice to alcohol.

"I don't use yeast—I don't even know what it is!" Duangporn tells me. "Other factories add yeast, but we make it the natural way."

After the starter has been given the chance to soak up all that good stuff in the air, it's dried in the sun and ground to a powder. It's then added to steamed sticky rice, and the mixture is moved to covered buckets to ferment. After three days, the rice has yielded a small amount of booze and is effervescent and bubbling, with a sour, yeasty fragrance; after five days, water is added to slow the fermentation; and after a total of approximately ten days, the grains of rice have shed most of their sugar in the form of alcohol, which is ready to be distilled.

Duangporn recently installed a flashy new stainless-steel still, but until the government comes to inspect it, she continues to rely on her old setup: a rusty oil barrel with a bamboo spout. The alcohol that slowly drips out of this homemade contraption is filtered once more, then it's funneled into recycled beer bottles. A 630-milliliter bottle of Duangporn's *lao khao* goes for 60 baht (approximately US$1.60), although more than half of this goes to the government in the form of taxes, making home distilling a tough way to earn a living.

"I sell to shops around here, and locals come and buy it directly from me," Duangporn tells me. "I can make around seventy bottles a day, and they all sell out!"

I'm given a glass, and Duangporn's *lao khao*, which comes in at about 30 percent alcohol, is mild, sweet, and fragrant—something akin to a strong, clear, herbaceous sake—the dried spices and herbs in the starter just noticeable in the background.

"The fragrance of the alcohol from each factory isn't the same; it depends on the starter," explains Duangporn, whose starter includes a mixture of twelve different dried spices, as well as fresh galangal, pandan leaf, and the branches of the Indian trumpet flower.

She offers me another glass that comes in at around 35 percent alcohol—nearing the 40 percent ceiling set by the government—and that subtle fragrance is edged out by a bracing burn.

"I don't drink it; I only make the stuff," Duangporn tells me as I sip. "But my son loves it! He only drinks ours; he doesn't trust the alcohol from elsewhere."

4

5

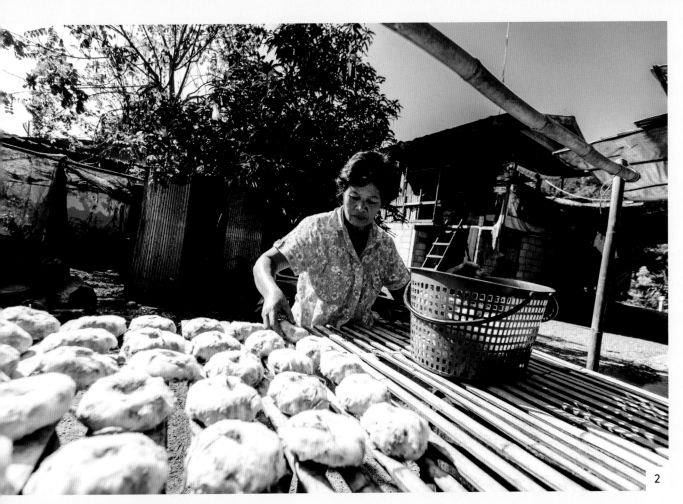

2

6

Duangporn Heepthong and other small-scale makers of *lao khao* in northern Thailand begin by making a rice-based starter, and from this step to bottling, the process can take as many as 18 days.

1. To make the starter, sticky rice flour is combined with a dried spice powder, ground fresh herbs, and water. This dough is shaped into bagel-sized cakes, spread out on dried rice stalks, covered with another layer of dried rice stalks and a blanket, and left for three nights to absorb the surrounding yeasts and bacteria.
2. By the fourth day, the starter cakes have developed a layer of white mold. They're transferred to racks to dry in the sun for about three days.
3. When the starter cakes are completely dry, they're ground into a fine powder.
4. To make the *lao khao*, the sticky rice is soaked overnight. The next day, the rice is steamed, rinsed in water, strained, combined with the starter powder, and put in buckets where it's left to ferment for about 10 days.
5. The alcohol is strained (the rice is used as cow feed) and distilled in a still topped with a large wok full of water. The liquid is brought to a boil, the alcohol evaporates, and it hits the bottom of the wok, condenses, and is channeled to a spout.
6. The resulting alcohol is filtered through several layers of cheese-cloth before being bottled.

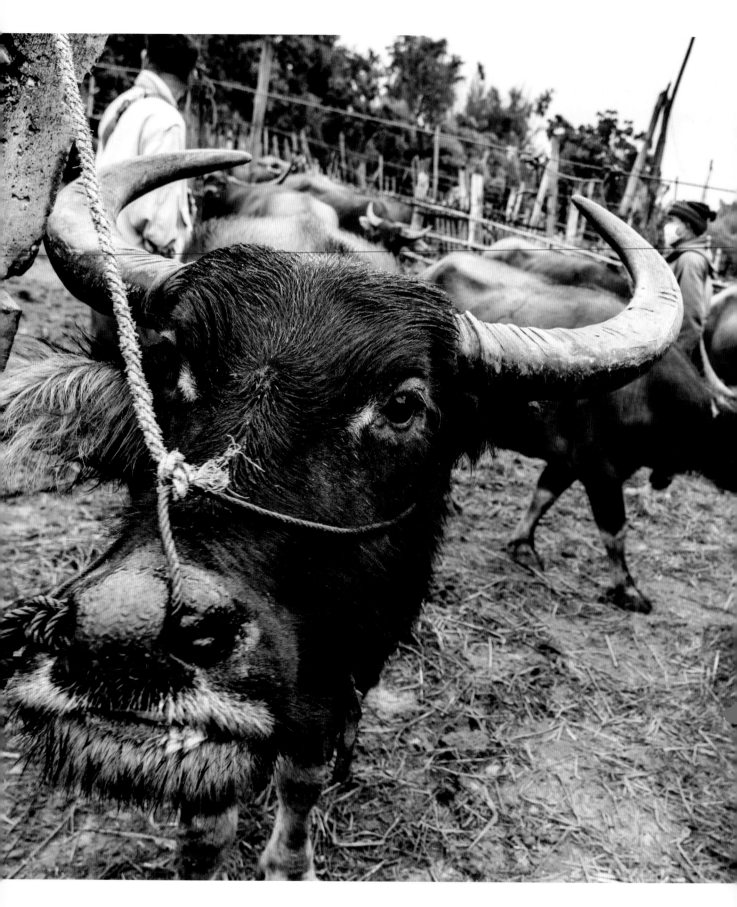

The Buffalo Market

The path that leads to the buffaloes passes by rows of used motorcycles for sale; stalls peddling country music CDs, clothing, and farm implements; vendors grilling meat; and a raucous cluster of fighting cocks. It's not unlike traveling back in time, and in many ways Chiang Mai's so-called buffalo market is an anachronism, although one that these days serves a slightly more contemporary purpose.

Every Saturday, as early as 4 a.m., hundreds of vendors, buyers, gawkers, and livestock fill an otherwise empty field in San Pa Tong, southwest of Chiang Mai. In the northern Thai dialect, the market is known as *kaat ngua*, "cow market," but these days the cows are far outnumbered by buffaloes.

"There are usually between two hundred and three hundred buffaloes for sale," explains Yan, a vendor at the market. "They're raised for eating; only Burmese and Lao people use buffaloes for work these days."

In the northern Thailand of today, the gas engine has taken over the role formerly held by the buffalo. Yet unlike in central Thailand, where the influence of Chinese Buddhism has convinced many that consuming large animals is bad for karma, the northern Thai continue to love their beef and buffalo meat. Raw buffalo *laap* is one of the most prized dishes in the region, and beef is a staple ingredient at every grill shack in the north.

Yan, a native of Chiang Mai who's been coming to the market for more than a decade, arrived at 5 a.m. with three buffaloes. When I ask how much the animals sell for, he replies, "A big one can go for 50,000 to 60,000 baht [approximately US$1,400 to US$1,700]."

Tethered to a wooden corral in a clearing ringed by trees, the immense beasts wear intimidating long horns and an expression that is simultaneously skittish and grumpy. This does little to deter the men who walk between them, pinching skin, scrutinizing muscle and teeth, haggling. As we chat, purchased buffaloes are dragged, unwillingly, toward a line of waiting trucks. Yan tells me that, after being bought, the animals will typically be fattened for a month before being slaughtered and sold at markets and to restaurants in Chiang Mai and elsewhere.

From the corral, I cross over to a shaded area where, under dozens of woven bamboo domes, are an equal number of cocks, crowing and strutting—yet another section of the vast, esoteric market.

"All the chickens here are for fighting," explains Tom, a young fighting-cock breeder who claims to keep more than one hundred chickens at his home-based farm. "I just come for fun, to see what's available. But if there's a strong chicken, I'll buy it."

As at the buffalo section, Tom and other potential buyers wander among the cages, plucking a chicken from its bamboo cage to inspect its plumage, its skin, its feet. Some men (and they're all men) stroke the birds affectionately as they consider a purchase. Occasionally, a pair of birds will be selected and an impromptu fight is initiated, an explosion of feathers and squawking ringed by onlookers and potential buyers—yet another unique aspect of Chiang Mai's past that continues to live on.

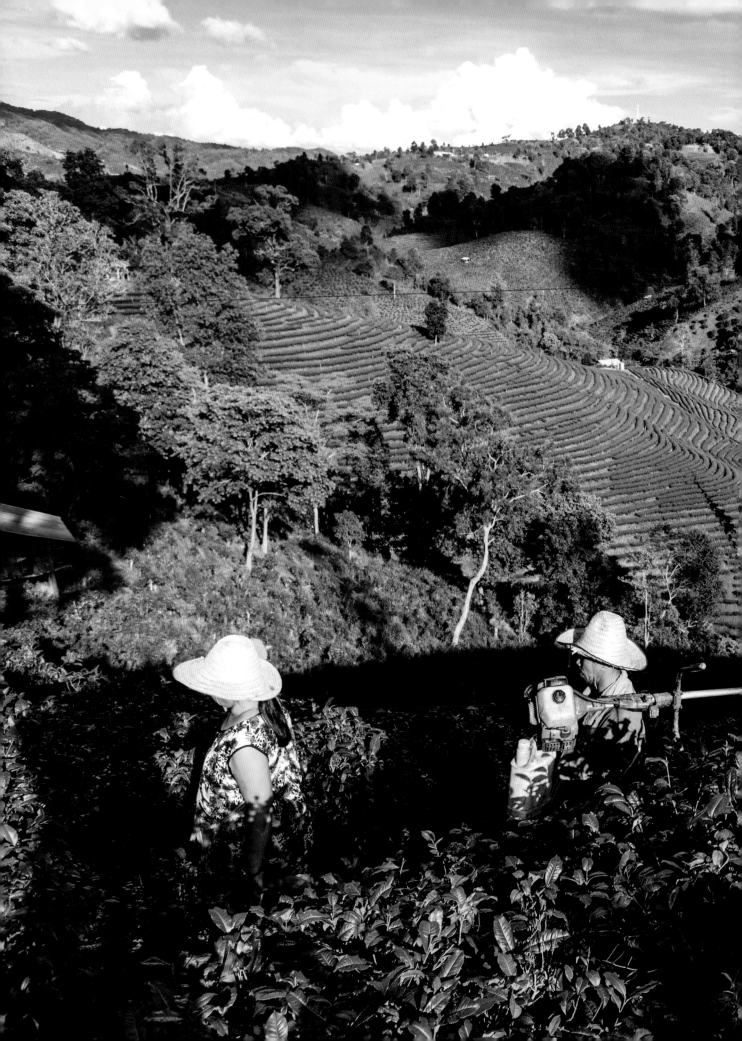

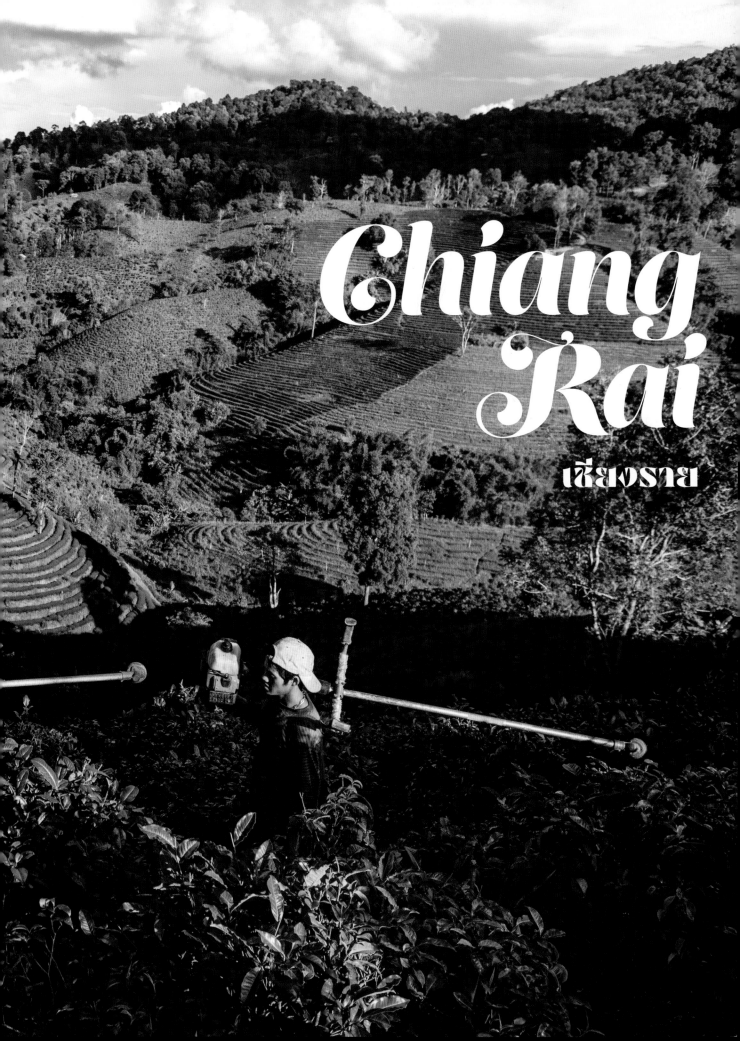

Chiang Rai

เชียงราย

\mathcal{I} find myself returning, over and over again, to the village of Ban Thoet Thai in Chiang Rai Province. Framed in a narrow river valley between some of Thailand's most breathtaking tea plantations and a remote stretch of the Burmese border, it doesn't look like much at first. Yet its previous life, Ban Thoet Thai was, during the late '70s and early '80s, a base for Khun Sa, the notorious Shan narco-warlord once dubbed the "Opium King." The surrounding mountains have been mercilessly deforested, and the town itself clings to a dusty, scruffy strip of road where people drive too fast and where there seem to be more karaoke bars than restaurants.

In repeated visits to Ban Thoet Thai, it revealed itself to me as one of Thailand's most diversely populated small towns. The bulk of the village's inhabitants appear to be Shan, but there are also Han Chinese, the descendants of Kuomintang fighters who fled communist takeover in 1949. The hills are home to many Akha, an ethnic minority group with origins in China, as well as other hill tribe groups including the Lahu, Hmong, Lua, and Liso. And there are Burmese, Thai Lue, and others.

This diversity is most apparent at Ban Thoet Thai's morning market, where every day the area's various communities converge to buy and sell ingredients and dishes unique to their cuisines: Shan vendors offer strips of dry buffalo skin and fermented soybeans bundled in leaves; Burmese, their cheeks stained yellow with the fragrant paste called *thanaka*, peddle packaged sweets and brightly painted conical bamboo hats from Myanmar; Akha women, wearing silver headgear and multicolored leggings, crouch behind stacks of potatoes or corn—crops that fare well in the high, cool mountainous areas where they live; Chinese vendors tout food from the homeland, ranging from steamed buns to a huge variety of pickled vegetables; and other groups, unknown to me, sell ant eggs, herbs, bamboo, and other exotic edibles scrounged from the surrounding forests. It's easily one of the more unique markets in Thailand.

In short, I keep coming back to Ban Thoet Thai because it's a microcosm of Chiang Rai Province, one of the country's wildest and most ethnically—not to mention culinarily—diverse.

Yet the history of Chiang Rai extends far beyond Ban Thoet Thai.

The origins of the province—indeed of contemporary Thailand—can be traced back to the area surrounding the present-day city of Chiang Saen. Tucked into Chiang Rai's northeastern corner, hugging the Mekong River, this area is thought to have served as the gateway for ethnic Tais migrating south from China into what is today known as Thailand, possibly as early as the twelfth century. Eventually, Chiang Saen's population swelled enough that it became home to one of northern Thailand's earliest *mueang*, or city-states. It was one of Chiang Saen's native sons, a powerful royal called Mengrai, who thought to unify the various *mueang* that had begun to form in the greater region. Employing both persuasion and force, in 1263 Mengrai cobbled together a loose unification of kingdoms and city-states called Lan Na, which existed, intermittently and in various forms, until the twentieth century.

Today, most people probably know Chiang Rai as a destination for trekking among the hill tribes or for its role as part of the so-called Golden Triangle, where virtually all of the world's heroin was once produced—much of which was overseen from Ban Thoet Thai. Those days, like those of King Mengrai, are long gone, and today the poppy fields have been replaced by coffee, tea, and other crops, many grown by Chiang Rai's more than thirty ethnic groups, the most of any Thai province.

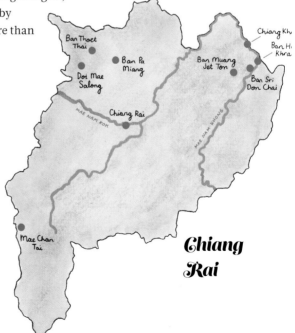

Chili and Salt:
What the Hill Tribes Eat

Meelong Chermue has lived nearly all of her fifty-seven years in Thailand. But I needed an interpreter to talk with her; she speaks only a few words of Thai. Like many other Akha people in Chiang Rai Province, she has lived an isolated existence, far from contemporary Thai life. Her village, Mae Chan Tai, is perched on a mountaintop at an elevation of nearly five thousand feet in a remote corner of the province. And although she and many of the village's 211 other residents live in modern houses and are relatively well off due to their involvement in coffee cultivation, their lifestyle—and diet—remain resolutely Akha.

The Akha is one of Thailand's nine officially recognized hill tribes, ethnic minority groups who inhabit the remote mountainous areas of the north. With origins in southern China and the Tibetan Plateau, the Akha and other hill tribes began to migrate south approximately two hundred years ago, eventually settling in Myanmar, Vietnam, Laos, and northern Thailand. With the more fertile valley areas of northern Thailand already occupied by the Thai and other groups, the hill tribes were forced to make do in the region's more distant elevated areas. Not surprisingly, living at high altitudes in far-flung locations meant that many hill tribe groups had to become almost entirely self-sufficient, subsisting on a repertoire of gathered items and the type of high-altitude, cold-weather crops—corn, potatoes, chayote, and a variety of leeks and onions—that one tends to associate more with the United States or Europe than rural Thailand.

"The food of the hill tribes is similar," explains Nami-u Panbue, a Lahu resident of Ban Pa Miang, a mixed hill tribe village in Chiang Rai. "It's very seasonal. If there's bamboo, we eat bamboo. If there are vegetables, we eat vegetables."

These ingredients are used in a simple and hearty repertoire of soups, stir-fries, grilled dishes, and chili-based dips, invariably eaten with a particular short-grained brown rice called "mountain" rice, which they also grow. But the heart of hill tribe cooking can be found in two staple ingredients.

"We use a combination of chili and salt to season most dishes," explains Jenny Yokruji, an Akha from Doi Chang, in Chiang Rai. "Fish sauce is a newer Thai thing—some old Akha people can't even eat it," she tells me, before adding emphatically, "We can't go without chili and salt!"

Yet before Thailand's rural infrastructure extended to most hill tribe villages, even these basic staples could be hard to come by.

"Before, if we wanted salt, we'd have to wait for a trader to visit the village or walk very far to get it," explains Meelong Chermue.

Today, relatively easy access to a diversity of ingredients, an increased variety of crops, and culinary cross-pollination from neighbors such as the Chinese, Shan, and Thai have resulted in cuisines that are both increasingly diverse and distinct. But as you'll see in the following recipes, chili and salt continue to rule the kitchens of northern Thailand's hill tribes.

Staple Ingredients in Akha Cookery

The Akha speak a language distantly related to Burmese, and scholars believe that they hail from Yunnan Province, in southern China. The first Akha village in Thailand was established in Chiang Rai Province around 1903, and today there are approximately sixty thousand Akha in Thailand, making them the country's fourth-largest hill tribe group, with the vast majority living in Chiang Rai Province. The staple ingredients of Akha-style cooking, a repertoire of hearty crops that thrive in higher elevations and more temperate areas, are similar to those of northern Thailand's other hill tribes.

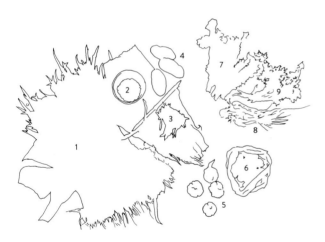

1. **Garlic chives** / *kui chaai* / กุยช่าย
2. **Salt** / *kluea* / เกลือ
3. **Chilies** / *phrik khii nuu* / พริกขี้หนู
4. **Potatoes** / *man farang* / มันฝรั่ง
5. **Bitter tomato** / *makhuea khom* / มะเขือขม
6. **Tomatoes** / *makhuea thet* / มะเขือเทศ
7. **Yu choy** / *phak kaat khiaw, phak kaat kwaang tung* / ผักกาดเขียว, ผักกาดกวางตุ้ง
8. **Chinese onion** / *hawm chuu* / หอมชู
9. **Cilantro** / *phak chee* / ผักชี

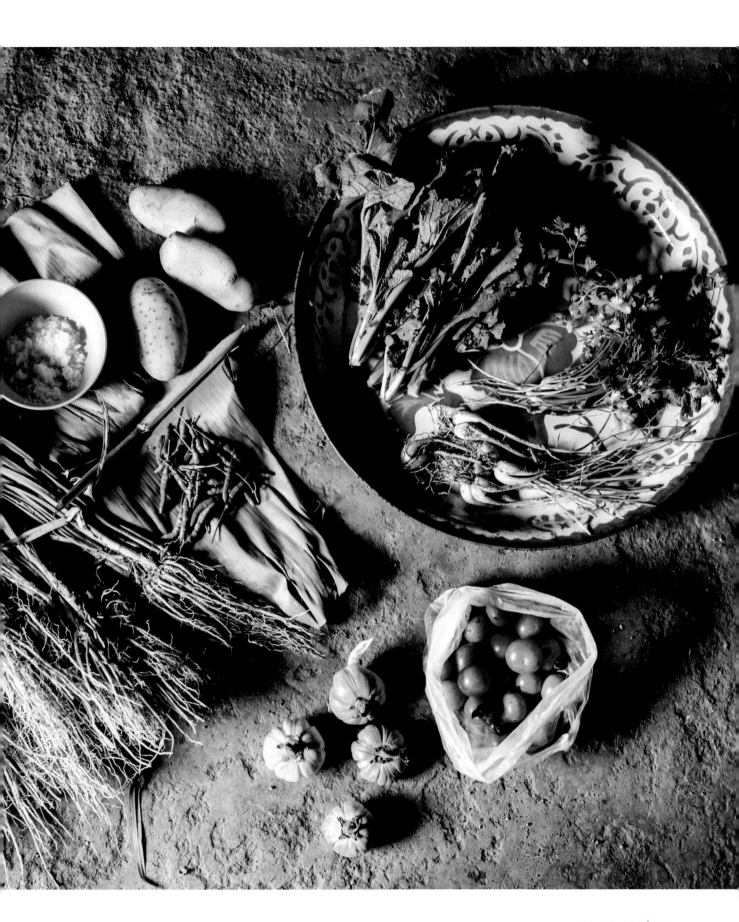

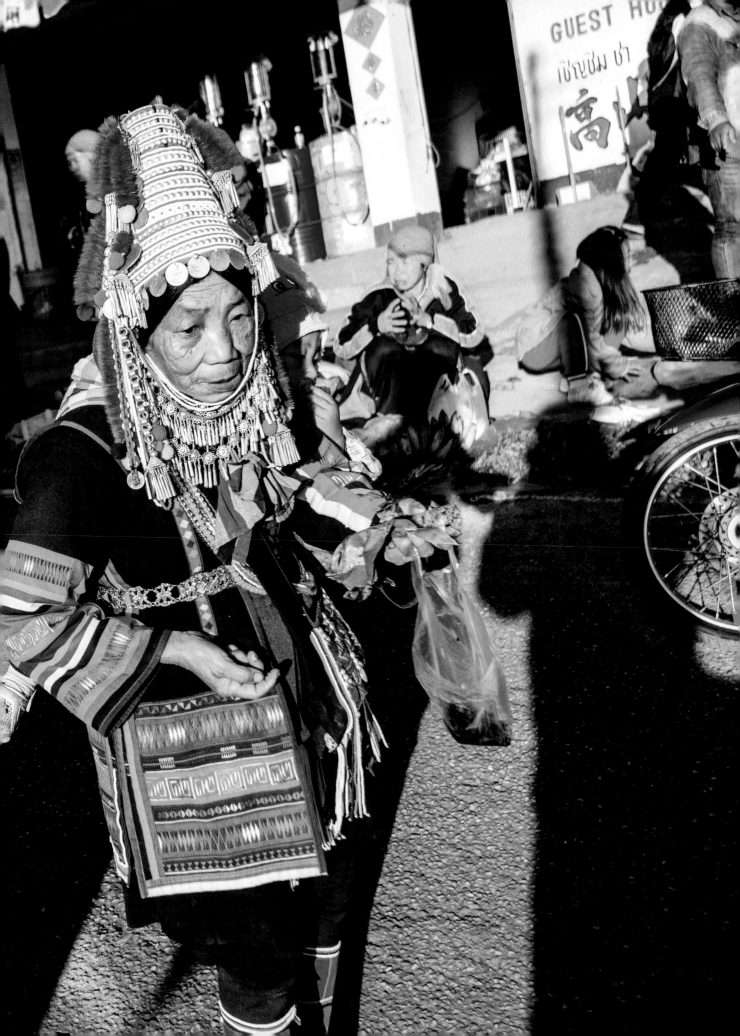

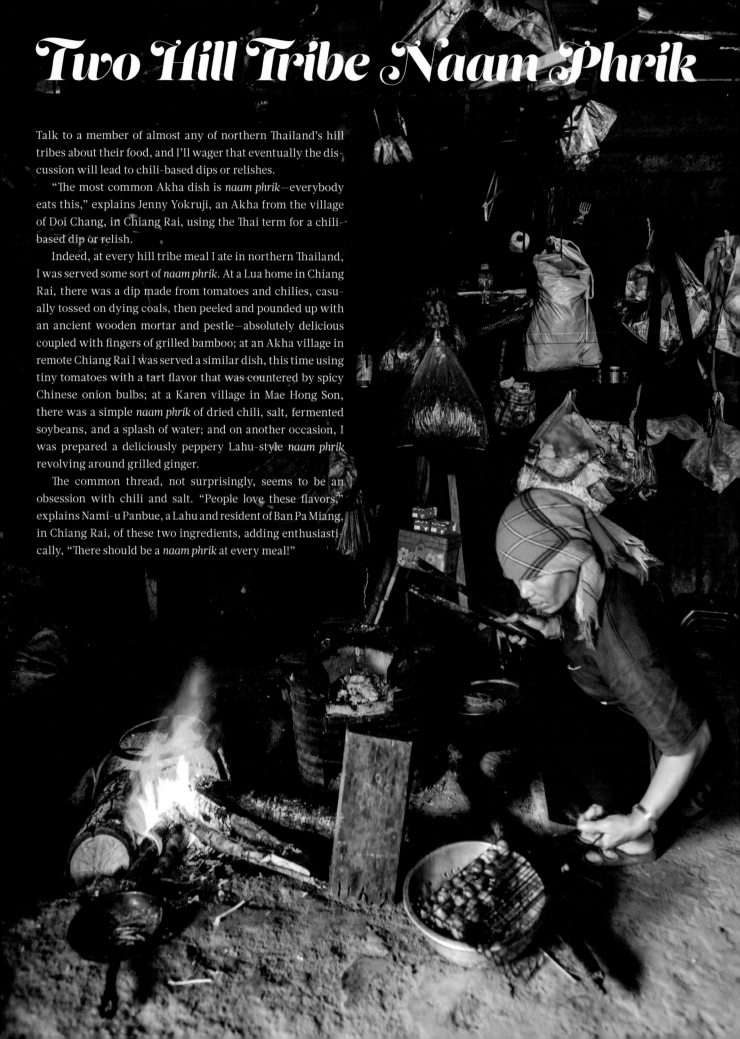

Two Hill Tribe Naam Phrik

Talk to a member of almost any of northern Thailand's hill tribes about their food, and I'll wager that eventually the discussion will lead to chili-based dips or relishes.

"The most common Akha dish is *naam phrik*—everybody eats this," explains Jenny Yokruji, an Akha from the village of Doi Chang, in Chiang Rai, using the Thai term for a chili-based dip or relish.

Indeed, at every hill tribe meal I ate in northern Thailand, I was served some sort of *naam phrik*. At a Lua home in Chiang Rai, there was a dip made from tomatoes and chilies, casually tossed on dying coals, then peeled and pounded up with an ancient wooden mortar and pestle—absolutely delicious coupled with fingers of grilled bamboo; at an Akha village in remote Chiang Rai I was served a similar dish, this time using tiny tomatoes with a tart flavor that was countered by spicy Chinese onion bulbs; at a Karen village in Mae Hong Son, there was a simple *naam phrik* of dried chili, salt, fermented soybeans, and a splash of water; and on another occasion, I was prepared a deliciously peppery Lahu-style *naam phrik* revolving around grilled ginger.

The common thread, not surprisingly, seems to be an obsession with chili and salt. "People love these flavors," explains Nami-u Panbue, a Lahu and resident of Ban Pa Miang, in Chiang Rai, of these two ingredients, adding enthusiastically, "There should be a *naam phrik* at every meal!"

Mal Qer Cael Tahq

AN AKHA-STYLE DIP OF GRILLED
TOMATOES AND CHILIES

SERVES 4

After my visit to the Akha village of Mae Chan Tai, I couldn't shake the memory of the simple but delicious grilled tomato *naam phrik* prepared by Akha matriarch Meelong Chermue.

Working in her dim wood-walled kitchen, separate from the home and made even darker by the thick layer of soot on the walls, she skewered and grilled cherry tomatoes and chilies over coals until blistered and fragrant before pounding them with pungent Chinese onion bulbs and a pinch of salt using a mortar and pestle. The result was a deceptively simple relish that was spicy and smoky with an unexpected umami kick, not to mention a pleasant tartness.

If you don't have an Akha kitchen, you can get away with cooking under the broiler, but do make an effort to find tart tomatoes. And immature Chinese onion bulbs are difficult to come by outside of northern Thailand, but the white parts of green onions work as a rough substitute.

In a Thai-style charcoal grill, light the charcoal and allow the coals to reduce to medium heat (approximately 350°F to 450°F, or when you can hold your palm 3 inches above the grilling level for 5 to 7 seconds).

Skewer the tomatoes and chilies separately and grill, turning occasionally, until soft and wilted and their skin has begun to blister and is intermittently charred, about 10 minutes. (Alternatively you can do this under an oven broiler, flipping the skewers every few minutes.) Cool and remove any charred exterior, if desired.

Pound and grind the chilies, onions, and salt with a mortar and pestle until you have a coarse paste. Add the tomatoes and grind until the relish has the consistency of a coarse, slightly watery dip (if the relish is too thick, loosen it with a tablespoon or so of water).

Taste and adjust the seasoning, if necessary; the *mal qer cael tahq* should taste equal parts tart and salty, and just slightly spicy.

Remove to a small serving bowl and serve, at room temperature, with parboiled vegetables and long-grained or brown rice for dipping, as part of an Akha meal.

For the Dip
30 tart cherry tomatoes (500 grams / 18 ounces total)
10 small fresh chilies (5 grams total; see page 324)
15 to 20 young Chinese onions (50 grams / 1¾ ounces total), white bulbs only, chopped
1 teaspoon table salt

For Serving
600 grams / 1¼ pounds parboiled or steamed vegetables such as long bean, mustard greens, and cabbage, cut into bite-sized pieces
cooked long-grained or brown rice

THAI KITCHEN TOOLS
Thai-style charcoal grill or barbecue
bamboo skewers, soaked in water
granite mortar and pestle

Naam Phrik Khing and Muu Yaang

น้ำพริกขิงกับหมูย่าง

A LAHU-STYLE DIP OF GRILLED
GINGER SERVED WITH GRILLED
PORK BELLY

SERVES 4 TO 6

Rarely have I been so fortunate: after getting lost twice and eventually following a winding, muddy, and seemingly never-ending road, I pulled into the Lahu village of Ban Pa Miang just in time to catch Nami-u Panbue at the grill. She was making *naam phrik khing*, a unique and delicious dip based on grilled ginger.

"This dish is good with boiled or fresh vegetables," explained Nami-u. "But it's especially good with grilled pork."

Working at a small charcoal stove with a Thai grilling basket, she began by grilling thin slices of fatty pork belly over coals, initially wrapping them in banana leaf so that the dripping fat wouldn't cause flare-ups. When the coals had reduced sufficiently, she discarded the leaf and grilled the pork, naked, until just crispy. Onto the few waning coals, she then casually tossed a short finger of ginger, a couple shallots, and some long, spicy chilies, flipping them occasionally until blistered and fragrant.

"You can use whatever chilies you like, big or small. I just happened to have these," Nami-u told me, while removing their burnt exteriors.

She then pounded the ingredients in a mortar and pestle, along with salt and MSG, garnishing the dish with no small amount of chopped cilantro. The resulting dip was pleasantly salty, fragrant, and more than a bit spicy, from both the chili and the ginger—the perfect foil for that fatty pork, and a dish that was well worth the drive.

Prepare the pork: Toss the pork with the salt. Marinate for at least 1 hour.

In a Thai-style charcoal grill or barbecue, light the charcoal and allow the coals to reduce to medium heat (350°F to 450°F, or when you can hold your palm 3 inches above the grilling level for 5 to 7 seconds).

Line the Thai-style grilling basket with two layers of banana leaf. Put the pork on the banana leaf and close the basket. Grill the pork, turning after 5 minutes, until just cooked through, about 10 minutes total.

Prepare the dip: Allow the coals to reduce to low heat (250°F to 350°F, or when you can hold your palm 3 inches above the grilling level for 8 to 10 seconds). When cool enough to handle, remove the pork, discard the banana leaf, and return the pork to the grilling basket. Skewer the chilies. Toss the ginger and shallots directly onto the coals, place the chilies 1 to 2 inches above the coals, and return the pork to the grill. Grill the shallots and chilies, turning occasionally, until charred and fragrant, 3 to 4 minutes. Grill the pork, flipping after 5 minutes, until golden and crispy, about 10 minutes total. Char the ginger, turning occasionally, until soft and fragrant, about 10 minutes.

Remove and discard the charred exteriors of the shallots, chilies, and ginger. Slice the ginger. To the mortar, add the salt, MSG (if using), ginger, shallots, and chilies. Pound and grind to a relatively coarse paste. Add the chopped cilantro and stir to combine.

Taste, adjusting the seasoning if necessary; the *naam phrik khing* should taste equal parts spicy and salty, and should be fragrant from the ginger and smoke.

Remove the dip to a small serving bowl and the pork to a serving dish. Serve at room temperature with long-grained or brown rice, as part of a hill tribe meal.

For the Grilled Pork
500 grams / 18 ounces pork belly (including skin, fat, and bone), 3 × ½-inch pieces
2 teaspoons table salt
4 feet of banana leaf, or as needed

For the Dip
20 medium fresh chilies (20 grams / ⅔ ounce total; see page 324)
75 grams / 2¾ ounces ginger
150 grams / 5¼ ounces shallots, unpeeled
1 teaspoon table salt
¼ teaspoon MSG (optional)
a few sprigs cilantro (10 grams / ⅓ ounce total), chopped

THAI KITCHEN TOOLS
Thai-style charcoal grill or barbecue
large Thai-style grilling basket (approximately 1 foot square)
bamboo skewers, soaked in water
granite mortar and pestle

Aq Lul Tahq

AKHA-STYLE MASHED POTATOES

SERVES 4

These jade-hued mashed potatoes may look like something out of a Dr. Seuss book, but they're a beloved—and delicious—staple dish in Akha communities across Chiang Rai. The green color comes from garlic chives, while immature Chinese onion bulbs and grilled chilies contribute pungency and heat. Young Chinese onion bulbs are hard to come across outside of northern Thailand, but the white bulbs of green onions will do in a pinch.

450 grams / 1 pound small potatoes, peeled
20 small fresh chilies (7 grams total; see page 324)
1 small bunch garlic chives (20 grams / ⅔ ounce total), chopped
6 young Chinese onions (50 grams / 1¾ ounces total), white bulbs only, chopped
1 teaspoon table salt

THAI KITCHEN TOOLS
granite mortar and pestle

Bring the potatoes and enough water to cover by a couple inches to a boil in a medium saucepan over high heat. Reduce the heat and simmer until the potatoes are fully cooked, about 15 minutes. (You should be able to insert a fork through them without much resistance.) Drain, and when cool enough to handle, slice.

While the potatoes are boiling, grill the chilies over coals or dry-roast in a wok over medium heat, turning occasionally, until charred and fragrant, 3 to 4 minutes. Remove and discard the charred exteriors of the chilies, if desired.

With a mortar and pestle, pound the chilies, garlic chives, Chinese onions, and salt to a coarse paste. Add a handful of the potatoes, and pound just until combined. Add the remaining potatoes, mixing with a spoon, pounding lightly. The idea isn't to obtain smooth Western-style mashed potatoes but rather a dish with a relatively chunky, coarse consistency.

Taste, adjusting the seasoning if necessary; the *aq lul tahq* should taste equal parts salty, spicy, and herbal.

Serve at room temperature, with long-grained or brown rice, as part of an Akha meal.

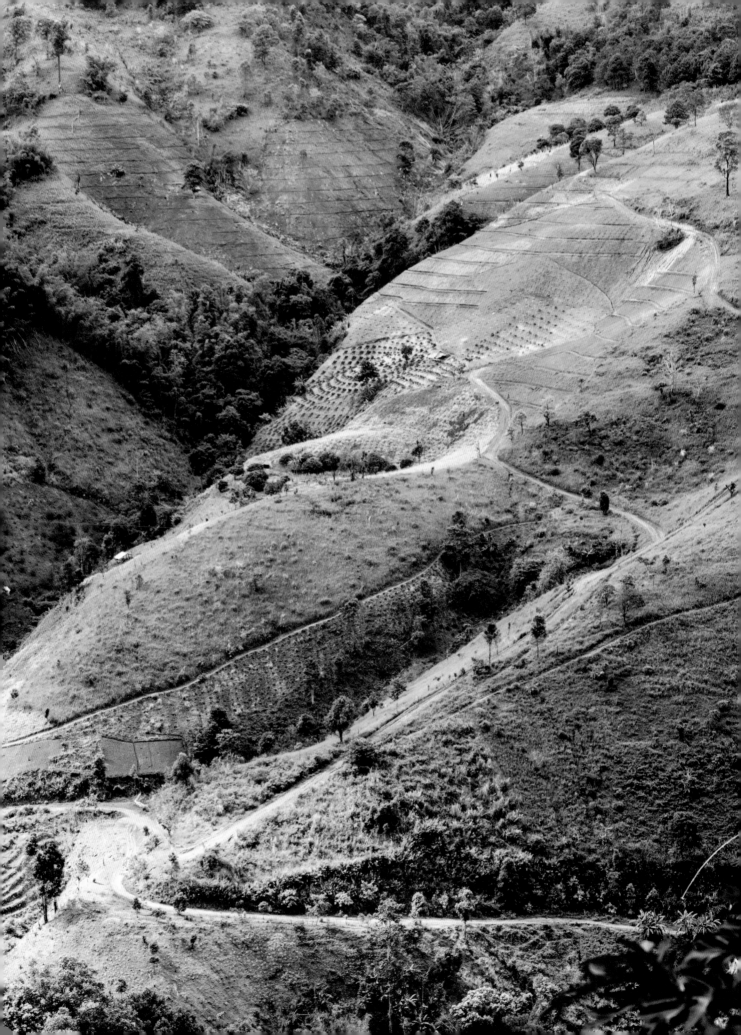

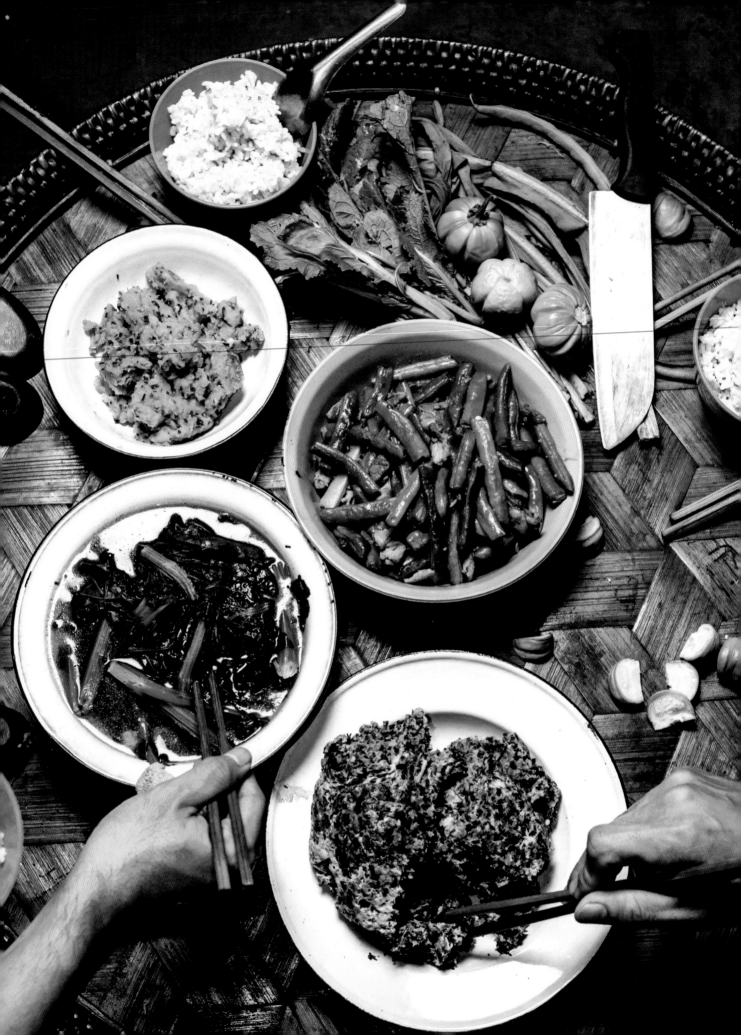

Saq Byaev Toe Umvq

AN AKHA-STYLE GRILLED LOAF
OF PORK AND HERBS

SERVES 4

This dish—at its core, minced meat seasoned with herbs—has much in common with *laap*, the Thai-style "salad" of finely chopped meat. Indeed, I've previously encountered a nearly identical dish made by ethnic Tai people in Myanmar's Shan State. Most likely it comes as the result of mixing cultures, as is the case with much of the Akha culinary repertoire.

To make the dish, Akha matriarch Meelong Chermue wraps a combination of minced pork and fresh herbs in a couple layers of banana leaf, then slowly grills the package over coals; the result is something like an assertively herbal meat loaf. (The home cook can also use the broiler or gas barbecue to cook the dish, but you'll lose that desirable smoke.)

Meelong likes to pair the dish with *makhuea khom*, astringent, thick-skinned, yellow/green eggplants sometimes known in English as bitter tomato. If that's unavailable, bitter-tasting Thai eggplant will do.

In a Thai-style charcoal grill, light the charcoal and allow the coals to reduce to medium heat (approximately 350°F to 450°F, or when you can hold your palm 3 inches above the grilling level for 5 to 7 seconds).

Place the pork, *rau răm*, cilantro, mint, and garlic chives on a large cutting board. Using a large cleaver and chopping much the same you would to make *laap* (see page 25), mince the pork and herbs until both are uniformly fine, approximately 10 minutes. Add the salt and chili powder; mince until thoroughly combined, another 2 minutes or so.

Cut the banana leaf in two sections approximately 1 foot long × 10 inches wide each. Add the pork mixture to the center of one section, folding the banana leaf around it to seal it completely in a flat, rectangular package, securing it with a toothpick. Wrap the remaining banana leaf around the package in the same manner.

Grill the banana leaf package, flipping occasionally. After about 30 minutes, open the package and confirm that the pork is cooked through and is just slightly dry.

Discard the banana leaf wrapper, remove the pork to a serving dish, and serve warm, with long-grained or brown rice and sliced bitter tomato (if using), as part of an Akha meal.

300 grams / 10½ ounces pork neck (or any other cut of pork with a bit of fat), cut into cubes
1 small bunch *rau răm* (15 grams / ½ ounce total), leaves removed, stems discarded
a few sprigs cilantro (5 grams)
1 small bunch mint (15 grams / ½ ounce), leaves removed, stems discarded
1 bunch garlic chives (50 grams / 1¾ ounces total), chopped
1 teaspoon table salt
½ teaspoon dried chili powder
2 feet of banana leaf, or as needed

For Serving
6 bitter tomatoes (see page 324) (or other Thai eggplants; 250 grams / 9 ounces total), sliced (optional)

THAI KITCHEN TOOLS
Thai-style charcoal grill or barbecue
large cleaver or *laap* knife

Rebel Food

Tofu, green tea, wheat noodles, pickled vegetables, air-dried pork, sausages flecked with Sichuan pepper—the culinary offerings of Doi Mae Salong, a village perched on the back hills of Chiang Rai Province, appear to have more in common with Beijing than Bangkok. And justifiably so: many of these dishes can be traced directly to China.

It was in Yunnan Province, in southern China, during the 1940s that Generalissimo Chiang Kai-shek's nationalist forces, known as the Kuomintang (or KMT), battled with the Mao-led communists, the People's Liberation Army. The communists eventually won, seizing control of China in 1949, forcing the KMT and aligned civilians to flee south into Burma, eventually reaching northern Thailand. During the 1960s, after aiding the Thai authorities in their struggle against communist insurgents, the ex-KMT were rewarded by the Thai government with Thai citizenship.

Throughout all this—a span of multiple generations across three countries—the ex-KMT and their descendants managed to cling to their cultural—and culinary—heritage. The remote border regions of northern Thailand were, geographically speaking, not unlike their homeland in southern China, and the hilly geography meant that the former soldiers could grow tea, preserve vegetables, and make tofu just as they had done in Yunnan.

"The Chinese came here and planted soybeans, rice, and corn," explains Manee Saelee, the daughter of Chinese immigrants who settled in Ban Thoet Thai, a remote village in Chiang Rai. "We made all our own ingredients—tofu, soy sauce, pickled vegetables. Some things we'd get from the market, but most stuff we grew ourselves."

This self-sufficiency, combined with the area's geographical isolation, has culminated in communities such as Doi Mae Salong, which, in terms of food—not to mention culture, language, and architecture—could even today be mistaken for villages in rural southern China.

Preserving, Chinese-Style

In semitropical, fecund northern Thailand, just about anything will grow at just about any time of year. And these days, meat is relatively cheap and ubiquitous. Yet in visiting the region's Chinese outposts, I frequently encountered preserved foods: pickled vegetables, dried tofu, salted radish, air-dried beef, smoked pork.

Why so much preserved food in such a fertile region?

"Today, people can slaughter pigs every day," explains Doi Mae Salong–based restaurateur Sue Hai, "but dried pork is still tastier than fresh meat."

In short, preserving food may no longer be necessary, but it continues to be delicious.

Clusters of mustard greens drying in the sun are a regular feature in Chiang Rai's Chinese outposts, which also buzz with the activity of chopping them and mixing them with salt and seasonings. At a stall in Ban Thoet Thai, a village near the border with Myanmar, I counted nearly a dozen types of preserved vegetables, ranging from the spindly, spicy roots of a leek-like plant to thin slices of mouse ear mushrooms, all intimidatingly red from the addition of dried chili powder and boasting a pleasantly funky odor.

"We pickle vegetables because we were taught to do this and because it's delicious," explains Siw Jern Sae Lee, a vendor at Doi Mae Salong's morning market.

She preserves mustard greens by drying them in the sun and rinsing and extracting their bitter juices before combining them with salt, dried spices, and sugar.

"The vegetables have to be preserved for a week," says the fifty-nine-year-old daughter of Chinese immigrants. "It takes at least four or five days to get rid of bitter flavors."

Despite the relatively short fermentation, the results are complex: pungent, earthy, salty, spicy, sweet, and tart. These and other pickled vegetables—carrots, green onion bulbs, leek roots, radishes—are eaten plain, used to accompany noodle dishes, or are included in dishes both simple (*muu sap phat kap phak dawng*, page 117) and complicated (*muu phan pii*, page 114), ensuring the continuation of a delicious legacy.

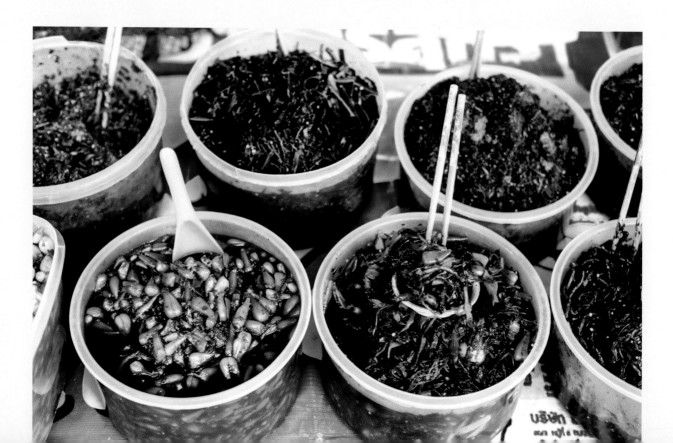

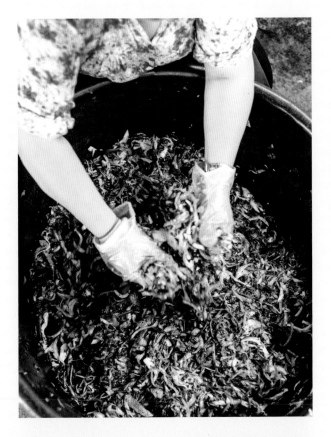

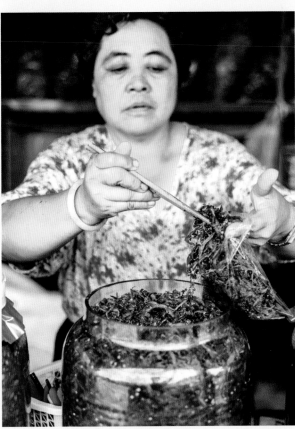

Phak Dawng

ผักดอง

YUNNANESE-STYLE PICKLED MUSTARD GREENS

SERVES 4 TO 6

This is the most basic recipe for Yunnanese-style pickled mustard greens; in Chiang Rai's Chinese hamlets, locals might supplement these ingredients with additional vegetables or dried spices such as star anise or black cardamom and, probably, lots of MSG.

1 kilogram / 2¼ pounds mustard greens
3 tablespoons table salt
1½ tablespoons chili powder
3 tablespoons white sugar

Separate and wash the mustard greens. Lay the greens out, separated, to dry in the sun (or in an electric food dehydrator) until they've reduced in weight by approximately 30 percent; on a sunny day in northern Thailand, this can take as little as a day.

Rinse the greens in plenty of water; drain. Cut off and discard the bottommost ½ inch of the coarse stems. In a large bowl, combine 2 cups of water and 2 tablespoons of salt, add the greens, and massage until soft and some green liquid has been extracted, about 5 minutes. When all the greens have been massaged, squeeze them by hand to expel any remaining bitter juices.

Slice any larger leaves lengthwise, then chop into sections approximately ½ inch long. In a large bowl, combine the chopped greens, the remaining salt, chili powder, and sugar. Stir thoroughly.

Put the greens in a plastic bag, expelling any additional air, and seal with a rubber band, but not so tightly that the bag is entirely airtight. Allow greens to ferment in a relatively cool, dark place for at least a week, depending on the weather. Taste; the *phak dawng* should taste equal parts funky, tart, spicy, sweet, and salty. Preserved mustard greens can kept, sealed tightly, in the refrigerator for a few weeks.

Muu Phan Pii

หมูพันปี

"THOUSAND-YEAR PORK"

SERVES 4

Just about every ex-KMT village in northern Thailand has a restaurant serving Chinese-Yunnanese dishes, and virtually every one of these restaurants serves *muu phan pii*, "thousand-year pork."

"At home, we don't make this dish often," explains Sue Hai, owner of the eponymous restaurant in Doi Mae Salong and the source of this recipe. "It's too time-consuming. We make it for festivals and celebrations."

Indeed, making *muu phan pii* involves an absurdly long series of steps that includes braising, marinating, deep-frying, and steaming pork belly—the lengthy process likely the origin of the dish's enigmatic name. After all of this, the pork is sliced thinly and steamed yet again, this time under a pile of minced Yunnanese-style pickled mustard greens and oolong tea. The result is a dish that's simultaneously umami, fatty, tart, and meaty, excellent when paired with *mantou* (Chinese-style steamed buns) but equally tasty when eaten with long-grained rice.

A day or two before serving, prepare the pork belly. Bring the pork belly, cinnamon stick, star anise, half the ginger, and enough water to cover by several inches to a boil in a medium saucepan over high heat. Reduce the heat and simmer for 30 minutes.

Drain the pork, discarding the liquid and spices. Marinate the pork with the green onions, black soy sauce, and the remaining ginger for 2 hours.

Remove the pork, discarding the marinade. Pat the pork dry with paper towels and allow it to air-dry on a rack or sieve for 1 hour.

Heat 2 inches of oil to 250°F in a wok over low heat. Add the pork and deep-fry, flipping occasionally, until the skin is just beginning to crisp, 7 to 10 minutes. Drain.

Using a Thai-style steamer, steam the pork until fully cooked, about 45 minutes. When cool enough to handle, slice the pork belly lengthwise as thinly as possible.

Crack the black cardamom pods, discarding the shells. Wipe out the wok, set over low heat, and add the black cardamom seeds. Toast until slightly dark and fragrant, about 10 minutes. Grind the seeds to a fine powder with a mortar and pestle or a spice grinder.

At least 5 hours before serving, bring 2 cups of water to a simmer in a medium saucepan. Remove from the heat, add the oolong tea, and steep for 3 minutes. Strain, retaining the liquid and the tea leaves separately. Chop the tea leaves. Return the tea water to the saucepan over high heat, add the tea leaves, pickled greens, white pepper, 1 teaspoon of the black cardamom powder, and the white soy sauce. Bring it to a boil, reduce the heat, and simmer until nearly all the liquid has evaporated, approximately 45 minutes.

Taste, adjusting the seasoning if necessary; the greens should be salty, spicy, and slightly astringent.

Neatly line the inside of a medium ceramic or glass bowl with the slices of pork. Top with the mustard green mixture. Add the dish to a steamer over high heat. Bring the water to a boil, reduce to low, and gently steam for 4 hours. Add water to the steamer as necessary so you don't scorch the pot.

To serve, invert the bowl on a serving plate. Garnish with the cilantro and serve warm or at room temperature, with *mantou* or long-grained rice, as part of a Chinese meal.

500 grams / 18 ounces pork belly, approximately 5 inches wide
1 cinnamon stick (7 grams)
2 whole star anise (3 grams total)
100 grams / 3½ ounces ginger, peeled and sliced
1 green onion (20 grams / ⅔ ounce total), sliced thinly
1 tablespoon black soy sauce (see page 328)
vegetable oil, for deep-frying
2 black cardamom pods (5 grams total)
2 tablespoons large-leaf oolong tea
350 grams / 12 ounces Yunnanese-style pickled mustard greens (see page 113), chopped
½ teaspoon ground white pepper
2 teaspoons white soy sauce (see page 328)
a few sprigs cilantro (5 grams total)
4 to 6 mantou (Chinese-style steamed buns), optional

THAI KITCHEN TOOLS
medium wok (approximately 12 inches)
Thai-style steamer
granite mortar and pestle

Muu Sap Phat Kap Phak Dawng

หมูสับผัดกับผักดอง

MINCED PORK STIR-FRIED WITH
YUNNANESE-STYLE PICKLED
MUSTARD GREENS

SERVES 4

If there's an equivalent to the ham sandwich in the Chinese outposts of northern Thailand, it's undoubtedly this simple dish of minced pork stir-fried with pickled mustard greens. Fast, funky, tart, meaty, salty, and satisfying, it's everything that's tasty about northern Thailand's Chinese-style cooking in one dish.

"We eat this for lunch or dinner—just about any time," explains Thawin Phimpha, a cook at Nong Ying, a bare-bones roadside restaurant in Ban Thoet Thai, an ex-KMT hamlet in remote Chiang Rai. "I got the recipe from my mother, who was born in China. Most people make it with homemade pickled vegetables."

Unlike a ham sandwich, this dish should have assertive flavors. But because Yunnanese-style pickled mustard greens can vary in flavor, it's a good idea to taste the dish before seasoning.

Heat the oil in a wok over medium-high heat. Add the pork and fry, stirring occasionally, until cooked through, 3 to 4 minutes. Add the garlic; stir to combine. Add the pickled mustard greens and fry, stirring occasionally, until combined and heated through, about 2 minutes.

Quickly taste the dish to see if it's already salty; if so, use a little less of the seasonings than prescribed. Add green cap soy sauce, oyster sauce, and sugar; stir to combine. The *muu sap phat kap phak dawng* should taste savory, salty, tart, and sweet (in that order).

Remove to a serving dish and serve hot, with long-grained rice, as part of a Chinese meal.

1 tablespoon vegetable oil
250 grams / 9 ounces ground pork
3 garlic cloves (15 grams / ½ ounce),
 peeled and minced
250 grams/ 9 ounces Yunnanese-style
 pickled mustard greens
 (see page 113), chopped
1 tablespoon green cap soy sauce
 (see page 328)
1 tablespoon oyster sauce
1 teaspoon white sugar

THAI KITCHEN TOOLS
medium wok (approximately
 12 inches)

The Preserved Meats
of Northern Thailand's Chinese Communities

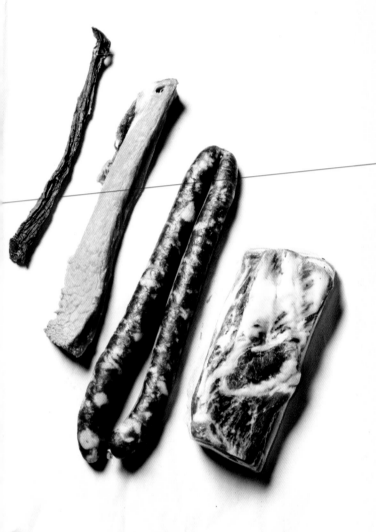

Following recipes handed down from their Yunnanese ancestors, the residents of northern Thailand's Chinese outposts, like Sue Hai, a restaurateur in Doi Mae Salong, prepare a variety of Chinese-style preserved meats:

1. **"Dewdrop beef"** / *nuea naam khaang* / เนื้อน้ำค้าง
"Dew drop beef" is a lean strip of beef loin that has been salted, seasoned, and left to air-dry for as long as a week; the name comes from the fact that the dish is exposed to dew overnight, which allegedly improves its flavor. Dewdrop beef is often deep-fried and eaten on its own as a side dish or used in a salad.

2. **"Dewdrop pork"** / *muu naam khaang* / หมูน้ำค้าง
Pork loin prepared in the same manner as dewdrop beef (above), "dewdrop pork" is sliced thinly and used in stir-fries or soups (for recipe, see opposite).

3. **Yunnan-style pork sausage** / *kun chiang yuunaan* / กุน เชียงยูนนาน These sausages, seasoned with chili, Sichuan pepper, black cardamom, and ginger before being air-dried for three or four days, are steamed or deep-fried and served as sides.

4. **Preserved pork belly** / *muu khem yuunaan* / หมูเค็มยูนนาน
Fatty pork belly marinates for three days with salt, Sichuan pepper, and rice alcohol before air-drying for as long as two weeks. "It can only be made in the cold season, and only when it's really cold," explains Sue Hai. "Otherwise the fat will spoil." It's used as an ingredient in stir-fries or in soups.

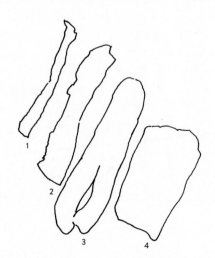

Muu Naam Khaang

หมูน้ำค้าง

"DEWDROP PORK"

SERVES 4 TO 6

Like many of the preserved meats made by Chiang Rai's Chinese communities, air-dried seasoned pork loin, *muu naam khaang*—literally "dewdrop pork"—was traditionally made only during the cool winter months, with an additional caveat: "At night it needs to be exposed to dew; that makes it tastier," explains Sue Hai, a restaurant owner in Doi Mae Salong, and the source of this recipe.

These days, *muu naam khaang* is made year-round, sliced thinly and used in stir-fries, such as *phat muu naam khaang* (page 121), or included as the protein element of a simple soup supplemented with potatoes or vegetables. But for that concentrated, pleasantly salty, slightly funky flavor, strive to make the dish during the cooler months, ideally those with some nocturnal mist. And it's worth noting that although folks in northern Thailand have been making and eating this dish for decades, there's always a slight risk in consuming preserved meat products.

A week before you plan to serve the pork, crack the black cardamom, keeping the seeds and discarding the shell.

Toast the black cardamom seeds in a wok over medium-low heat until fragrant and dark, about 10 minutes. Remove from the pan and cool. In the same pan, dry-roast the coriander seed until fragrant and dark, about 3 minutes. Remove from the pan and cool.

Pound and grind the black cardamom seeds with a granite mortar and pestle (or a spice or coffee grinder) until you have a fine powder. Add the coriander and pound and grind until you have a fine powder.

Combine the pork loin with the salt and the black cardamom and coriander mixture. Massage it into the pork, and allow it to marinate at room temperature for 3 to 4 hours.

Tie butcher's twine around the pork and hang it outdoors in a place that doesn't receive a lot of direct sunlight, ideally during relatively cool, moist weather (approximately 60°F to 70°F), for about 1 week. At the end of the week, the pork should be relatively firm, dry, and fragrant. It can be kept, sealed tightly, in the refrigerator for several weeks.

1 black cardamom pod (2 grams)
1 tablespoon coriander seeds
300 grams / 10½ ounces lean pork loin, 2 × 16-inch pieces
2 tablespoons table salt

THAI KITCHEN TOOLS
medium wok (approximately 12 inches)
granite mortar and pestle

Phat Muu Naam Khaang

ผัดหมูน้ำค้าง

A STIR-FRY OF "DEWDROP PORK"
AND FRESH CHILI

SERVES 4

This is one of the simplest—and most satisfying—dishes of the Chiang Rai Chinese repertoire. When flash-cooked over a strong flame, the dish epitomizes the best aspects of Chinese cookery: vegetables that have retained their crispiness; salty, smoky flavors; and just a hint of chili heat. As air-dried pork can vary in saltiness, it's a good idea to taste the dish before seasoning.

Heat the vegetable oil in a wok over high heat. When smoking, add the pork and onion and fry, stirring occasionally, until the pork is cooked through and the onion is slightly singed but not yet soft, about 1 minute. Add the chilies and soy sauce and fry, stirring occasionally, until the chilies are slightly singed, another 2 minutes or so.

Taste; the *phat muu naam khaang* should be salty, smoky, and slightly spicy, and the vegetables should remain crisp.

Remove to a serving plate and serve hot, with long-grained rice, as part of a Chinese meal.

1 tablespoon vegetable oil
50 grams / 1¾ ounces "dewdrop pork"
 (see page 119), sliced thinly
1 small onion (100 grams /
 3½ ounces), sliced ¼ inch wide
4 large fresh chilies (120 grams /
 4¼ ounces total; see page 324),
 ¼-inch slices
1 teaspoon white soy sauce
 (see page 328)

THAI KITCHEN TOOLS
medium wok (approximately
 12 inches)

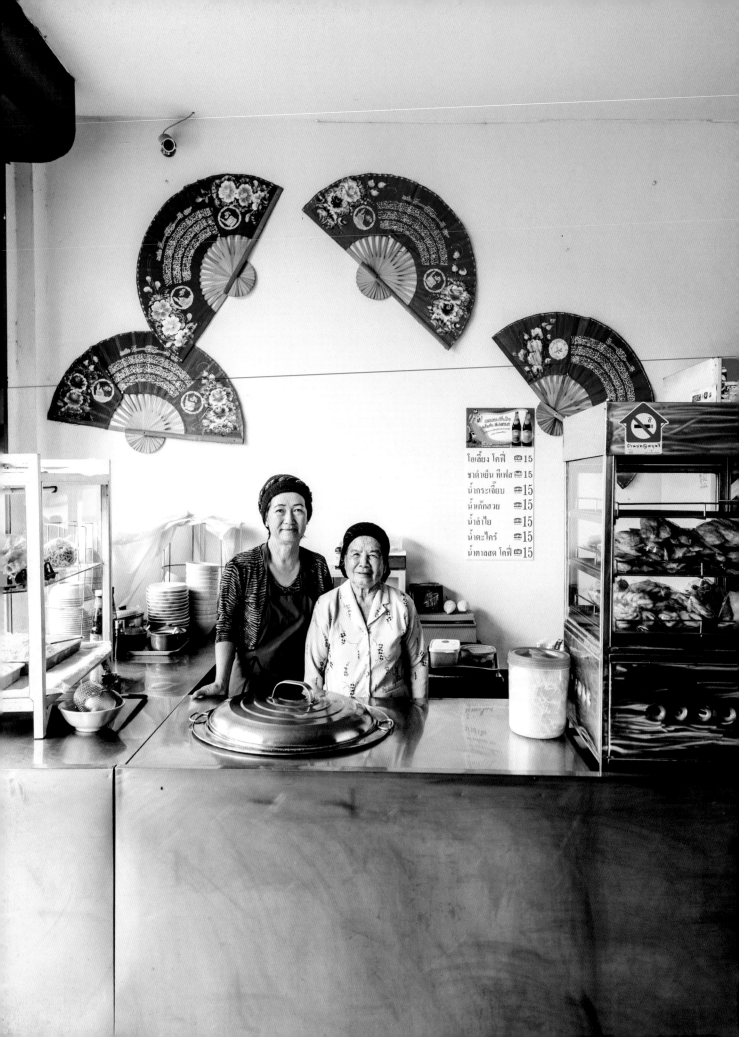

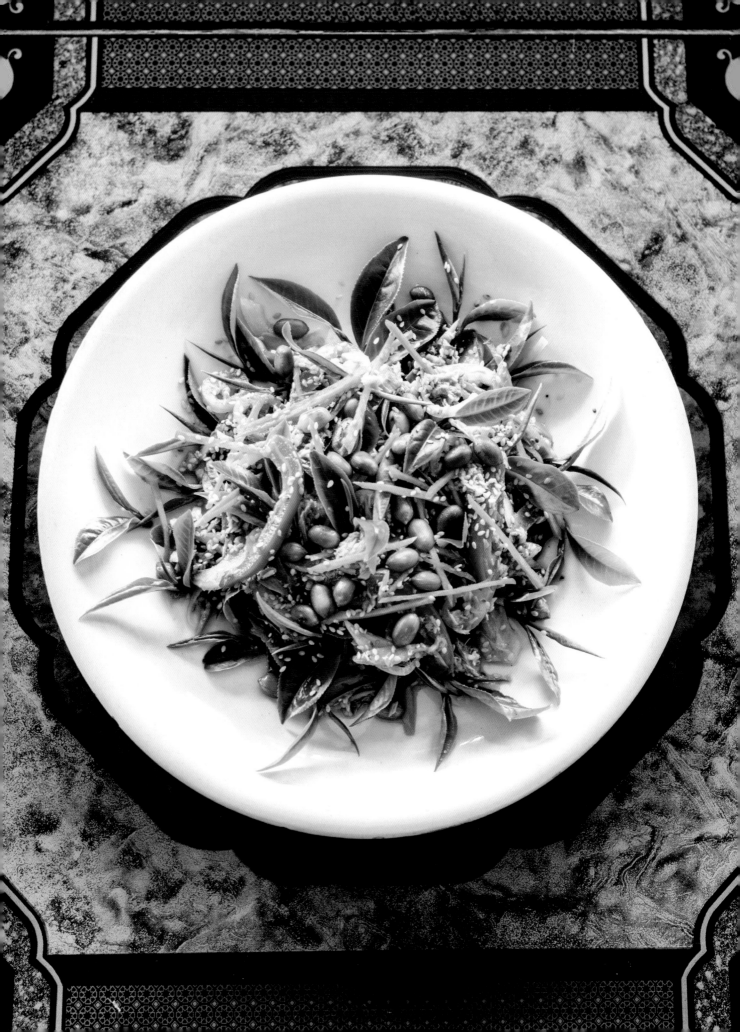

Giant Mekong Catfish
ปลาบึก

As far as tall fishing tales go, Bunriang Jinnarat doesn't exactly need to exaggerate.

"The largest one I ever caught was about four hundred pounds," casually offers the former fisherman, while sitting in front of his riverside home in Ban Hat Khrai, in Chiang Rai. Bunriang is describing an exceptionally large giant Mekong catfish, known locally as *plaa buek*, that he caught in the Mekong River some twenty years ago. Considered the world's largest freshwater fish, and once an important source of income for Bunriang and other villagers in Ban Hat Khrai, today giant Mekong catfish are a rarity, officially declared critically endangered, and thought to be limited to a small stretch of the middle Mekong. Catching the fish has been banned since 2006.

"I'd been fishing for giant Mekong catfish for thirty or forty years, since I was fourteen or fifteen years old," explains Bunriang. "It was hard work! The fish are so big, and you need a lot of knowledge and experience to know how to catch them."

Bunriang tells me that to catch *plaa buek*, he and other villagers employed a variety of nets, both mobile and stationary, and, on occasion, spears. I'm shown one of the nets, which is made from thick, coarse rope with gaps big enough for a baby to crawl through, ensuring that only the largest fish would get snagged.

"There needs to be four people in a boat to catch them," explains Bunriang. "It takes at least this many people to pull a fish to land!"

Records indicate that sixty-nine fish were caught in 1990, but in the last year commercial fishing was allowed, only a single giant Mekong catfish was caught. The fishing period traditionally spanned from late March to May, when the river was at its lowest point and the fish migrate north to lay eggs in the shallow sandy strip of river near Ban Hat Khrai. Bunriang tells me that a select group of people, only villagers from Ban Hai Khrai, were permitted to catch the fish.

"The fish we caught were usually sold to big restaurants in Bangkok; we didn't eat them ourselves," he tells me, adding that twenty years ago, a particularly big catch could sell for as much as US$2,000 or more.

Although overfishing has undoubtedly contributed to the demise of the giant Mekong catfish, the growing number of dams on the Mekong River (in 2017, there were seven in existence and at least eleven more proposed) is also thought to have impacted both the fish's spawning cycle and its source of food.

"Actually, all the fish are disappearing," explains Niwat Roykaew, founder of the Chiang Khong Mekong School of Local Knowledge, a community center with the goal of promoting local culture. "Even small fish, like Jullien's mud carp, which used to be found in huge schools, are practically gone now; we don't see them anymore. This shows that there's something wrong with the Mekong River."

For now, the moratorium on fishing the world's largest freshwater fish remains, although its future continues to be under threat.

"It's good for the fish; they can recover," says Bunriang, when I ask him about the moratorium. "But it's not good for the villagers; they don't have a way to earn money."

Laap Kai

ลาบไก่

PRASIT KHAMSAI'S CHICKEN *LAAP*

SERVES 4

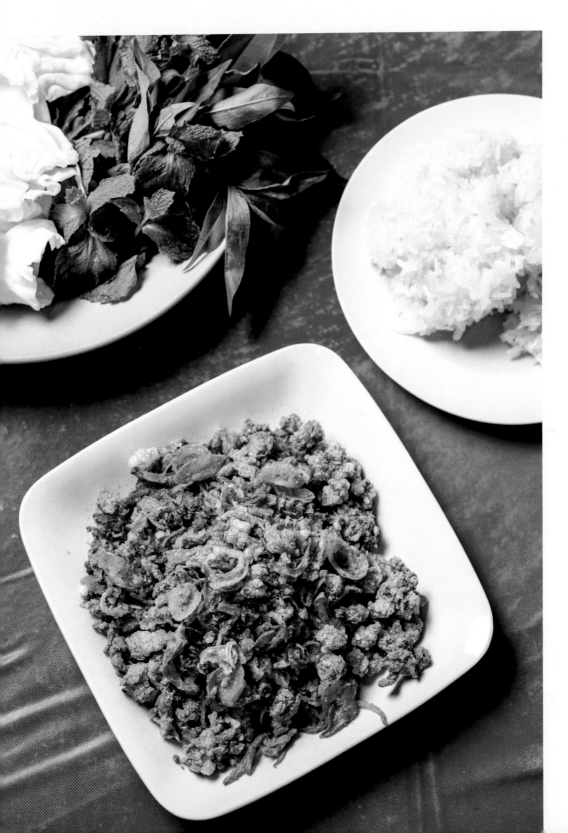

Prasit Khamsai, a fifty-eight-year-old restaurateur and native of Chiang Rai, serves one of the most delicious versions of *laap kai*, a "salad" of finely minced chicken and seasonings, I've encountered anywhere in northern Thailand. But in talking with him, I became convinced that he was motivated less by creating the perfect dish and more by avoiding catastrophe.

"I used to eat *laap kai* a lot," explains Prasit. "But I noticed that the flavor was always too strong—people would faint from eating it!"

So Prasit set out to create a milder, more balanced version of the dish by tweaking the herb-and-spice-based paste that provides *laap kai* with much of its flavor.

"I changed the recipe several times before I arrived at this one," explains Prasit. "I used long pepper, cumin—a total of six or seven different dried spices. But it didn't work, so I started removing different things until I reached this recipe, which has only three."

The result is a *laap kai* paste that includes coriander seed, dill seed, and fennel seed—the latter two virtually unheard of in the northern Thai kitchen—in addition to the usual fragrant herbs: lemongrass, galangal, shallots, garlic, and chili. Yet Prasit uses these ingredients with such balance and moderation that I struggled to identify their individual flavors. Admittedly, though, discerning subtle fragrances becomes difficult when you consider the dish's imposing garnish, a crispy, savory tangle of deep-fried shallots, garlic, and chicken joints that seems to dominate the dish (in a good way). Bringing these elements together are breast and thigh meat minced so finely that they're as tender as tofu.

"Chicken *laap* is much harder to make than other types of *laap*," adds Prasit. "There's a lot of ingredients that need to be prepared in advance. It's really time-consuming."

Indeed, it is an involved dish to make, but the results are worth it.

Note that this recipe makes enough curry paste for two batches of *laap kai*; the remainder can be kept in a refrigerator, sealed tightly, for a couple weeks.

For the Garnish

10 chicken "knees" (60 grams / 2 ounces total; see opposite)
20 grams / ⅔ ounce Thai garlic (or 4 standard garlic cloves, peeled)
1 cup vegetable oil
90 grams / 3 ounces shallots, peeled and sliced

Prepare the garnish: Bring the chicken knees and enough water to cover by a couple inches to a boil in a small saucepan over high heat. Reduce the heat to a rapid simmer, simmering until the joints are tender but not yet soft and sticky, about 5 minutes. Remove the joints from the water and, when cool enough to handle, slice into pieces about ¼ inch wide.

Pound and grind the garlic with a mortar and pestle to a very coarse paste. Heat the vegetable oil and shallots in a wok over medium-low heat. Fry until the shallots are just starting to turn golden, about 10 minutes. Add the pounded garlic and fry until both are golden, fragrant, and starting to crisp up, another 10 minutes. Strain the shallots and garlic from the oil and set them on paper towels to drain, leaving the oil in the wok. Fry the chicken knees until golden, fragrant, crispy, and swollen, about 10 minutes. Strain the chicken knees, drain on paper towels, and combine with the shallot and garlic mixture. Reserve ¼ cup of the cooking oil for this recipe, and refrigerate the rest to flavor other dishes.

Make the curry paste: Add the coriander seeds to a wok over low heat. Dry-roast until toasted and fragrant, 3 to 5 minutes. Repeat with the fennel seeds and dill seeds, dry-roasting each separately until toasted and fragrant, 3 to 5 minutes. Pound and grind the salt, coriander seeds, fennel seeds, and dill seeds with a mortar and pestle to a coarse powder (or use a spice or coffee grinder). Add the chilies; pound and grind to a coarse powder. Add the ginger, galangal, and lemongrass; pound and grind to a coarse paste. Add the shallots and garlic; pound and grind to a coarse paste. Add the shrimp paste and MSG (if using); pound and grind to a fine paste.

Heat the reserved oil in a wok over low heat. Add the curry paste and fry, stirring frequently, until slightly darker in color and fragrant, 5 to 7 minutes. Remove from the heat and set aside.

Prepare the laap: Using a heavy cleaver, mince the chicken breast and thigh meat using a forceful chopping motion, folding the minced meat back onto itself, until very fine; this should take about 10 minutes. Combine the minced chicken, half of the curry paste, cilantro, green onion, *rau răm*, and mint in a bowl. Heat the chicken mixture and ½ cup of water in a wok over medium-high heat. Cook, stirring frequently, until the chicken is just done and liquid has begun to reemerge, about 5 minutes.

Taste, adjusting the seasoning if necessary; the *laap kai* should be salty, spicy, and fragrant from the herbs and dried spices.

Remove to a serving plate, top with the garnish, and serve warm or at room temperature, with cabbage, herbs, and sticky rice, as part of a northern Thai meal.

Chicken Knees
เอ็นไก่

Unheard of elsewhere but a common cut in Thailand, *en kai* (literally "chicken joints") are the bottommost part of the drumstick, essentially the combination of skin and cartilage that link the drumstick and leg. Across the country, *en kai* are battered and deep-fried as a crunchy and popular drinking snack, but Chiang Rai–based restaurateur Prasit Khamsai opts to use deep-fried chicken knees as a unique garnish for his chicken *laap*. Outside of Thailand, you're unlikely to find this cut at the butcher, but if you have enough whole chicken legs, you can make them yourself.

For the Curry Paste
2 tablespoons coriander seeds
2 teaspoons fennel seeds
2 teaspoons dill seeds
1 teaspoon table salt
24 medium dried chilies (12 grams / ½ ounce total; see page 325), peeled and sliced thinly
6 stalks lemongrass (150 grams / 5¼ ounces total), exterior tough layers peeled, green section discarded, pale section sliced thinly
150 grams / 5¼ ounces shallots, peeled and sliced
12 garlic cloves (60 grams / 2 ounces) , peeled and sliced
2 teaspoons shrimp paste
1 teaspoon MSG (optional)

For the Laap
2 boneless, skinless chicken breasts (250 grams / 9 ounces total)
2 boneless, skinless chicken thighs (300 grams / 10½ ounces total)
a few sprigs cilantro (10 grams / ⅓ ounce total), sliced thinly
2 green onions (40 grams / 1½ ounces total), sliced thinly
1 bunch *rau răm* (30 grams / 1 ounce total), leaves only, sliced thinly
a few sprigs mint (15 grams / ½ ounce total), leaves only, sliced thinly

For Serving
1 small head of cabbage (400 grams / 14 ounces), quartered
80 grams / 3 ounces of a mixture of Southeast Asian herbs such as *rau răm*, mint, and/or Asian pennywort

THAI KITCHEN TOOLS
granite mortar and pestle
medium wok (approximately 12 inches)
large cleaver or *laap* knife

The Thai Lue

The Thai Lue are a Tai people with a reputation as talented farmers who rarely strayed from their ancestral home in the Mekong River valley of southern China. That is, until the eighteenth century, when many of them were forcibly relocated by the kingdom of Lan Na as part of a policy intended to "put vegetables in the baskets and people in the cities" of northern Thailand, many of which had been devastated by centuries of conflict with Myanmar.

As a result, Thai Lue communities are scattered throughout the eastern half of northern Thailand, especially in the provinces of Chiang Rai, Phayao, Phrae, and Nan. And although centuries have passed since this diaspora, their agricultural roots remain apparent in their cuisine.

"The Thai Lue diet is easy," explains Sangwan Wongchai, a resident of the predominately Thai Lue village of Ban Sri Don Chai, when I ask her to describe the food of her people. "We don't need to eat meat at every meal. Just a soup of greens with some ginger in it is enough for us."

In visiting Thai Lue communities in northern Thailand, I found this to be the case: greens seemed to rule their diet, whether included fresh in soups or preserved in *naam phrik naam phak* (see page 131), a unique dip made from preserved yu choy greens. Other dishes tended to revolve around simple, predominately indigenous ingredients such as freshwater fish, herbs, and soybeans, all of which tended to highlight relatively mild, savory flavors—ingredients and tastes seemingly indicative of the origins of Thai cuisine itself.

Plaa Aep

ปลาแอบ

THAI LUE-STYLE HERBAL GRILLED FISH

SERVES 4

Sangwan Wongchai had just pounded up a curry paste, one fragrant from lemongrass and garlic and yellow-orange from fresh turmeric, and was smearing it on a fresh fish.

"If we make a fish dish, we'll usually eat it with vegetables, and we'll always eat it with sticky rice," explained the resident of Ban Sri Don Chai, a Thai Lue village located near the Mekong River in rural Chiang Rai.

Sangwan was describing the ideal way to eat *plaa aep*, a dish of freshwater fish coated in an herbaceous paste and then grilled over coals. But she could just as well have been describing the cuisine of her people. Living close to water, and with a long-standing reputation as skilled farmers, the Thai Lue have traditionally subsisted on a simple diet that emphasizes vegetables, herbs, rice, soybeans, and perhaps the occasional fish.

"Turmeric gives the fish a nice yellow color, and it also covers up any fishy flavors," explains Sangwan. Chilies are also present in the paste, but *plaa aep* isn't particularly spicy; any heat and salt are strategically countered by the addition of fresh herbs such as lemon basil—a rarity in northern Thailand—and a strategic squeeze of lime. "The Thai Lue like balanced flavors," she adds.

In the past, *plaa aep* was made with small fish caught in the Mekong River. "They're tastier," the forty-two-year-old weaver and cook tells me, "but nowadays the price is too high." Instead, Sangwan opts for farmed Nile tilapia, these days an increasingly common ingredient in northern Thailand. Likewise, Sangwan has adapted the recipe by grilling the fish in aluminum foil, but not before wrapping it in a layer of banana leaf, because, as she explains, "It makes the fish fragrant."

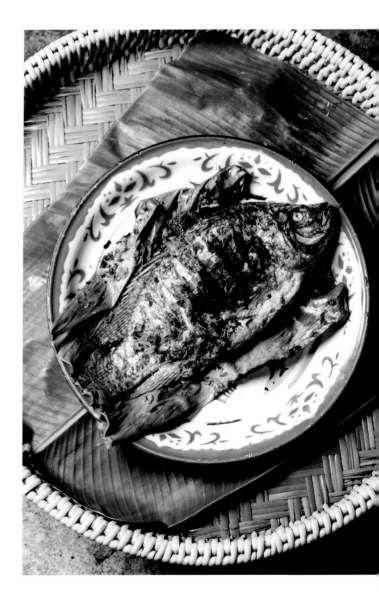

RECIPE CONTINUES

For the Curry Paste

1 teaspoon table salt

2 stalks lemongrass (50 grams / 1¼ ounces total), exterior tough layers peeled, green section discarded, pale section sliced thinly

10 grams / ⅓ ounce fresh turmeric, peeled and sliced

20 small fresh chilies (15 grams / ½ ounce total; see page 324)

70 grams / 2½ ounces shallots, peeled and sliced

15 grams / ½ ounce Thai garlic (or 3 standard garlic cloves, peeled)

For the Fish

a few sprigs cilantro (5 grams), chopped

1 green onion (20 grams / ⅔ ounce), chopped

a few sprigs lemon basil (5 grams), leaves only, chopped

juice of 1 lime

1 tablespoon white soy sauce (see page 328)

¼ teaspoon MSG (optional)

1 whole medium Nile tilapia (500 grams / 18 ounces), gutted and scaled

3 feet of banana leaf, or as needed

THAI KITCHEN TOOLS

Thai-style charcoal grill or barbecue granite mortar and pestle

In a Thai-style charcoal grill, light the charcoal and allow the coals to reduce to medium heat (approximately 350°F to 450°F, or when you can hold your palm 3 inches above the grilling level for 5 to 7 seconds).

Pound and grind the salt, lemongrass, and turmeric with a mortar and pestle to a coarse paste. Add the chilies, shallots, and garlic; pound and grind to a relatively fine paste.

Combine the curry paste, cilantro, green onion, lemon basil, the juice of the lime, white soy sauce, and MSG (if using) in a large bowl. Using a spoon (fresh turmeric will stain bare hands), coat the fish with the mixture, pushing any of the excess paste into the cavity of the fish. Marinate for 5 minutes.

Wrap the fish in two layers of banana leaf, and wrap this package with aluminum foil, sealing tightly. Grill the fish, flipping every 15 minutes or so, until fragrant and fully cooked through, a total of about 1 hour.

Serve warm or at room temperature, with sticky rice, as part of a northern Thai meal.

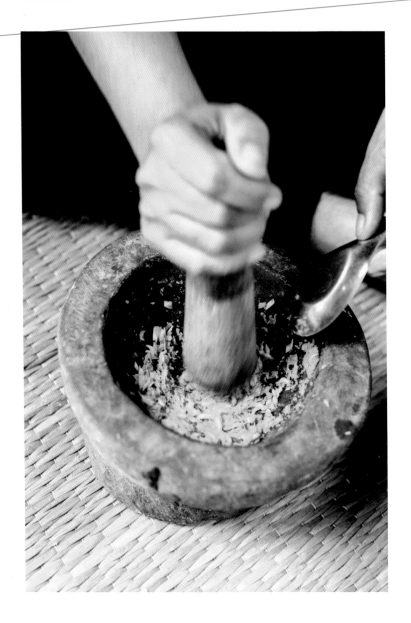

Naam Phrik Naam Phak

น้ำพริกน้ำผัก

**A DIP OF PRESERVED
YU CHOY GREENS**

SERVES 4 TO 6

To make *naam phrik naam phak*, the villagers of Ban San Thang Luang, in rural Chiang Rai, take freshly picked yu choy greens and dry them in the sun for a day, pickle them for as many as two nights, and boil them for an hour before finally pounding them with a mortar and pestle with herbs and spices.

"We didn't have refrigerators in the past!" says Saeng-in Tatorngjai, eighty-four, by way of explanation. "Before, these greens were only available during the winter. *Naam phrik naam phak* was a way of preserving food."

Saeng-in and the other residents of Ban San Thang Luang are Thai Yong, an ethnic group related to the Thai with roots in southern China. Thai Yong have a reputation as talented farmers, and Saeng-in explains that pickling was a useful way to extend the life of the harvest a few days. But, she adds, boiling the pickled greens and making them into a spicy paste bought them even more time.

Today, yu choy is available year-round across northern Thailand, but the villagers of Ban San Thang Luang continue to dry, pickle, boil, and pound their greens before eating them, the multiple stages of preservation serving to intensify the flavor of the yu choy. And it certainly doesn't hurt that the greens are seasoned with salt, dried chili, garlic, and *makhwaen*, culminating in a dish that's intense, paradoxically meaty, and, without a doubt, worth all that fuss.

Note that this recipe makes enough *naam phrik naam phak* for two meals; the remainder can be kept, sealed tightly, in the refrigerator, for a couple weeks.

RECIPE CONTINUES

600 grams / 1¼ pounds yu choy

2 heaping tablespoons steamed sticky rice (see page 54)

6 medium dried chilies (4 grams total; see page 325)

2 teaspoons table salt

¼ teaspoon MSG (optional)

2 heaping teaspoons *makhwaen* (see page 326)

20 grams / ⅔ ounce Thai garlic (or about 4 standard garlic cloves, peeled)

For Serving

A few sprigs cilantro (5 grams), chopped

160 grams / 5½ ounces deep-fried pork rinds (see page 70)

THAI KITCHEN TOOLS

granite mortar and pestle

medium wok (approximately 12 inches)

At least 3 days before serving the dish, spread the yu choy out and dry in the sun for 1 full day, or until it's wilted and relatively dry but not yet brittle. That evening, wash the greens and slice thinly. Squeeze the yu choy to tenderize it and expel any bitter liquid. In a large bowl, combine the yu choy, sticky rice, and enough water to just cover the greens and rice. Cover with plastic wrap and leave the yu choy at room temperature to ferment until just tart, which should take from 24 to 48 hours, depending on how hot the weather is.

Strain the greens, reserving the liquid, and mince them. Using a mortar and pestle, pound and grind the greens to a relatively coarse paste; depending on the size of your mortar, it may be necessary to do this in batches. Heat the pounded greens and the reserved liquid in a large saucepan over medium heat. Bring to a rapid simmer, reduce the heat to a gentle simmer, and cook, stirring occasionally, until the liquid has almost entirely evaporated, about 1 hour.

Heat the chilies in a wok over low heat. Dry-roast, tossing and stirring occasionally, until fragrant, swollen, and toasted, dark in color but not yet black, about 10 minutes. Using a mortar and pestle, pound and grind the salt, MSG (if using), and roasted dried chilies to a fine powder. Add the *makhwaen*; pound and grind to a fine powder. Add the garlic; pound and grind to a fine paste. When cool enough to handle, add the greens to the mortar and pestle, pounding and grinding to a uniform paste. Taste, adjusting the seasoning if necessary; the *naam phrik naam phak* should taste equal parts salty and umami, slightly tart and spicy, and should be fragrant from the garlic and *makhwaen*.

Remove to a small serving bowl, garnish with the cilantro, and serve with sticky rice and deep-fried pork rinds as part of a northern Thai meal.

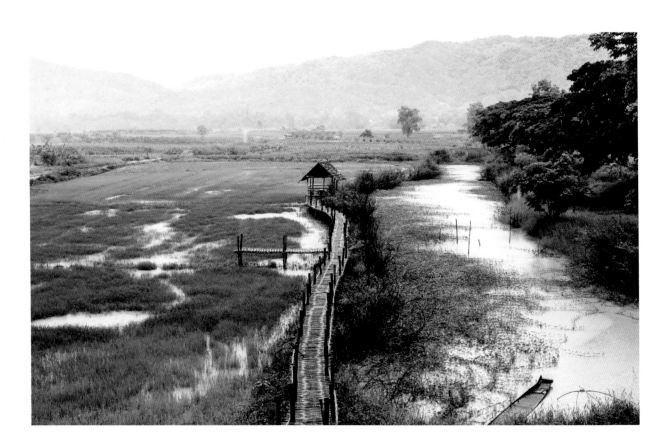

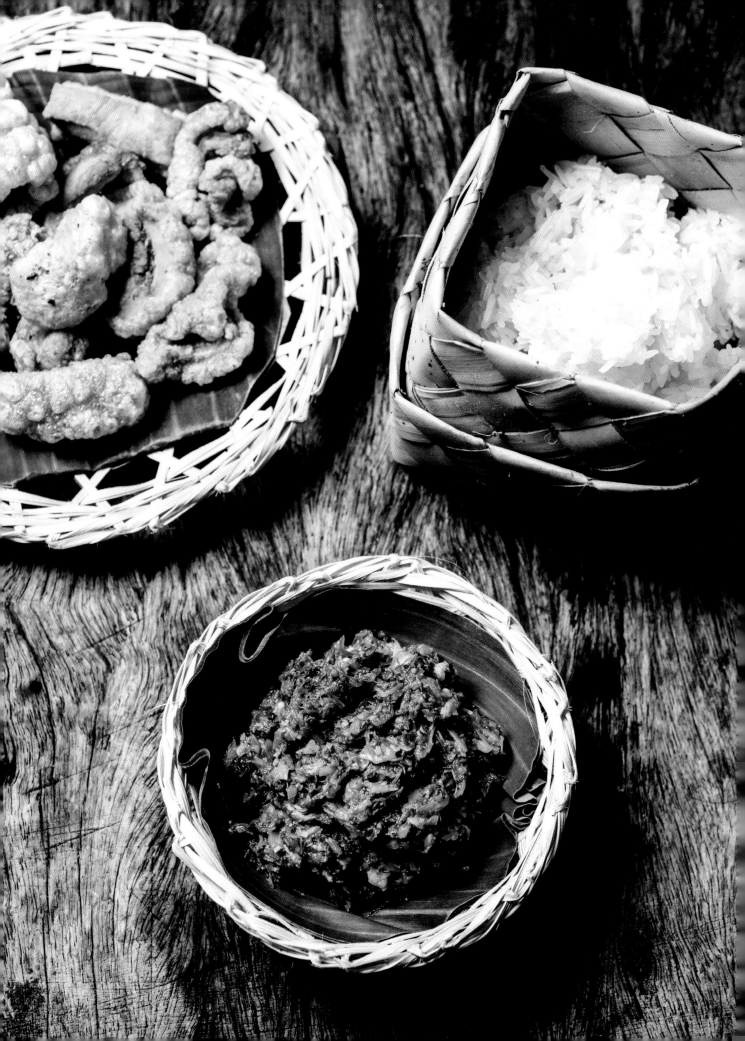

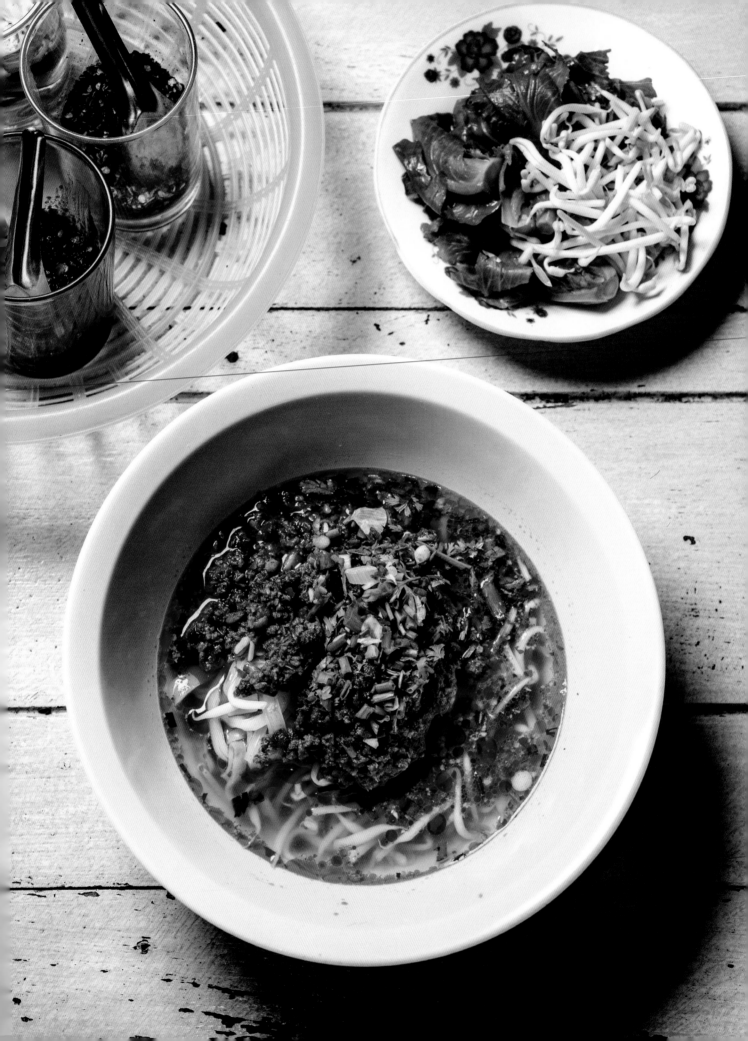

Khao Soi Naam Naa

ข้าวซอยน้ำหน้า

THAI LUE-STYLE RICE NOODLES
IN PORK BROTH WITH A SAVORY TOPPING

SERVES 4 TO 6

Mention *khao soi* (see page 35). and most people reflexively think of Chiang Mai's emblematic coconut milk–based noodle soup. This is frequently a problem for restaurateur Somjai Phantiboon.

"Some people order the dish and expect curry noodles with chicken!" explains the third-generation owner of Pa Orn, a Chiang Khong restaurant that serves *khao soi naam naa*, a noodle dish with a familiar name but, for many, an unfamiliar form.

In Somjai's hometown, *khao soi* means rice noodles in a simple, clear pork-bone broth crowned with a generous dollop of a pork-and-chili-based topping, a dish he claims has its origins abroad.

"My grandmother was Thai Lue, born in China," explains Somjai. "She moved here forty-five years ago and was the first to serve this dish."

Khao soi naam naa's defining element is that topping—the eponymous *naam naa*—made from chilies that have been boiled for hours until tender and mild before being ground to a paste and slow-simmered with garlic, minced pork belly, and *thua nao* (fermented soybeans), the latter providing the dish with a pleasant funk and a powerful boost of umami. These ingredients culminate in a rich, meaty, crumbly garnish that, when warmed by the broth, dissipates in a pleasantly spicy red oil.

A bowl is served with optional sides that range from rice cakes—which can be crumbled directly into the soup—to parboiled vegetables. For the latter, Somjai opts for long beans, pea shoots (if in season), and a kale-like green called *phak khanaeng*, for which mature Brussels sprouts work as a fine replacement.

You're going to struggle to find raw *thua nao* outside of northern Thailand, but *natto* (Japanese-style fermented soybeans) can serve as an approximate substitute. This recipe makes enough of the topping for two meals; the remainder can be kept in the fridge, sealed tightly, for a couple weeks.

RECIPE CONTINUES

For the Topping

30 large dried chilies (50 grams / 1¾ ounces total; see page 325)

50 grams / 1¾ ounces Thai garlic (or 10 standard garlic cloves, peeled)

120 grams / 4¼ ounces *thua nao* (fermented soybeans)

½ cup vegetable oil

500 grams / 18 ounces pork belly, minced finely

For the Broth

1 kilogram / 2¼ pounds pork bones

8 cilantro roots (30 grams / 1 ounce total)

1 teaspoon table salt

½ teaspoon black soy sauce (see page 328)

For Serving

300 grams flat / 10½ ounces wide dried rice noodles

200 grams / 7 ounces long beans, 2-inch pieces (optional)

200 grams / 7 ounces *phak khanaeng* (or Brussels sprouts), halved lengthwise (optional)

150 grams / 5¼ ounces mung bean sprouts (optional)

2 green onions (40 grams / 1½ ounces total), chopped

1 small bunch cilantro (20 grams / ⅔ ounce total), chopped

crispy garlic and garlic oil (see page 32)

160 grams / 5½ ounces deep-fried pork rinds (see page 70; optional)

4 to 6 rice cakes (the crisp, puffed kind; optional)

fish sauce

chili powder

sliced mild chilies in vinegar

sugar

THAI KITCHEN TOOLS

granite mortar and pestle

medium wok (approximately 12 inches)

Thai noodle basket

Advance prep: Make the topping at least 6 hours and up to 1 day before serving.

Prepare the topping: Bring the large chilies and enough water to cover by several inches to a boil in a small saucepan over high heat. Reduce the heat to a rapid simmer, cover with a lid, and simmer for 3 hours, adding water as necessary to keep the chilies covered.

While the chilies are simmering, pound and grind the garlic to a rough paste with a mortar and pestle. Remove and set aside. Pound and grind the fermented soybeans to a smooth paste; remove and set aside. When cool enough to handle, strain the chilies, discarding the water, and add to the mortar. Pound and grind to a fine paste.

Heat the oil and garlic paste in a wok over medium-low heat. Simmer until the garlic is fragrant, golden, and crispy, about 20 minutes. Add the pounded fermented soybeans and chilies, and fry until brick red in color, about 20 minutes. At this point, remove about ¼ cup of the mixture and set it aside; this can serve as an optional condiment for the noodle dish. Add the minced pork belly, reduce the heat, and maintain at a very low simmer, stirring frequently, until the mixture is reduced, fragrant, and somewhat crumbly in texture; has a deep red color; and a layer of oil has emerged, about 1 more hour.

Prepare the broth: On the day of serving, bring the pork bones, cilantro roots, and 2½ quarts of water to a boil in a large stockpot over high heat. Skim off any foam or debris and reduce the heat, simmering the broth until it's reduced slightly and fragrant, 1½ to 2 hours. Add the salt and black soy sauce, and maintain at a low simmer.

Taste, adjusting the seasoning if necessary; the broth should be slightly salty and aromatic from the pork bones and cilantro roots.

Put the noodles in a large bowl and cover with room-temperature water. Soak for 10 minutes. Drain the noodles thoroughly, discarding the water.

Prepare the bowls: Bring at least 6 inches of water to a boil in a large stockpot over high heat. Place the long beans (if using) in a noodle basket and parboil until just tender, 2 to 3 minutes. Drain thoroughly and remove to a serving dish. Repeat with the *phak khanaeng* (if using). Place 100 grams / 3½ ounces of the soaked noodles and a small handful of mung bean sprouts (if using) in the noodle basket, and boil, agitating the basket until the noodles are just cooked and the mung beans sprouts just tender, about 20 seconds. Drain thoroughly and place in a serving bowl. Cover the noodles with 1 to 1½ cups of the broth, top this with a heaping ¼ cup of the chili and pork topping, and garnish with green onion, cilantro, and 1 teaspoon or so of crispy garlic and garlic oil. Repeat with the remaining ingredients for each serving.

Serve the noodles hot with optional sides of the parboiled long beans, *phak khanaeng*, the remaining mung bean sprouts, deep-fried pork rinds, and/or rice cakes, and season with the reserved chili paste, fish sauce, chili powder, sliced chilies in vinegar, and sugar.

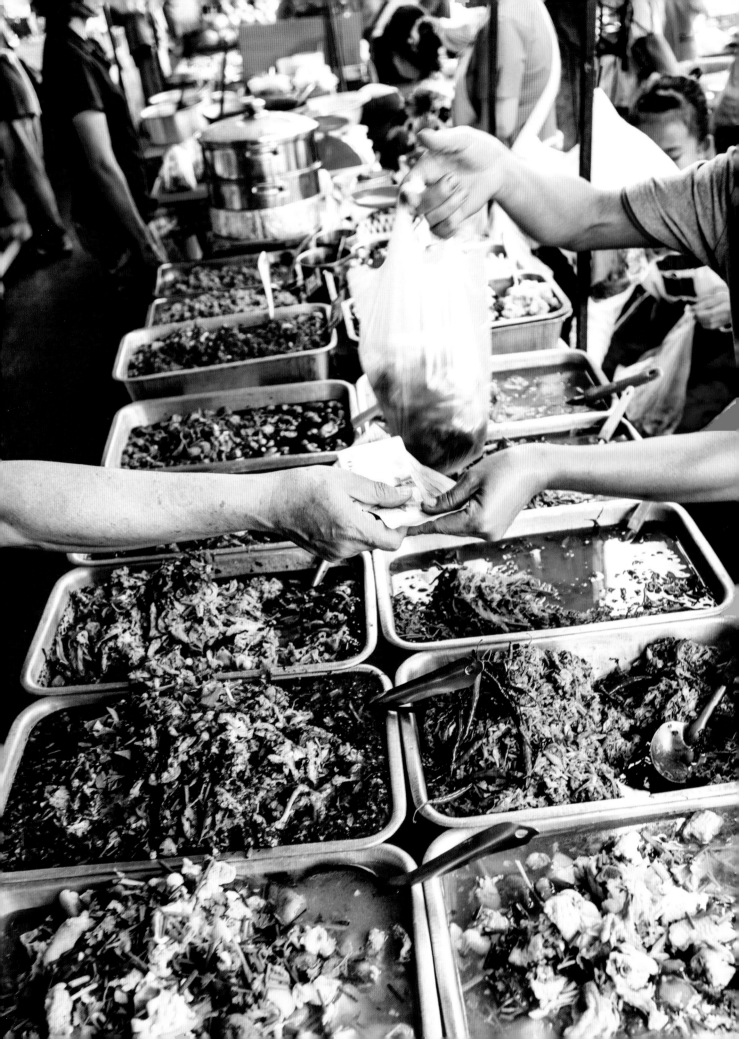

Two Pounded Salads

In northern Thailand, there's an entire repertoire of dishes that exist somewhere between salad and stir-fry, the linking element being that their ingredients are combined by pounding them together with a mortar and pestle. The following two recipes represent one of the most ubiquitous of these types of dishes, known as *tam*, and another slightly more obscure one.

Tam Khanun

ตำขนุน

A POUNDED SALAD OF YOUNG JACKFRUIT

SERVES 4

Tam khanun, a dish of unripe jackfruit, boiled until tender, pounded up with seasonings, and briefly stir-fried, is one of the most common northern Thai dishes. It's also one of the more diverse: in restaurants, homes, and markets in northern Thailand, I've come across versions that include peanuts, dishes bulked out with minced pork or pork rinds, some given a subtle tart flavor and a pink hue with tomato, and others garnished with deep-fried garlic and chili. It's almost never made the same way twice, probably because *tam khanun*'s central ingredient is little more than a vehicle for seasonings.

"Young jackfruit isn't like ripe jackfruit; it doesn't have much flavor," explains Saiphin Suthana, a home-based cook in Mae Suay, Chiang Rai, and the source of this recipe. "So you have to season it a lot."

Indeed, the ripe fruit—the world's largest to come from a tree—has a bright flavor and fragrance reminiscent of—you'll have to trust me here—Juicy Fruit chewing gum. But young jackfruit possesses little more than a subtle richness, a flavor that Saiphin accentuates via additions of meaty ingredients including minced pork and cubes of crispy deep-fried pork fat. She cleverly counters these with ginger, garlic, shallots, and julienned kaffir lime leaf—welcome breezes of fragrant herbs in a dish that otherwise risks being stodgy and heavy.

"It should be a bit coarse, a bit stringy," she adds of her take on *tam khanun*, which has elements of a dip, a salad, and a stir-fry at the same time—yet another testament to its diversity.

If cooking outside of Southeast Asia, you're most likely to find canned young jackfruit, which doesn't need to be boiled or peeled.

RECIPE CONTINUES

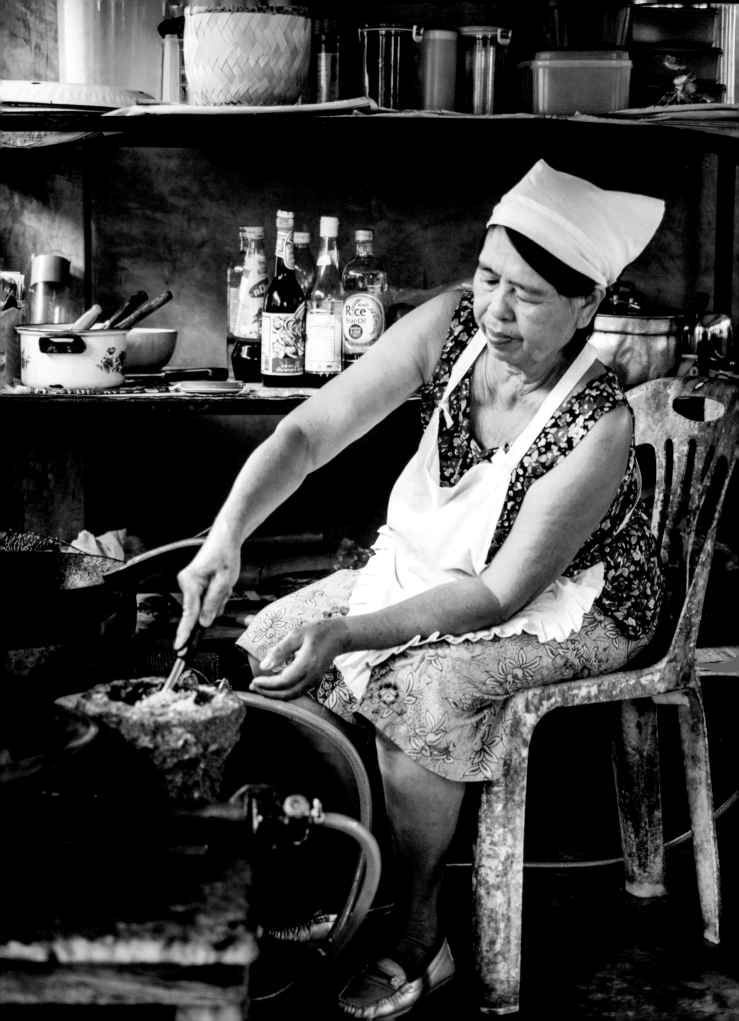

For the Salad

1 small, young, unripe jackfruit
 (1 kilogram/ 2¼ pounds total),
 1-inch-thick rings
100 grams / 3½ ounces pork back or
 jowl fat, 1-inch cubes
1 tablespoon vegetable oil
50 grams / 1¾ ounces shallots, peeled
 and sliced thinly
100 grams / 3½ ounces ground pork
1 teaspoon white sugar (optional)
8 kaffir lime leaves, julienned
1 tablespoon fish sauce
a few sprigs cilantro (5 grams),
 chopped
1 green onion (20 grams / ⅔ ounce),
 chopped

For the Curry Paste

4 large dried chilies (7 grams total;
 see page 325)
½ teaspoon table salt
20 grams / ⅔ ounce ginger, peeled
 and sliced
4 garlic cloves (20 grams / ⅔ ounce),
 peeled
50 grams / 1¾ ounces shallots, peeled
 and sliced thinly
1 teaspoon shrimp paste

THAI KITCHEN TOOLS

medium wok (approximately
 12 inches)
granite mortar and pestle
clay mortar and wood pestle
 (optional)

Prepare the salad: If you're using canned jackfruit, simply drain and chop the fruit. If you're using fresh jackfruit, place it and enough water to cover by several inches in a large saucepan over high heat. Bring it to a boil, reduce the heat to a rapid simmer, and simmer until the jackfruit is tender, about 1 hour. Drain, discarding the water. When the jackfruit is cool enough to handle, cut the hard exterior and tough innermost core away, discarding both (you should end up with approximately 500 grams / 18 ounces of jackfruit). Coarsely chop the remaining jackfruit flesh.

While the jackfruit is boiling, heat the pork fat and oil in a wok over medium heat. Fry, stirring occasionally, until fat is crispy and golden, about 10 minutes. Remove the pork and drain, reserving 2 tablespoons of the oil. Wipe out the wok.

Prepare the curry paste: Add the chilies to the wok over low heat. Dry-roast until lightly toasted and fragrant, about 5 minutes. Pound and grind the chilies and salt with a mortar and pestle to a coarse powder. Add the ginger and pound and grind to a coarse paste. Add the garlic and shallots; pound and grind to a coarse paste. Add the shrimp paste; pound and grind to a fine paste. Add the reserved jackfruit, pounding and grinding until fully combined but not entirely smooth; it should remain just slightly coarse and stringy (this last step is done most conveniently in a deeper clay mortar).

Heat the reserved 2 tablespoons of oil in a wok over medium-low heat. Add the shallots and fry until fragrant, about 30 seconds. Add the ground pork and sugar (if using), stirring to combine until the pork is just cooked, about 5 minutes. Add the jackfruit mixture, stirring and pressing against the wok to combine, about 5 minutes. Add the deep-fried pork fat, kaffir lime leaves, and fish sauce, stirring to combine.

Taste and adjust the seasoning if necessary; the *tam khanun* should taste rich and salty, just slightly spicy, and fragrant from the garlic and kaffir lime leaves.

Remove to a serving dish, garnish with the cilantro and green onion, and serve at room temperature, with sticky rice, as part of a northern Thai meal.

Yam Makhuea Mathua

ยำมะเขือมะถั่ว

A POUNDED SALAD OF EGGPLANT AND LONG BEANS

SERVES 4

"It's a vegetable dish, but it can also include a little bit of meat," explains Phatsorn Rotklueng, a Chiang Rai–based cook, of *yam makhuea mathua*, a dish that revolves around the eponymous eggplants (*makhuea*) and long beans (*mathua*).

As the name implies, the titular ingredients—as well as a basic curry paste—are obligatory. But according to Phatsorn, *yam makhuea mathua* can include just about anything; her version boasts ground pork and thin slices of bitter gourd.

"You can add less bitter gourd if you don't like bitter flavors," Phatsorn tells me, pounding away at an immense clay mortar in her ramshackle kitchen. "And if you don't like spicy, you can reduce the number of chilies in the paste," she adds, reminding me that northern Thai recipes are essentially rough outlines, not commandments.

To make the dish, Phatsorn steams the long beans, eggplant, and bitter gourd until tender ("Some people parboil the vegetables, but I prefer to steam them—it preserves their flavor"), bruises them and the curry paste with a mortar and pestle, and then fries the mixture with a bit of ground pork, serving it with a rather decadent garnish of crispy garlic and deep-fried pork rinds.

"You don't have to include ground pork," she reiterates, "but it should include pork rinds—they give the dish a crunchy texture."

I'm offered a taste, and the result is pleasantly bitter, slightly spicy, and surprisingly meaty for what is, in name at least, a vegetable dish.

RECIPE CONTINUES

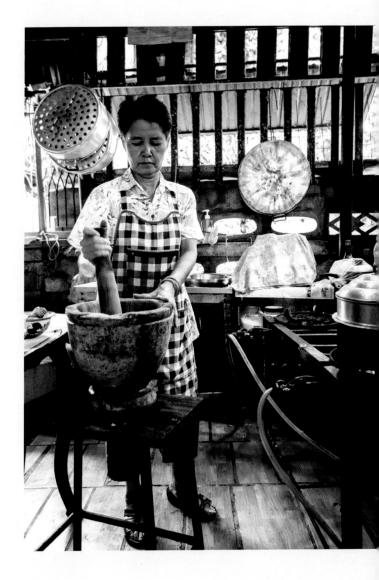

For the Curry Paste

½ teaspoon table salt
9 large dried chilies (15 grams / ½ ounce total; see page 325)
13 grams / ½ ounce galangal, peeled and sliced
2 or 3 cilantro roots (4 grams)
35 grams / 1¼ ounces shallots, peeled and sliced
16 grams / ½ ounce Thai garlic (or about 3 standard garlic cloves, peeled)
2 teaspoons shrimp paste

For the Salad

12 long beans (180 grams / 6¼ ounces total)
2 green Japanese eggplants (200 grams / 7 ounces total)
1 small bitter gourd (170 grams / 6 ounces)
1 teaspoon table salt
1 tablespoon vegetable oil
100 grams / 3½ ounces ground pork
1 tablespoon unfiltered fish sauce (*plaa raa*; see page 325)
a few sprigs cilantro (10 grams / ⅓ ounce total), chopped
15 grams / ½ ounce pork rinds
1 tablespoon crispy garlic and garlic oil (see page 32), for garnish

THAI KITCHEN TOOLS
Thai-style steamer
granite mortar and pestle
clay mortar and wood pestle (optional)
medium wok (approximately 12 inches)

Prepare the curry paste: Pound and grind the salt and dried chilies to a coarse powder with a mortar and pestle. Add the galangal and cilantro roots, and pound and grind to a coarse paste. Add the shallots and garlic, and pound and grind to a coarse paste. Add the shrimp paste, and pound and grind to a fine paste.

To make the salad: Slice the long beans into ½-inch pieces. Halve the eggplants lengthwise and slice thinly. Halve the bitter gourd lengthwise, remove the seeds, and slice thinly. Wash the vegetables in water mixed with 1 teaspoon of salt (this will prevent the eggplants from turning brown). Using a Thai-style steamer, steam the vegetables until tender, about 10 minutes. Cool.

Add the curry paste and steamed vegetables to the mortar and bruise lightly, ensuring that the ingredients are combined (this step is done most conveniently in a larger clay mortar).

Heat the oil in a wok over medium heat. Add the ground pork and fry until it's cooked through, about 5 minutes. Add the unfiltered fish sauce and the curry paste–vegetable mixture, and fry, stirring to combine, about 5 minutes.

Taste, adjusting the seasoning, if necessary: the *yam makhuea mathua* should taste slightly bitter from the bitter gourd, meaty from the ground pork and the unfiltered fish sauce, and equal parts salty and spicy.

Remove to a serving dish, garnish with the cilantro, pork rinds, and crispy garlic, and serve warm or at room temperature, with sticky rice, as part of a northern Thai meal.

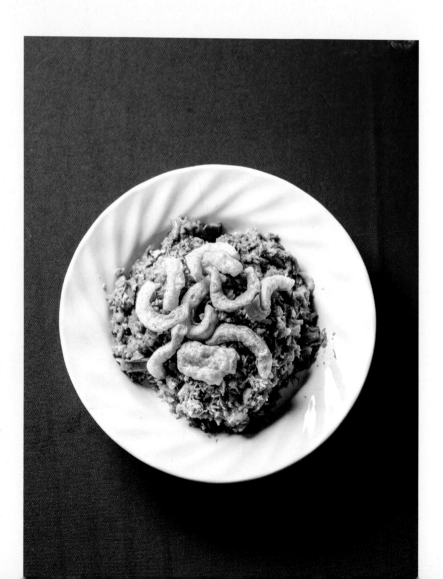

Northern Thailand's Dining Table

ขันโตก

Almost certainly the most ubiquitous—and sometimes the only—piece of furniture in a rural northern Thai home is the *khan tok*, a low-slung, round table. Come mealtime, northern Thai traditionally sit on the floor encircling the *khan tok*, its surface covered with a spread of shared dishes all within easy dipping distance—a necessity when eating meals by hand with sticky rice.

"People in cities eat at Western-style tables, but people in the countryside still eat sitting on the floor," explains Kitti Leephaibun, a Chiang Rai–based producer of *khan tok* for more than a decade.

In the old days, villagers sat down to eat at heavy, chunky *khan tok* typically carved out of a single piece of wood, while the more affluent ate from glossy red lacquer tables. Today, most *khan tok* are woven from strips of rattan or, increasingly, synthetic rattan (i.e., plastic).

"We make *khan tok* from real rattan, not the fake, plastic stuff," explains Kitti, adding that, for a large table, weaving a *khan tok* can take as many as four days. "We use the old techniques, but I use my own patterns to weave them. They're distinct and unlike anybody else's."

This innovation stems from necessity: the *khan tok* has emerged as a cultural icon of the north, but even Kitti begrudgingly admits that he eats from a Western-style table. "These days, *khan tok* are mostly used for decoration," he says.

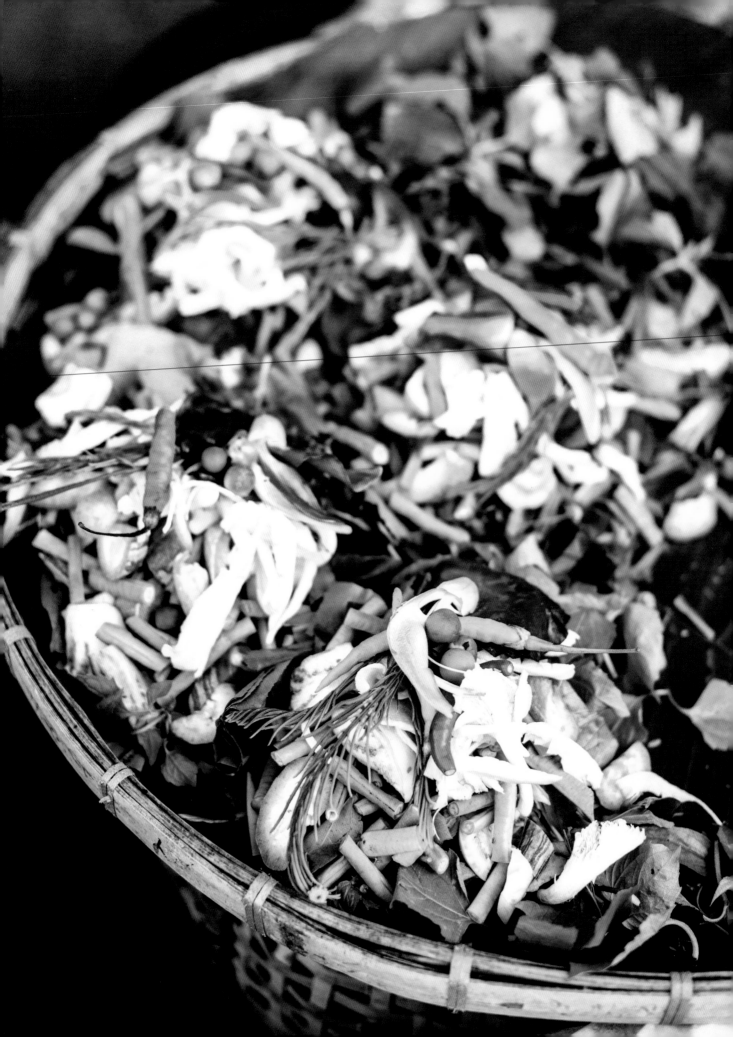

Two Variations on Kaeng Khae

More than once, when I've asked a northern Thai to name the classic northern dish, the response has been *kaeng khae*. An herb-and-vegetable-heavy soup, typically supplemented with frog or chicken, it is a dish rarely seen at restaurants but is made in virtually every home. It's also something of a shape-shifter. Across northern Thailand, locals are happy to ditch the soup element of the dish, taking *kaeng khae*'s essential ingredients—vegetables, herbs, some sort of protein, and a basic curry paste—and wrapping them up in banana leaves and steaming them, a dish known as *haw nueng*. And in Lampang, I even came across a variation on *kaeng khae* in which its normally soup-bound ingredients were made into a rich stir-fry (see page 147 for this recipe).

Kaeng Khae Kop

แกงแคกบ

A NORTHERN THAI-STYLE SOUP OF MIXED VEGETABLES AND HERBS WITH GRILLED FROG

SERVES 4

The trouble with writing a book like this is that northern Thai can be *too* accommodating. I'm constantly pursuing details and specifics, but when I ask people how a dish should taste or what ingredients it should include, a typical reply is "Whatever you like!"

But this response is, quite frankly, the most sensible approach to *kaeng khae*.

"You can include just about anything in this dish," explains Sriwai Saengsawang, the head of a ladies' community group in Chiang Rai, and the source of this recipe.

Apart from a couple of standard items in the curry paste, there is no set list of ingredients for *kaeng khae*, an herbaceous, aromatic soup that's among the most beloved dishes in northern Thailand. If anything, the one rule for *kaeng khae* is that it should be made mostly of items that have been gathered around the house.

"We have all these ingredients at home," explains Sriwai, gesturing toward a plate heaped with leaves, herbs, edible flowers, eggplants, and other vegetables.

"When we make this dish, we don't even have to go to the market. And if you forget something, you can just walk to a neighbor's house and grab it!"

For those in a more urban setting, prebundled mixes of vegetables and herbs specifically for *kaeng khae* are sold at virtually every market in northern Thailand.

Sriwai's *kaeng khae* includes more than a dozen ingredients, including exotic items such as aromatic galangal shoots and a mouth-numbing leaf known as *phak phet*. But she's keen to make clear that eggplant, long beans, mushrooms, angled luffa, and, of course, a couple different fragrant herbs (wild betel leaf is almost standard) are enough to make a good *kaeng khae*. She opted to supplement her *kaeng khae* with frogs grilled over coals—a favorite in northern Thailand—but as with the greens, just about any protein can go into the dish, and chicken and pork ribs are also fair game.

RECIPE CONTINUES

For the Curry Paste

½ teaspoon table salt

7 medium dried chilies (4 grams total; see page 325)

2 stalks lemongrass (40 grams / 1½ ounces total), exterior tough layers peeled, green section discarded, pale section sliced thinly

40 grams / 1½ ounces shallots, peeled and sliced thinly

20 grams / ⅔ ounce total Thai garlic (or about 4 standard garlic cloves, peeled)

1 teaspoon shrimp paste

For the Soup

3 large frogs (750 grams / 1¾ pounds total) or protein of your choice

1 tablespoon vegetable oil

350 grams / 12 ounces of mixed vegetables, herbs, and mushrooms (see Note)

1 teaspoon *makhwaen* (see page 326)

4 grams Thai garlic (or 1 standard garlic clove, peeled)

2 teaspoons fish sauce

½ teaspoon MSG (optional)

THAI KITCHEN TOOLS

granite mortar and pestle

Thai-style charcoal grill or barbecue

Thai grilling basket

Note: These can include long bean, cut into sections approximately 2 inches long; angled luffa, peeled, halved lengthwise, and cut into sections about 1 inch long; green Japanese eggplant, halved lengthwise and cut into sections about 1 inch long; pea eggplants; wild betel leaf (see page 328), torn; sawtooth coriander, torn into sections about 1 inch long; the tender leaves of *cha-om*; the tender leaves of the ivy gourd, larger leaves torn; wood ear mushrooms; oyster mushrooms; and large green chilies, cut into sections about ½ inch long.

Prepare the curry paste: Pound and grind the salt and chilies to a coarse powder with a mortar and pestle. Add the lemongrass; pound and grind to a coarse paste. Add the shallots and garlic; pound and grind to a coarse paste. Add the shrimp paste; pound and grind to a fine paste.

Prepare the frogs: Using a Thai-style charcoal grill, light the charcoal and allow the coals to reduce to medium heat (approximately 350°F to 450°F, or when you can hold your palm 3 inches above the grilling level for 5 to 7 seconds). While the coals are reducing, gut and clean the frogs. Put the frogs in a grilling basket and grill, flipping every 5 minutes, until cooked through and slightly charred, a total of 10 to 15 minutes. When cool enough to handle, chop the legs and arms into sections approximately ½ inch wide using a cleaver, discarding the central body cavities and heads.

Make the soup: Heat the oil in a large saucepan over medium-low heat. Add the curry paste and fry, stirring frequently, until fragrant, about 2 minutes. Add the frog, stirring to combine with the curry paste, until fragrant. Increase the heat to high, and add 1 quart of water. When the mixture reaches a boil, reduce the heat to a rapid simmer. Add the mixed vegetables, herbs, and mushrooms, and allow to simmer until the vegetables are just tender, about 5 minutes.

While the soup is simmering, pound and grind the *makhwaen* and garlic with the mortar and pestle to a fine paste. Add this to the soup along with the fish sauce and MSG (if using).

Taste, adjusting the seasoning, if necessary; the *kaeng khae kop* should taste spicy from the chilies—both fresh and dried—and slightly salty and overtly fragrant from the herbs and the *makhwaen*-garlic mixture.

Remove to a serving bowl and serve warm or at room temperature, with sticky rice, as part of a northern Thai meal.

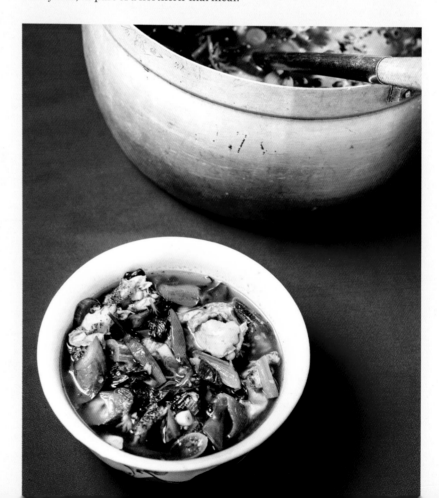

Haw Nueng Kai

ห่อนึ่งไก่

STEAMED BANANA LEAF PACKETS OF CHICKEN, HERBS, AND VEGETABLES

SERVES 4 TO 6

"It's portable!" explains Khamhai Butdee of *haw nueng*, a variation on *kaeng khae* in which the soup element is abandoned altogether, its ingredients wrapped in banana leaf packets and steamed. "It's easy to take to the rice field, and you don't even need to bring a plate: you can eat it right off the banana leaf."

Khamhai is a farmer in Ban Muang Jet Ton, a village outside of Chiang Khong, in Chiang Rai Province, that is ringed by some of the greatest expanse of rice fields I've witnessed anywhere in northern Thailand. Just about everybody in Ban Muang Jet Ton is involved in agriculture, and they all bring their lunch to work—usually a bamboo basket of sticky rice, some sort of chili-based dip, and perhaps another dish—to be eaten in the shade of covered huts in the middle of the rice fields. As Khamhai suggests, *haw nueng* was seemingly invented for this purpose.

Khamhai's take on the dish is pleasantly spicy and overtly herbal, with a hearty texture from *khao khua* (toasted rice powder). She removes the dish even further from its soupy origins by briefly frying the curry paste and chicken beforehand: "This makes the curry paste more fragrant."

Toasted rice powder is sometimes available in packaged form at Thai supermarkets, if you'd prefer not to make it. Khamhai used a small, whole free-range chicken, including the heart, liver and gizzards, but about two pounds of any chicken parts can be used in making *haw nueng*.

RECIPE CONTINUES

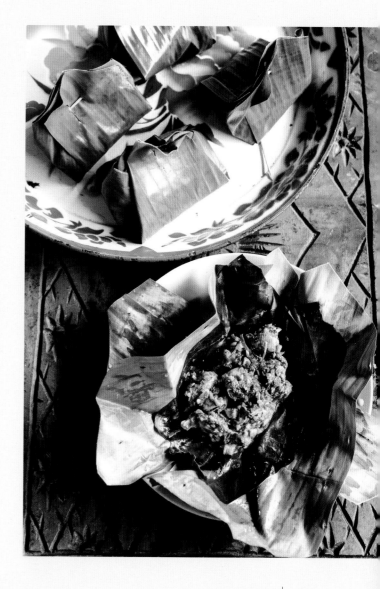

For the Toasted Rice Powder
1 cup uncooked sticky rice

For the Curry Paste
2 teaspoons table salt
¼ teaspoon MSG (optional)
24 medium dried chilies (12 grams /
 ½ ounce total; see page 325)
1 stalk lemongrass (25 grams /
 1 ounce), exterior tough layers
 peeled, green section discarded,
 pale section sliced thinly
50 grams / 1¾ ounces shallots, peeled
 and sliced
6 grams Thai garlic (or 1 standard
 garlic clove, peeled)
1 teaspoon shrimp paste

For the Haw Nueng
½ tablespoon vegetable oil
500 grams / 1 pound assorted chicken
 parts, ½-inch-wide pieces
½ cup pea eggplants (45 grams /
 1½ ounces total)
2 long beans (40 grams / 1½ ounces
 total), ½-inch lengths
2 Thai eggplants (75 grams /
 3 ounces total), cut into eighths
2 kaffir lime leaves, sliced thinly
a few sprigs cilantro (5 grams total),
 chopped
1 green onion (20 grams), chopped
approximately 4 feet of banana leaf,
 or as needed
4 noni leaves (optional)

THAI KITCHEN TOOLS
large heavy-bottomed wok
 (19 inches or larger)
granite mortar and pestle
medium wok (approximately
 12 inches)
Thai-style steamer

Make the toasted rice powder: The night before cooking, soak the sticky rice in plenty of water for at least 8 hours. Drain the rice thoroughly, discarding the water. Add the sticky rice to a large heavy-bottomed wok over medium-low heat. Toast, stirring constantly, until the rice is fragrant and a shade of brown roughly like that of lightly roasted coffee beans, approximately 20 minutes. Remove from the wok and cool. Grind the rice to a coarse powder with a granite mortar and pestle (or a coffee grinder); you should end up with a scant cup of toasted rice powder. Remove to a tightly sealed container; toasted sticky rice powder can be kept at room temperature for several weeks.

Make the curry paste: With a mortar and pestle, pound and grind the salt, MSG (if using), and chilies until you have a coarse powder. Add the lemongrass; pound and grind to a coarse paste. Add the shallots and garlic; pound and grind to a coarse paste. Add the shrimp paste; pound and grind to a fine paste. Divide the curry paste in half; you may store it for a week or two, refrigerated

Prepare the haw nueng: Heat the oil in a wok over medium heat. Add half the curry paste and chicken, and fry, stirring to combine, until the paste is fragrant and the chicken is just cooked on the outside, 3 to 4 minutes. Remove the wok from the heat and add the pea eggplants, the long beans, the Thai eggplants, the kaffir lime leaves, the cilantro, green onion, and ½ cup of the roasted rice powder. Stir to combine.

Prepare the banana leaves as described opposite; you should end up with approximately 10 packages. Add to a Thai-style steamer over high heat. When the banana leaf packets have turned pale green in color, after about 40 minutes, open one of the packets to confirm that the pea eggplants are soft and the chicken cooked through.

Serve the *haw nueng* warm or at room temperature, with sticky rice, as part of a northern Thai meal.

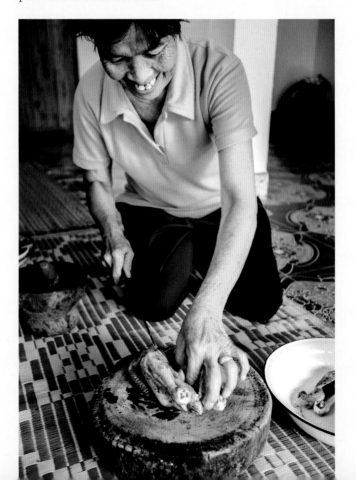

HOW TO *Fold Banana Leaf Packages for Haw Nueng Kai*

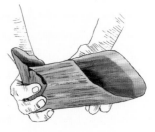

1. Cut the banana leaf into 10 sections 8 inches wide × 10 inches long. Trim off each of the 4 corners. Cut another 8 sections that are 3 inches wide × 10 inches long. Place a noni leaf (if using) on the wide banana leaf and top this with a heaping ½ cup of the chicken mixture.

2. Fold the banana leaf lengthwise around the chicken mixture.

3. Fold the near end of the banana leaf over the chicken mixture, wrapping the folds around the exterior. Repeat with the far end.

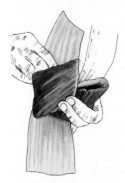

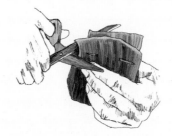

4. Holding the two folds in place, wrap the narrow strip of banana leaf around the package vertically. Seal the package with a toothpick.

5. Using scissors, cut off the protruding corners of the banana leaf at an angle. Repeat with the remaining banana leaves and chicken mixture.

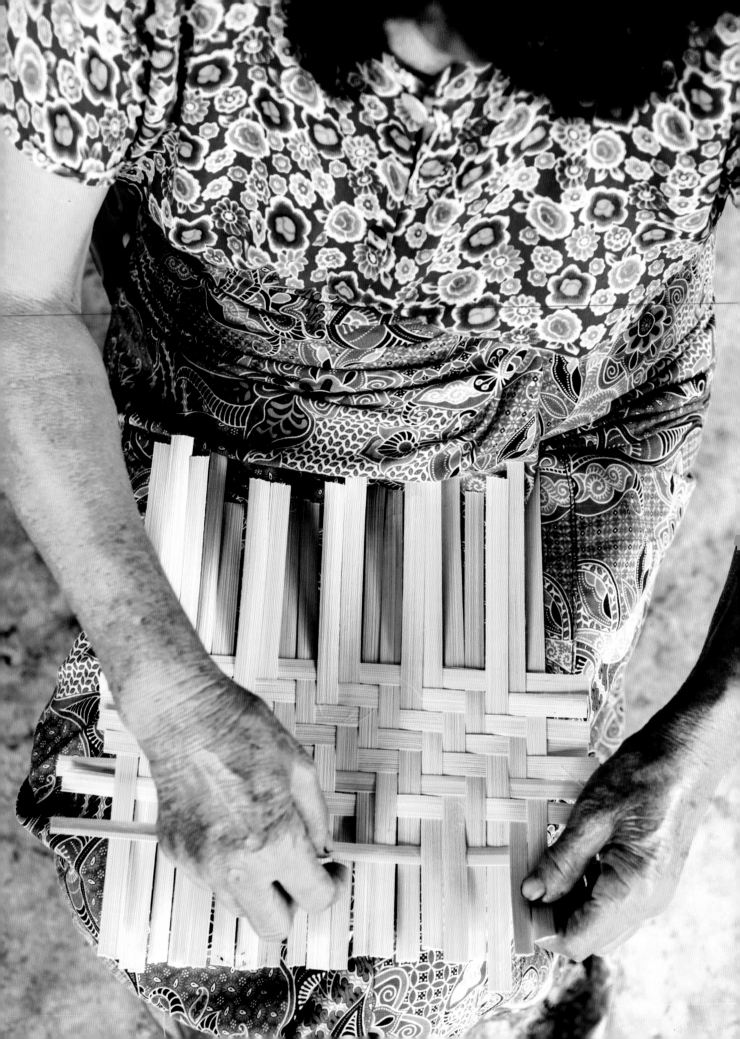

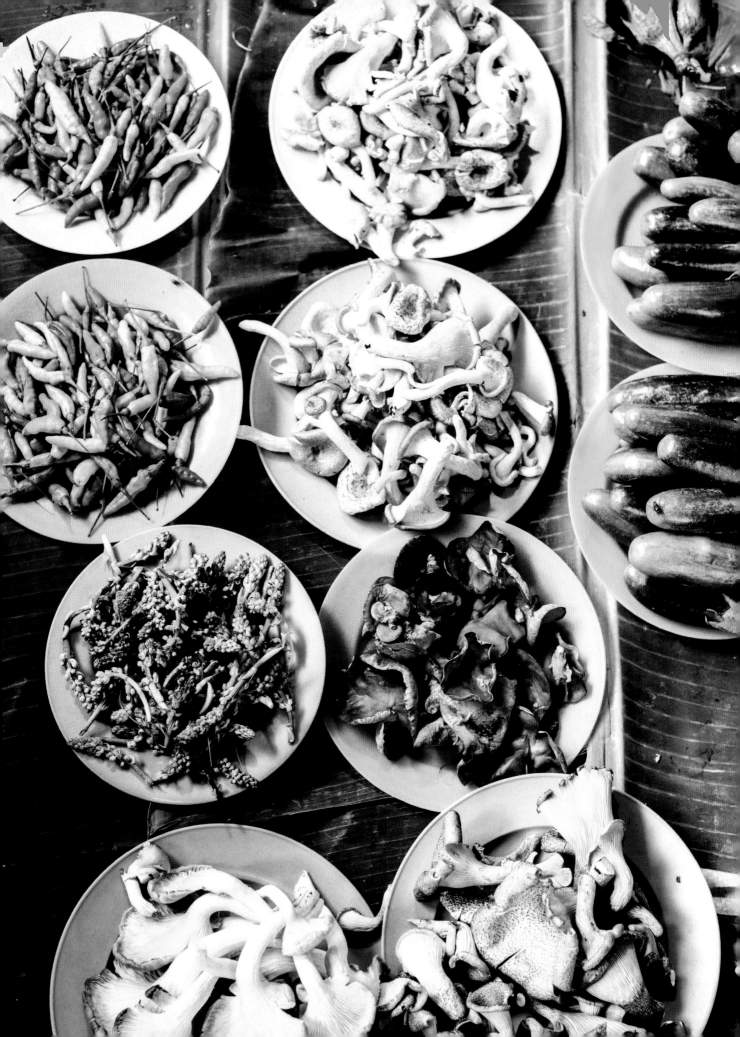

Het Nueng and Naam Phrik Khaa

เห็ดนึ่งกับน้ำพริกข่า

STEAMED MUSHROOMS
SERVED WITH GALANGAL DIP

SERVES 4

The heavy monsoon rains that define Thailand's wet season bring both obstacles and opportunities. It is during this period that the soil is tilled and rice is planted—without a doubt one of the busiest times of year for Thai farmers. During the beginning of the wet season, it's not unusual for northern Thai who live elsewhere to take time off work, come back to the home village, and lend a hand in the planting. This period is also when items such as insects, bamboo, and mushrooms are gathered in the region's mountainous forests. Indeed, it wasn't that long ago that mushrooms were *only* available during the rainy season and were gathered by hand.

"I used to pick mushrooms in the forest when I was young," says Saiphin Suthana, a sixty-three-year-old cook in Mae Suay, Chiang Rai, and the source of this recipe. "My grandmother taught me how. It's hard work! Sometimes we'd run across snakes. If you grew up in the countryside, you had to learn how to do stuff like that."

Saiphin, chatting with me in the comfort of her daughter's modern Chiang Rai home, goes on to say that, after confirming that the mushrooms weren't deadly ("You boil the mushrooms with uncooked rice; if the rice turns black, then you know that the mushrooms

are poisonous"), her family would steam them and eat them with *naam phrik khaa*, a dry, fragrant, and spicy dip revolving around galangal.

These days, Saiphin makes *naam phrik khaa* year-round, selling the dish from home or at markets in Chiang Rai. She insists on using only mature—that is, at its most fragrant—galangal, leaving it in the sun for a day until any moisture has evaporated and it's concentrated in flavor. It's then pounded up with dried, toasted chilies, and garlic, resulting in a dip with a powerful aroma and a pleasantly crumbly texture. It's the ideal counterpart to the soft mushrooms, but *naam phrik khaa* is also frequently served with beef or buffalo steamed over herbs until tender and fragrant; it's also very tasty served with sticky rice.

Saiphin serves the dip with a variety of mushrooms typical to Thailand—straw mushrooms, king oyster mushrooms, even some wild mushrooms—but if you're cooking outside of the region, any type of mushroom that doesn't have a strong flavor, such as button mushrooms, should work just fine. This recipe makes enough *naam phrik khaa* for two meals; the remainder can be kept, sealed tightly, in the refrigerator for weeks.

RECIPE CONTINUES

200 grams / 7 ounces mature galangal
20 large dried chilies (30 grams /
 1 ounce total; see page 325)
2 heaping teaspoons table salt
1 teaspoon white sugar (optional)
60 grams / 2 ounces garlic, peeled
300 grams / 10½ ounces assorted
 mushrooms

THAI KITCHEN TOOLS
large cleaver or *laap* knife
Thai-style charcoal grill or barbecue
granite mortar and pestle
large heavy-bottomed wok (19 inches
 or larger)
Thai-style steamer

A day before serving, peel and slice the galangal and, using a large cleaver, mince finely. Put the minced galangal on a tray in direct sunlight for one full day, or until completely dry; when sufficiently dry, the galangal will be pale in color and fluffy in texture.

The next day, using a Thai-style charcoal grill, light the charcoal and allow the coals to reduce to low heat (approximately 250°F to 350°F, or when you can hold your palm 3 inches above the grilling level for 8 to 10 seconds). Thread the dried chilies on metal skewers. Toast the chilies, holding them approximately 3 inches above the coals, turning frequently, until fragrant and just toasted but not yet dark, around 5 minutes. When the chilies are cool enough to handle, pound and grind them to a fine powder using a mortar and pestle. Remove and set aside.

Using a mortar and pestle, pound and grind the salt, dried galangal, and sugar (if using) to a fine powder. Add the garlic and pound and grind to a fine paste.

Heat the galangal mixture in a large wok over very low heat (if heat is too high, the garlic will become acrid). Dry-roast, stirring constantly and vigorously scraping the bottom of the wok, until the mixture is dry, fragrant, and no longer sticking to the bottom of the wok, a total of about 20 minutes. Remove from the heat and combine the galangal mixture and the ground chilies.

Taste, adjusting the seasoning if necessary; the *naam phrik khaa* should be fragrant, slightly spicy, and salty, with a touch of sweetness (if you're using sugar).

Using a Thai-style steamer over high heat, steam the mushrooms until tender, about 5 minutes.

Remove the *naam phrik khaa* to a small serving bowl and the mushrooms to a small plate, and serve with sticky rice as part of a northern Thai meal.

Khanom Bataeng

ขนมบะแตง

A SWEET OF FRAGRANT THAI MELONS

SERVES 4

Even after living in Thailand for nearly twenty years, I'm still somewhat wary of Thai sweets. Admittedly, I've never had much of a sweet tooth, but for those like me who didn't grow up with them, the textures of Thai sweets can sometimes be challenging, the flavors unsubtly sugary. But if you find yourself in northern Thailand, a good entry point is *khanom bataeng*, a dish based on fragrant Thai melons that, rather than being rubbery and sweet, is soft and fragrant—especially En Doenwilay's version.

"The original northern Thai dish includes rice flour and can be a bit too firm," explains the Chiang Rai–based sweets vendor. "So I adapted the recipe a bit and include tapioca starch, which is softer."

En was born in China and is Thai Lue. Upon moving to Chiang Rai more than forty years ago, she combined the basics of Thai Lue cooking and the information gleaned from Thai-language cookbooks to make and sell Thai-style sweets from home. For her take on *khanom bataeng*, she insists on using very ripe—"almost bruised"—melons in an effort to provide the dish with maximum fragrance. And to give the sweet an attractive orange hue, she swaps out the yellow food coloring that some vendors use for steamed kabocha squash, also known as Japanese pumpkin. But she still opts to serve her *khanom bataeng* the old way: in banana leaves.

"People like the banana leaf cones; they're attractive and easier to eat from," En tells me, while effortlessly folding banana leaves in her home kitchen.

If you're pressed for time (or intimidated by folding banana leaves), *khanom bataeng* can also be steamed in a tray or baking pan, and I've provided instructions for both methods. You're unlikely to find fragrant Thai melons outside of Southeast Asia, but Andy Ricker, in his book *Pok Pok*, suggests that overripe cantaloupe or muskmelon functions as an acceptable substitute.

RECIPE CONTINUES

200 grams / 7 ounces kabocha squash
1 small, very ripe, fragrant Thai melon
 (about 680 grams / 1½ pounds)
250 grams / 9 ounces tapioca starch
100 grams / 3½ ounces rice flour
250 grams / 9 ounces white sugar
1 cup coconut milk
½ teaspoon table salt
60 feet of banana leaf, or as needed
 (optional), shaped into cones

THAI KITCHEN TOOLS
Thai-style steamer
Thai sweets tray, 12 × 12 × 1½ inches
 (if not using banana leaf cones;
 optional)

Note: If you're steaming *khanom bataeng* in banana leaf cones, you'll need a Thai-style steamer with large holes; prepare the leaves in advance as described opposite.

Place the squash in a Thai-style steamer over high heat. Steam until very tender, approximately 30 minutes. Remove and discard the hard exterior.

While the squash is steaming, scoop out the contents of the fragrant Thai melon, discarding the tough skin. Add the flesh to a blender or food processor along with the steamed squash, and process until smooth. Pour the mixture through a strainer, discarding the seeds; you should have approximately 750 grams / 1¾ pounds of the strained melon and squash mixture.

Whisk together the tapioca starch, rice flour, sugar, coconut milk, and salt in a large bowl. Stir in the melon and squash mixture.

If using banana leaf cones (see opposite), insert them into the large holes of a Thai-style steamer. Using a funnel or pitcher, pour the batter into the cones until just short of full; you should end up with about 30 cones. Put the steamer over high heat and cover with the lid. When the water reaches a boil, steam the sweets, removing the lid occasionally to ensure that the contents don't bubble over, until they are just firm, about 15 minutes. When cool enough to handle, use scissors to trim off the banana leaf that extends beyond the top of the sweet. Serve *khanom bataeng* as a sweet snack.

Alternatively, if steaming *khanom bataeng* in a tray, put the empty tray in the Thai-style steamer over high heat and cover with the lid. After the water comes to a boil, allow the tray to warm up for a minute or two (this prevents the batter from sticking). Remove the lid and pour 2 cups of the batter into the tray. Replace the lid and steam until the batter is firm, about 3 minutes. Add another 2 cups of the batter, replace the lid, and steam until firm, another 5 minutes. Add the remainder of the batter, replace the lid, and steam until the *khanom bataeng* is just firm, another 12 minutes, for a total of 20 minutes.

Allow the *khanom bataeng* to cool to room temperature. Cut into 2-inch-square pieces and serve as a sweet snack.

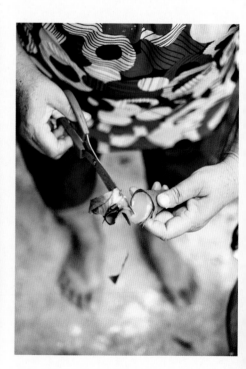

HOW TO *Fold Banana Leaf Cones for Khanom Bataeng*

In doing this particular banana leaf fold, it's important to ensure that you seal the bottom of the cone; otherwise the batter will leak out during steaming.

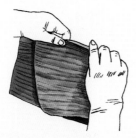

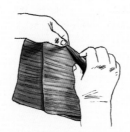

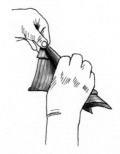

1. Cut banana leaf into 60 sections, each approximately 1 foot long. On a table or other flat surface, lay out a banana leaf section, with the grain running from right to left.

2. Place another section on top, its left-hand edge approximately in the center of the first leaf. With your left hand, make a tiny fold at the junction of the two sheets; this will be the bottom of the cone, and it needs to be watertight.

3. Using your right hand, roll the banana leaves toward your body, continuing to pinch the bottom, forming a relatively tight cone.

4. Cut the excess banana leaves away from the top, resulting in a cone that's approximately 6 inches long and 1½ inches wide at its mouth.

5. Insert the cone into the wide hole of a Thai-style steamer before filling it to maintain its shape.

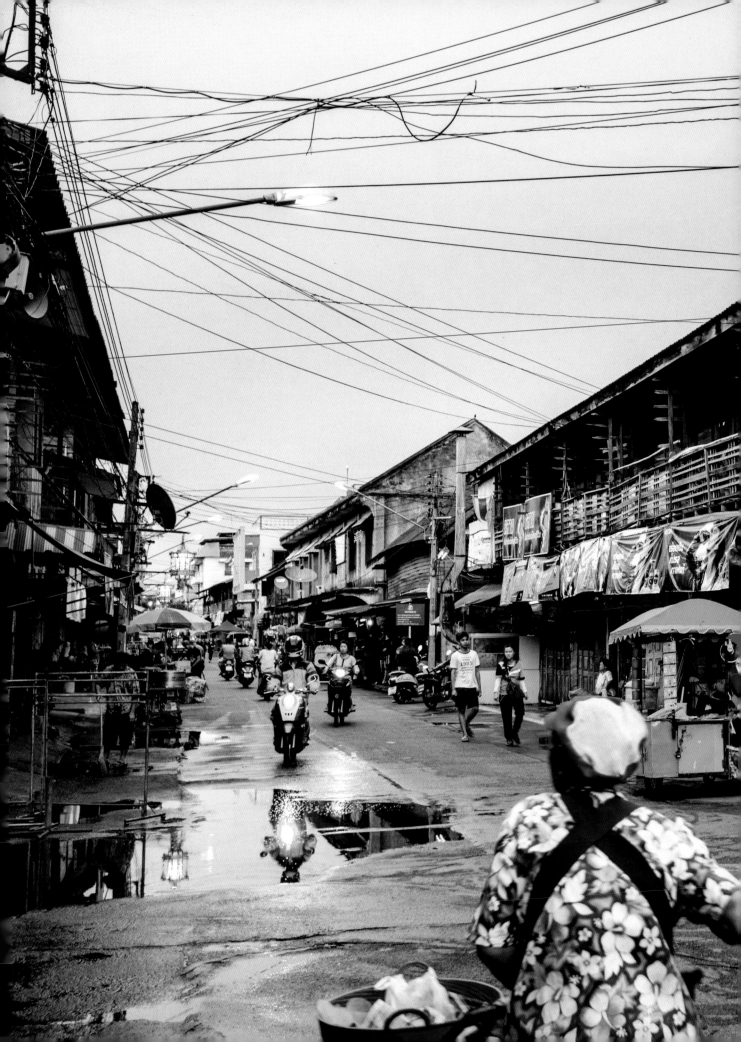

Lampang

ลำปาง

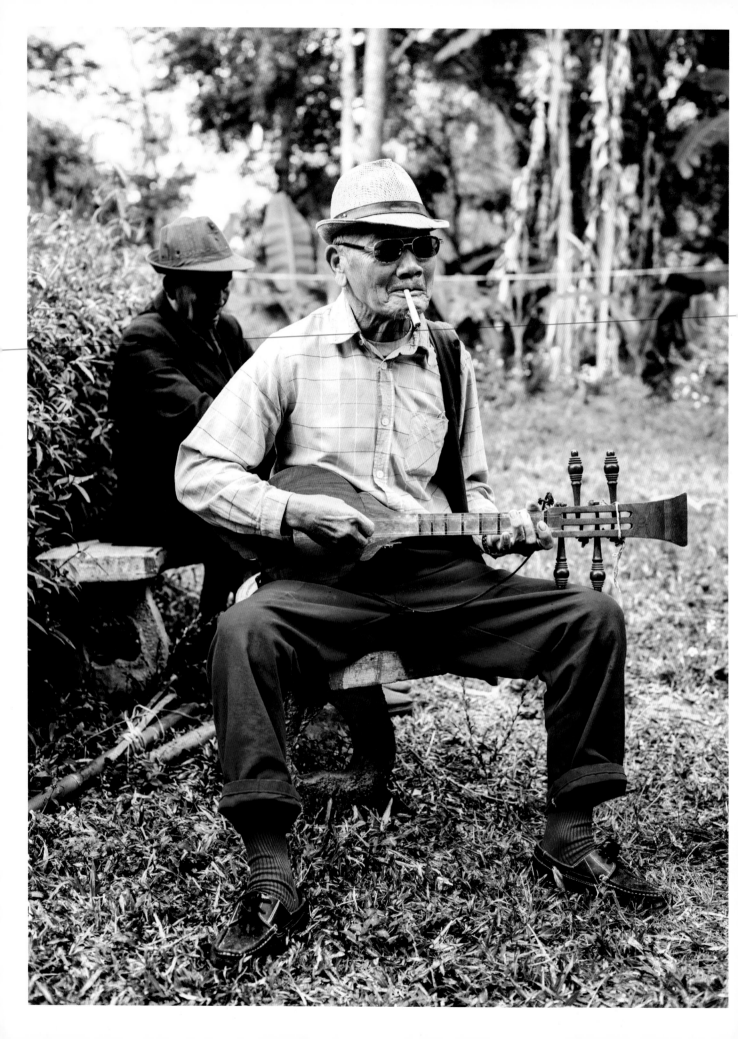

"When I was a kid, I remember seeing people from the countryside arriving in Lampang by boat, carrying bamboo baskets of sticky rice," recounts Dr. Vithi Phanichphant, seventy, a native of the city and an acknowledged authority on northern Thai art and culture. "They'd go to a Chinese restaurant and would eat noodles with their sticky rice, dipping it into a bowl of soup!"

This image—of people so attached to their homegrown carb that they felt compelled to bring it to a restaurant in the city—struck me as the perfect encapsulation of Lampang, a province where rural and urban sensibilities frequently cross paths.

With its vast, flat plains bordered by imposing hills, Lampang is an important rice basket of northern Thailand. It was also formerly home to huge swathes of thick teak forest. Not surprisingly, the food in these rural, remote areas is as rustic and classically northern as anywhere in northern Thailand. Ask people in Lampang's countryside for an example of a local dish, and they'll inevitably cite *kaeng khae*, a vegetable-heavy, herbal soup that essentially requires access to free-range chickens and a home garden. *Khai paam* is a unique method of cooking eggs for those who don't have access to fat or oil, and is still used in the more remote corners of the province. And Lampang is arguably the most famous producer of *miang*, fermented tea leaves, quite possibly the most old-school snack in northern Thailand.

Yet the province's largest city—also known as Lampang—was among the first places in northern Thailand to become modernized.

"Lampang was an important hub," explains Dr. Vithi, sitting in the cool, tall-ceilinged living room of the colonial-style mansion that previously belonged to his grandmother, "so there were lots of different groups here: first the Chinese, and then the Burmese rulers installed people here to administrate and collect taxes. Then later, the British brought more people from Burma, but they weren't always Burmese; they were Karen, Shan, Mon, and Indian. These groups influenced all aspects of life in Lampang, including food."

Indeed, several dishes that are today considered staples of the northern Thai repertoire—the pork-and-tomato noodle soup known as *khanom jiin naam ngiaw*, or the rich pork curry known as *kaeng hang lay*—are Shan and Burmese, respectively, in origin. And given the province's role as a cultural, commercial, and transport center during the late nineteenth and early twentieth centuries, it's possible that Lampang is where some of them were introduced, essentially shaping northern Thai food as we know it today.

Lampang

City Food

The food of northern Thailand is unabashedly rustic, a country bumpkin at heart. Yet the longer I spent in the city of Lampang, the more I began to see elements of a cosmopolitan northern Thai cuisine, a sophisticated urban cousin.

In Lampang, I frequently stumbled across dishes with apparent foreign roots. I also encountered plates and bowls featuring ingredients such as palm sugar, coconut milk, or shrimp paste—items normally associated with Bangkok and the central Thai kitchen.

"We have many of the same dishes as elsewhere in northern Thailand," explains Saifon Khrueachinchoi, a culinary student and native of Lampang, when I ask her what makes the city's food unique. "But we season them differently, we use different ingredients."

This culinary legacy can, quite possibly, be traced back to a single day. On April 1, 1916, the train from Bangkok rolled into Lampang for the first time. The line wouldn't reach Chiang Mai for another five years, essentially cementing Lampang's position as northern Thailand's first administrative, transportation, and commercial center. Along with the train came Thai migrants from Bangkok and an influx of Chinese migrants, both eager to be involved with the growing trade in the region. A vast market, known today as Talat Jao Kao, sprang up near the train station, boasting exotic goods such as Chinese-style seasonings and central Thai ingredients.

"There's a lot of Chinese food here," explains Phairot Chaimuangchun, a native of Lampang, a professor, and the author of *Delicious Lampang Food*, a guide to the city's restaurants and food culture. He says this while chatting with me in a restaurant located in an old wooden house in Lampang that serves, fittingly, Chinese-influenced dishes. "It's a great city for noodles—there's no need to go to Bangkok or central Thailand."

As Thai food becomes more homogenous, many of the ingredients and influences that made Lampang's food unique are, today, mainstream. But given the city's role as northern Thailand's culinary gateway, many of Lampang's dishes offer a unique glance at both the past and the future.

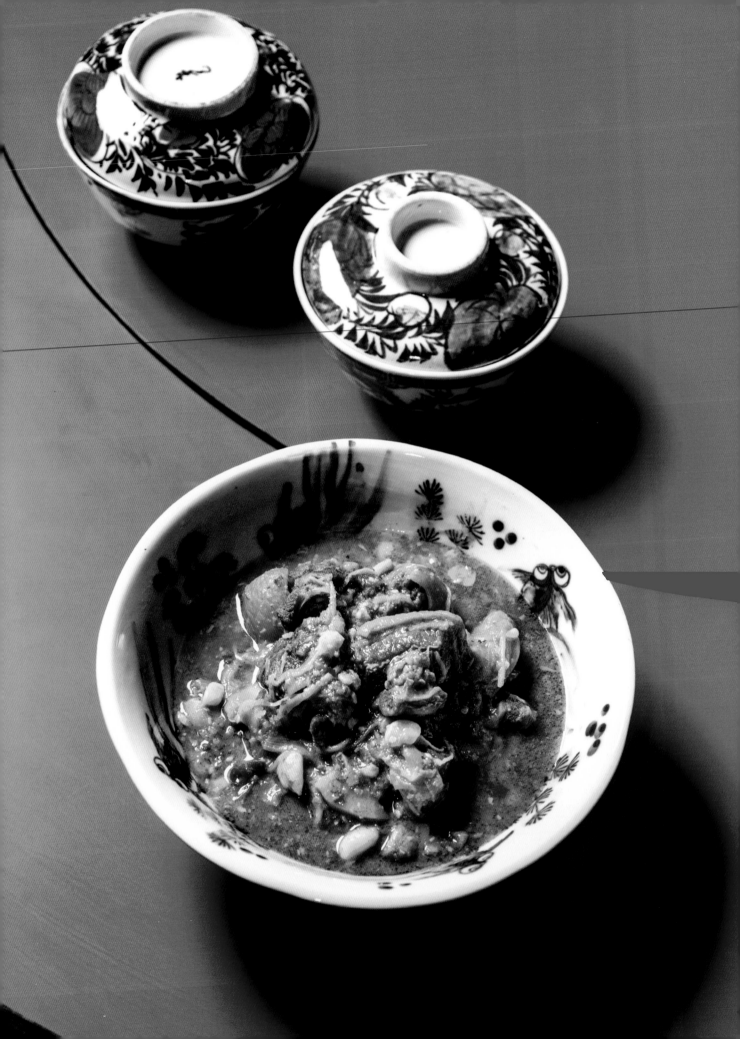

Kaeng Hang Lay

แกงฮังเล

BURMESE-STYLE PORK CURRY

SERVES 4

The Burmese ruled northern Thailand from approximately 1558 to 1775, and were in the region in significant numbers during the latter half of the nineteenth century. But relatively little, culturally speaking, remains of their time there—except the dish I'm eating with Dr. Vithi Phanichphant and the house we're eating it in.

"*Kaeng hang lay* was probably brought here by Burmese people," the professor tells me. He's describing a rich, fragrant pork-based curry, one whose foreign roots are evident in its name: *hang* is a corruption of *hin*, Burmese for "curry." But according to Dr. Vithi, its other attributes also out it as an import.

"It's oily—Burmese people love oily food," Dr. Vithi explains. "It's hard to eat with sticky rice; this type of curry is best eaten with long-grained rice, just like the Burmese people do. And northern Thai curries don't usually include dried spices."

We're chatting and eating *kaeng hang lay* in the house that previously belonged to Dr. Vithi's grandmother, a grand two-story structure that intertwines British and Chinese architectural flourishes. Records indicate that his grandmother bought the house from a Burmese immigrant, quite possibly one of the administrators, businessmen, or merchants brought by the British, who most likely introduced *kaeng hang lay* to northern Thailand. But one would struggle to find an exact counterpart to the dish in contemporary Myanmar.

"It's an adulterated Burmese dish that has been taken over by northern Thais," says Dr. Vithi, explaining that northern Thai added to it a local-style curry paste that includes fragrant herbs such as lemongrass and galangal, and seemingly Chinese-influenced ingredients like pickled garlic, peanuts, and santol, a type of tart fruit. Over time, these influences and ingredients culminated in a rich, meaty curry that, not surprisingly, was associated more with ceremonies and festivals than weekday supper.

Today, like many former celebratory dishes, *kaeng hang lay* has made the transition to the everyday, and is cooked at home and sold in markets and restaurants in Lampang and elsewhere in northern Thailand. Yet like Dr. Vithi's house, it also serves as a rare and decadent reminder of Burma's time in northern Thailand.

RECIPE CONTINUES

For the Curry Paste

6 large dried chilies (10 grams /
⅓ ounce total; see page 325),
soaked in water until soft

½ teaspoon table salt

2 stalks lemongrass (50 grams /
1¾ ounces total), exterior tough
layers peeled, green section
discarded, pale section sliced
thinly

15 grams / ½ ounce galangal, peeled
and sliced thinly

15 grams / ½ ounce Thai garlic (or
3 standard garlic cloves, peeled)

60 grams / 2 ounces shallots, peeled
and sliced

1 heaping tablespoon shrimp paste

For the Curry

230 grams / ½ pound pork shoulder,
1 × 2 × 2-inch pieces

450 grams / 1 pound pork belly
(including skin and fat),
1 × 2 × 2-inch pieces

1 tablespoon *hang lay* powder (see
page 325)

1 teaspoon black soy sauce
(see page 328)

1 teaspoon fish sauce

5 shallots (60 grams / 2 ounces total),
peeled and halved lengthwise

15 grams / ½ ounce Thai garlic
(or about 3 standard garlic cloves),
peeled

60 grams / 2 ounces ginger, peeled,
sliced thinly, and julienned

3 heads pickled garlic (40 grams /
1½ ounces total), sliced thinly

50 grams / 1¾ ounces peeled,
sliced santol (from ½ of a small,
400 gram / 14 ounce fruit)

¼ cup pickled garlic liquid

THAI KITCHEN TOOLS
granite mortar and pestle

Make the curry paste: With a mortar and pestle, pound and grind the chilies and salt to a coarse paste. Add the lemongrass and galangal; pound and grind to a coarse paste. Add the garlic and shallots; pound and grind to a coarse paste. Add the shrimp paste; pound and grind to a fine paste.

Prepare the curry: In a large bowl, combine the curry paste, pork, ½ cup of water, the *hang lay* powder, black soy sauce, and fish sauce. Marinate for 10 minutes.

Heat the pork mixture in a large saucepan or a small stockpot over medium heat. Cook, stirring occasionally, until the pork has started to firm up, is fragrant, and some oil has started to emerge, about 5 minutes. Increase heat to medium-high, add enough water to nearly cover the pork (about 2 cups), the shallots, garlic, ginger, pickled garlic, and santol. Bring to a simmer, reduce the heat to medium-low, cover, and simmer until the pork is just tender and pleasantly chewy, the dish is fragrant, and a layer of oil has risen to the top, about 1 hour. Add the pickled garlic liquid, bring to a simmer, and taste, adjusting the seasoning, if necessary; the *kaeng hang lay* should taste equal parts slightly sweet and tart, and should be fragrant from the garlic and spice powder.

Remove to a serving bowl and serve warm or at room temperature, with long-grained or sticky rice, as part of a northern Thai meal.

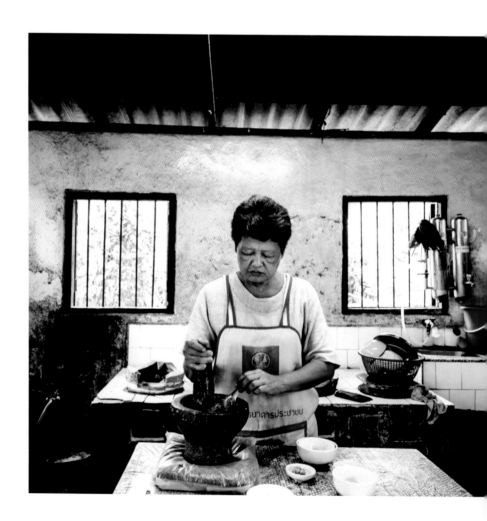

Kaeng Ho

แกงโฮะ

A STIR-FRY OF GLASS NOODLES
AND LEFTOVER CURRY

SERVES 4

Motivated by frugality but also, I'd like to think, driven
by a desire to create delicious new dishes, people waste
little food in northern Thailand. The epitome of this inno-
vative parsimony is probably *kaeng ho*, a unique way of
giving yesterday's dinner a new life by stir-frying it with
glass noodles and pickled bamboo.

"*Ho* means to bring several things together," explains
Chanpen Boonyaoosaya, the woman behind this recipe,
"in this case, combining leftover dishes into one."

Chanpen, a former cook and caterer, tells me this at
her house, located a few miles outside of Lampang. On
a balcony overlooking the Wang River, she has set up an
open-air cooking station that, in addition to the usual raw
ingredients and bottled seasonings, includes two curries
she made the previous day.

"Suppose somebody makes a big pot of *kaeng hang lay*
[Burmese-style pork curry, page 165]," explains Chanpen
of the rich pork-based curry. "If there's any left over, we'll
use it to make *kaeng ho*."

For northern Thai, *kaeng hang lay* is considered the
baseline supplement to *kaeng ho*. But Chanpen also likes
to throw in *kaeng phet*, a central Thai–style curry, aug-
menting it with additional coconut milk, also a central
Thai ingredient, in the process adding both a bit of spice
and richness to the dish. To these she adds a few vegeta-
bles (in this case Thai eggplants and long beans) and herbs
(lemongrass, kaffir lime leaves, and *cha-om*, the latter a
pungent leaf), providing the dish with a pleasant crunch
and aroma. But she's quick to point out that there is no set
recipe for the dish: "*Kaeng ho* can include whatever you
want," she explains, "just as long as it has sour bamboo
and glass noodles."

RECIPE CONTINUES

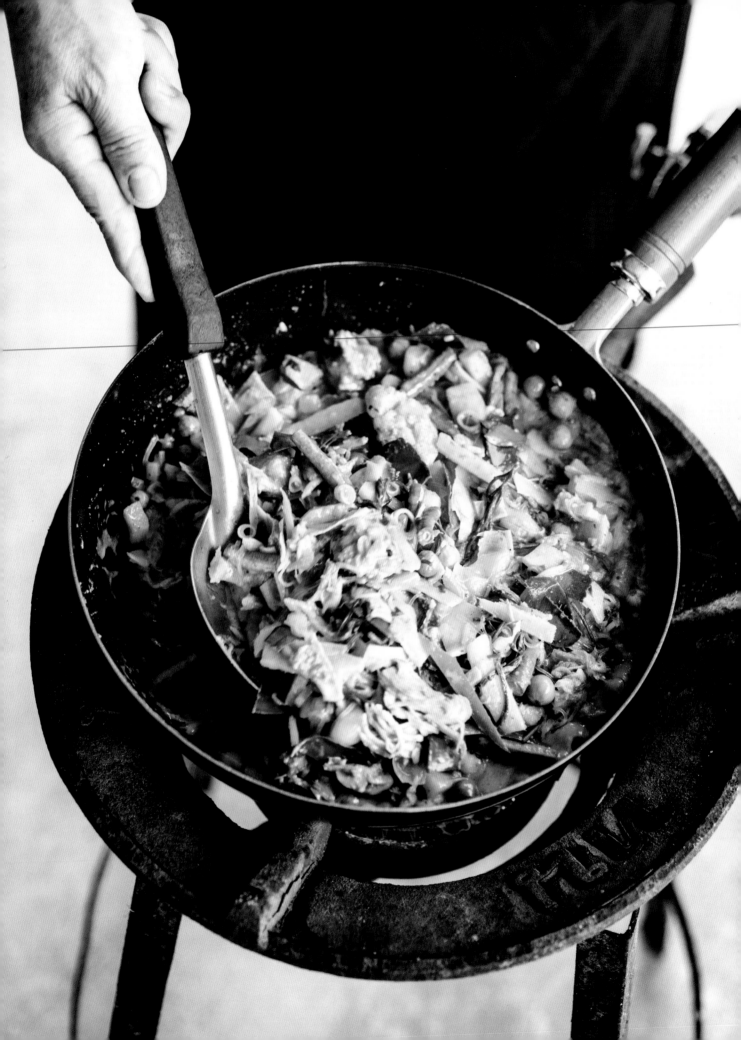

Bring the pickled bamboo and enough water to cover by 2 inches to a boil in a small saucepan. Reduce the heat and simmer for 20 minutes. Drain the bamboo, discarding the water.

In a large bowl, combine the dried glass noodles and plenty of water. Soak for at least 15 minutes. Drain, discarding the water, and set aside.

Heat the vegetable oil in a wok over medium-high heat. Add the chopped garlic and fry, stirring frequently, until fragrant, about 30 seconds. Add the pickled bamboo, Burmese-style pork curry, and other curry (if using), stirring to combine. Bring to a simmer and add the lemongrass, pea eggplants, and long beans. When the pea eggplants and long beans have just begun to soften, after 4 to 5 minutes, add the *cha-om* and drained glass noodles.

When the glass noodles have absorbed much of the liquid, after another 2 to 3 minutes, add the coconut milk, fresh chilies, kaffir lime leaves, sugar, and fish sauce. Simmer until mostly, but not yet completely, dry, another 1 minute or so (the noodles will continue to soak up any moisture after the dish has been cooked).

Taste, adjusting the seasoning if necessary; the *kaeng ho* should taste slightly sweet and rich, and should be pleasantly crunchy from the pickled bamboo and vegetables and fragrant from the *cha-om* and other herbs.

Remove to a serving dish and serve warm or at room temperature, with sticky rice, as part of a northern Thai meal.

200 grams / 7 ounces pickled bamboo, sliced into thin sheets

100 grams / 3½ ounces dried glass noodles

1 tablespoon vegetable oil

2 garlic cloves (10 grams / ⅓ ounce), peeled and minced

1 cup *kaeng hang lay* (Burmese-style pork curry) (page 165)

1 cup any coconut milk–based curry (such as red or green curry, or add an additional cup of Burmese-style pork curry)

2 stalks lemongrass (50 grams / 1¾ ounces total), exterior tough layers peeled, green section discarded, pale section sliced thinly

½ cup pea eggplants (60 grams / 2 ounces)

6 long beans (100 grams / 3½ ounces total), 1½-inch lengths

10 sprigs *cha-om* (100 grams / 3½ ounces total), tender leaves removed, coarse stalks discarded

⅓ cup coconut milk (see page 325)

3 large fresh chilies (50 grams / 1¾ ounces total; see page 324), sliced

8 kaffir lime leaves, torn

1 teaspoon white sugar

1½ teaspoons fish sauce

THAI KITCHEN TOOLS
medium wok (approximately 12 inches)

Jaw Phak Kaat

จอผักกาด

A SOUP OF YU CHOY GREENS AND PORK RIBS

SERVES 4

Suwaphee Tiasiriwarodom's recipe for *jaw phak kaat*, a classic northern Thai soup combining pork ribs, greens, tamarind, and tomatoes, was handed down from her mother and is more than fifty years old. But it would be a stretch to call it traditional.

"If you eat this dish in the countryside, it's going to be very tart and a bit salty," explains Suwaphee, the second-generation owner of Mae Hae, one of Lampang's oldest restaurants. "In the city, we like to add a bit of sugar," she adds, chuckling.

Sweet flavors are rare in the northern Thai kitchen. But like many cooks in Lampang's past, Suwaphee's mother—the eponymous Mae Hae—was almost certainly influenced by the advent of the train line, which in 1916 brought Bangkok-style sensibilities and ingredients to the north. Palm sugar and shrimp paste, two classic central Thai ingredients that feature in her *jaw phak kaat*, are examples of the items that would have been perceived as new and desirable—probably even exotic—in Lampang's past, and eagerly incorporated into restaurant recipes. But in tasting the dish, it's clear to me that Mae Hae's *jaw phak kaat* is less about sugar and more about balance, the sweet, tart, and salty flavors working in precise tandem, none getting more attention than any of the others.

50 grams / 1¾ ounces dried tamarind pulp

350 grams / 12 ounces meaty pork back ribs, 2-inch pieces

1 small onion (60 grams / 2 ounces), peeled and quartered

140 grams / 5 ounces tomato, cut in wedges

8 tart cherry tomatoes (100 grams / 3½ ounces total), halved

1 heaping tablespoon palm sugar

2 scant tablespoons shrimp paste

1 teaspoon table salt

300 grams / 10½ ounces yu choy (see page 328), coarse stalks discarded, larger leaves halved

3 large dried chilies (3 grams total; see page 325)

THAI KITCHEN TOOLS
medium wok (approximately 12 inches)

Bring ½ cup of water to a boil in a small saucepan over medium heat. Remove it from the heat, add the tamarind pulp, and mash with a spoon to combine. Set aside for 15 minutes. Pour the tamarind mixture through a sieve, pushing to extract as much of the pulp as possible and discarding the solids; you should end up with about ¼ cup of tamarind liquid.

Bring the pork and 3 cups of water to a boil in a large saucepan over high heat. Reduce the heat to a simmer, cover the pan, and simmer for 10 minutes. Add the reserved tamarind liquid, onion, tomatoes, cherry tomatoes, palm sugar, shrimp paste, and salt. Simmer until the tomatoes are just starting to get tender, about 4 minutes. Add the yu choy and simmer until tender but not overcooked, another 5 minutes.

While soup is simmering, toast the chilies in a wok over medium heat, stirring frequently, until fragrant and dark, 3 to 4 minutes.

Taste the soup, adjusting the seasoning if necessary; the *jaw phak kaat* should have a near-perfect balance of sweet, salty, and tart flavors.

Remove the soup to a serving bowl and crumble the toasted chilies over the soup as a garnish. Serve warm or at room temperature, with sticky rice, as part of a northern Thai meal.

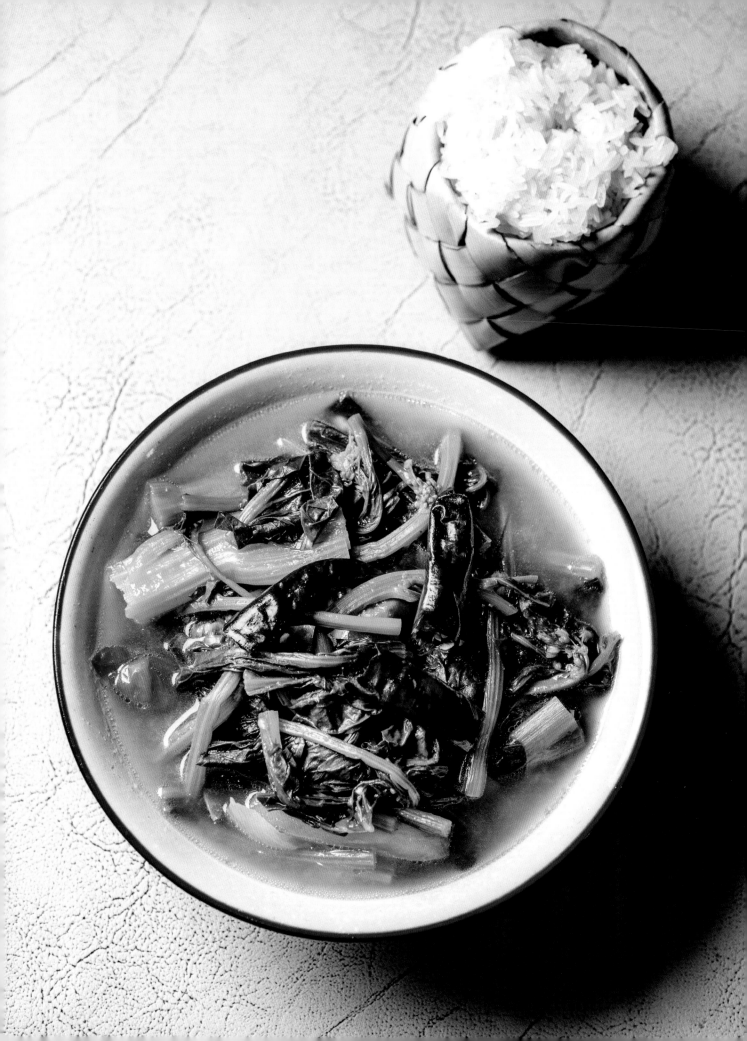

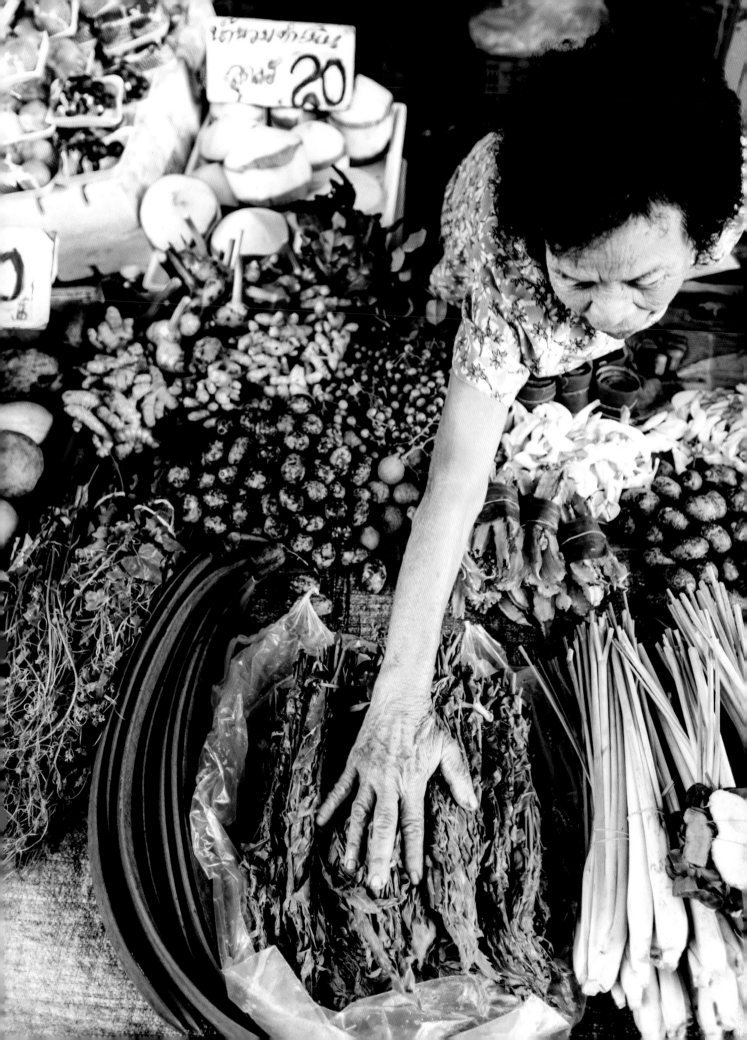

Northern Thailand's
Water Fountains
หม้อน้ำ

"In the old days, we didn't have 7-Eleven," explains Dr. Vithi Phanichphant, "so we kept these pots in front of our houses to offer water to people passing by."

Dr. Vithi, a former professor and authority on northern Thai culture, is describing the role of *maw naam*, the distinctive, rustic, reddish-orange earthenware pots that, despite the almost comical ubiquity of convenience stores in today's Thailand, can still be found in front of some homes in northern Thailand.

To see how *maw naam* are made, I drive to the village of Mon Khao Kaew, just outside Lampang, a long-standing producer of the pots. At a dwindling number of home-based factories, *maw naam* are spun by hand from local clay, decorated by slapping the still-soft exterior with carved wooden paddles, and fired under a scaffolding of bamboo and a pile of rice husk (the former is said to provide the pots with their distinctive red hue). The result is undeniably rustic—unglazed, often featuring irregularities and burn marks—but charming.

Traditionally, *maw naam* were kept on small, elevated, roofed platforms—an effort to keep the water cool— typically located just beside the gateway or entrance to a home. The pots have a lid and are usually accompanied by a coconut shell scoop connected to a carved wooden handle—the communal cup. But you'd be hard-pressed to find water in most *maw naam*; these days they serve a decorative or even cultural role, a reminder of a uniquely northern Thai gesture of generosity.

Khua Khae Kai

ค่ัวแคไก่

A NORTHERN THAI-STYLE STIR-FRY OF CHICKEN AND HERBS

SERVES 4

It's likely that the original inhabitants of Baan Sao Nak, a wooden house built in 1895 by a wealthy Mon immigrant and his local wife, enjoyed the occasional bowl of *kaeng khae kai*, a rustic northern Thai soup that blends vegetables, herbs, and chicken. But Baan Sao Nak—"The House of Many Pillars"—is an elegant, sophisticated home befitting an elegant, sophisticated dish. So at some point, one of the house's inhabitants took the soup's essential elements and opted to *khua*, "fry," them—a cooking technique that, requiring relatively expensive items such as a wok and cooking oil, was probably seen as foreign and decadent in northern Thailand's past.

"The original owners [of Baan Sao Nak] probably ate mostly Burmese- or Mon-influenced food," explains Chalada Chiwarak, the fourth-generation owner of the house, which today functions as a museum and event space. "Later generations probably blended their recipes with northern Thai food—like a kind of fusion cuisine."

Indeed, the transition from soup to stir-fry struck me as unlikely or even arbitrary, but in the Lampang of the past—where there was newfound wealth, where cultures and cuisines mixed and collided, and where there was access to unusual ingredients—this kind of reassessment and tweaking of cuisines was the norm.

Fast-forward a couple more generations, and Chalada has decided yet again to augment *khua khae kai*, as the dish is now known, this time by adding coconut milk, shrimp paste, and palm heart—ingredients typically associated with Bangkok and central Thailand.

"Only northern people can eat the original *khua khae kai*; the flavors are too strong!" Chalada tells me as we sit in the shade between the teak pillars that support Baan Sao Nak. "So we decided to add coconut milk to make it more unique, to serve guests at the house for weddings, dinners, and other events."

The result is a dish with its roots firmly in the past but with a subtly modern—and of course, sophisticated and elegant—feel.

RECIPE CONTINUES

For the Curry Paste

½ teaspoon table salt

4 large dried chilies (9 grams total;
 see page 325)

6 medium dried chilies (3 grams total;
 see page 325)

25 grams / 1 ounce galangal, peeled
 and sliced thinly

2 stalks lemongrass (50 grams /
 1¾ ounces total), exterior tough
 layers peeled, green section
 discarded, pale section sliced
 thinly

4 garlic cloves (20 grams / ⅔ ounce),
 peeled and sliced

30 grams / 1 ounce shallots, peeled
 and sliced

1 teaspoon shrimp paste

For the Stir-Fry

2 tablespoons vegetable oil

2 boneless chicken thighs
 (300 grams / 10½ ounces total),
 halved lengthwise and cut into
 1-inch pieces

1 small heart of palm (125 grams /
 4 ounces), ½-inch dice

85 grams / 3 ounces oyster
 mushrooms, ¼-inch slices

5 Thai eggplants (130 grams /
 4½ ounces total), cut into eighths

3 long beans (75 grams / 2¾ ounces
 total), 1-inch pieces

⅔ cup pea eggplants (75 grams /
 2¾ ounces)

1 small bunch sawtooth coriander
 (20 grams / ⅔ ounce total),
 chopped

15 sprigs *cha-om* (50 grams /
 1¾ ounces total), tender leaves
 removed, coarse stalks discarded
 (see page 324)

10 grams / ⅓ ounce total wild batel
 leaves, torn

½ cup coconut milk

3 tablespoons toasted rice powder
 (see page 147)

1 tablespoon fish sauce

THAI KITCHEN TOOLS

granite mortar and pestle

medium wok (approximately
 12 inches)

Make the curry paste: With a mortar and pestle, pound and grind the salt, large dried chilies, and medium dried chilies to a coarse powder. Add the galangal and lemongrass; pound and grind to a coarse paste. Add the garlic and shallots; pound and grind to a coarse paste. Add the shrimp paste; pound and grind to a fine paste.

Prepare the stir-fry: Heat the oil in a wok over medium-low heat. Add the curry paste and fry, stirring constantly, until fragrant, about 1 minute. Increase the heat to medium, add the chicken, and fry, stirring occasionally, until it has begun to firm up, 3 to 4 minutes. Add ½ cup of water, and bring to a rapid simmer. Add the heart of palm, and return to a simmer. Add the oyster mushrooms and Thai eggplants, and return to a simmer. Add the long beans and pea eggplants, and return to a simmer. Allow the mixture to simmer and reduce until it's thick but not entirely dry, about 5 minutes. Add the sawtooth coriander, *cha-om*, and wild betel leaves, then add the coconut milk, toasted rice powder, and fish sauce, and return to a simmer.

Taste, adjusting the seasoning if necessary; the *khua khae kai* should be just slightly spicy, rich (from the coconut milk and chicken), and herbal; it should also be fragrant from the curry paste and herbs, and pleasantly crunchy from the heart of palm and pea eggplants.

Remove to a serving dish and serve, warm or at room temperature with sticky rice, as part of a northern Thai meal.

Jin Kluea

จิ้นเกลือ

LAMPANG-STYLE SUN-DRIED "BEEF"

SERVES 4 TO 6

Walk into just about any market in Lampang and you're bound to encounter piles of fire-truck-red slices of sun-dried beef that, actually, are pork. Confusing, delicious, and, well, also slightly alarming, this is *jin kluea.*

"People used to make *jin kluea* with beef, but the price got too high," explains Nitaya Kruachinjoy of the broad, hearty slices of pork, slathered with food coloring, seasoned with salt, and left in the hot Thai sun until partially dried.

Other vendors I spoke with in Lampang corroborated this fact, explaining that upon finding themselves priced out, they simply shifted to pork, supplementing it with red food coloring to emulate the naturally red hue of beef (the dish is also known as *jin daeng,* "red beef" or "red meat"). As the head of a community group that promotes local culture and food in the Wat Pong Sanuk neighborhood of Lampang, Nitaya uses considerably less red food coloring than the average market vendor, but she would never consider ditching the ingredient entirely, as it makes the dish look, in her words, "more delicious"—an opinion, I must admit, that I sympathize with.

"You can grill it, fry it, or even steam it," says Nitaya, explaining that after the *jin kluea* is dressed up and dried in the sun, it's still only half finished. "If you grill it, it'll be fragrant from the smoke. If you steam it, it'll be very tender, and you can add herbs such as lemongrass or kaffir lime leaf to the water to make it fragrant."

After drying the pork in the hot April sun, Nitaya opted to deep-fry her version of *jin kluea,* giving it a concentrated, pleasantly salty flavor, a slightly crispy texture, and a deep and, yes, beefy red hue.

This recipe makes enough *jin kluea* for two meals. When dried, the pork can be kept in the refrigerator for several days. Note that, as with all preserved meat products, this preparation carries some risk. If the pork looks or feels slimy or smells off as it's drying, it may be safest to dispose of it.

Slice the pork loin along the grain, approximately ⅛ inch thick.

In a medium bowl, combine the pork, salt, and red food coloring (if using). Marinate for an hour.

Spread the pork out on a permeable tray. Leave in direct sunlight, flipping every 30 minutes or so, for a half to a full day, depending on the sun; when the pork appears dry and you can lift a slice without it bending, it's done.

Heat 1½ inches of oil to 250°F in a wok over medium-high heat. Deep-fry the pork in batches until just slightly crispy and fragrant, approximately 5 minutes. Drain on paper towels.

Remove to a serving dish and eat *jin kluea* on its own as a snack or with sticky rice as part of a northern Thai meal.

680 grams / 1½ pounds pork loin
3½ teaspoons table salt
4 to 6 drops of red food coloring
 (optional)
vegetable oil, for deep-frying

THAI KITCHEN TOOLS
large permeable bamboo or plastic
 tray, for air-drying
large heavy wok (19 inches or larger)

Tam Mamuang

ตำมะม่วง

A POUNDED SALAD OF GREEN MANGOES

SERVES 4

When the weather is hot, northern Thai tend to have one dish on their minds: *tam mamuang*, a salad of shredded unripe mangoes bruised with seasonings.

Thai mangoes are at their peak of sweetness in April, coincidentally also the peak of Thailand's summer. Yet local logic argues that the only thing palatable during this period of excruciatingly balmy weather is tart-tasting dishes. I happened to be in Lampang in late April, on one of the hottest days of the year, during one of the hottest years on record, and was compelled to test this theory.

"I use mangoes that are somewhere between sweet and sour, adding a bit of lime juice," explains Somphit Kaewphikun, the source of this recipe and chef/owner of Paew, a rambling, ramshackle open-air restaurant in Lampang. "Northern Thai–style pounded salads should taste a bit tart," she adds.

Somphit's take on *tam mamuang* is also fragrant, not only from the addition of smoked fish but also from wild betel leaf and *cha-om*, pungent herbs that have emerged as obligatory sides to the dish. It's also appealingly crispy.

"You shouldn't pound the dish too much," warns Somphit, reminding me that, although *tam mamuang* is made using a mortar and pestle, it's not a dip. "It should have the consistency of crunchy strips."

When making *tam mamuang*, Somphit uses what are known colloquially as *mamuang man*, mangoes that have a green exterior, a crispy texture, and a flavor just between tart and sweet—a product generally unavailable outside of Southeast Asia. Tart green mangoes can be substituted, but their overt sourness means that lime juice can probably be omitted from the recipe. This recipe makes enough curry paste for two dishes; the remainder can be kept, sealed tightly, in the refrigerator for weeks.

RECIPE CONTINUES

For the Curry Paste

6 large dried chilies (12 grams /
 ½ ounce total; see page 325)
4 medium dried chilies (2 grams total;
 see page 325)
6 shallots (60 grams / 2 ounces total),
 peeled
18 grams / ⅔ ounce Thai garlic (or
 about 4 standard garlic cloves,
 peeled)
¼ teaspoon table salt
1 teaspoon unfiltered fish sauce
 (*plaa raa*; see page 325)

For the Salad

1 small dried snakehead fish
 (90 grams / 3 ounces total; see
 page 328)
2 medium sweet/tart green mangoes
 (500 grams / 18 ounces total)
4 grams Thai garlic (or 1 standard
 garlic clove, peeled)
2 teaspoons unfiltered fish sauce
 (*plaa raa*; see page 325)
½ teaspoon fish sauce
1 lime, juiced

For Serving

25 grams / 1 ounce shallots, peeled
 and sliced thinly
4 sprigs *cha-om* (approximately
 50 grams / 1¾ ounces total)
 (see page 324)
approximately 40 grams / 1½ ounces
 total wild betel leaves

THAI KITCHEN TOOLS

medium wok (approximately
 12 inches)
granite mortar and pestle
Thai-style charcoal grill or barbecue
papaya shredder (or mandoline with
 the julienne blade)
clay mortar and pestle

Make the curry paste: Using a wok over medium-low heat, dry-roast the dried chilies, shallots, and garlic separately until toasted and fragrant, approximately 5 minutes for each item. Combine the chiles and salt in a mortar and pestle; pound and grind to a coarse powder. Add the shallots and garlic; pound and grind to a coarse paste. Add the unfiltered fish sauce; pound and grind to a fine paste.

Prepare the salad: Using a Thai-style charcoal grill, light the charcoal and allow the coals to reduce to medium heat (approximately 350°F to 450°F, or when you can hold your palm 3 inches above the grilling level for 5 to 7 seconds). Grill the dried fish, turning occasionally, until toasted and fragrant, approximately 15 minutes. (Alternatively, you can use a stovetop grill pan or a broiler, or microwave the fish for 2 minutes, but you'll lose that smoky flavor.) When cool enough to handle, remove the fish flesh, discarding any bones and skin. Pound and grind the fish flesh with a mortar and pestle to a fine, dry powder.

Peel the mangoes and, using a knife, make deep lengthwise incisions in the mango approximately ¼ inch apart. With a Thai papaya shredder (not a box grater—the results will be too thin), shred the mangoes into relatively hearty strands approximately 2 inches long; you should end up with about 250 grams / 9 ounces of shredded mango.

To a clay mortar and pestle, add the garlic. Pound until you have a very coarse paste. Add half of the curry paste; pound to a coarse paste. Add 2 tablespoons of the snakehead fish powder (the remainder can be sealed tightly and kept for weeks in a refrigerator), the unfiltered fish sauce, and the fish sauce; pound to a coarse paste. Add the mango and approximately 1 tablespoon of lime juice; pound and mix gently to combine and bruise the mango (you don't want mush here).

Taste, adjusting the seasoning, if necessary; the *tam mamuang* should taste slightly tart, spicy, and fragrant, from the fish, garlic, and unfiltered fish sauce.

Remove to a serving plate, garnish with the sliced shallots, and serve, along with the *cha-om*, betel leaves, and sticky rice, as part of a northern Thai meal.

Phat Thai Muu

ผัดไทหมู

PHAT THAI WITH PORK

SERVES 4

The origins of *phat thai*—thin, flat rice noodles fried with tofu, egg, and seasonings—are murky. Some maintain that it was invented as part of a culinary competition during the 1930s, while several restaurants claim that they served the dish long before this.

What is clear is that *phat thai* is a blend of Chinese ingredients and cooking techniques (rice noodles, preserved radish, tofu, stir-frying) and Thai seasonings (chili, tamarind, fish sauce). In central Thailand, where the dish most likely originated and where there's ample access to the sea, *phat thai* is usually made with shrimp. Yet upon reaching the landlocked north, those who wanted to make it were forced to get creative.

"My mother opened this stall more than forty years ago," explains Witan Jinajul of the alley-bound *phat thai* restaurant in Lampang that he's run for the last eight years. "It was her idea to include Vietnamese pork sausage and minced pork; northern Thai people love pork!"

Fried in lard, the dried noodles rendered soft by the addition of a ladleful of pork stock, Witan's *phat thai* is undeniably porky. Other unique, if not entirely local, touches include hearty squares of tofu deep-fried until crispy and a side of lettuce leaves—features that have led to long lines of impatient and hungry locals on a nightly basis. As is the case with *phat thai* across Thailand, Witan prepares the dish slightly underseasoned, since one of the pleasures of *phat thai* is the ability to add more chili, fish sauce, and lime juice to accommodate one's own tastes.

Smooth, peppery Vietnamese pork sausage is available in Asian grocery stores as *chả lụa*. It's worth noting that this recipe makes four servings of *phat thai*, which, unless you have access to a very large wok, is most easily done by seasoning the noodles in two stages, then stir-frying the portions individually.

RECIPE CONTINUES

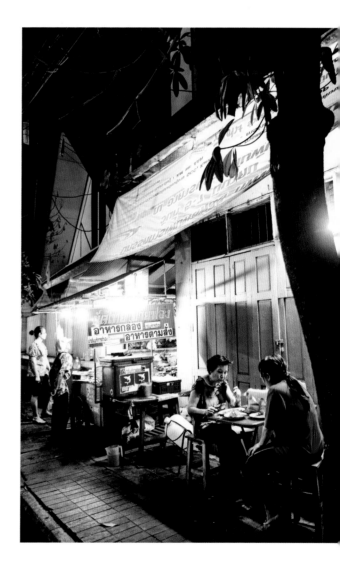

100 grams / 3½ ounces dried
 tamarind pulp
200 grams / 7 ounces raw peanuts,
 shelled
¼ cup vegetable oil
300 grams / 10½ ounces firm tofu,
 drained, 1-inch cubes
300 grams / 10½ ounces pork bones
250 grams / 9 ounces ground pork
140 grams / 5 ounces Vietnamese
 pork sausage, ½-inch cubes
300 grams / 10½ ounces thin, flat
 dried rice noodles, broken into
 8-inch lengths
6 tablespoons lard
1 teaspoon white soy sauce
 (see page 328)
1 teaspoon green cap soy sauce
 (see page 328)
1 teaspoon black soy sauce
 (see page 328)
200 grams / 7 ounces bean sprouts
2 heaping tablespoons diced
 preserved radish
2 heaping tablespoons dried shrimp
2 teaspoons white sugar
100 grams / 3½ ounces garlic chives,
 top 1 inch trimmed off and
 discarded
4 eggs
80 grams / 3 ounces lettuce leaves
1 lime, cut into wedges
ground chili flakes
fish sauce

THAI KITCHEN TOOLS
medium wok (approximately
 12 inches)
granite mortar and pestle

Bring 1 cup of water to a boil in a small saucepan over high heat. Remove it
from the heat, add the tamarind pulp, and mash with a spoon to combine. Set
aside for 15 minutes. Pour the tamarind mixture through a sieve, pushing to
extract as much of the pulp as possible and discarding the solids; you should
end up with about ½ cup of tamarind liquid.

Heat the peanuts in a wok or sauté pan over medium-low heat. Toast,
stirring, until slightly dark and fragrant, around 5 minutes. (If your peanuts
are already roasted, you may skip this step.) When cool enough to handle,
grind them with a mortar and pestle to a relatively fine consistency.

Heat the oil in a large saucepan over medium heat. Pat the tofu very dry
with paper towels. When the oil is shimmering hot, carefully add the tofu
and fry, stirring occasionally, until just crispy and starting to brown, about
10 minutes. Remove the tofu and drain on paper towels.

Bring the pork bones and 1 quart of water to a boil in a medium
saucepan over high heat. Reduce the heat slightly, place the ground pork
and Vietnamese sausage in a metal sieve, and dip the pork mixture in the
pork bone stock to cook it, about 3 minutes. Set aside the ground pork and
Vietnamese sausage. Reduce the heat and allow the broth to simmer for
another 10 minutes.

In a large bowl, soak the noodles in enough water to cover for 10 minutes,
or until they're reached a point just between soft and slightly firm. Drain the
noodles thoroughly.

Heat 1 tablespoon of the lard in a wok over medium heat. Add half of the
drained rice noodles, approximately ¼ cup of pork stock, and 2 tablespoons
of tamarind liquid. Fry, stirring in a circular motion with the tip of a wok
spatula to combine, until the liquid has reduced slightly, about 20 seconds.
Add half of the white soy sauce, half of the green cap soy sauce, and half of
the black soy sauce, stirring to distribute the seasonings. If the mixture is too
dry, add another ¼ cup of the pork stock. Add 1 cup of the bean sprouts, half of
the preserved radish, half of the dried shrimp, and half of the sugar, stirring
to combine. Remove the wok from the heat and add 2 heaping tablespoons of
ground peanuts, stirring to combine.

Taste, adjusting the seasoning if necessary; the *phat thai* should be subtly
sweet, tart, and salty, in that order. Remove the noodles, and repeat with the
seasonings, and bean sprouts.

Tear 2 sprigs of garlic chives into sections 1 inch long. On each of 4 serving
plates, arrange a quarter of the ground pork and Vietnamese sausage, a
quarter of the tofu, and a quarter of the garlic chives. Heat 1 tablespoon of
lard in a wok over medium-high heat until very hot. Add 1 egg, immediately
break the egg yolk with the spatula, and tip the wok to spread the egg into an
omelet as thin and wide as possible. Add a quarter of the cooked noodles to the
center of the omelet, folding the edges of the egg around the noodles to create
a package. When the egg has set, after about 1 minute, flip the mixture as a
whole and fry briefly on the opposite side. Place the *phat thai*, egg side up, on
top of the ground pork mixture. Repeat with the remaining eggs and noodles.

Serve *phat thai*, hot or at room temperature, with sides of lettuce, the
remaining garlic chives, bean sprouts, the remaining sugar and ground
peanuts, lime wedges, ground chili flakes, and fish sauce.

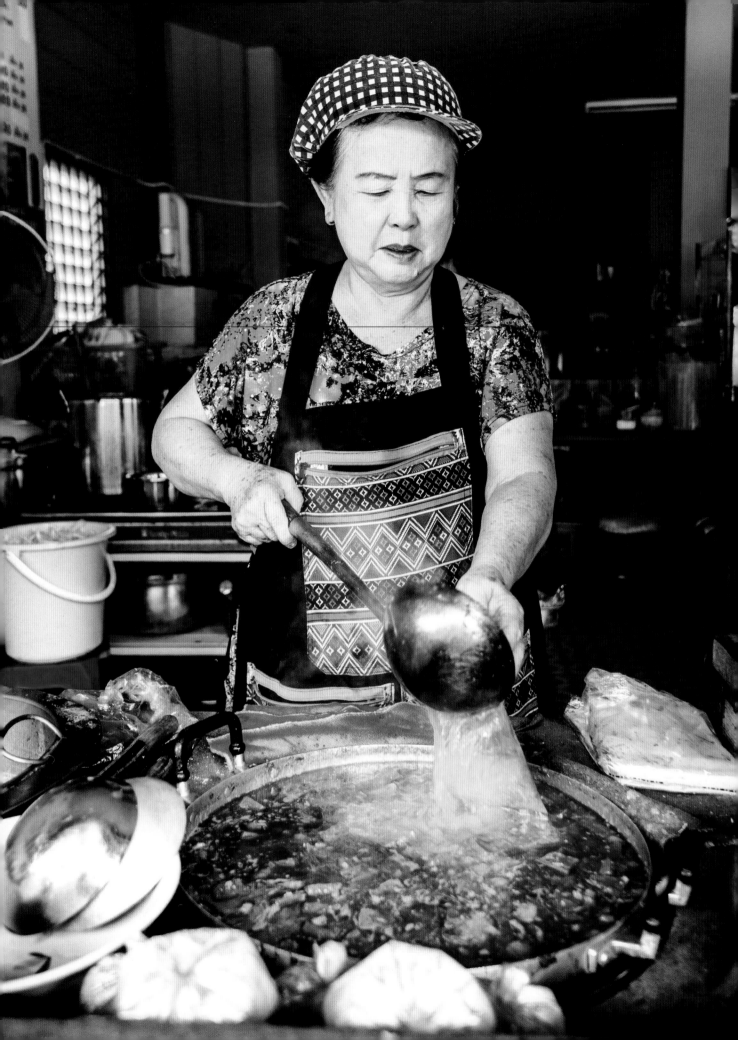

Kuaytiaw Naam Ngiaw

ก๋วยเตี๋ยวน้ำเงี้ยว

A RICH PORK-RIB AND TOMATO BROTH
SERVED OVER FLAT RICE NOODLES

SERVES 4 TO 6

Khanom jiin naam ngiaw, a hearty soup of pork ribs and tomatoes served over thin round rice noodles, is easily one of the most beloved dishes in the region. Yet like *khao soi, kaeng hang lay,* and some of northern Thailand's other most famous dishes, it's actually an immigrant.

Ngiaw is a not entirely polite term for the Shan people, an ethnic group closely related to the Thais suggesting that they had a role in creating or spreading the dish. Today, most Shan reside in Myanmar, but conflict during the eighteenth and nineteenth centuries meant that they crossed to northern Thailand in great numbers, bringing with them their cuisine. Yet as *khanom jiin naam ngiaw* spread across northern Thailand, it took varying forms: in Chiang Mai, it is balanced in flavor and features chewy cotton-tree flowers; in Chiang Rai, the dish is rich and oily, and is sometimes made with beef; in Mae Hong Son, locals prefer a thin, tart broth with little or no meat; in Phrae and Nan, the soup is clear, fragrant, and overtly porky. And in Lampang, a city known for its access to a diversity of ingredients, one local opted to swap out the carb.

"You can eat it with whatever noodle you want," posits Bunsri Phisitsupharak, the owner of Pa Bunsri, a long-standing riverside restaurant known for its *naam ngiaw,* as the dish is colloquially known, and where this is the de facto policy. "It's just like Italian pasta: there's several types of noodle, and each one has its own flavor."

At Pa Bunsri, customers can opt to accompany their *naam ngiaw* with round wheat-and-egg noodles, flat wheat-and-egg noodles, glass noodles, flat or round dried rice noodles—or even a plate of rice, as I saw one customer do.

If ordered with *kuaytiaw* (flat rice noodles), the dish is served in a deep bowl, with more broth than one would receive with a traditional serving. And despite being unconventional (and perhaps for some, heretical), it works, as Bunsri's broth is meaty and rich—if a bit spicy—heavy on cubes of steamed blood and tomatoes ("Burmese MSG," as she calls the latter), easily capable of holding its own with the hearty noodles.

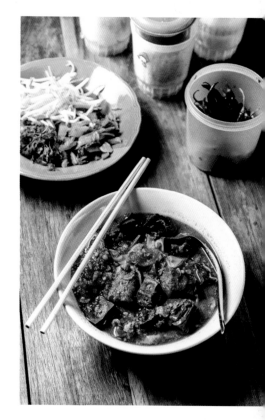

RECIPE CONTINUES

For the Curry Paste

20 large dried chilies (25 grams /
 1 ounce total; see page 325)
1 teaspoon table salt
2 stalks lemongrass (50 grams /
 1¾ ounces), exterior tough layers
 peeled, green section discarded,
 pale section sliced thinly
25 grams / 1 ounce galangal, peeled
 and sliced
4 small cilantro roots (4 grams total),
 chopped
75 grams / 2¾ ounces shallots, peeled
 and sliced
30 grams / 1 ounce Thai garlic (or
 6 standard garlic cloves, peeled)
2 teaspoons shrimp paste
3 tablespoons Thai-style salted
 fermented soybeans or fermented
 soybean paste (see page 227)

For the Broth

2 tablespoons lard
1 kilogram / 2¼ pounds pork back
 ribs, 2-inch pieces
400 grams / 14 ounces chicken- or
 pork-blood cake, ¾-inch cubes
500 grams / 18 ounces tart cherry
 tomatoes or halved larger tomatoes
150 grams / 5¼ ounces ground pork
¼ teaspoon MSG (optional)
300 grams / 10½ ounces thin, flat
 dried rice noodles

For Serving

2 green onions (40 grams / 1½ ounces
 total), chopped
A few sprigs cilantro (20 grams /
 ⅔ ounce total), chopped
4 teaspoons crispy garlic and garlic oil
 (see page 32)
crispy dried chilies (page 325)
200 grams / 7 ounces pickled mustard
 greens, chopped
150 grams / 5¼ ounces mung bean
 sprouts
4 limes, cut into wedges
fish sauce

THAI KITCHEN TOOLS
granite mortar and pestle
noodle basket

Prepare the curry paste: Bring the dried chilies and enough water to cover by a couple inches to a boil in a small saucepan over high heat. Remove from the heat, cover, and soak the chilies until soft, at least 20 minutes. Drain the chilies thoroughly. With a mortar and pestle, pound and grind the salt and chilies to a coarse paste. Add the lemongrass, galangal, and cilantro roots; pound and grind to a coarse paste. Add the shallots and garlic; pound and grind to a coarse paste. Add the shrimp paste and fermented soybeans; and pound and grind to a fine paste.

Prepare the broth: Heat the lard in a medium stockpot over medium-low heat. Add the curry paste and fry, stirring constantly, until fragrant and the oil begins to separate, about 10 minutes. Add the pork ribs and 2½ quarts of water, increase the heat to high, and bring to a boil. Reduce the heat to a simmer, cover, and simmer for 30 minutes. Add the blood cake. When the broth reaches a simmer again, add the tomatoes, ground pork and MSG (if using). When the broth reaches a simmer again, simmer until the minced pork is cooked through and the tomatoes are just tender, about 15 minutes.

Taste, adjusting the seasoning if necessary; the *kuaytiaw naam ngiaw* should taste equal parts spicy, umami, and salty, and should be fragrant from the herbs and fermented soybeans, and pleasantly oily. At this point, you can allow the broth to continue at a very low simmer for as long as a couple hours, concentrating its flavor (as is done at Pa Bunsri).

Prepare the noodles: Soak the noodles with enough water to cover in a large bowl for 10 minutes. Drain the noodles thoroughly.

Bring at least 6 inches of water to a boil in a large stockpot over high heat. Put 100 grams / 3½ ounces of the soaked noodles in a noodle basket and place in the boiling water, agitating the basket until the noodles are just tender, about 20 seconds. Drain the noodles thoroughly and put in a serving bowl.

To serve, top the noodles with 1½ to 2 cups of the broth, and garnish with the green onions, cilantro, and 1 teaspoon of crispy garlic and garlic oil. Repeat for subsequent bowls. Accompany the noodles with sides of crispy dried chilies, pickled mustard greens, mung bean sprouts, lime, and fish sauce.

Chicken Bowls

ชามตราไก่

Order a bowl of noodles just about anywhere in Thailand, and it's likely that they'll arrive in a cream-colored bowl emblazoned with a hastily painted chicken—almost certainly Lampang's most famous export. But this local icon originated abroad, more than a hundred years ago.

Until the middle of the twentieth century, Thailand's ubiquitous and so-called chicken bowls were almost exclusively imports from China. But in 1955, a Chinese immigrant discovered kaolin, the clay used to make the bowls, at a quarry outside of Lampang. Collaborating with other Chinese immigrants, he constructed an earthen kiln and started to produce cheap copies of the bowls for domestic consumption. Business proceeded relatively slowly until 1957, when a xenophobic Thai dictatorship barred the importation of goods from China. Virtually overnight, demand for the Lampang-made bowls soared, ensconcing their status as a contemporary Thai staple.

Today, production of chicken bowls has nearly died out in China, while more than three hundred ceramics factories are said to make them in Lampang. The bowls produced there continue to the follow the tradition of the Chinese prototypes: a white or off-white background with impressionistic depictions of chickens, flowers, and banana trees, painted using five different colors. Increasingly, however, hand-shaped bowls and manually painted designs are becoming a thing of the past, and contemporary chicken bowls are likely made in a factory, sometimes even from plastic.

Khao Taen Naam Taengmo

ข้าวแต๋นน้ำแตงโม

DEEP-FRIED RICE CAKES SEASONED WITH
WATERMELON JUICE AND PALM SUGAR

SERVES 4 TO 6

It's a cool early morning in Lampang, that last hour or so before the sun rises over the mountains and mercilessly heats up the city, and Seri Jaiya is spreading tiny pucks of seasoned sticky rice on a series of reappropriated, elevated window screens. After drying for two days in the northern Thai sun, the rice cakes will be briefly deep-fried, then drizzled with palm sugar, culminating in *khao taen naam taengmo*, a sweet snack that's become almost synonymous with the city.

"In the past, people would make *khao taen* from the leftover sticky rice that monks didn't eat," explains Seri, the co-owner of Khun Manee, a family-run factory that has become the city's most famous producer of the sweet. "The original version was big, with a slight drizzle of sugar-cane syrup," he adds.

Khao taen may have its roots in Buddhist temple leftovers, but that didn't stop Seri and his wife from taking it in a different direction. They began by shrinking the size of the rice cakes to just beyond bite-sized. To provide their *khao taen* with a subtly sweet flavor, they mix the sticky rice with watermelon juice (the eponymous *naam taengmo*). And instead of the thin swirl of sugarcane syrup that defines the traditional version, they decided to go with a generous dollop of melted palm sugar flecked with toasted sesame seeds. The result is a crunchy, fragrant, just-sweet-enough bite-and-a-half—if you ask me, one of the most appealing and delicious sweet snacks in northern Thailand.

At least 48 hours before serving, wash the sticky rice in several changes of water. Put it in a large bowl and cover with several inches of water. Soak the sticky rice for at least 8 hours.

Drain the sticky rice, discarding the water. Steam the sticky rice (see page 54) for 20 minutes, flipping the rice and steaming another 5 to 10 minutes, until the rice is entirely cooked through and tender. Remove the rice to a large bowl and cool until warm enough to handle.

While the rice is cooking, juice and strain a portion of the watermelon (this can be done with a blender and a fine sieve) to get ½ cup of watermelon juice. Combine the watermelon juice, raw sugarcane sugar, and salt in a medium bowl, stirring until the sugar and salt have dissolved completely. Add the sticky rice and 2 teaspoons of the white sesame seeds, mixing by hand until any clumps of rice have been separated and the watermelon juice mixture and sesame seeds are evenly distributed throughout the rice. You can wet your hands or add a couple tablespoons of water if the mixture is too dry. Cover the rice with a damp towel.

Clear and clean a flat surface. Wet your hands and press 1 tablespoon of the rice mixture into a 2-inch cookie cutter, using some sort of tool to tamp the rice into a disk approximately ¼ inch thick (I used the small end of a pestle). Pop the rice disk out onto a permeable tray. Repeat until all the rice is used up; this should produce approximately 60 *khao taen*. If, during this process, the rice in the bowl is beginning to dry out, wet your hands or sprinkle it with a couple tablespoons of water.

Put the rice cakes in direct sunlight, flipping occasionally, until completely dry, which can take 2 to 3 full days. (Alternatively, 2 hours in an electric food dehydrator will produce the same results.)

Heat 2 inches of oil to 350°F in a wok over medium-high heat. As a test, deep-fry one or two rice cakes until puffed and golden but not yet dark, which should take approximately 20 seconds. Remove from the oil and allow to drain on paper towels or a rack. If you find that the rice cakes are hard or chewy in the center, they're probably too thick or did not dry completely in the sun. Maintaining the oil at 350°F, deep-fry the remaining rice cakes in small batches and drain them on paper towels.

Add the remaining white sesame seeds to a clean wok over low heat. Dry-roast until toasted, about 4 minutes.

Microwave the palm sugar in a microwave-safe bowl until melted, 1 to 2 minutes. Add the toasted sesame seeds, stirring to combine. Drizzle 1 teaspoon of the palm sugar–sesame mixture over each rice cake. Allow to set until the palm sugar is hard.

Serve the *khao taen naam taengmo* as a sweet snack. Any that aren't consumed on the same day can be kept in an airtight container for up to 3 or 4 days.

500 grams / 18 ounces uncooked sticky rice
1 small watermelon (approximately 3 kilograms / 6½ pounds)
60 grams / 2 ounces raw sugarcane sugar
½ teaspoon table salt
⅓ cup white sesame seeds
vegetable oil, for deep-frying
1 cup palm sugar

THAI KITCHEN TOOLS
Thai-style sticky rice steaming pot and basket
large permeable bamboo or plastic tray, for air-drying
large heavy-bottomed wok (19 inches or larger)

Khanom Paat

ขนมปาด

A CELEBRATORY SWEET
OF COCONUT AND RICE FLOUR

SERVES 4 TO 6

"It's a dish associated with special occasions: ordinations, housewarming ceremonies, things like this," explains Phannee Khanthalak about *khanom paat*, one of the most cherished sweet snacks in Lampang.

I was at Phannee's vast home kitchen in Lampang, where she has earned a reputation for making the dish, a rich, fragrant, almost caramel-like mass of rice flour, coconut milk, sugar, and coconut meat. And seeing it made firsthand, I understood why *khanom paat* just might not be your everyday dish: in addition to involving some pretty decadent ingredients, it's also kind of a pain to make.

I had arrived at Phannee's around 10 a.m., just as she and her staff were pouring vast amounts of rice flour, coconut cream, and sugar into a wok the size of a satellite dish. A flame was lit, and a man was summoned who would dutifully stir the mixture with a long wooden paddle for the next four hours.

"It needs to be cooked at a low heat; otherwise it will burn," says Phannee.

The *khanom paat* began its life as a watery, pale liquid, yet after an hour or so of simmering and ceaseless stirring, it began to resemble a bubbling porridge. Dark raw cane sugar and shredded coconut meat were added, at which point Phannee told me, "There's nothing to see! Come back later!"

When I returned after nearly three hours, the man still stirring, the mixture had transformed entirely: its volume had been reduced by nearly two-thirds, it was the color of dark leather, and it was thick and sticky. And after another hour or so of more reducing and stirring, it was finally deemed finished.

A thin layer of *khanom paat* was poured into several trays, and when cool and firm, it was sliced (the eponymous *paat*; *khanom* means "a sweet snack") into small diamonds. I was given a taste and, expecting it to be cloyingly sweet and sticky, was surprised to find *khanom paat* rich and fragrant, with both a soft texture and a pleasant crunch from the shredded coconut meat.

It's worth noting that Phannee's original recipe makes approximately twenty large trays of *khanom paat*, enough to feed several dozen people, so for the home cook, I've reduced the quantities significantly. The smaller amount means a shorter cooking time, giving less opportunity for sugars to caramelize and for the dish to turn as dark in color and smooth in texture as Phanee's version, although the flavor remains roughly the same.

The day before cooking, combine the rice flour and enough water to cover by 3 inches in a large bowl, stirring to combine. Allow to rest at room temperature for 4 hours. Pour off the layer of clear water on the top. Add more water to cover by 3 inches, stir to combine, and allow it to rest overnight. In the morning, pour off the clear layer of water, and add enough water to cover by 1 to 2 inches.

Combine the rice flour–water mixture, white sugar, and coconut cream in a wok over medium heat, stirring constantly with a wooden spoon or paddle. After approximately 5 minutes, the mixture should be lightly simmering; at 10 minutes it should have the consistency of a thick, bubbling porridge; at 15 minutes the mixture should be slightly viscous; at 30 minutes the mixture should be thick and almost taffy-like. At this point, add the raw sugarcane sugar and the coconut meat. Continue to stir until the volume is reduced by approximately a third and the mixture is dark, thick, and fragrant, about another 30 minutes. Pour the mixture into a shallow metal tray and spread it out evenly.

Allow the *khanom paat* to cool, and when firm, slice into 1 × 2-inch diamonds. Serve as a sweet snack.

250 grams / 9 ounces rice flour
150 grams / 5¼ ounces white sugar
1½ cups coconut cream (see page 325)
300 grams / 10½ ounces raw
 sugarcane sugar
150 grams / 5¼ ounces shredded,
 unsweetened coconut meat

THAI KITCHEN TOOLS
large heavy-bottomed wok (19 inches
 or larger)
shallow 12-inch-diameter metal tray

Miang

I was struggling to maintain my balance on a patch of steep, jungly hillside at the edge of Ban Pa Miang, a remote village in Lampang. Just beyond the path, blending in seamlessly with the greenery, were dozens of *Camellia sinensis* var. *assamica* trees—known locally as *miang* and to us as tea. I probably wouldn't have noticed them at all if busy locals hadn't been tending them. This was in June, the early rainy season, when the young, tender tea leaves are at their peak. Just about everybody in the village was busy plucking them, swiping at the leaves with a tool improvised by attaching a razor to a finger, deftly removing only the topmost three-quarters of each leaf—a practice that's thought to ensure that the tree will continue to produce quality leaves the next season.

At the end of the day, the villagers take the leaves home and steam them until tender, after which they sell them to middlemen, who submerge them underwater in airtight containers for up to a year. If you know anything about how tea is made, this process will seem highly unorthodox. But for the villagers of Ban Pa Miang and the residents of northern Thailand, tea leaves are for eating, not drinking.

"Old people eat *miang* with just a bit of salt, after a meal," explains Saengduean Kamlangkla, a native of Ban Pa Miang and a producer of *miang*.

Long before potato chips and strips of dried squid became the snacks of choice in northern Thailand, people ate *miang*, morsels of tart-tasting fermented tea leaves. And although the consumption of *miang* is almost entirely relegated to the older generation these days, production of it continues in Ban Pa Miang just as it has for several generations.

Located in a sharp river valley at the edge of a national park ringed by virgin forest, Ban Pa Miang boasts a back-in-time feel fitting with its status as one of the most lauded sources of one of the region's most ancient snacks. To see how *miang* makes the transition from fresh tea leaves to snack, I visit one of the village's three damp, sour-smelling, home-based factories. There, villagers pack the recently steamed bundles of tea leaves into large cement containers, covering them with water. The leaves are then left to ferment for as briefly as a couple months to as long as a couple years, during which they gradually turn tender and gain a tart, astringent flavor.

"I've seen *miang* preserved for as long as two years," explains Saengduean. "It was very sour and soft. It's amazing that it doesn't spoil."

Saengduean offers me a tiny ball of *miang* that has been fermented for three months. It's coarse and firm in texture, slightly tart and a bit too astringent for my taste. She then hands me a pinch of *miang* that's been fermented a year. It's significantly more tender, and the tartness is in overdrive, rising into my nose almost like wasabi.

"If you eat it while driving, you won't fall asleep!" says Saengduean, reminding me that what I'm consuming are indeed tea leaves.

These days, as far as tastes are concerned, tart and astringent have fallen by the wayside in most of northern Thailand. But *miang* live on as a sweet snack, wrapped around a ball of sugar and toasted coconut—a subtle spike of sweetness to quell those uniquely ancient flavors.

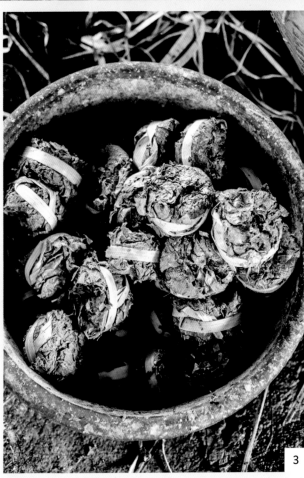

3

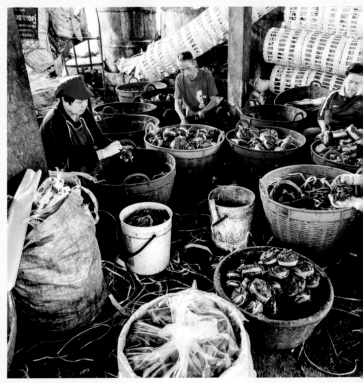

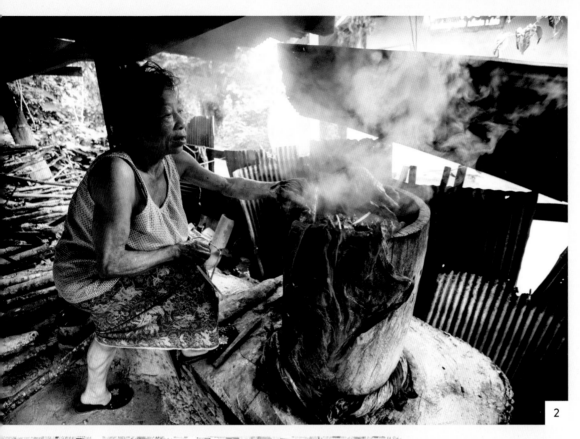

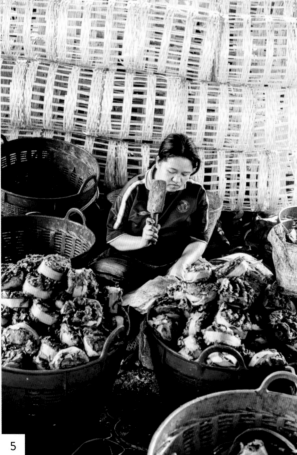

Making *miang* in Ban Pa Miang involves the following steps:

1. During the rainy season, from approximately May to October, villagers pluck only the young, tender tea leaves.
2. The same day they're picked, the leaves are tied into bundles and steamed until tender, which can take up to two hours.
3. The next day, the bundles are sold to middlemen who pack them tightly into airtight cement containers and cover them with water.
4. After a couple months or so, the bundles are removed and sorted: the younger, tender leaves can be consumed at this point and are known as *miang faat* ("astringent" *miang*), while any coarse leaves are sorted out, rebundled, resubmerged, and left to ferment for up to a year, at which point they're known as *miang som* ("sour" *miang*).
5. When fermented sufficiently, the leaves are tenderized by pounding, yet again sorted by quality and size, rebundled, put in plastic sacks to which salty water is added, and brought to market.

Mae Hong Son
แม่ฮ่องสอน

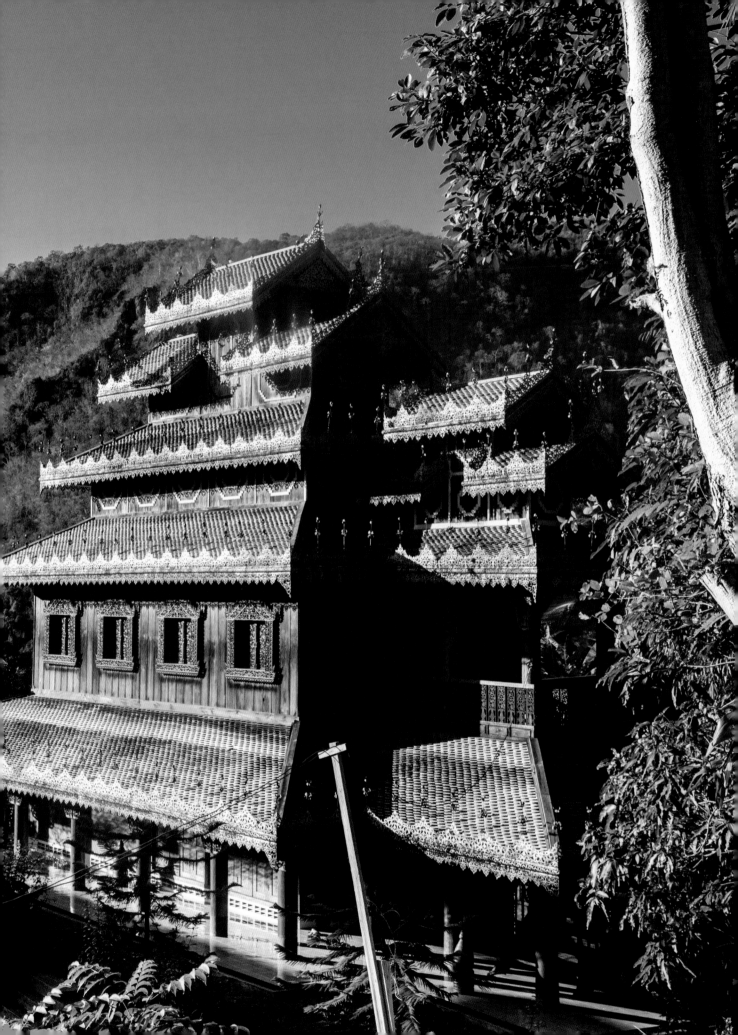

From Bangkok, the bus ride to Mae Hong Son City takes at least fifteen hours, and given the winding, mountainous roads, the experience is not unlike being on a boat during rough seas. If you're coming from Chiang Mai, it's only slightly easier: a six-hour, vomit-inducing drive or, if you're brave enough, a brief hop in an airplane the size of a minivan.

Simply put, there's no easy way to get to Mae Hong Son—which is exactly why it's one of my favorite places in Thailand.

Clinging to the border with Myanmar, seemingly abandoned in Thailand's northwesternmost corner, Mae Hong Son's impenetrable geography has rendered it a place quite unlike anywhere else in the country. It's among the most mountainous provinces in Thailand; karst cliffs, jutting defiantly from the horizon, define the landscape. Thick, cold morning fog blankets the province's valleys year-round, and come winter—when nighttime temperatures can dip perilously close to freezing—the leaves of the dipterocarp trees change color en masse, rendering entire hillsides a patchwork of purple, pink, orange, and red more reminiscent of New England than Southeast Asia. In terms of people and culture, it's also an anomaly. Boasting hill tribe, Karen, and Shan inhabitants; Burmese-influenced temples; and a unique repertoire of dishes not found elsewhere in the country, Mae Hong Son always struck me as something of a different country altogether.

It shouldn't come as a surprise, then, that what's today considered Mae Hong Son Province was regarded as a distant wilderness until the early nineteenth century. This is when the rulers of neighboring Chiang Mai decided to look westward in an effort to capture elephants—essential tools for transport and war during this period. By 1830, the village of Mae Hong Son had become a remote but important outpost for the training of elephants. Yet it wasn't until fighting in neighboring Burma led to an influx of Shan refugees, coupled with the incursion of a growing British-administered logging trade, that the area began to be developed. Mae Hong Son was officially granted city status in 1873 and provincial status nearly twenty years later. Yet poor infrastructure meant that mule trains remained a common way to reach the province until the 1960s.

Today, Mae Hong Son remains among the most sparsely populated provinces in Thailand, consisting mostly of small villages nestled in narrow river valleys, often edging teak forests. It's home to more than eight ethnic groups, but if remoteness, karst, and mist define the geography of Mae Hong Son, it is the Shan, an ethnic group related to the Thai, who have come to shape its culture—and its cuisine.

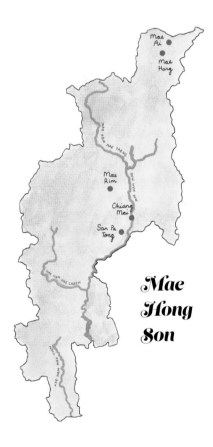

Mae Hong Son

What the Shan Eat

"The Thai have a very sophisticated way of seasoning and preparing food," Prasert Pradit tells me. "Our food is simpler; there's not so many seasonings. In the past, there was just chili, salt, and soybeans—just these three ingredients!"

Prasert, a teacher of Shan language and culture at Mae Hong Son's Tai Yai Studies Institute, was doing his best to encapsulate the food of his people. Also known as Thai Yai, Tai, or, somewhat pejoratively, Ngiaw, the Shan are an ethnic group related to the Thai. Yet for centuries, the majority of the world's Shan have lived in Myanmar. And although they've managed to retain their language and culture, their cuisine has developed a bit of a Burmese accent.

"We're a people who have always been moving, fleeing conflict," adds Prasert, "so we've had to learn to eat from the forests."

Much like the province itself, Mae Hong Son's Shan-style food can seem down-right foreign. A walk through a fresh market in Mae Hong Son reveals ingredients more evocative of Myanmar than Thailand: dried spice mixtures with cheesily antiquated labels, pungent disks of fermented soybeans, bags of lentils and split peas, used booze bottles full of practically fluorescent orange turmeric powder, and bottles of virgin sesame oil.

"Shan food isn't spicy, and we don't use sugar at all in our cooking," Prasert tells me. A love of savory flavors, a general absence of chili heat, the use of a mild Indian-influenced curry powder, and oil used as a seasoning rather than simply as a cooking medium are other attributes of Burmese food that pop up in Shan cookery. Likewise, many Shan ingredients and dishes have traveled far beyond the border regions and today are considered staples of the greater northern Thai repertoire.

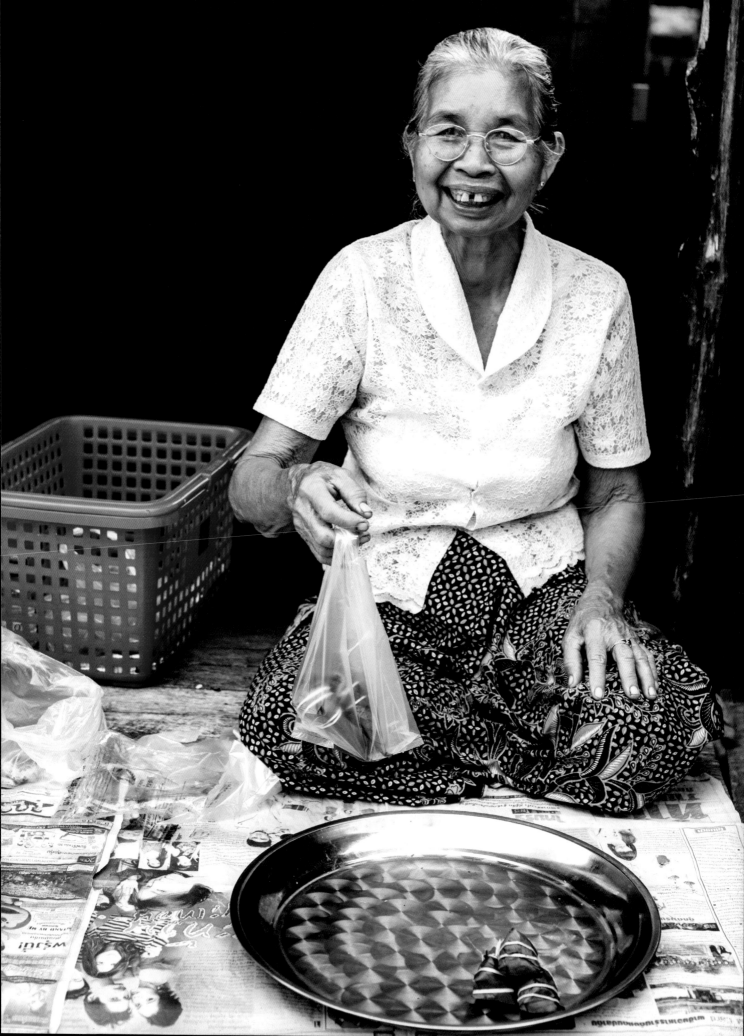

Staple Ingredients in Mae Hong Son's Shan Cookery

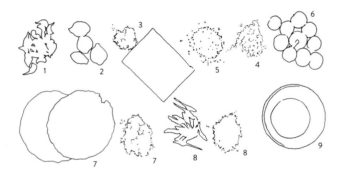

1. **Thai garlic** / *krathiam kliip lek* / กระเทียมกลีบเล็ก
2. **Shallots** / *hawm daeng* / หอมแดง
3. **Shan-style masala powder** / *phong hang lay/phong masalaa* / ผงฮังเล/ผงมะสล่า
4. **Turmeric** / *khamin* / ขมิ้น
5. **White sesame seeds** / *ngaa khao* / งาขาว
6. **Tomatoes** / *makhuea thet* / มะเขือเทศ
7. **Preserved soybeans** (in dried, grilled, and powder form) / *thua nao* / ถั่วเน่า
8. **Dried Karen chilies** (in whole and powdered form) / *phrik kariang haeng* / พริกกะเหรี่ยงแห้ง
9. **Sesame oil** / *nam man ngaa* / น้ำมันงา

Up Kai Asii Pian

อุ๊บไก่อะสีปย่าน

A SHAN-STYLE AROMATIC CHICKEN CURRY

SERVES 4

Miakhin Charoensuk has spent nearly every single day of her life in Muang Pon, a tiny Shan village located in the center of Mae Hong Son Province. Ringed by tiered rice fields, made up of tidy wooden houses fronted by flower-draped fences, and bookended by a Buddhist temple at one end and a tiny market at the other, it's the epitome of a traditional Shan village. Likewise, Miakhin is, in many ways, the epitome of an old-school Shan woman. She's the third generation to have been born and raised in the village; most of the ingredients she cooks with come straight from her garden; and she continues to eat her meals the old way: with her fingers, eschewing a dining table for her home's smooth wooden floor.

Miakhin was kind enough to share with me her recipe for *up kai asii pian*, a chicken curry that's considered one of the signature dishes of the Mae Hong Son Shan repertoire. And although its name may be a mouthful, *up kai asii pian* is about as simple as a Thai curry can get.

Up is a Shan word meaning, roughly, "to bake," which in practice means to cook a dish while covered, concentrating its flavors. *Asii pian* is a corruption of the Burmese *hsi pyan*, meaning literally "oil returns," a reference to a cooking method in which liquids are encouraged to evaporate, resulting in a relatively dry dish characterized by an aromatic amalgam of fat and herbs. Although these two cooking methods are the converse of each other, Shan cooks use them in tandem, cooking a curry first covered and then with the lid off, extracting and distilling its aromas respectively.

"The dish should be fragrant," suggests Miakhin of the ideal *up kai asii pian*. Indeed, aromatic Southeast Asian herbs—in particular, galangal—rule her version of *up kai asii pian*, shattering the notion that Thai food has to be spicy, while also serving as an example of the type of dish that Thai love for its aroma perhaps even more than its flavor. And although she stays true to the roots of the dish, Miakhin has bowed to contemporary Thai tastes with her addition of shrimp paste and fish sauce—umami-boosting ingredients most likely unavailable in Muang Pon when she was young.

Prepare the curry paste: With a mortar and pestle, pound and grind the salt, lemongrass, chopped galangal, and chilies to a coarse paste. Add the garlic and shallots; pound and grind to a coarse paste. Drain and add the coriander seed; pound and grind to a coarse paste. Add the turmeric powder and shrimp paste; pound and grind to a fine paste.

Prepare the curry: Heat the oil in a wok over medium-low heat. Add the curry paste and fry, stirring constantly, until fragrant, about 3 minutes. Add the chicken, ½ cup of water, and the julienned galangal, stir to combine, and cover with a lid. Simmer for 10 minutes, lifting lid only occasionally to stir. Remove the lid and simmer until the curry is relatively dry and fragrant, and the oil has reemerged, about 5 more minutes. Add the kaffir lime leaves, fish sauce, and MSG (if using), stir to combine, and cook for 1 more minute.

Taste and adjust the seasoning, if necessary; the *up kai asii pian* should be pleasantly oily and taste overtly herbal, salty, and spicy (in that order). Remove from the heat, and stir in the cilantro and green onion.

Serve warm or at room temperature, with long-grained rice, as part of a Shan meal.

For the Curry Paste
½ teaspoon table salt
2 stalks lemongrass (50 grams / 1¾ ounces total), exterior tough layers peeled, green section discarded, pale section sliced thinly
25 grams / 1 ounce young galangal, peeled and chopped
12 dried *phrik kariang* chilies (3 grams total; see page 325)
15 grams / ½ ounce Thai garlic (or 3 standard garlic cloves, peeled)
30 grams / 1 ounce shallots, peeled and sliced
2 teaspoons coriander seed, soaked in water for 10 minutes
½ teaspoon turmeric powder
1 teaspoon shrimp paste

For the Curry
5 tablespoons vegetable oil
2 whole chicken legs (600 grams / 1¼ pounds total), 1-inch pieces
25 grams / 1 ounce young galangal, peeled and julienned
12 to 14 kaffir lime leaves, torn
1 teaspoon fish sauce
½ teaspoon MSG (optional)
a few sprigs cilantro (5 grams), chopped
1 green onion (20 grams / ⅔ ounce), chopped

THAI KITCHEN TOOLS
granite mortar and pestle
medium wok (approximately 12 inches)

Kaeng Hang Lay Tai

แกงฮังเลไต

SHAN-STYLE PORK BELLY CURRY

SERVES 4

The first time I tasted Mae Hong Son–style *kaeng hang lay*, a rich curry typically revolving around pork belly, the notion struck me like a lightning bolt: American barbecue sauce. Specifically, the kind of stuff that you'd buy at Safeway or Fred Meyer. This is not a critique; who doesn't like BBQ sauce, a seasoning that brings together salty, sweet, sour, and spicy in one celebrity-endorsed, squeezable bottle?

It isn't hard to understand, then, why *kaeng hang lay* is one of the most famous northern Thai dishes. But much like *khao soi*, the curry noodle soup that is arguably the region's other superstar, its appeal may be obvious, but its origins are somewhat murky.

"It's a Burmese dish, but the Shan brought it to Thailand," suggests Teng-u Somdet, a Shan food vendor, native of Mae Hong Son, and the source of this recipe.

Indeed, *hang lay* is thought to be a corruption of *hin lay*, colloquial Burmese for "strongly seasoned pork curry" (*kaeng* simply means "curry"). Possibly with the help of the Shan, *hin lay* crossed the border and eventually spread across northern Thailand. Yet upon reaching urban centers like Lampang and Chiang Mai, the dish became increasingly Thai, made with lemongrass and galangal, ingredients normally associated with the central Thai kitchen.

But the dish as made by Shan cooks in Mae Hong Son remains a relatively simple, rustic affair, with palpable links to its Burmese origins. As is the case with many Burmese-style curries, Mae Hong Son–style *kaeng hang lay* is not made from a curry paste that has been pounded in a mortar and pestle, but rather ground dried herbs are added to the dish as seasonings. Other than a dash of mild bottled chili sauce, chilies don't generally factor into the recipe. And a final Burmese influence—by way of India—is seen in the use of *hang lay* powder, a mild, fragrant dried spice mixture (for background on *hang lay* powder, including an approximate substitute, see page 325).

"It has three flavors," Teng-u tells me, "sour in the lead, sweet, and salty—but not too sweet." Although it may appear unusual, Teng-u's recipe includes a dash of ketchup, a common ingredient in contemporary Mae Hong Son, the result of a Shan tendency to add tomatoes to just about every dish (in the process, adding even more umami, tartness, and, well, barbecue sauciness). Mae Hong Son–style *kaeng hang lay* can revolve around main ingredients ranging from dried fish to potatoes, yet pork belly has emerged as the definitive version. Indeed, the dish appears to be little more than an excuse to combine fatty pork with just about every salty, umami-heavy condiment in the kitchen—not quite as far from American-style barbecue as geography might suggest.

RECIPE CONTINUES

100 grams / 3½ ounces tamarind pulp

800 grams / 1¾ pounds pork belly (including fat and skin), 1 × 2-inch pieces

1 teaspoon turmeric powder

1 teaspoon black soy sauce (see page 328)

1 teaspoon shrimp paste

50 grams / 1¾ ounces shallots, peeled, halved, and sliced lengthwise

25 grams / 1 ounce Thai garlic (or 5 standard garlic cloves, peeled)

50 grams / 1¾ ounces ginger, peeled and julienned

1 teaspoon white soy sauce (see page 328)

1 teaspoon Maggi liquid seasoning

1 tablespoon oyster sauce

½ teaspoon bouillon powder

1 teaspoon white sugar

1 tablespoon *hang lay* powder (see page 325)

1 tablespoon ketchup

1 tablespoon mild chili sauce (such as Shark brand sriracha sauce)

THAI KITCHEN TOOLS
medium wok (approximately 12 inches)

Bring ½ cup of water to a boil in a small saucepan over medium heat. Remove it from the heat, add the tamarind pulp, and mash with a spoon to combine. Set aside for 15 minutes.

Place the pork belly, turmeric powder, black soy sauce, shrimp paste, and enough water to nearly cover in a wok over medium-low heat. Cover with a lid and bring to a simmer. Reduce the heat to low and simmer, covered, for 10 minutes, stirring occasionally. Stir the shallots, garlic, and ginger into the wok. Simmer, uncovered, another 20 minutes, to reduce the liquid slightly. Stir in the white soy sauce, Maggi, oyster sauce, bouillon powder, sugar, *hang lay* powder, ketchup, and chili sauce. Simmer, uncovered, another 20 minutes, at which point the liquid should have reduced by a quarter or a third of its original volume, the pork should start to become tender, and a thin layer of oil should begin to appear.

Using a spoon, mash the tamarind pulp again and strain the liquid through a sieve into the pork mixture, pressing to extract as much liquid as possible, discarding the solids. Simmer, uncovered, until the pork is tender but not yet falling apart, another 10 to 20 minutes.

Taste, adjusting the seasoning if necessary; the *kaeng hang lay tai* should be relatively thick in consistency and dark in color, and should taste predominately tart and of umami, and to a lesser extent, salty and sweet.

Remove to a serving bowl and serve warm or at room temperature, with long-grained rice, as part of a Shan meal.

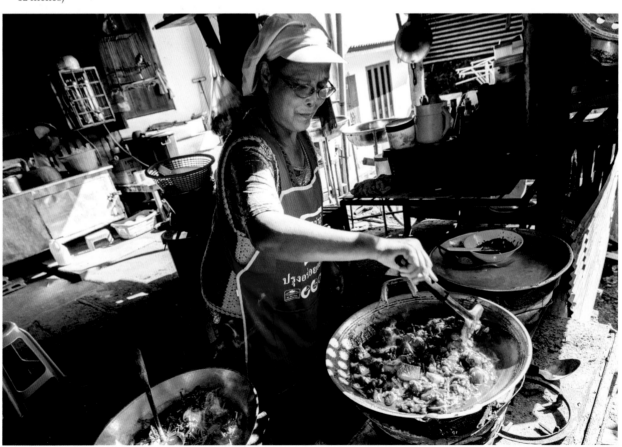

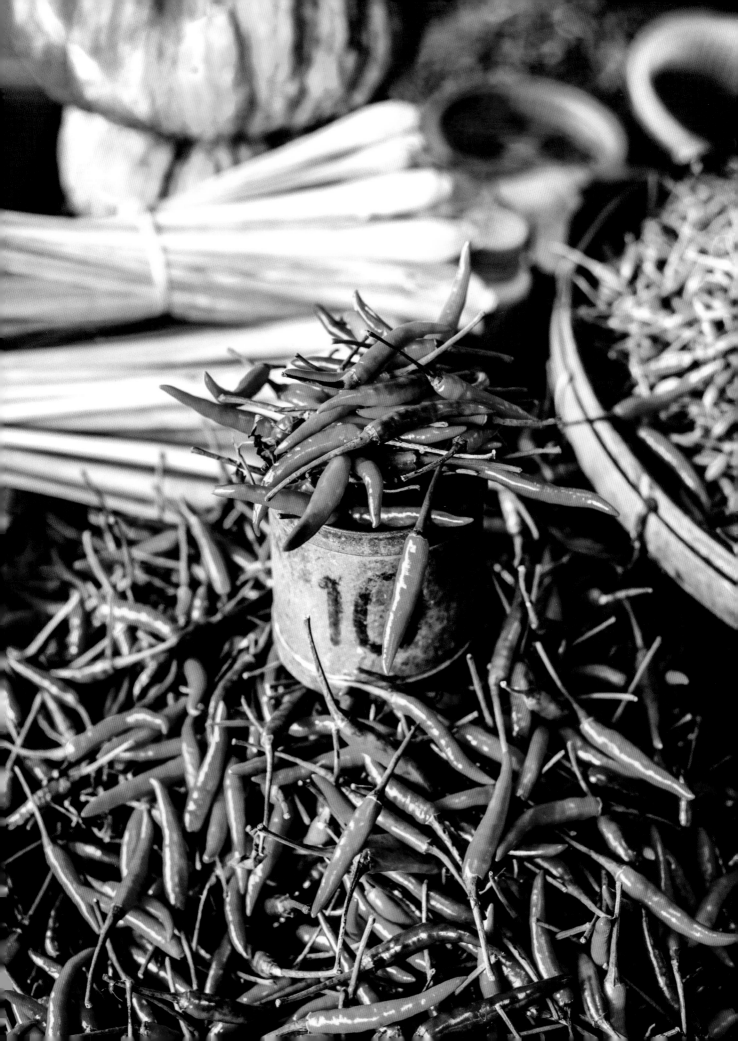

Hang Lay Powder

Several dishes in Mae Hong Son, including *kaeng hang lay tai* (page 213), are seasoned with *phong hang lay*, known in Mae Hong Son as *phong masalaa*, a spice blend with obvious links to South Asia.

"The original masala is from India, but my father got the recipe from Burma," explains Preecha Sirikun, a second-generation Mae Hong Son–based producer of the spice mixture.

Preecha tells me that, approximately sixty years ago, his father, Jeng Ong, a Shan from Myanmar, arrived in Mae Hong Son. He began his life in Thailand as a laborer, bringing goods—including dried spices—imported by river from Burma (current-day Myanmar) to Mae Hong Son, before ultimately deciding to get into the masala business.

"Masala from India has more spices than ours," explains Preecha, who continues to employ his father's blend of nineteen different ingredients in his *phong hang lay*, a blend that includes seemingly local flourishes such as white sesame seeds and more exotic spices such as cubeb (also known as tailed pepper). Once a month, Preecha orders whole spices from Chiang Mai and, after washing and drying them, roasts them in a large wok, over coals, and grinds them in an old electric mill—the same equipment his father used. The result is a rather coarse, mild yet fragrant curry powder with a distinct emphasis on coriander seed.

"I do it by weight and have the proportions memorized," explains Preecha. "Coriander seeds is the biggest part—it's 70 or 80 percent of the mixture. We all have different recipes, but I can't tell you what proportions I use."

And so it will remain a secret. But fortunately for those of us without access to Preecha's *phong hang lay*, store-bought garam masala powder supplemented with 50 percent of its volume in toasted and freshly ground coriander seed serves as a decent substitute.

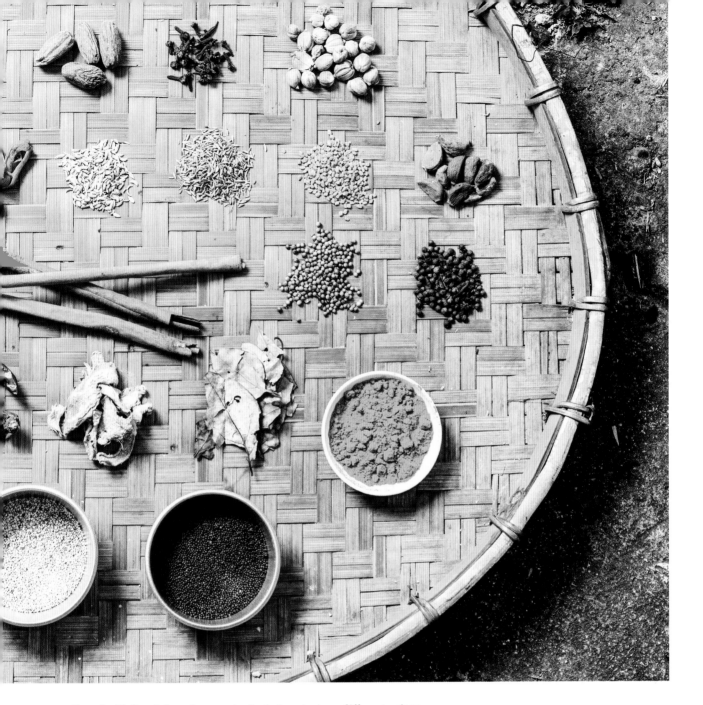

Preecha Sirikun's *hang lay* powder includes nineteen different spices:

1. **Long pepper** / *dii plii* / ดีปลี
2. **Nutmeg** / *luuk jan thet* / ลูกจันทน์เทศ
3. **Clove** / *kaan phluu* / กานพลู
4. **Siam cardamom or camphor seeds** (*Amomum kravanh* Pierre) / *krawaan thai* / กระวานไทย
5. **Black pepper** / *phrik Thai dam* / พริกไทยดำ
6. **Mace** / *dawk jan thet* / ดอกจันทน์เทศ
7. **Fennel** / *thien khao plueak* / เทียนข้าวเปลือก
8. **Cumin** / *yiiraa* / ยี่หร่า
9. **Fenugreek** / *luuk sat* / ลูกซัด
10. **Garlic** (dried) / *krathiam* / กระเทียม
11. **Cinnamon** / *op choey* / อบเชย
12. **Coriander seed** / *look phak chii* / ลูกผักชี
13. **Cubeb** (tailed pepper) / *phrik haang* / พริกหาง
14. **Chili** / *phrik chii faa* / พริกชี้ฟ้า
15. **Ginger** (dried) / *khing* / ขิง
16. **"Bay leaf"** (actually the leaf of the Siam cardamom or camphor seed plant [*Amomum kravanh* Pierre]) / *bai krawaan* / ใบกระวาน
17. **Turmeric powder** / *phong khamin* / ผงขมิ้น
18. **White sesame seeds** / *ngaa khao* / งาขาว
19. **Mustard seeds** / *met phak kaat* / เมล็ดผักกาด

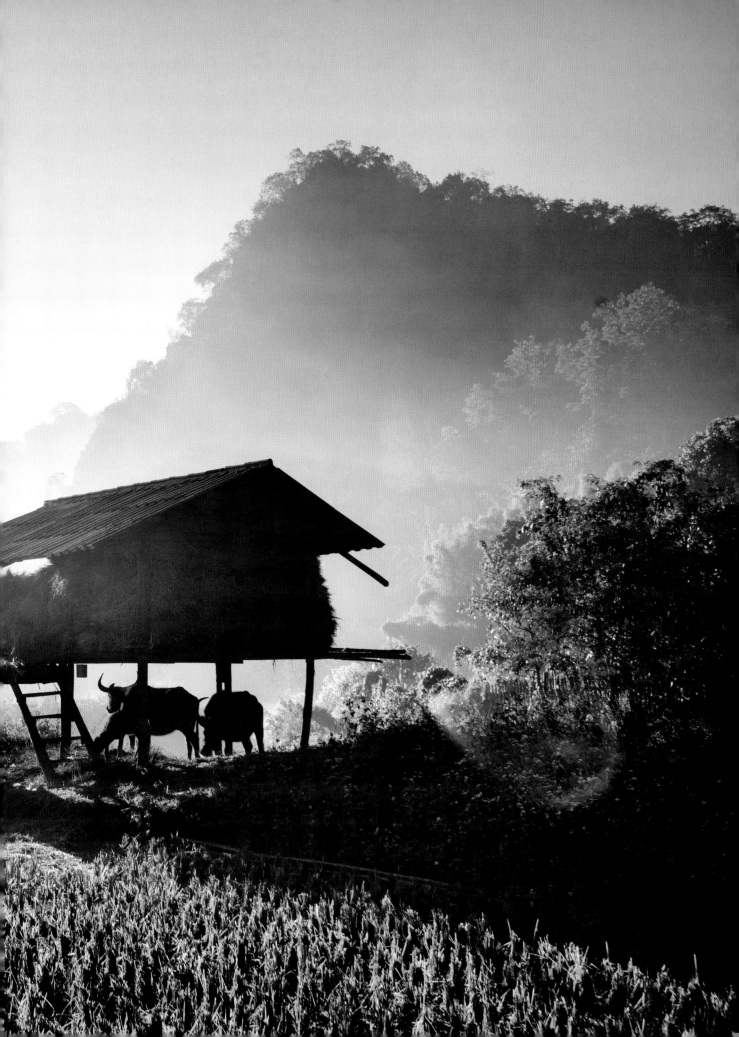

Nuea Tam

เนื้อตำ

SHAN-STYLE "POUNDED MEAT"

SERVES 4 TO 6

Many of the dishes today associated with northern Thai cooking are meat-based—an irony for a region that, by most accounts, ate very little flesh until recently.

"In the past, we didn't have pigs; there were just cows and buffalo," explains Buatong Silamanee, a sixty-five-year-old food vendor in Muang Pon, a Shan village south of the city of Mae Hong Son, who provided this recipe. "We'd use them until they were too old to work, then slaughter them—that's the only time we got to eat meat."

Buatong goes on to describe that such slaughters were limited to special occasions, and if the meat wasn't consumed then, it had to be preserved. *Nuea tam*—literally "pounded meat"—stems from this tradition.

"It's a way of preserving food," explains Buatong of the almost comically long cooking process that involves grilling, boiling, pounding, and frying pork. Not only do these steps render the pork shelf-stable, but they also concentrate its meaty essence, and throwing in a few herbs results in a dish of fragrant, spicy, crispy, smoky, almost jerky-like strands. And although meat is available today on a daily basis in most of Mae Hong Son, Buatong and others across the province continue to make *nuea tam*, a testament to the deliciousness of preservation.

This recipe makes enough *nuea tam* for at least two meals; any leftovers can be kept in the refrigerator, sealed tightly, for up to a couple weeks.

Prepare the pork: Using a Thai-style charcoal grill, light the charcoal and allow the coals to reduce to low heat (approximately 250˚F to 350˚F, or when you can hold your palm 3 inches above the grilling level for 8 to 10 seconds). Grill the pork, flipping it every 10 minutes, until brown and slightly charred on the outside and somewhat dry, 40 to 60 minutes total.

Place the grilled pork and enough water to cover by 3 inches in a large saucepan over high heat. Bring to a boil, reduce the heat, and simmer, covered, until tender, approximately 1½ hours. Remove the pork from the water and cool on a wire rack.

Make the curry paste: While the pork is simmering, use a mortar and pestle to pound and grind the chilies, galangal, ginger, and garlic to a fine paste.

When the pork is cool enough to handle, cut it along the grain into ½-inch slices. Using the mortar and pestle, pound 2 or 3 pieces of the pork until shredded and falling apart, but not mush. Use your hands to pull any tough pieces of pork into thin strands. Repeat with the remaining pork.

Heat the oil in a wok over medium-high heat. Add the curry paste, MSG (if using), and salt, and fry, stirring frequently, until fragrant, 1 to 2 minutes. Add the pork and fry, stirring constantly, using a spatula to press the pork to the bottom and sides of the wok; the idea is to combine the pork and curry paste and also to separate the pork into strands that are somewhat dry, crispy, and slightly singed in parts (the larger the wok, the easier this is to do); this should take a total of 10 minutes of frying and stirring.

Add the fish sauce, taste, and adjust the seasoning if necessary; the *nuea tam* should taste spicy and herbal, umami and salty (in that order). Remove to a small serving bowl and serve at room temperature, with long-grained rice, as part of a Shan meal.

For the Pork
300 grams / 10½ ounces lean pork
 shoulder, 1½ to 2 inch-thick piece
2 tablespoons vegetable oil
¼ teaspoon MSG (optional)
¼ teaspoon table salt
1 teaspoon fish sauce

For the Curry Paste
24 dried *phrik kariang* chilies
 (5 grams total; see page 325)
50 grams / 1¾ ounces galangal, peeled
 and sliced
50 grams / 1¾ ounces ginger, peeled
 and sliced
30 grams / 1 ounce Thai garlic (or
 6 standard garlic cloves, peeled)

THAI KITCHEN TOOLS
Thai-style charcoal grill
granite mortar and pestle
large heavy-bottomed wok (19 inches
 or larger)

Three Mae Hong Son–Style Salads

In contemporary Thailand, the blanket term *yam* has come to describe most salad-like dishes. But in northern Thailand—especially in Mae Hong Son—local-style salads carry a variety of names, with subtle variations between them. The following salads are the three main types of those eaten among the Shan of Mae Hong Son, courtesy of Teng-u Somdet, a Shan food vendor in the town.

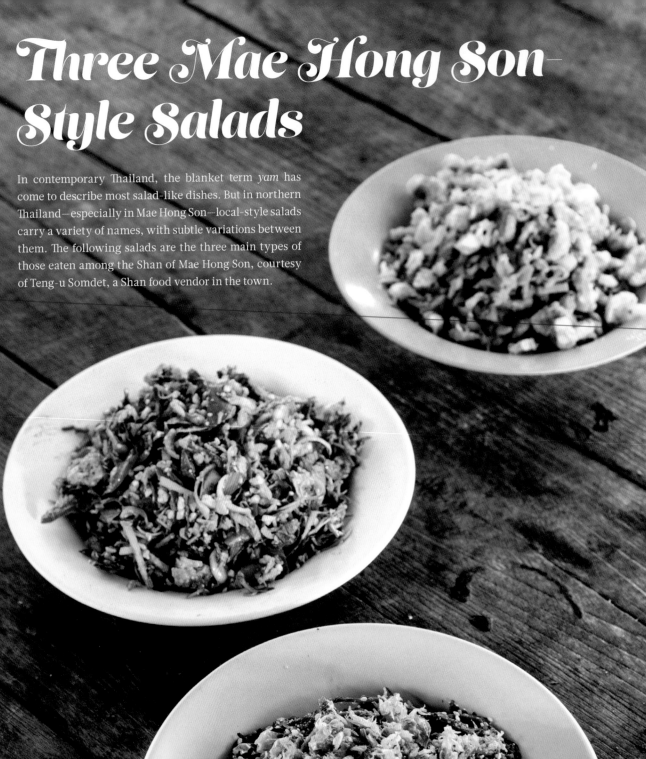

Thua Taep Ko

ลั่นแตบโก้

A MAE HONG SON–STYLE SALAD OF LABLAB (HYACINTH) BEANS

SERVES 4

Ko is a Mae Hong Son–style salad in which the main ingredient is almost always parboiled. Other attributes include the dish's slightly spicy curry paste–based dressing and a decadent garnish of crumbled deep-fried pork rinds.

This version of *ko* revolves around *thua taep*, known in English as lablabs or hyacinth beans, and is a cold season favorite in Mae Hong Son. When *thua taep* aren't available, the people of Mae Hong Son are happy to make the dish with long bean, banana flower, yu choy greens, young jackfruit, or even shredded bamboo—and so can you.

With a mortar and pestle, pound and grind the shallots, garlic, and chilies to a coarse paste. Add the tomatoes, and pound and grind to a fine paste.

In a wok over low heat, combine the oil, the pounded shallot mixture, and the turmeric powder. Cook, stirring frequently, until the ingredients are combined and fragrant, about 2 minutes. Add the shrimp paste and fermented soybean powder, continue to fry over a low heat, stirring, mashing, and scraping until the mixture is fragrant and amalgamated, and the oil has begun to reemerge, another 5 minutes. Remove the wok from the heat.

Bring a stockpot of well-salted water to a boil over high heat. Add the lablabs and boil until swollen and tender, about 5 minutes. Drain the beans and shock them in cold water; drain again and cool. When cool enough to handle, slice the beans, crosswise, about ¼ inch wide.

In the wok (or a medium bowl), combine three-fourths of the curry paste, the beans, the crispy garlic and garlic oil, and salt to taste. Mix by hand, squeezing gently to combine.

Taste and adjust the seasoning, adding salt and/or the remaining curry paste if necessary; the *thua taep ko* should taste savory and salty, slightly spicy and tart (in that order). Add the green onion and cilantro, stirring to combine.

Remove the mixture to a serving dish and garnish with pork rinds (if using). Serve with long-grained rice as part of a Shan meal.

For the Curry Paste
50 grams / 1¾ ounces shallots, peeled and sliced
10 grams / ⅓ ounce Thai garlic (or 2 standard garlic cloves, peeled)
10 small fresh chilies (3 grams total; see page 324)
7 cherry tomatoes (50 grams / 1¾ ounces total), quartered
2 tablespoons vegetable oil
½ teaspoon turmeric powder
1 tablespoon shrimp paste
2 tablespoons fermented soybean powder (see page 328)

For the Salad
table salt
300 grams / 10½ ounces lablabs (hyacinth beans), stringy bits removed (see page 326)
2 tablespoons crispy garlic and garlic oil (see page 32)
1 green onion (20 grams / ⅔ ounce), chopped
a few sprigs cilantro (10 grams / ⅓ ounce total), chopped
20 grams / ⅔ ounce deep-fried pork rinds (see page 70), chopped (optional)

THAI KITCHEN TOOLS
granite mortar and pestle
medium wok (approximately 12 inches)

OPPOSITE: From the top—
Thua Taep Ko,
Phak Nawk Saa,
and *Phak Kuut Sanaap.*

Phak Kuut Sanaap

ผักกูดสะนาบ

A MAE HONG SON-STYLE SALAD OF VEGETABLE FERNS

SERVES 4

350 grams / 12 ounces vegetable ferns
 or fiddlehead ferns
2 tablespoons raw white sesame seeds
1 tablespoon vegetable oil
1 scant tablespoon shrimp paste
2 tablespoons crispy garlic and garlic
 oil (see page 32)

THAI KITCHEN TOOLS
medium (approximately 12-inch) wok

Sanaap is a type of salad characterized by a dressing that blends shrimp paste, deep-fried garlic, garlic oil, and toasted sesame seeds and/or peanuts.

The most common version of the dish sees these ingredients countered by tart fruit, such as shredded unripe starfruit or green mango. Yet a particularly beloved variant revolves around *phak kuut*, known in English as vegetable ferns, an edible plant that flourishes in the rainy season in Mae Hong Son. If you can find the requisite ingredients (young, tender fiddlehead ferns serve as a decent substitute for *phak kuut*), the dish is surprisingly easy to make, and the crunchy greens, nutty sesame, and pleasantly oily dressing come together deliciously.

Prepare the vegetable ferns by removing and discarding the coarse/woody lower stalks and breaking the tender upper part into sections about 2 inches long. Place 2 quarts of water in a large pot over high heat. When boiling, add the fern shoots and parboil until just tender, 30 seconds to 1 minute. Strain the fern shoots and shock in cold water. Strain again and allow to drain thoroughly.

In a wok over medium-low heat, toast the sesame seeds, stirring constantly until fragrant and light brown, about 2 minutes. Remove the sesame seeds and set aside. Add the vegetable oil and shrimp paste to the wok. Using a spatula, stir and mash the shrimp paste until it becomes fragrant, darker, and somewhat dry and crumbly (but not burnt), about 4 to 5 minutes. Remove the wok from heat, add the ferns, the toasted sesame seeds, and 1 tablespoon of the crispy garlic and garlic oil.

Mix to combine and taste; the *sanaap phak kuut* should taste toasted, garlicky, and salty (in that order), and should be pleasantly oily. The shrimp paste should provide enough saltiness, but the salt can be added to taste if this isn't the case.

Remove to a serving plate and garnish with an additional 1 tablespoon of the crispy garlic and garlic oil. Serve at room temperature with long-grained rice as part of a Shan-style meal.

Phak Nawk Saa

ผักหนอกส้า

A MAE HONG SON–STYLE SALAD OF ASIAN PENNYWORT

SERVES 4

Saa is a type of salad based around a strongly flavored, leafy ingredient that is sliced thinly and countered with an oil-based dressing that includes fermented soybean powder. Typical ingredients in *saa* include tart young tamarind or mango leaves; this version revolves around *phak nawk*, the Shan name for Asian pennywort, a pleasantly astringent herb that flourishes in Mae Hong Son. In an effort to make the salad heartier, many cooks in Mae Hong Son supplement the salad with deep-fried pork rinds or flakes of steamed mackerel.

In the past, the oil in the dressing would have been pressed from raw sesame seeds, providing the dish with a subtle nutty flavor. Today, most people use vegetable oil, but a rough approximation of virgin sesame oil can be made by combining any neutral-tasting oil and a quarter its volume of Chinese-style toasted sesame oil.

———

Wash the Asian pennywort and remove and discard the stems; you should have approximately 2 loosely packed cups (30 grams / 1 ounce) of the leaves. Slice thinly.

In a medium-sized mixing bowl, combine the pennywort, tomatoes, shallots, galangal, fermented soybean powder, chili powder, MSG (if using), virgin sesame oil, and salt.

Taste and adjust seasoning; the *phak nawk saa* should taste herbal, pleasantly oily, savory, salty, and just slightly spicy (in that order).

Transfer it to a serving dish and garnish with pork rinds. Serve with long-grained rice as part of a Shan meal.

50 grams / 2 ounces Asian pennywort

10 large cherry tomatoes (80 grams / 3 ounces total), quartered lengthwise

80 grams / 3 ounces shallots, peeled and sliced thinly counter-lengthwise

50 grams young galangal, peeled, sliced very thinly and julienned

1½ tablespoons fermented soybean powder (see page 328)

½ teaspoon chili powder

¼ teaspoon MSG (optional)

2½ tablespoons virgin sesame oil

½ teaspoon table salt

20 grams deep-fried pork rinds, chopped (see page 70)

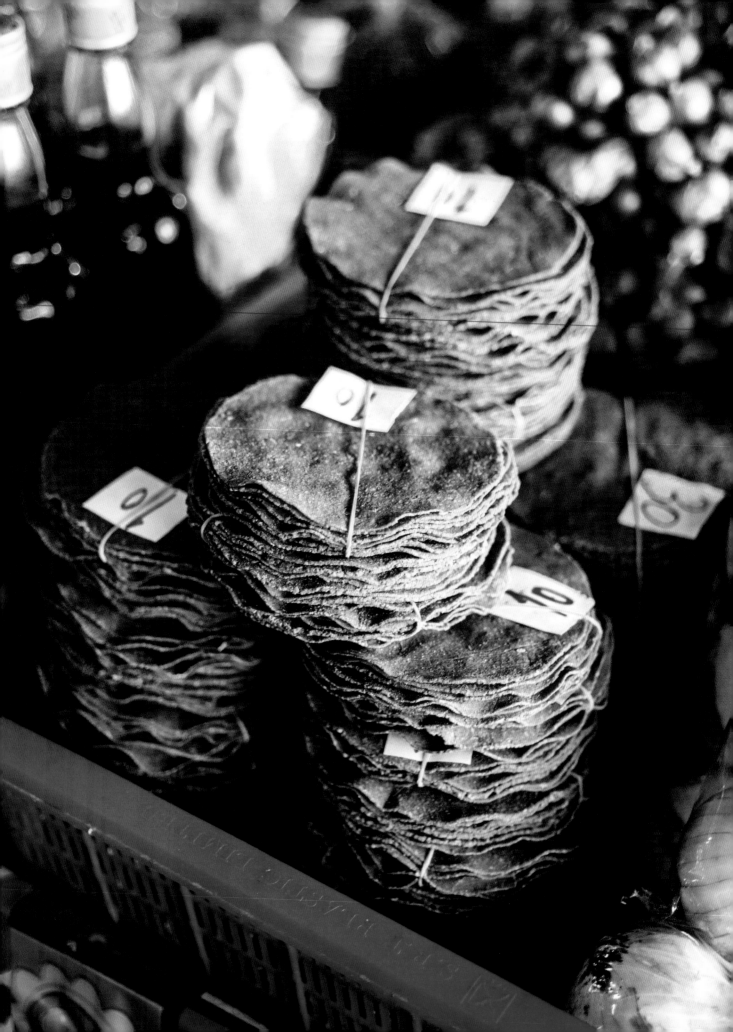

The Sacred Soybean

For me, there's no smell more evocative of Mae Hong Son than the earthy, toasty, funky odor of *thua nao khaep*, thin disks of fermented dried soybeans, on the grill. Ride a motorcycle through any Shan village in the province around dinnertime, and the aroma is guaranteed to strike, promising a great meal and forming a lasting sense memory all in one whiff.

Thua nao khaep—literally "rotten bean disks"—are arguably the most important ingredient in Shan-style cookery, playing largely the same role as shrimp paste in the central Thai kitchen: that of an unglamorous yet essential seasoning. After being grilled until golden, pockmarked and fragrant, the disks are pounded into curry pastes and added to a variety of soups, curries, and spicy dips, or ground to a powder and mixed with salads, providing these dishes with a distinctly savory flavor. *Thua nao khaep* can also be eaten on their own, and in leaner times, a meal in Mae Hong Son meant little more than a disk or two toasted over coals and crumbled over rice.

To see how this staple is made, I headed to Ban Pang Mu, a Shan village just outside of Mae Hong Son.

"About fifty percent of the people here make *thua nao*," explains Sujit Wichaisa-kunwan, herself a producer, while effortlessly flattening balls of fermented soybean paste in a homemade wooden press. "I've been making *thua nao* since I was fifteen. We used to do it by hand! It took so long to make each disk."

Shan farmers in Mae Hong Son typically practice crop rotation, swapping out rice for soybeans (or other crops) during the drier parts of the year. Come April or May, the soybeans are harvested and dried. After being sorted and boiled, the soybeans are fermented, resulting in a product similar to *natto* (Japanese-style fermented soybeans) that locals call *thua nao saa* ("moldy rotten beans"). The beans can be eaten at this stage and are sometimes used, uncooked, in salads, or cooked with herbs in a number of different preparations. But the preference is to preserve them, typically by grinding the beans to a paste, flattening balls of the paste into disks, and drying them in the sun—*thua nao khaep*. Today, electric meat grinders and wooden presses have superseded the giant wooden mortar and pestle and manual disk shaping of the past. Yet, making *thua nao khaep* remains a labor-intensive task.

"We have to start early in the morning, at 3 or 4 a.m.," Sujit tells me, "so that we can dry the disks in the sun." But, as with any staple food, the results are worth the effort. "If you don't add *thua nao*," adds Sujit, "Shan food doesn't taste right." And I'd add that without *thua nao*, Mae Hong Son wouldn't smell like Mae Hong Son.

Thua nao khaep, disks of fermented, dried soybeans, are made via a process that spans several days:

1. Dried soybeans are sorted and washed.
2. The beans are boiled until soft.
3. After they have cooled, the soybeans are wrapped in plastic sacks (or, in more traditional areas, in leaves known as *bai tawng tueng*—see opposite) and placed in baskets. The beans are left to ferment for two nights or until a thin white mold has formed on their surface.
4. Any residual liquid is drained from the beans, which are then ground into a thick paste using an electric meat grinder (or, in the past, a giant wooden mortar and pestle).
5. Using a wooden press, balls of the paste are flattened into thin disks.
6. The disks are placed on bamboo racks and dried in direct sunlight for one day. The finished *thua nao khaep* are dry yet pliable, dark in color, and can be kept at room temperature for weeks. Outside of northern Thailand, *thua nao khaep* are difficult to find, but Chinese-style fermented soybean paste is a rough substitute, although its high salt content means that seasonings will have to be adjusted accordingly when cooking with it.

1

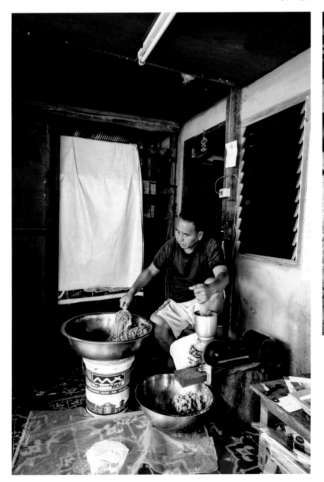

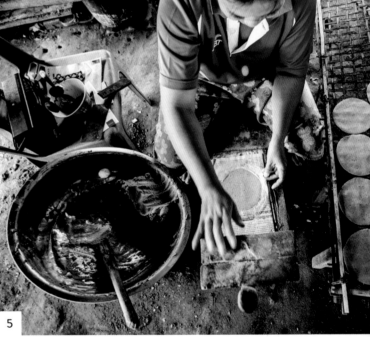

5

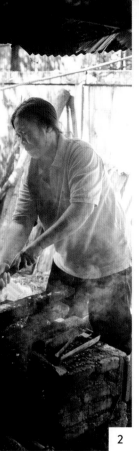

2

3

4

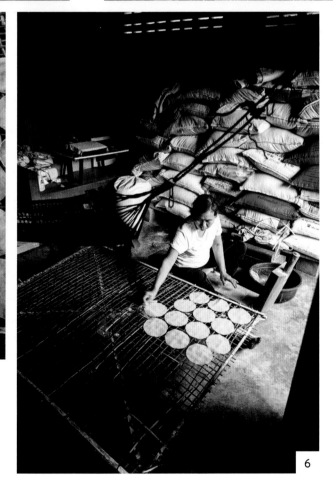

6

Dipterocarpus tuberculatus
ใบตองตึง

Or, as it's known in Mae Hong Son, *bai tawng tueng*.
For a few brief weeks in winter, the broad leaves
of this deciduous tree turn an astonishing array
of colors, blanketing entire hillsides in tones of
red, orange, pink, and purple, before dropping.
Yet among locals, the tree is known more for its
practicality than its beauty. The young, pliable green
leaves of *Dipterocarpus tuberculatus* remain a common
way to wrap food (especially fermented soybeans) in
Mae Hong Son, while the dried leaves are gathered
from the forest floor and used as roofing material.

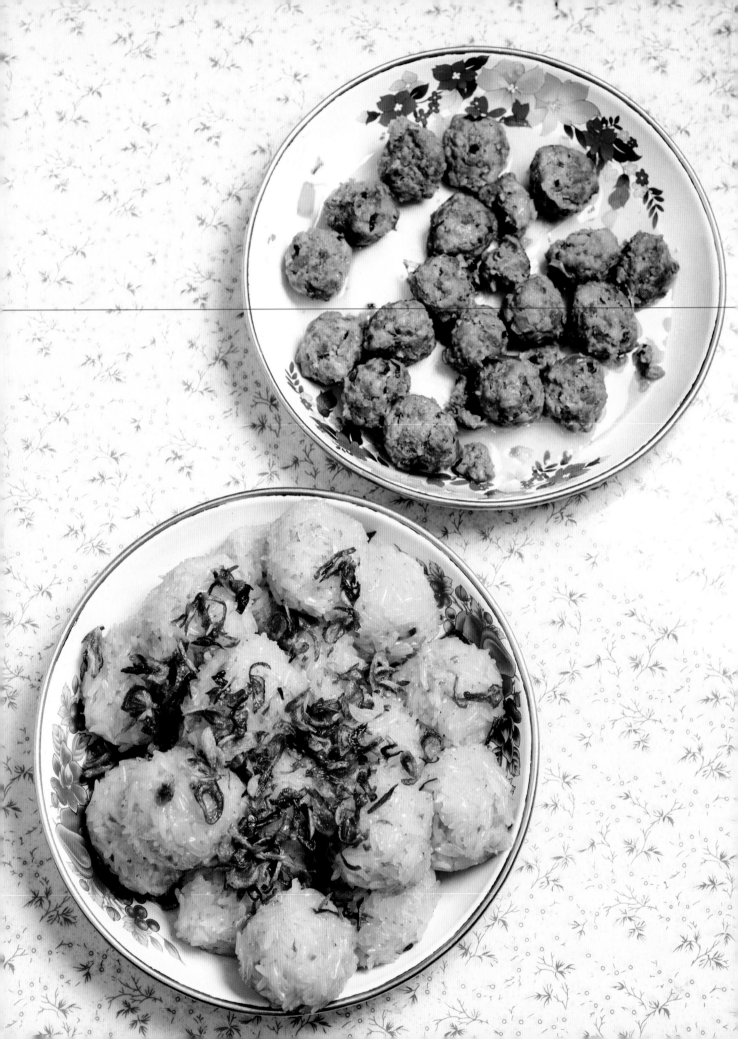

Khao Lueang and Nuea Lung

ข้าวเหลือง เนื้อลุง

YELLOW STICKY RICE WITH
SHAN-STYLE HERBAL PORK BALLS

SERVES 4 TO 6

In northern Thailand, there's often a significant gulf between city food and country food—a gap that persists even in overwhelmingly rural places such as Mae Hong Son. Dishes made and eaten in the city typically include more sophisticated ingredients, tend to take more time and effort to prepare, and often revolve around meat. Such dishes may have previously been relegated to celebrations, yet in modern times they have made the leap to vendor food.

"It's a special dish, for special occasions, or to serve to visitors," suggests Chuleekorn Supana, a Shan food vendor in Mae Hong Son, when I asked her to describe *khao lueang* and *nuea lung*, a unique combination of seasoned balls of sticky rice and herbaceous pork meatballs.

These days, Chuleekorn prepares this recipe several times a week, selling it at an open-air stall across from Mae Hong Son's city hall. Yet it's easy to see why the dish would have been linked with celebrations. The balls of rice boast a distinctly sunny hue—the result of turmeric powder—and also include coconut milk, a relatively rare ingredient generally used only among more urban Shan, and only then for certain dishes.

"People in the countryside use shallot oil [to season the sticky rice], but it's more fragrant if you use coconut milk," Chuleekorn tells me.

Accompanying the unctuous, chewy rice balls are *nuea lung*, herbal pork meatballs that, according to Chuleekorn, should be "a bit spicy, not too salty—balanced in flavor." Indeed, if you don't have time to make the yellow sticky rice, Chuleekorn suggests that *nuea lung* can be made on their own and served with long-grained rice—ideally drizzled with pan drippings.

Like many city dishes, *khao lueang* and *nuea lung* require a fair bit of advance planning. But the ingredients aren't too obscure, and the dish offers a genuine taste of Mae Hong Son—in itself an excuse to celebrate.

RECIPE CONTINUES

For the Yellow Sticky Rice

500 grams / 18 ounces uncooked
 sticky rice
2 teaspoons turmeric powder
1¼ cups coconut cream (see page 325)
2 tablespoons white sugar
2 teaspoons table salt

For the Shallot Oil

100 grams / 3½ ounces shallots,
 peeled and sliced thinly
¾ cup vegetable oil

For the Meatballs

1 teaspoon table salt
2 stalks lemongrass (50 grams /
 1¾ ounces total), exterior tough
 layers peeled, green section
 discarded, pale section sliced
 thinly
1 cilantro root (1 gram)
1 teaspoon coriander seeds, toasted
3 small fresh chilies (1 gram total; see
 page 324)
30 grams / 1 ounce shallots, peeled
 and sliced
10 grams / ⅓ ounce Thai garlic (or
 2 standard garlic cloves, peeled),
 chopped
1 tablespoon shrimp paste
60 grams / 2 ounces tomato, chopped
300 grams / 10½ ounces ground pork
1 teaspoon turmeric powder
a few sprigs cilantro (5 grams), sliced
 finely
1 green onion (20 grams / ⅔ ounce),
 sliced finely
a few sprigs sawtooth coriander
 (10 grams / ⅓ ounce), sliced finely

THAI KITCHEN TOOLS

medium wok (approximately
 12 inches)
Thai-style sticky rice steaming pot
 and basket
granite mortar and pestle

Advance prep: Wash and soak the
sticky rice the night before making
the dish

Make the shallot oil: A day or several hours before cooking the dish, heat the
shallots and oil in a wok over low heat. The oil should start to simmer lightly
after about 5 minutes; after 10 minutes the shallots should start to turn
yellow; after 30 minutes the shallots should start to turn brown and fragrant.
Fry, stirring occasionally, until the shallots are dark brown (but not burnt),
fragrant, and starting to crisp, a total of about 40 minutes. Remove the wok
from the heat, pour the oil and shallot mixture into a heatproof container,
cover, and set aside.

Make the yellow sticky rice: Wash the sticky rice in several changes of
water. In a large stainless-steel bowl (the turmeric will stain just about
anything else), stir together the sticky rice, at least two times its volume of
water, and the turmeric powder. Leave to soak, covered loosely with plastic
wrap, for about 12 hours.

A couple hours before serving, steam the sticky rice (see page 54) for
20 minutes, flip the rice, and steam until tender, another 5 to 10 minutes.
Return the rice to the stainless-steel bowl and cover with a kitchen towel.
While the sticky rice is cooling, heat the coconut cream, sugar, and salt in a
small saucepan over low heat. Bring to a simmer, stirring to dissolve the sugar
and salt. When the rice is cool enough to handle, add the coconut mixture and
3 tablespoons of the fried shallots/shallot oil to the reserved rice. Coat your
hands with a thin layer of the shallot oil, and knead the rice until the rice has
incorporated all of the coconut cream mixture and is relatively smooth and
amalgamated. Taste the rice and adjust the seasoning if necessary; it should
taste pleasantly oily, slightly sweet, and salty (in that order). Shape the sticky
rice into smooth, tightly packed, golf-ball-sized spheres; you should end up
with approximately 20 balls. Arrange on a plate or platter, cover with plastic
wrap, and set aside.

Make the meatballs: With a mortar and pestle, pound and grind the salt,
lemongrass, and cilantro root to a coarse paste. Add the coriander seeds;
pound and grind to a coarse paste. Add the chilies, shallots, and garlic; pound
and grind to a coarse paste. Add the shrimp paste and tomato; pound and
grind to a coarse paste. Add the ground pork and turmeric powder; pound and
grind until the mixture is smooth and amalgamated. Remove it to a medium
bowl, and add the cilantro, green onion, and sawtooth coriander.

Coat your hands with a thin layer of the shallot oil and blend the pork
mixture by hand until thoroughly combined. Shape the pork mixture into
gumball-sized balls weighing around 20 grams / ⅔ ounce each; you should
end up with about 20 meatballs. Arrange the meatballs in the bottom of a
medium wok over medium heat. Add 3 tablespoons of the shallot oil and ½ cup
of water, and cover with the lid. Bring to a simmer, and simmer for 5 minutes.
Remove the lid and simmer until all the liquid has evaporated, leaving only
a thin layer of oil, approximately 10 minutes. Fry the meatballs in this oil,
stirring occasionally to ensure that they're cooked on all sides, until brown
and fragrant, another 10 minutes. Cool slightly, and remove the meatballs to a
serving plate, drizzling them with the pan drippings.

When the meatballs have cooled to room temperature, serve an equal
number of rice balls and meatballs, drizzled with additional shallot oil and
fried shallots, as a Shan meal.

Khao Som

ข้าวส้ม

SHAN-STYLE "SOUR" RICE

SERVES 4 TO 6

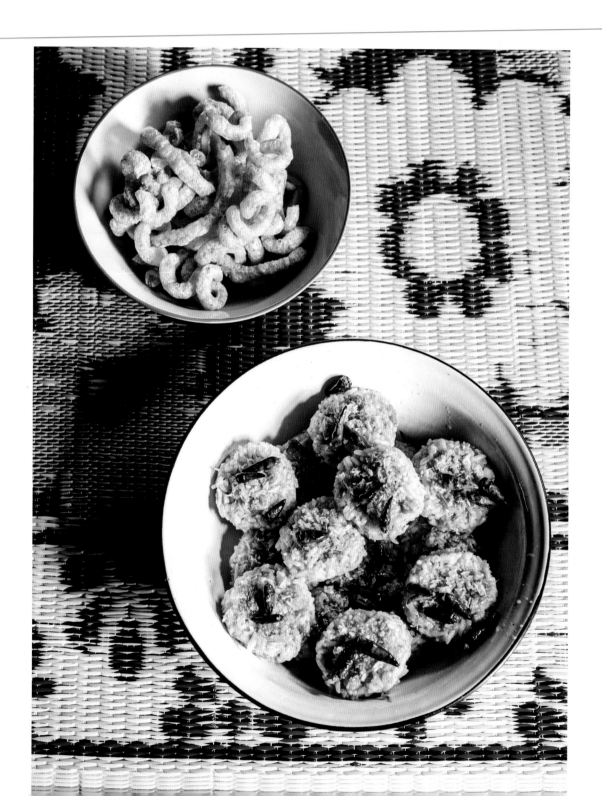

I can hardly think of a Thai dish more foreign to the central or even northern repertoire than *khao som* ("sour rice"), long-grained rice kneaded with tomatoes, shaped into patties, and drizzled with garlic oil. From its seasoning—a turmeric-tinged tomato sauce—to its essential form—a tart-tasting rice dish—it's an anomaly in almost every way.

But the Shan, especially those in Myanmar, eat a variety of seasoned, molded rice dishes. Across the border, rice is kneaded with turmeric and oil until the grains have nearly fused together into thin, flat disks, which are typically eaten with fresh herbs. In Mae Hong Son, the preference is for heartier balls or patties of rice, often paired with *ko*, a Shan-style salad based on long beans or young jackfruit (see page 326), or, depending on the cook, other sides.

"*Khao som* should be eaten with deep-fried pork rinds," suggests Miakhin Charoensuk, a Shan food vendor in Muang Pon, who shared this recipe.

In Thai—and Shan—cooking, there's usually an effort to balance flavors and textures, and pairing the tart, savory rice with fatty, crunchy pork rinds is an effort to achieve this.

Or perhaps I'm overthinking it. When asked why these two dishes should go together, Miakhin told me, "Because it's tasty."

At least an hour before serving, rinse the rice, drain it well, and cook it in a rice cooker with 2¼ cups of water. Allow the rice to rest, with the lid on, for at least 15 minutes after cooking.

Heat 2 tablespoons of the garlic oil in a wok over medium heat. Add the mushrooms and fry, stirring until moisture from the mushrooms emerges and then disappears, and the mixture is relatively dry, about 5 minutes. Increase the heat to medium-high, add ½ cup of water, the tomatoes, salt, turmeric powder, and MSG (if using). Fry, stirring and pressing to crush the tomatoes, for an additional 10 minutes or until the mixture is reduced and somewhat thick, similar in consistency to a pasta sauce.

When the rice is cool enough to handle, put it and the tomato mixture in a large bowl. Lightly coat your hands with garlic oil, and knead the ingredients until thoroughly amalgamated and capable of being shaped.

Taste, adjusting the seasoning if necessary; the *khao som* should taste savory, tart, and salty, and be pleasantly oily.

Lightly coat your hands in garlic oil and shape the rice-tomato mixture into golf-ball-sized spheres. Place a pinch of crispy garlic on the top of each ball, press into a disk approximately 2½ inches in diameter and 1 inch thick, and arrange on a serving tray. Continue until the rice has been used up; this should yield approximately 20 rice patties. Garnish each rice patty with crispy dried chilies, additional crispy garlic and garlic oil (if desired), and serve with deep-fried pork rinds, or *ko* as part of a Shan meal.

350 grams / 12 ounces uncooked long-grained rice
Crispy garlic and garlic oil (see page 32)
120 grams / 4¼ ounces oyster mushrooms, ¼-inch slices
300 grams / 10½ ounces cherry tomatoes, halved
1 teaspoon table salt
½ teaspoon turmeric powder
¼ teaspoon MSG (optional)
40 crispy dried chilies (see page 325)
160 grams / 5½ ounces deep-fried pork rinds (see page 70)

THAI KITCHEN TOOLS
medium wok (approximately 12 inches)

Note: When cooking rice, the ideal amount of water may vary depending on the type of rice and personal preference, generally somewhere between 1:1 rice to water to 1:1.5. Feel free to vary the amount of water in this recipe to your preference.

Once there was a KFC in Mae Hong Son. I think it appeared around 2013, yet when I returned less than a year later, it was gone. Now, the residents of the city are in no way opposed to Western-style fast food; hot dogs in a variety of preparations (and a rainbow of colors) are ubiquitous and beloved. But when it comes to a quick snack or meal, the local cuisine appears to possess considerably more staying power.

Take Paa Jaang, a home-based stall that's been in business for fifty years. Every afternoon, the middle-aged, fourth-generation owners open their old wooden house to serve two hometown favorites: *khao sen*, a pork-and-tomato-based noodle soup, and *khao kan jin*, balls of seasoned rice. They're old-school Shan dishes, decidedly not as sexy as the other more Western food items available these days in Mae Hong Son, but Paa Jaang and other similar stalls still manage to pull a variety of loyal customers, from chatty teens on their way home from school to taciturn, traditionally dressed Shan aunties.

Or drive to Ban Pha Bong, a picturesque village located just outside Mae Hong Son, where, instead of deep-fried fishballs served with that sweet, gloopy sauce, you'll encounter roadside stalls selling *khaang pawng*, herb-heavy fritters of shredded green papaya, or *thua phuu kho*, golden triangles of crispy goodness made from split peas. Like those sold at Paa Jaang, they are dishes generally only available in the early morning or in the afternoon, they straddle the line between a snack and a light meal, and they embody the Shan love of savory, herbal flavors. And, if history is any indicator, they'll be around for a while.

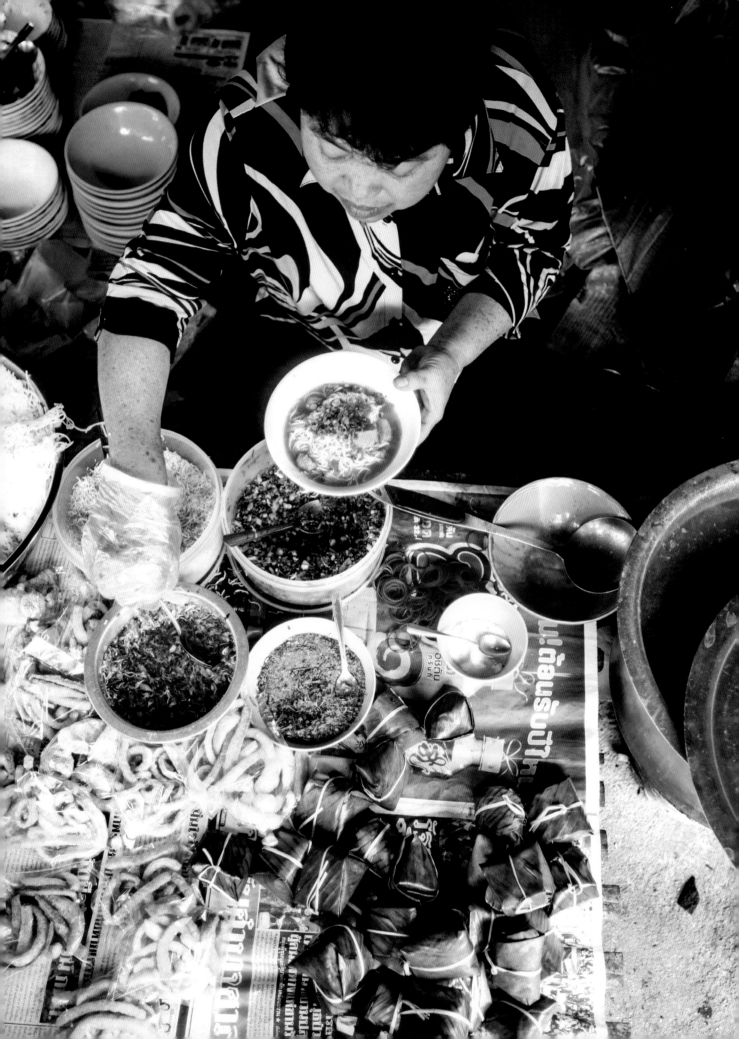

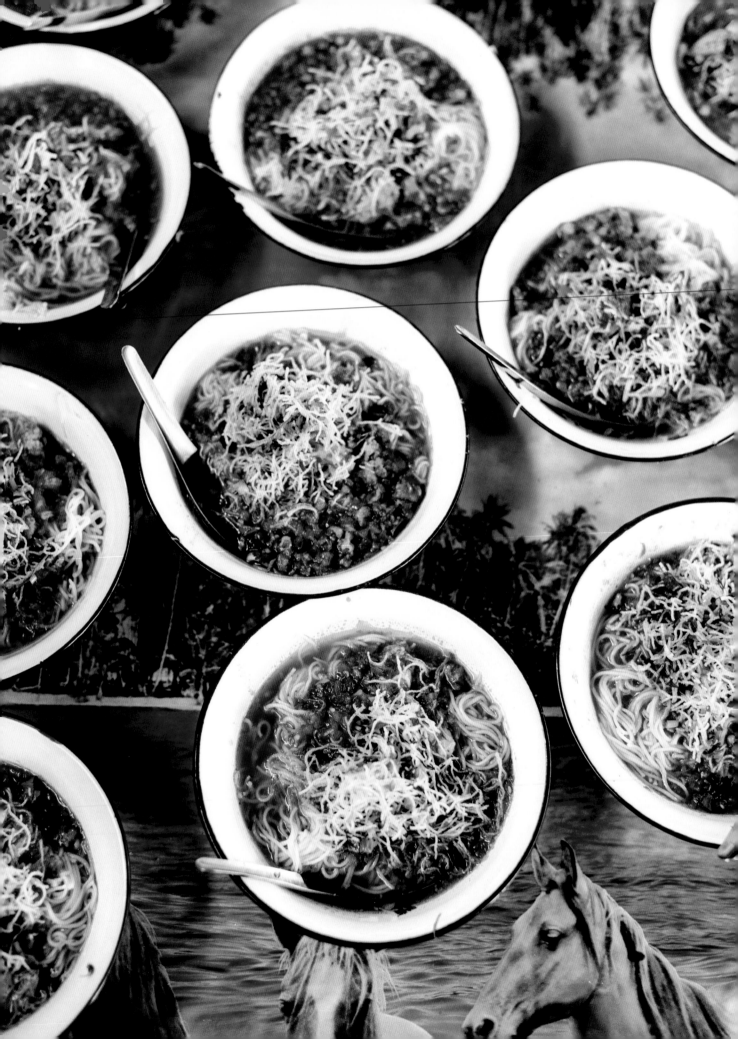

Khao Sen

ข้าวเส้น

SHAN-STYLE NOODLE SOUP WITH PORK AND TOMATO

SERVES 4 TO 6

This just might be the most beloved dish in Mae Hong Son. Indeed, it's a variation on *khanom jiin naam ngiaw* (see page 189), the pork-and-tomato-based noodle soup that is one of the most beloved and ubiquitous dishes in northern Thailand. But where the standard northern Thai version boasts a broth that tends toward the meaty and hearty, the Mae Hong Son variant is thin and tart, its bulk stemming from a generous knot of thin rice noodles or ingredients like the crunchy pith of the banana tree.

In Mae Hong Son, locals prefer to call the dish *khao sen*, literally "rice threads," a reference to the dish's thin, round noodles, made via a labor-intensive and time-consuming process of soaking, pounding, boiling, and extracting a rice-based dough (see page 87). Consumed as a light meal or a snack, *khao sen* is sold both from stalls in the city's market in the morning and home-based restaurants in the afternoon, typically alongside *khaang pawng* (page 243), deep-fried herbal fritters delicious with—or in—the soup.

Note that fresh *khanom jiin* noodles are generally not available outside of Southeast Asia. If cooking in the United States, Andy Ricker of Pok Pok suggests using fine-gauge dried *bún* (Vietnamese rice noodles), following the cooking instructions on the package.

RECIPE CONTINUES

For the Soup

3 tablespoons vegetable oil

100 grams / 3½ ounces shallots, peeled, halved lengthwise, and sliced thinly

10 garlic cloves (50 grams / 1¾ ounces total), peeled and minced

1 tablespoon shrimp paste

½ (93-gram / 3-ounce) can Thai-style mackerel in tomato sauce (such as Three Lady Cooks brand)

50 to 60 tart cherry tomatoes (500 grams / 18 ounces total), halved

250 grams / 9 ounces pork loin, ¾-inch cubes

500 grams / 18 ounces pork stock bones (such as back or neck bones)

1 teaspoon bouillon powder

1½ teaspoons table salt

For Serving

600 grams / 1⅓ pounds *khanom jiin* noodles

crispy garlic and garlic oil (see page 32)

1 small bunch cilantro (20 grams / ⅔ ounce total), chopped

2 green onions (40 grams / 1½ ounces total), chopped

200 grams / 7 ounces cabbage, shredded finely

4 limes, cut into wedges

¼ cup table salt

¼ cup chili powder

Make the soup: Heat the oil in a medium stockpot over medium-low heat. Add the shallots and garlic and fry until fragrant, about 5 minutes. Add the shrimp paste, stirring until it has disintegrated and become fragrant, another 2 minutes. Add the canned mackerel (including the tomato sauce), stirring until disintegrated, fragrant, and a thin layer of oil emerges, another 5 minutes.

Increase the heat slightly and add the tomatoes. Fry, stirring frequently, until the tomatoes have mostly disintegrated, the mixture has reduced slightly, and the oil reemerges, about 20 minutes.

Add the pork and fry, stirring frequently, until the oil reemerges, another 10 minutes. Add the pork bones and 2 quarts of water, and increase the heat to high. When the mixture reaches a simmer, reduce the heat and simmer for 20 minutes. Add the bouillon powder and salt, and simmer another 10 to 15 minutes.

Taste, adjusting the seasoning if necessary; the broth should be relatively thin, and should taste tart, savory, and salty (in that order).

To each shallow serving bowl, add 100 grams / 3½ ounces of *khanom jiin* noodles and top with 1 cup of the broth (remove stock bones if they are too big to serve). Garnish with crispy garlic and garlic oil, cilantro, and green onion, and serve with with shredded cabbage, lime wedges, and small bowls of salt and chili powder.

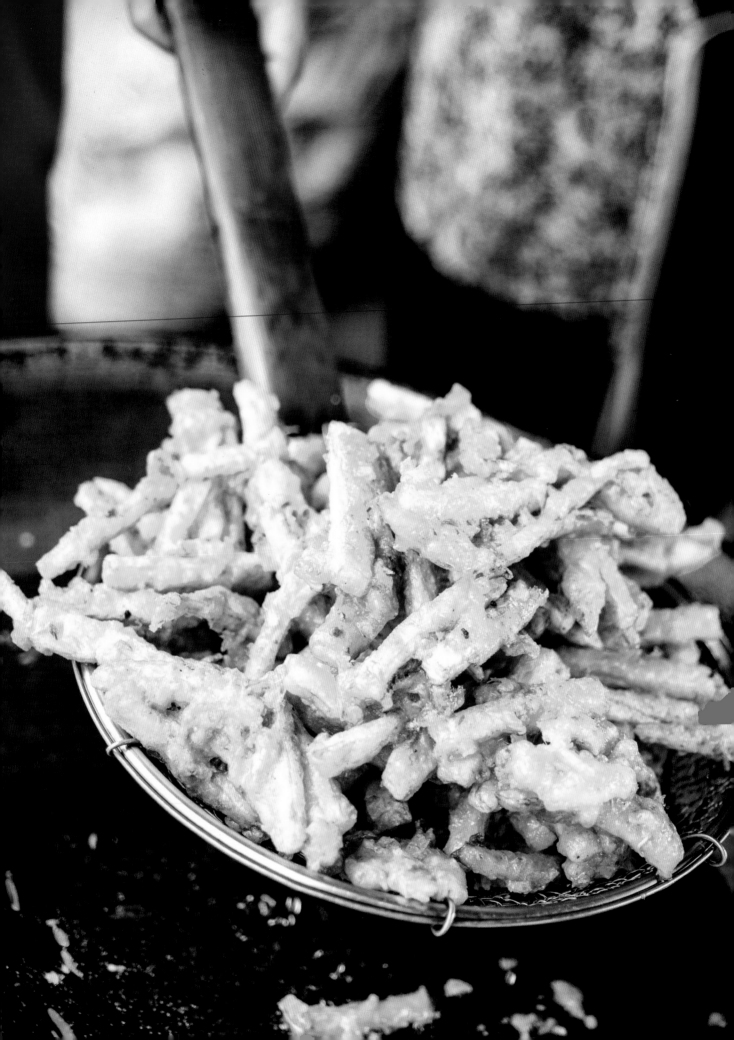

Khaang Pawng

ข่างปอง

SHAN-STYLE HERBAL FRITTERS

SERVES 4

In the United States, deep-fried dishes tend toward the salty, meaty, or even spicy. Not *khaang pawng.* These crispy bundles of green papaya, banana blossom, or shallots boast an herb-forward flavor, the result of a batter studded with chili, garlic, lemongrass, and turmeric. The mix also includes fermented soybean powder (see page 328), giving these a savory kick also lacking in most deep-fried snacks.

As such, *khaang pawng* are well seasoned enough to be eaten on their own—and are absolutely delicious this way—but most vendors opt to either serve them with a sweet/tart dipping sauce or pair them with another dish altogether.

"They're perfect with *khao sen* [page 239]," explains Saowakhon Rattanachaichotikun, a vendor of *khaang pawng* for more than thirty years and the source of this recipe. And the people of Mae Hong Son and I can attest to the fact that crumbling the fritters directly into the Shan-style noodle soup provides the latter with a crunchy boost of herb and spice—and a uniquely local eating experience.

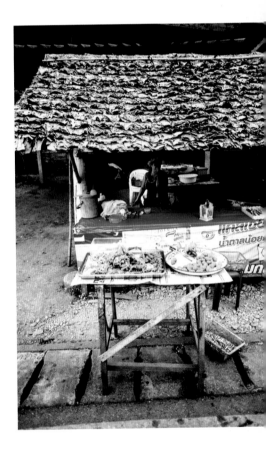

RECIPE CONTINUES

Shan Sweets

It's always dark and often chilly when Phaithoon Iamkrasin wakes up for work at 4 a.m. Yet he's used to this, as he's been doing it every day—except, of course, on Buddhist holidays—for the last four decades.

Phaithoon is one of a handful of people in Mae Hong Son who continue to make and sell Shan-style sweets. "I learned these recipes from my wife," the seventy-three-year-old tells me, "who learned them from her mother." Phaithoon continues to follow the original recipes of these Mae Hong Son natives, and his early wake-up call is a testament to his dedication to the old methods, which extend to extracting his own coconut cream by hand.

Virtually unknown elsewhere in Thailand, most of Mae Hong Son's sweets can be traced back to neighboring Myanmar. Some, like *suay thamin*—the name a corruption of *shwe thamin*, Burmese for "golden rice"—have clear Burmese origins, while others, such as *aalawaa*, likely a derivation of the Arabic word *halwah* (or halvah), appear to have roots that extend as far as the Middle East.

Although they take different forms, the four sweets Phaithoon makes—some almost pudding-like, some cake-like—are essentially variations on a combination of carbohydrates (rice, rice flours, or wheat flour), sugar (white and palm), and coconut cream. Phaithoon tells me that in the past, the more exotic ingredients—wheat flour, butter, condensed milk—were only available via boats from then Burma. Even today, he explains, coconut palms are a rarity in relatively cool, mountainous Mae Hong Son, and coconuts often have to be trucked in from Sukhothai, several hundred kilometers to the south.

Phaithoon's sweets are prepared in and sold from shallow round trays, and his final flourish is to cover each tray with a layer of coconut cream, which is then "baked" by hot coals until thick and seductively charred (for more on this process, see page 253). The sweets are then brought, still warm, to the front of the house, where his wife sells them by the slice, attractively wrapped up to go in banana leaf packages secured with a bamboo pin—a charming and delicious way to warm up on a chilly Mae Hong Son morning.

Khaang Pawng

ข่างปอง

SHAN-STYLE HERBAL FRITTERS

SERVES 4

In the United States, deep-fried dishes tend toward the salty, meaty, or even spicy. Not *khaang pawng*. These crispy bundles of green papaya, banana blossom, or shallots boast an herb-forward flavor, the result of a batter studded with chili, garlic, lemongrass, and turmeric. The mix also includes fermented soybean powder (see page 328), giving these a savory kick also lacking in most deep-fried snacks.

As such, *khaang pawng* are well seasoned enough to be eaten on their own—and are absolutely delicious this way—but most vendors opt to either serve them with a sweet/tart dipping sauce or pair them with another dish altogether.

"They're perfect with *khao sen* [page 239]," explains Saowakhon Rattanachaichotikun, a vendor of *khaang pawng* for more than thirty years and the source of this recipe. And the people of Mae Hong Son and I can attest to the fact that crumbling the fritters directly into the Shan-style noodle soup provides the latter with a crunchy boost of herb and spice—and a uniquely local eating experience.

RECIPE CONTINUES

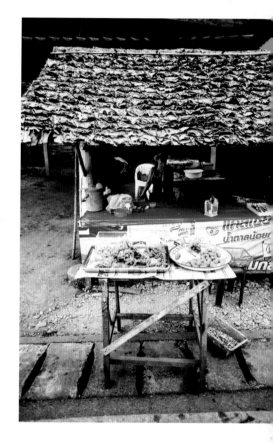

For the Dip

¹⁄₃ cup white sugar

1 teaspoon table salt

juice of 2 limes

2 small cucumbers (100 grams / 3½ ounces total), quartered lengthwise and sliced thinly

50 grams / 1¾ ounces shallots, peeled, halved lengthwise, and sliced thinly

4 medium fresh Thai chilies (12 grams / ½ ounce total; see page 324), sliced thinly

For the Curry Paste

1 fermented soybean disk (15 grams / ½ ounce; see page 328)

2 stalks lemongrass (50 grams / 1¾ ounces total), exterior tough layers peeled, green section discarded, pale section sliced thinly

2 small dried *phrik kariang* chilies (3 grams total; see page 325)

1 teaspoon table salt

30 grams / 1 ounce shallots, peeled and sliced

2 garlic cloves (10 grams / ⅓ ounce total), peeled and sliced

½ teaspoon turmeric powder

½ tablespoon shrimp paste

For the Khaang Pawng

1 large green, unripe papaya (about 1 kilogram / 2 pounds), peeled (or equivalent amount of shallots and/or prepared banana blossom [purple layers removed, halved, rubbed with lime juice to prevent discoloring, and sliced thinly crosswise]; see page 315)

75 grams / 2¾ ounces rice flour

50 grams / 1¾ ounces sticky rice flour

vegetable oil, for deep-frying

THAI KITCHEN TOOLS

granite mortar and pestle

papaya shredder (or mandoline with the julienne blade)

large heavy-bottomed wok (19 inches or larger)

Make the dip: Heat ¹⁄₃ cup of water, the sugar, and salt in a small saucepan over medium heat. Bring to a simmer to dissolve the sugar and salt. Remove the saucepan from the heat and cool. Add the lime juice, cucumber, shallots, and chilies, mixing to combine.

Taste, adjusting seasoning if necessary; the dip should be equal parts tart and sweet, and slightly spicy. Set aside.

Make the curry paste: Over coals, a stovetop burner, or even in a toaster, toast the fermented soybean disk until fragrant, golden, and pockmarked, about 2 minutes. With a mortar and pestle, pound and grind the lemongrass, dried *phrik kariang*, and salt to a coarse paste. Add the shallots and garlic; pound and grind to a coarse paste. Add the turmeric powder, shrimp paste, and toasted fermented soybean disk; pound and grind to a fine paste. Set aside.

Make the khaang pawng: Using a papaya shredder, shred the papaya into thin strands 3 inches long; you want 500 grams / 18 ounces of shredded papaya.

In a bowl, combine the papaya, curry paste, rice flour, sticky rice flour, and ¾ cup of water. The mixture should have a slightly wet consistency.

Heat 3 inches of oil to 350°F in a large wok over medium-high heat. Using a spoon, scoop 30 grams / 1 heaping tablespoon of the papaya mixture and slide it into the oil. Deep-fry, flipping the *khaang pawng* after about 2 minutes, until golden, fragrant, and crispy on the outside, and slightly soft inside; if you're maintaining the heat at 350°F, this should take about 4 minutes total. Remove from the oil and drain on a rack or paper towels.

Taste, adjusting the seasoning if necessary; the *khaang pawng* should taste herbal, savory, salty, and spicy (in that order). Repeat, filling the wok until full but not crowded, with the remaining batter.

Serve *khaang pawng* hot with the dip or with—or in—bowls of *khao sen* (page 239).

Khao Kan Jin

ข้าวกั้นจิ๊น

SHAN-STYLE "KNEADED" RICE

SERVES 4 TO 6

RECIPE CONTINUES

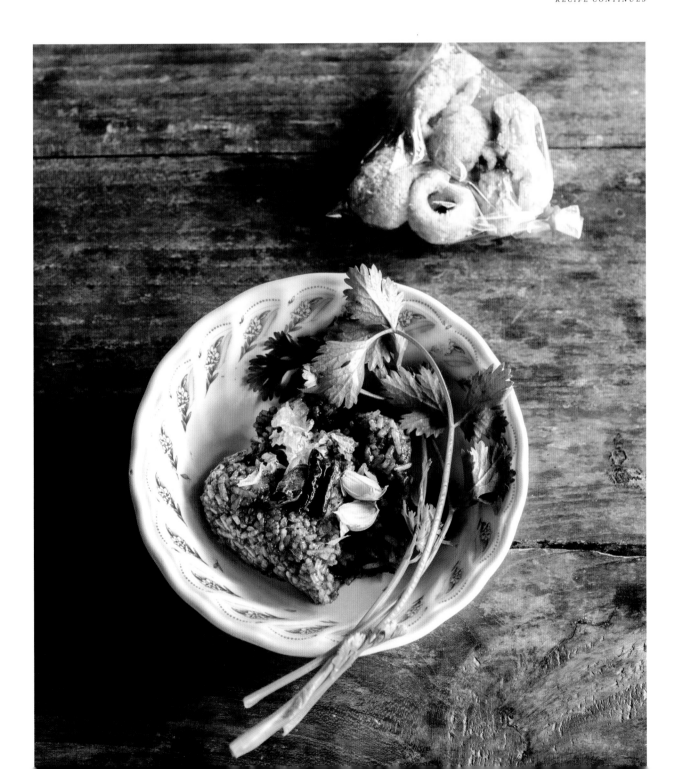

500 grams / 18 ounces uncooked long-grained rice
1 cup raw pork blood
1 stalk lemongrass (25 grams / 1 ounce)
a few sprigs holy basil (5 grams total), leaves only
100 grams / 3½ ounces finely ground pork
1 tablespoon table salt
½ teaspoon MSG (optional)
crispy garlic and garlic oil (see page 32)
approximately 35 feet of banana leaf, or as needed, cut into 20 10" × 10" sections, and 20 10" × 8" sections

For Serving

10 small sprigs fresh cilantro
50 grams / 1¾ ounces Thai garlic (or 10 standard garlic cloves, peeled)
crispy dried chilies (page 325)
160 grams / 5½ ounces deep-fried pork rinds (see page 70; optional)

THAI KITCHEN TOOLS

granite mortar and pestle
medium wok (approximately 12 inches)
Thai-style steamer

Note: When cooking rice, the ideal amount of water may vary depending on the type of rice and personal preference, generally somewhere between 1:1 rice to water to 1:1.5. Feel free to vary the amount of water in this recipe to your preference.

Kneading, blood, and rice are concepts that don't usually cross paths, even in Thai kitchens. But stick with me.

Khao kan jin—literally "rice kneaded with meat"—most likely has its origins in Myanmar's Shan State, where variations on the molded, seasoned-rice theme are numerous and beloved.

To make the dish, warm rice, finely minced pork, and raw pork blood are combined by hand and shaped into small balls, which are wrapped in banana leaves and steamed (or, for the hardcore, served uncooked). In most cases, including the version here, which comes from long-standing Mae Hong Son restaurant Paa Jaang, there's little—if any—taste of blood. Instead, that ingredient imparts the rice with an almost purple hue and an unidentifiable savory flavor.

Khao kan jin is served with a drizzle of garlic oil and sides of deep-fried dried chilies, tiny cloves of raw garlic, and a sprig of fresh cilantro. And through what I can only assume is some sort of Shan magic, these disparate ingredients—including that blood—come together in a beautifully savory, herbal package that will cause you to forget about its constituent parts.

A few hours before serving, cook the rice in an electric rice cooker with 3 cups of water. Allow the rice to rest, with the lid on, for at least 15 minutes after cooking.

While the rice is cooking, in a blender or food processor, blitz the pork blood with the lemongrass and holy basil leaves to infuse it with flavor and to break up any clumps. Pour the mixture through a fine sieve, reserving the liquid and discarding the solids. Set the blood aside in the refrigerator.

In a large bowl, combine the warm rice, reserved blood mixture, ground pork, salt, MSG (if using), and 3 tablespoons of the garlic oil. Mix by hand until thoroughly combined and rather dense.

Lightly coat your hands with garlic oil and shape approximately 75 grams / 2¾ ounces of the rice mixture into a dense sphere slightly larger than a golf ball. Repeat with the remaining rice; you should end up with approximately 20 balls.

Prepare the banana leaves and wrap each rice ball as described opposite.

Using a large steamer tray over simmering water, steam the banana leaf packages until the banana leaf has softened and turned pale green in color and the rice mixture is cooked all the way through, about 20 minutes. Depending on the size of your steamer, you may have to do this in batches.

Serve *khao kan jin* at room temperature, garnished with a drizzle of crispy garlic and garlic oil and with optional sides of cilantro, garlic cloves, crispy dried chilies, and deep-fried pork rinds.

HOW TO *Fold a Banana Leaf for Khao Kan Jin*

1. Place a large leaf, shiny side facing down, with the grain running away from your body, on a flat surface and top with the smaller leaf, shiny side facing down, with the grain running in the same direction.

2. Top each banana leaf stack with one rice ball, pinching the right and left sides of the leaves over the rice mixture to retain its round shape.

3. Fold the near end of the leaf over the ball and fold the far end of the leaf over the top.

4. Secure the package lengthwise with a rubber band, or a thin strip of bamboo.

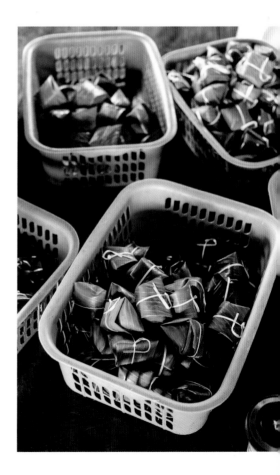

Shan Sweets

It's always dark and often chilly when Phaithoon Iamkrasin wakes up for work at 4 a.m. Yet he's used to this, as he's been doing it every day—except, of course, on Buddhist holidays—for the last four decades.

Phaithoon is one of a handful of people in Mae Hong Son who continue to make and sell Shan-style sweets. "I learned these recipes from my wife," the seventy-three-year-old tells me, "who learned them from her mother." Phaithoon continues to follow the original recipes of these Mae Hong Son natives, and his early wake-up call is a testament to his dedication to the old methods, which extend to extracting his own coconut cream by hand.

Virtually unknown elsewhere in Thailand, most of Mae Hong Son's sweets can be traced back to neighboring Myanmar. Some, like *suay thamin*—the name a corruption of *shwe thamin*, Burmese for "golden rice"—have clear Burmese origins, while others, such as *aalawaa*, likely a derivation of the Arabic word *halwah* (or halvah), appear to have roots that extend as far as the Middle East.

Although they take different forms, the four sweets Phaithoon makes— some almost pudding-like, some cake-like—are essentially variations on a combination of carbohydrates (rice, rice flours, or wheat flour), sugar (white and palm), and coconut cream. Phaithoon tells me that in the past, the more exotic ingredients—wheat flour, butter, condensed milk—were only available via boats from then Burma. Even today, he explains, coconut palms are a rarity in relatively cool, mountainous Mae Hong Son, and coconuts often have to be trucked in from Sukhothai, several hundred kilometers to the south.

Phaithoon's sweets are prepared in and sold from shallow round trays, and his final flourish is to cover each tray with a layer of coconut cream, which is then "baked" by hot coals until thick and seductively charred (for more on this process, see page 253). The sweets are then brought, still warm, to the front of the house, where his wife sells them by the slice, attractively wrapped up to go in banana leaf packages secured with a bamboo pin—a charming and delicious way to warm up on a chilly Mae Hong Son morning.

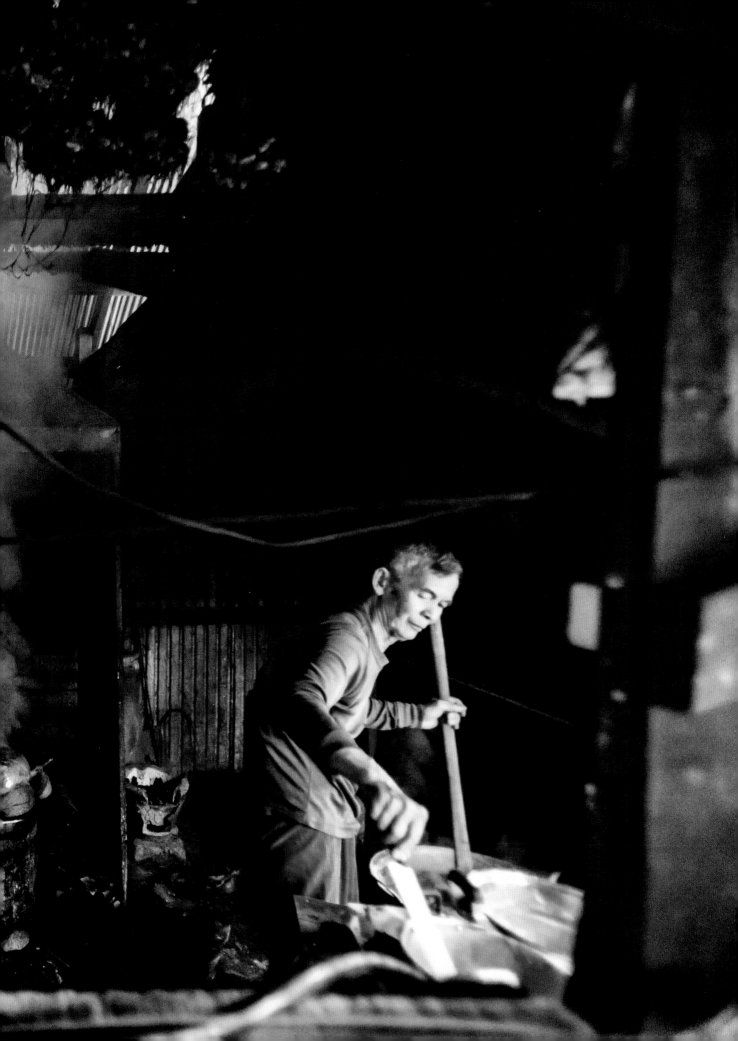

The Shan sweets Phaithoon makes include:

1. *Suay thamin* / ส่วยทะมิน See recipe opposite.
2. *Aalawaa* / อาละหว่า Ostensibly a distant cousin of the Middle Eastern dessert *halwah*, this sweet most likely arrived in Mae Hong Son via Burma, where it is known as *halawa*. The dish, which is made from rice flour and coconut cream sweetened with sugar and condensed milk, has the texture of a firm pudding.
3. *Aalawaa jong* / อาละหว่าจ่ง See recipe on page 254.
4. *Peng mong* / เปงม้ง Rice flour leavened with baking soda gives this sweet its cake-like texture; a thick topping of singed coconut cream functions as its frosting.

Suay Thamin

ส่วยทะมิน

A SHAN-STYLE STICKY RICE "CAKE"

SERVES 4 TO 6

The Shan name of this dish, a "cake" of tender, sweetened sticky rice and coconut milk, is an approximation of *shwe thamin*, Burmese for "golden rice"—so called because in Myanmar, where the dish originated, the grains gain a light brown hue from the use of palm sugar and food coloring. In Mae Hong Son, the dish's name has lost both its linguistic and practical significance, as *suay thamin* is typically more pearly than golden.

Rinse the rice several times under running water until clear, and then, in a large bowl, combine it with approximately twice its volume of water. Soak the rice overnight.

Drain the rice and put it in a sticky rice steaming basket. Steam the rice over high heat for 30 minutes; flip the rice over and steam until quite tender, another 5 to 10 minutes. Remove the rice to a large baking pan, spread it out, and cover loosely with a tea towel. (For more on how to steam sticky rice, see page 54.)

Heat 2 cups of the coconut cream, the salt, white sugar, and palm sugar in a wok over medium heat. Bring to a simmer. Stirring frequently, allow it to simmer until mixture becomes somewhat syrupy (the mixture should form viscous, sticky trails when scooped with a spoon) and has reduced by approximately half, 25 to 30 minutes. Add the sticky rice to the wok, stirring to combine. Continue to stir until the coconut cream mixture has been completely absorbed by the rice, about 5 minutes.

Pour the rice mixture into the round baking pan, distributing it evenly and packing the rice until the top is flat and level. Pour the remaining 1 cup of oconut cream over the surface of the rice. Phaithoon finishes his sweets via a unique yet, for home cooks, impractical technique (see page 253 for details). Those cooking outside of northern Thailand will find it easier to put the tray under a broiler, turning the pan occasionally, until the coconut cream has thickened almost to the consistency of heavy cake frosting and is intermittently charred, about 10 minutes.

When cool enough to handle, cut the *suay thamin* into 2 × 1-inch rectangles. Keep it at room temperature, covered, and serve it within a day or two.

750 grams / 1¾ pounds uncooked sticky rice
3 cups coconut cream (see page 325)
1 teaspoon table salt
150 grams / 5¼ ounces white sugar
150 grams / 5¼ ounces palm sugar

THAI KITCHEN TOOLS
Thai-style sticky rice steaming pot and basket
large heavy-bottomed wok (19 inches or larger)
10 × 2-inch round metal baking pan

Advance prep: Soak the sticy rice overnight before cooking.

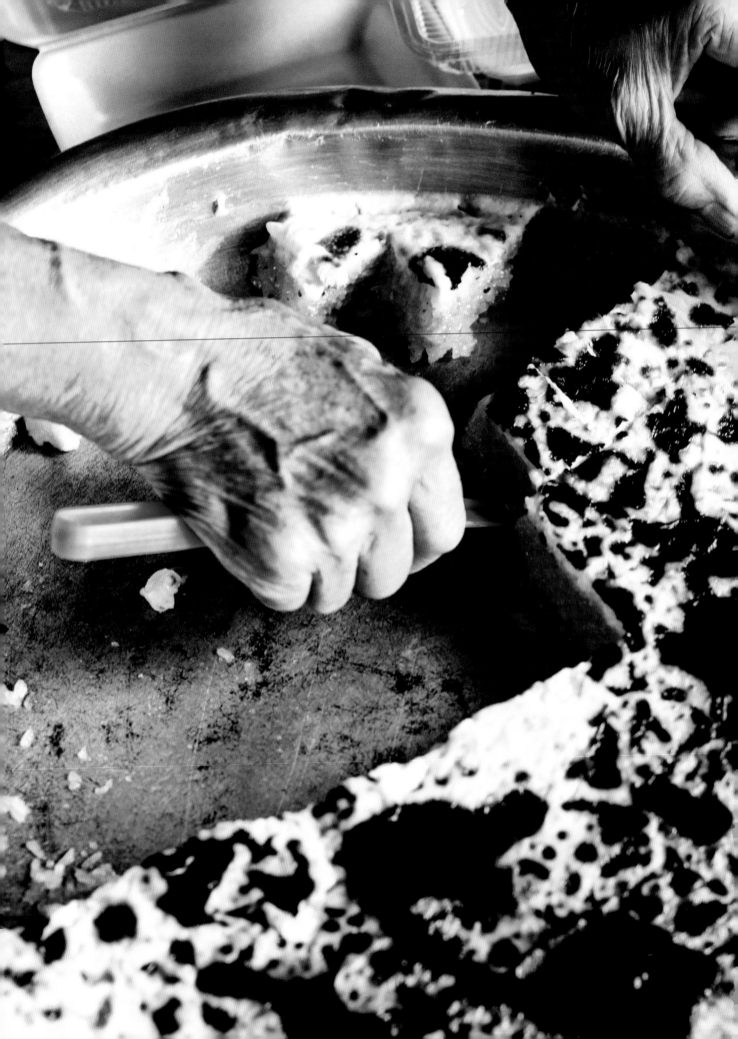

Burning Coconut Husks
การเผาขนมแบบไต

Phaithoon's Shan-style sweets are delicious and unique, but perhaps their most intriguing attribute is the way they're finished.

After spreading a sweet into a shallow round pan, Phaithoon covers its entire surface with a generous layer of coconut cream. The pan is then covered with a thin sheet of metal, upon which a small pile of dry coconut husks are stacked. These are ignited and reduced to coals, which are distributed and allowed to smolder. After about 30 minutes, the top layer of the sweet has firmed up and the water in the coconut cream has evaporated, resulting in a topping that's deliciously thick and intermittently charred—a rich, smoky, singed frosting of sorts.

Aalawaa Jong

อาละหว่าจ่ง

A SHAN "CAKE" OF TOASTED WHEAT FLOUR

SERVES 4 TO 6

2 quarts coconut milk
3 cups coconut cream (see page 325)
300 grams / 10½ ounces all-purpose
 flour
1 teaspoon table salt
200 grams / 7 ounces white sugar
200 grams / 7 ounces palm sugar
½ cup sweetened condensed milk
100 grams / 3½ ounces (7 tablespoons)
 unsalted butter

THAI KITCHEN TOOLS
large heavy-bottomed wok (19 inches
 or larger)
10 × 2-inch round metal baking pan

Aalawaa is ostensibly a distant cousin of the Middle Eastern dessert *halwah*; *jong* is a Shan term that means "combined," most likely a reference to the fact that this version includes more ingredients—in this case wheat flour, butter, and sometimes durian—than the standard *aalawaa*. The dish has a light brown color—the result of toasted wheat flour—a rich flavor, and a dense, slightly chewy texture somewhere between a firm pudding and taffy.

In a large bowl, combine the coconut milk and 2 cups of the coconut cream. Set aside the remaining 1 cup of coconut cream.

Sift the flour into a wok over medium-low flame. Toast, stirring frequently, until it is fragrant and light blond in color, about 30 minutes. Add the salt, white sugar, palm sugar, condensed milk, and 1 quart of the coconut milk–coconut cream mixture. Stir the mixture, scraping the wok, with a large wooden spoon or paddle for about 5 minutes. Just as the mixture starts to thicken and becomes somewhat dry and firm, add the remaining coconut milk–coconut cream mixture, about 1 cup at a time, stirring constantly to combine; repeat this process until you've used up all the coconut milk and cream, which should take a total of about 45 minutes. At this stage, you should have a rather thick yet still relatively soft and pliable ball that doesn't stick to the wok. Add half of the butter, stirring to combine. When the mixture begins to firm up, add the remaining butter, stirring to combine. When the mixture becomes soft and pliable again, remove from the heat.

Remove the mixture to a baking pan, distributing it evenly and packing until it's flat and level. Pour the reserved coconut cream over the surface.

Phaithoon finishes his sweets with a unique yet, for home cooks, impractical technique (see page 253 for details). Those cooking outside of northern Thailand will find it easier to put the tray under a broiler, turning the pan occasionally, until the coconut cream has thickened to the near consistency of a heavy cake frosting and is intermittently charred, about 10 minutes.

When cool enough to handle, cut into 2 × 1-inch rectangles. Keep it at room temperature, covered, and serve within a day or two.

Khao Muun Khuay

ข้าวมูนช่วย

SHAN "DONUTS"

SERVES 4 TO 6

In dozens of visits to Mae Hong Son over a span of nearly twenty years, I've encountered *khao muun khuay*—deep-fried, donut-shaped, syrup-soaked, sticky rice–based Shan sweets—many, many times. But I had dismissed them as the type of heavy, starchy sweet that only the people who grew up with them could appreciate.

Then, last year, I tried one.

Imagine a thin, crispy shell encasing a pleasantly chewy and syrupy-in-a-*gulab-jamun*-way interior that boasts the distinct fragrance and appealing bitterness of raw sugarcane syrup. It's a genius intersection of texture and flavor, and it's now among my favorite sweets in Thailand.

Khemchira Arun makes *khao muun khuay* in Ban Pha Bong, a Shan village with a hot spring and a reputation for talented cooks. She has a day job in an office but makes the sweet on weekends for a bit of extra cash, and because she enjoys cooking. After deep-frying the sesame-flecked rings for as long as thirty minutes, rendering the exterior brittle and the interior molten, she submerges them in a mixture of palm and raw sugarcane syrup and coconut cream.

"Most people don't include coconut cream," Khemchira explains. "I add it for a more balanced flavor. *Khao muun khuay* should taste sweet—the syrup should go all the way to the center—but not too sweet."

If you can't get black sticky rice flour, it's fine to use an equal amount of white sticky rice flour instead, replacing the white sesame seeds with black sesame seeds. Either way, measuring the flour by weight will lead to better, more consistent results.

RECIPE CONTINUES

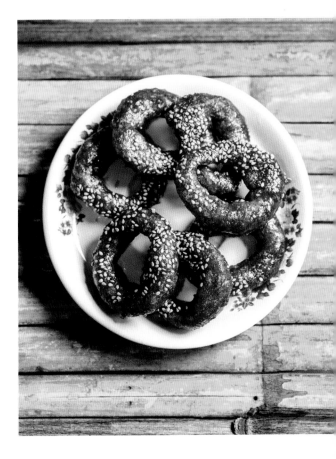

180 grams / 6¼ ounces white sticky
 rice flour
60 grams / 2 ounces black sticky rice
 flour
150 grams / 5¼ ounces raw sugarcane
 sugar
75 grams / 2¾ ounces palm sugar
½ cup coconut cream (see page 325)
1 12-inch-long pandan leaf, tied
 into a knot (it's easier to handle
 this way)
oil, for deep-frying
2 tablespoons untoasted raw white
 sesame seeds

THAI KITCHEN TOOLS
large heavy-bottomed wok
 (19 inches or larger)

In a large bowl, combine the sticky rice flours and ¾ cup plus 2 tablespoons of water. Knead the dough for 5 minutes, until smooth and combined, adding more water, if necessary; the dough should not stick to your fingers and should have a consistency just between wet and dry, similar to Play-Doh. Form the dough into a ball, return to the bowl, and cover with plastic wrap.

Combine the sugarcane sugar, palm sugar, coconut cream, ½ cup of water, and pandan leaf in a small saucepan over medium heat. Bring to a boil, reduce the heat, and simmer, stirring frequently, until the ingredients have dissolved (with the exception of the pandan leaf) and reduced just slightly, about 10 minutes.

Heat 1½ inches of oil to 250°F in a large wok over medium heat. Take a ball of dough the size of a large gumball (weighing about 20 grams / ⅔ ounce) and roll into a cylinder about 5 inches long and ½ inch thick. Form it into a ring, dip one half of the ring in the sesame seeds, and slide it into the hot oil. Repeat until the wok is full but not crowded, as the rings tend to stick to each other. Simmer the rings in oil until the thin exterior of each ring becomes crispy yet flexible (not hard and unyielding), while the interior is soft and pleasantly chewy; if the oil temperature is maintained at 250°F, this should take between 15 and 20 minutes.

Spear 4 or so rings out of the oil (this is best done with a metal skewer), shake off the excess oil, and, while still hot, dip them into the syrup mixture, stirring until all the rings are submerged, leaving them to soak for 20 seconds or so. Again using a skewer, fish the rings out of the syrup mixture and suspend them over the saucepan, allowing the excess syrup to drip. Repeat with remaining rings. The finished rings should have a thin, crispy exterior encasing a moist interior similar to that of the Indian sweet *gulab jamun*.

Repeat the frying process with the remaining dough (you should end up with about 20 *khao muun khuay*), working to maintain a consistent oil temperature of 250°F; if the oil is hotter than this, large blisters will form on the surface of the sweets.

Eat *khao muun khuay* hot or at room temperature as sweet snack or dessert.

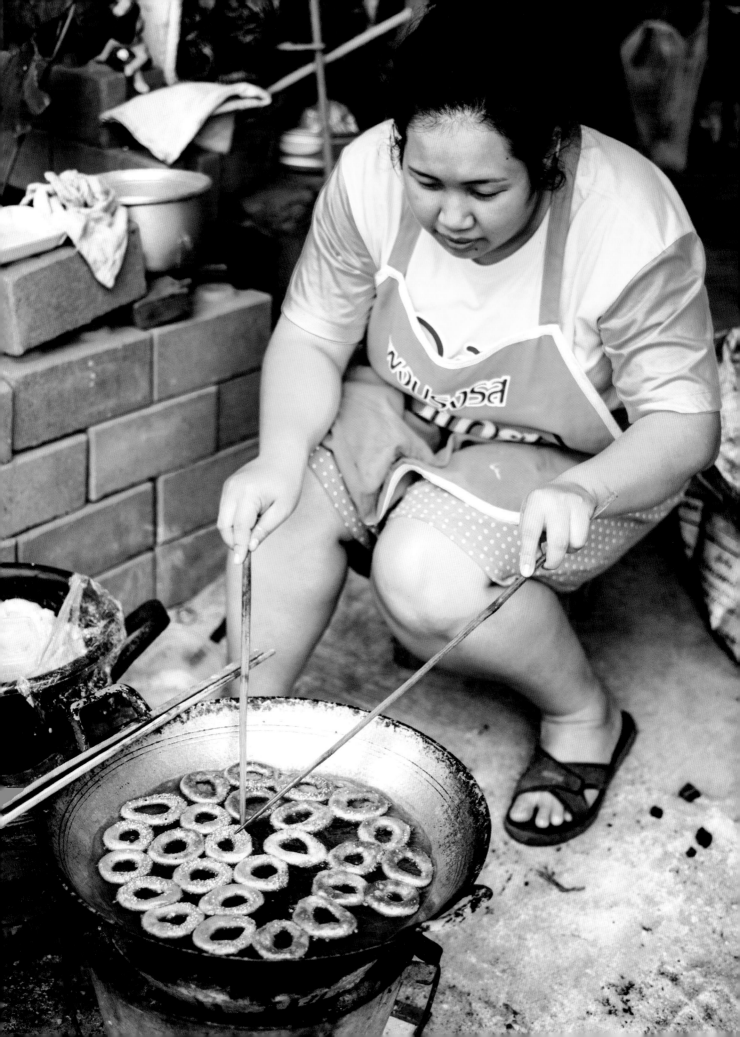

Nuea Thup

เนื้อทุบ

POUNDED BEEF

SERVES 4

Northern Thailand's preferred meat tenderizer? Your typical hardware-store hammer—at least when it comes to *nuea thup*, hunks of stringy beef loin that have been slow-grilled until almost jerky-like before being thwacked.

It's a dish that's brought to great heights at Phen, a northern Thai meat shack in Mae Sariang, in the southern part of Mae Hong Son Province.

"It should taste a bit salty but balanced, and smoky," explains Samaen Kengphraiwan, in charge of grilling the beef at Phen for fifteen years. "It should be a bit dry, almost burnt on the outside."

Indeed, *nuea thup* is all of these things, its pleasantly dry texture necessitating the tenderizing force of the hammer. It also has an intense beefiness, the result of marinating the beef in fish sauce and salt. It's paired with a tamarind-based sauce that's an intersection of salty, tart, and sweet. This is a dish that manages to hit nearly all tastes—and techniques.

Prepare the beef: In a small bowl, combine the beef, fish sauce, salt, and MSG (if using). Marinate at room temperature for 3 hours.

Prepare the dipping sauce: Heat ¾ cup of water in a small saucepan over high heat. Bring to a boil, and remove from the heat. Add the tamarind pulp and mash with a spoon to combine. Set aside for at least 15 minutes. Using a fine strainer, strain the tamarind, pressing on the pulp to extract as much liquid as possible, discarding the solids; reserve a scant ½ cup of the tamarind liquid. In a small bowl, combine the reserved tamarind liquid, shallots, garlic, fish sauce, salt, MSG (if using), and cilantro.

Taste, adjusting the seasoning if necessary; the dip should be equal parts tart, salty, and umami.

Using a grill, light the charcoal and allow the coals to reduce to low heat (approximately 250°F to 350°F, or when you can hold your palm 3 inches above the grilling level for 8 to 10 seconds). Grill the beef on one side until somewhat dry—almost jerky-like—and lightly charred, about 1 hour. Flip and grill until the other side is similar, 1 more hour, all the while adding coals to maintain a low but constant temperature. Add coals, fanning them to increase temperature slightly, and grill the beef another 30 to 45 minutes, flipping occasionally, until it is uniformly dry and lightly charred. When cool enough to handle, cut the beef into sections approximately 4 inches long, pound them with a hammer until they're almost falling apart, and slice, along the grain, into strips approximately 1 inch wide.

Remove to a serving plate and serve with the dipping sauce and sticky rice as part of a northern Thai meal.

For the Pounded Beef
500 grams / 18 ounces strip steak
1 tablespoon fish sauce
1 teaspoon table salt
¼ teaspoon MSG (optional)

For the Dipping Sauce
50 grams / 1¾ ounces tamarind pulp
50 grams / 1¾ ounces shallots, peeled and minced finely
5 garlic cloves (25 grams / 1 ounce total), peeled and minced finely
1 teaspoon fish sauce
1 teaspoon table salt
¼ teaspoon MSG (optional)
a few sprigs cilantro (5 grams), chopped finely

The Karen Kitchen

"People say our food is tasty; actually, it's not that delicious, but I think it's pretty good!"

This somewhat confusing comment came from Pairoj Pasupe, a resident of the remote Karen village of Ban Huay Ha, in southern Mae Hong Son, when I asked him about the cuisine of his people.

The Karen, who reside primarily in Myanmar and who speak a language distantly related to Burmese, are one of the largest minority groups in northern Thailand, but little has been written about what they eat. What I came to learn during my time staying with Pairoj and his family is that the Karen diet is simple but indeed tasty: a hearty, flavorful repertoire of soups, grilled and stir-fried dishes, and chili-based dips, boosted by basic but strong seasonings such as salt, dried chilies, and fresh turmeric.

"We usually eat vegetables, but we'll eat a bit of meat if we have it," explains Pairoj, as he tends to a bubbling soup in his dark, smoky, bamboo-walled kitchen, a task that, even at noon, requires the use of a headlamp. The Karen have an intimate knowledge of the forest, which serves as the source of much of their diet. "There are many things from the jungle that we like to eat: bamboo, banana blossoms, insects, herbs, and vegetables," the sinewy fifty-four-year-old tells me.

Indeed, items such as banana blossom, banana stalk, and a wild herb with a curiously numbing flavor featured in all the meals that Pairoj prepared. When I ask if he always does the cooking, he replied enthusiastically, "In a Karen home sometimes the men cook, sometimes the women cook; we help each other!"

Many Karen are Christian, and our lunch, taken on the bamboo floor, was preceded by a brief prayer. Dinner that night began with yet another prayer, featured piles of rice, a delicious soup of pork and potatoes, and a stir-fry of thinly sliced chayote; it was bookended by long, hushed conversations by the fire and lots of smoking—sweet, homegrown tobacco smoked through homemade bamboo pipes. In the end, the food of the Karen struck me as anything but confusing, and I found their way of eating warm, hospitable, and delicious.

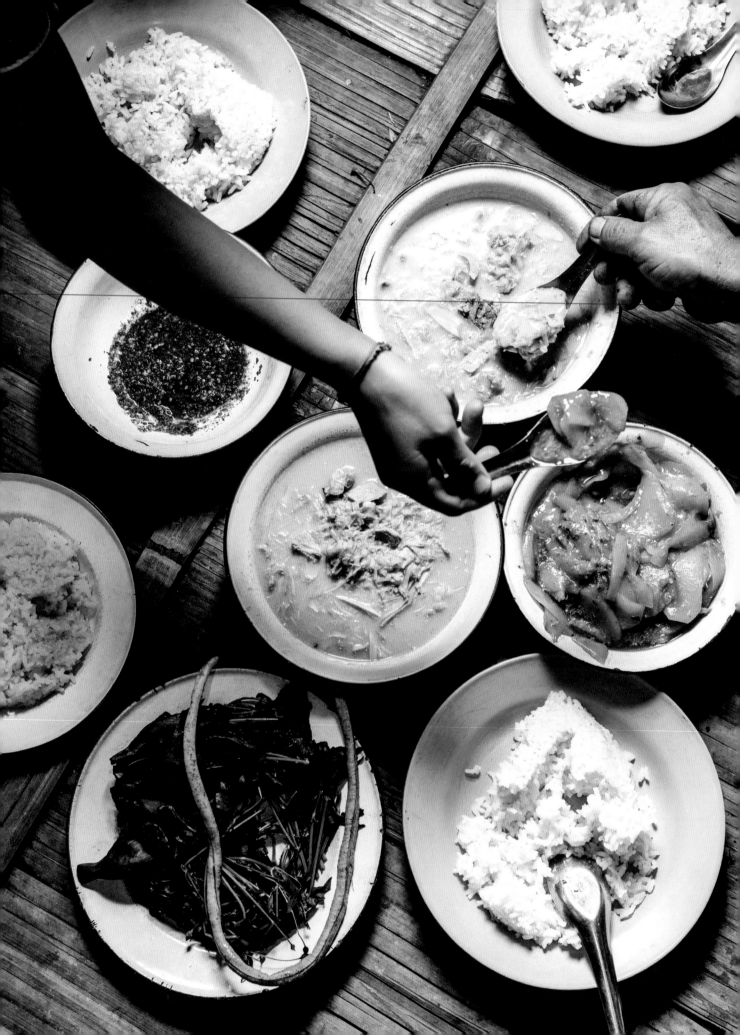

Taj Hpau Pauf

A KAREN SOUP OF
RICE AND VEGETABLES

SERVES 4 TO 6

If there's a single dish that can be said to represent Karen cooking, it's *taj hpau pauf*, a hearty soup bulked out with rice.

"It's our staple food. Even Karen people living abroad make this dish," explains Watcharaphong Krathomromprai, a native of the Karen village of Ban Huay Ha, who spent two years studying abroad in Australia.

Less a recipe and more a broad concept, *taj hpau pauf* stems from a need to stretch a few basic ingredients.

"It should have rice and vegetables—banana stalk, banana blossom, whatever you have," explains Pairoj Pasupe, a Karen resident of Ban Huay Ha and the source of this recipe.

Meat can also be added, if available, Pairoj tells me, and the dish as prepared at his home combined pork belly and banana blossom, generously seasoned with a fragrant paste made from salt, the famous *phrik kariang* chilies, garlic, and fresh turmeric. These elements came together in a stew-like dish that is, like many beloved staples around the world, equal parts hearty and comforting, but with just enough spice to remind you that you're in Southeast Asia.

If you can't obtain dried *phrik kariang* chilies, other small, spicy dried chilies are fine.

RECIPE CONTINUES

For the Curry Paste
1 teaspoon table salt
12 dried *phrik kariang* chilies
(3 grams total; see page 325)
1 small piece fresh turmeric (5 grams
total), peeled and sliced
15 grams / ½ ounce Thai garlic (or
3 standard garlic cloves, peeled)

For the Soup
¼ cup uncooked long-grained rice
200 grams / 7 ounces pork belly,
½-inch slices
1 medium banana blossom
(680 grams / 1½ pounds)
¼ teaspoon MSG (optional)

THAI KITCHEN TOOLS
granite mortar and pestle

Make the curry paste: With the mortar and pestle, pound and grind the salt and dried chiles to a coarse powder. Add the turmeric and garlic, and pound and grind to a fine paste.

Make the soup: Combine 1½ quarts of water and the rice in a small stockpot over high heat. Bring it to a boil, reduce to a simmer, and simmer for 10 minutes. Add the pork and simmer for another 10 minutes.

While the soup is simmering, peel and discard the coarse, dark exterior leaves from the banana blossom, halve it lengthwise, and slice the inner core thinly; you should have 350 grams / 12 ounces of sliced banana blossom. Increase the heat to a rapid simmer, add the banana blossom to the soup, and simmer, stirring frequently to help release the thickening liquid of the banana blossom, for 10 minutes. Add the curry paste and MSG (if using), stirring to combine, and cook another 5 minutes or so.

Taste, adjusting the seasoning if necessary; the *taj hpau pauf* should be rather thick in consistency, the pork and the banana blossom should be tender, and the soup should taste slightly salty and meaty and should be fragrant from the garlic and turmeric.

Remove to a large serving bowl and serve hot, with long-grained rice, as part of a Karen meal.

Karen Chilies
พริกกะเหรี่ยง

Mae Hong Son's Shan and Karen cuisines aren't known for their spice, but paradoxically, the province is home to what might be one of the hottest chilies in the country. *Phrik kariang*—"Karen" chilies, named after the ethnic group who reside in great numbers in Mae Hong Son—are broad-shouldered, stubby chilies that range in color from pale green to orange. Fresh, they pack an acidic, spicy flavor with a lingering burn. Yet they're most commonly used when dried, often deep-fried until crispy and served as an optional side with Shan dishes such as *khao kan jin* (page 245).

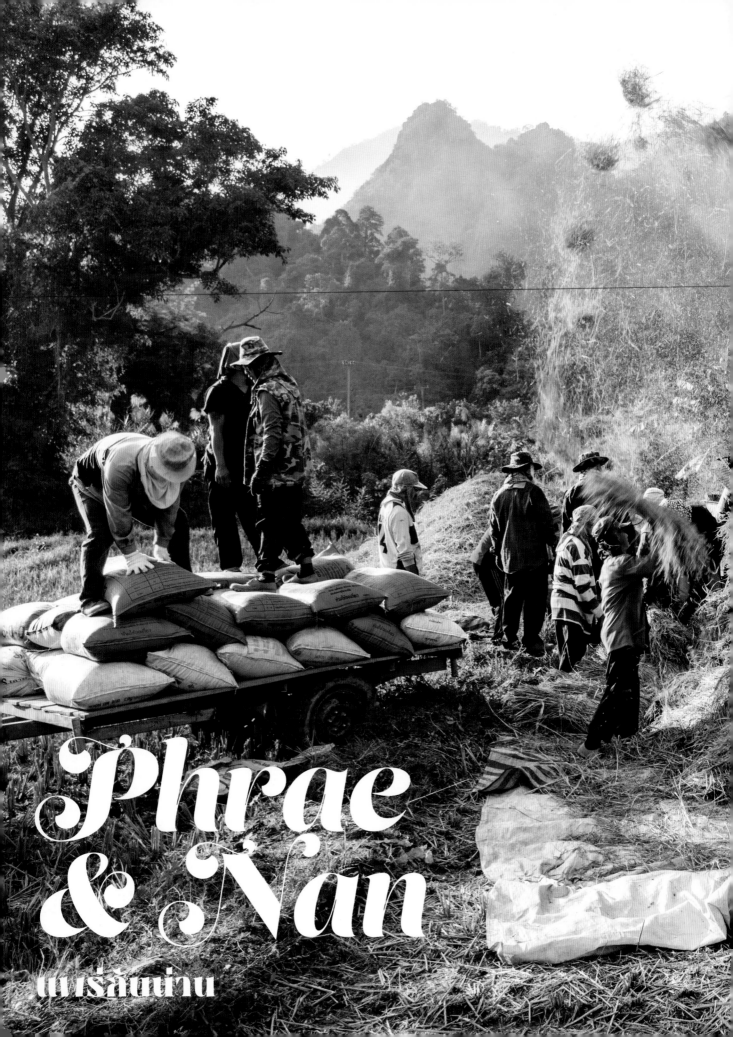

Phrae & Nan
แพร่และน่าน

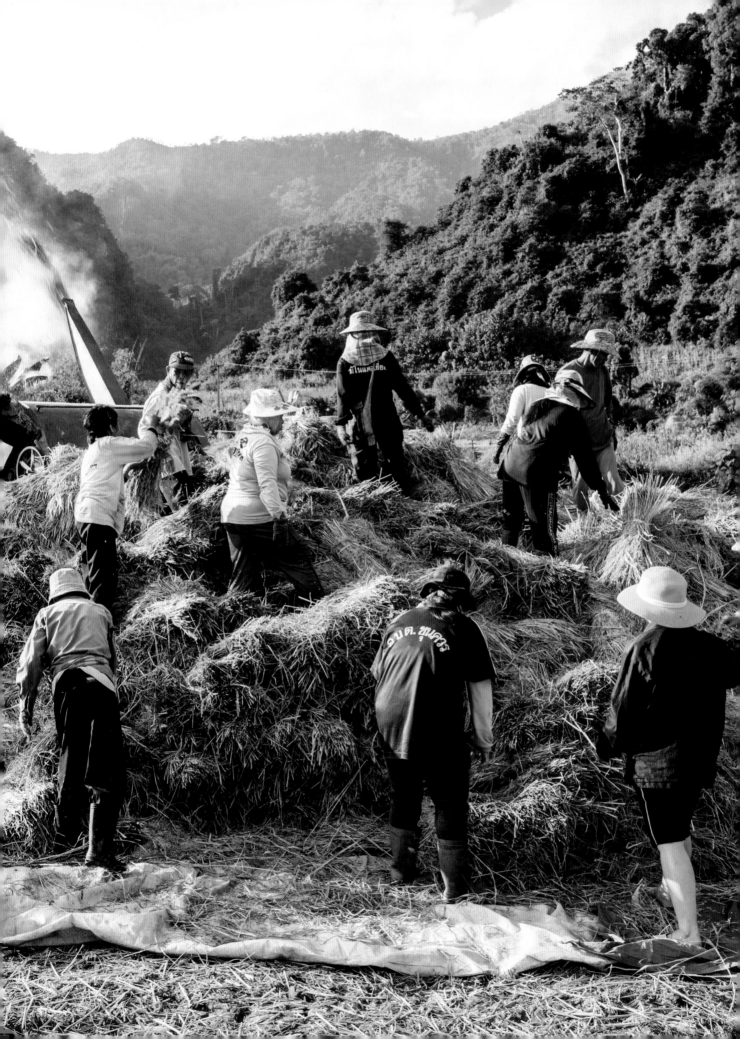

*T*here's something different about Phrae and Nan, two provinces quietly tucked into northern Thailand's northeastern corner.

I noticed it back in 1999, on one of my first trips to upcountry northern Thailand. A friend and I were in Nan, doing some self-guided trekking through national parks and villages, and the area struck me as one of the more remote places I'd ever been. We were walking between villages—there were no roads in these parts—sleeping at nights in a tent, a rural schoolhouse, or in the home of a friendly Hmong family. We had brought our own food, but with the ingrained hospitality so often shown by people who live in far-flung places, meals were prepared for us. I hadn't been speaking Thai for very long at that point, and most people we encountered could speak only the northern dialect—for me at the time an entirely different and mostly unintelligible language. And although human encroachment had already begun to take its toll on Nan's natural environment, it was clear just how wild the area still was: sharp mountains that we stood no chance of crossing blocked our way frequently, and in the valleys we came across rushing rivers and thick forests with some of the biggest trees I'd seen in Thailand. It felt like exploration, compounded by the fact that at no point did we encounter any foreign tourists.

I've been back to Phrae and Nan many, many times since that trip, and they continue to strike me as unique and remote—even today, it's rare that I'll see a foreign tourist—qualities that undoubtedly go back to the provinces' roots as two of the more distant and autonomous *mueang*, or former city-states, in northern Thailand.

Phrae was founded as early as the eighth century, but it wasn't brought into the loose fold of the Chiang Mai–based Lan Na kingdom until around the middle of the fifteenth century. Yet, perhaps aided by its distance from Chiang Mai, Phrae was able to exist more or less independently until the nineteenth century, when it emerged as an important outpost in the British-administered logging indus-

try. Neighboring Nan has maintained an even more coy position. The present-day capital was founded in 1368, yet Nan didn't fall under the control of Siam until 1788, and even then, it managed to maintain a large degree of independence until 1931. Nan's physical remoteness from the rest of Thailand persisted as late as the 1980s, when parts of the province were a hotbed for anti-government communist guerillas.

These legacies of independence have provided the people of Phrae and Nan with plenty of time to reflect on and hone what it is that makes them different from the rest of the country. When asked, some locals might cite the provinces' uber-northern, agricultural, self-sufficient lifestyle. Others might bring up their ethnic diversity—together Phrae and Nan are home to sixteen different ethnic groups, including people rarely seen elsewhere, such as the Htin, Lua, and Mrabri. But Wiwat Kanka, chef/owner of Jin Sot, a popular restaurant serving local dishes in Phrae, prefers to sum it up like this: "People in central Thailand eat pork. Here, we like buffalo."

Sripana Vongburi, an amateur cook and food historian with links to Phrae's former royal family, has a different take. "The difference is in the spices," she offers. "*Makhwaen* is used more here than elsewhere," she explains, referring to what is arguably the most important ingredient in local dishes, a relative of Sichuan pepper that boasts a strong fragrance and a unique numbing sensation.

In Phrae and Nan, this obsession with meat and spice culminates in dishes such as *laap*, a "salad" of minced meat that today is virtually synonymous with the region. And although politics and infrastructure may have dragged these former kingdoms into modern-day Thailand, their food continues to set them apart—a culinary manifestation of autonomy.

Phrae & Nan

Meaty, Manly Food

In rural northern Thailand, if a town is big enough to have a restaurant, it's most likely a shack serving meaty dishes, and, odds are, it's called Laap Phrae.

Not the moniker of a chain, rather the name is a reference to the province, an area with a strong reputation for meat-based dishes, especially *laap*, a "salad" of minced meat.

"The real Phrae-style *laap* is made from beef and is served raw," explained Decha Jankaew, sixty-two, a native of Phrae and chef/owner of Jaa Det, a restaurant specializing in northern-style meat dishes.

In Phrae, *laap* and similar dishes are probably most notable for being eaten uncooked. *It's sweeter, more delicious,* I was told by many a diner. Yet locals' preferences don't stop at raw beef; Phrae-style meat dishes also include ingredients such as pork, blood, liver, tripe, and beef bile, all of which are often served uncooked.

"It's said that people in Phrae eat so much blood that it makes us mean!" adds Decha, laughing.

Eating raw blood and other uncooked animal products carries a host of risks, some potentially deadly. But the people of Phrae (who, I would add, are among the friendliest people I've met anywhere in Thailand) appear somewhat in denial of this reality. I have spoken to dozens of people about raw *laap* and other similar dishes and have yet to encounter anybody who will fess up to having suffered for it, or even anybody who will admit to knowing somebody who has. Perhaps this is because the people of Phrae have developed a clever technique to counter the perils of eating raw animal products: "They eat it with alcohol to kill the bad stuff," explains Thanyaphorn Wongthip, the third-generation owner of Paa Maa, another destination for meaty dishes in Phrae.

In Phrae, eating meat and drinking alcohol go hand in hand. And not surprisingly, given the macho ingredients and links with boozing, *laap* and the like are consumed almost exclusively by men. They're also the only northern Thai dishes that are almost exclusively prepared by men. This may stem from the fact that *laap* is also closely linked with northern Thai celebrations and ceremonies—events typically led by men—and the meat-heavy dish is regarded as a generous offering.

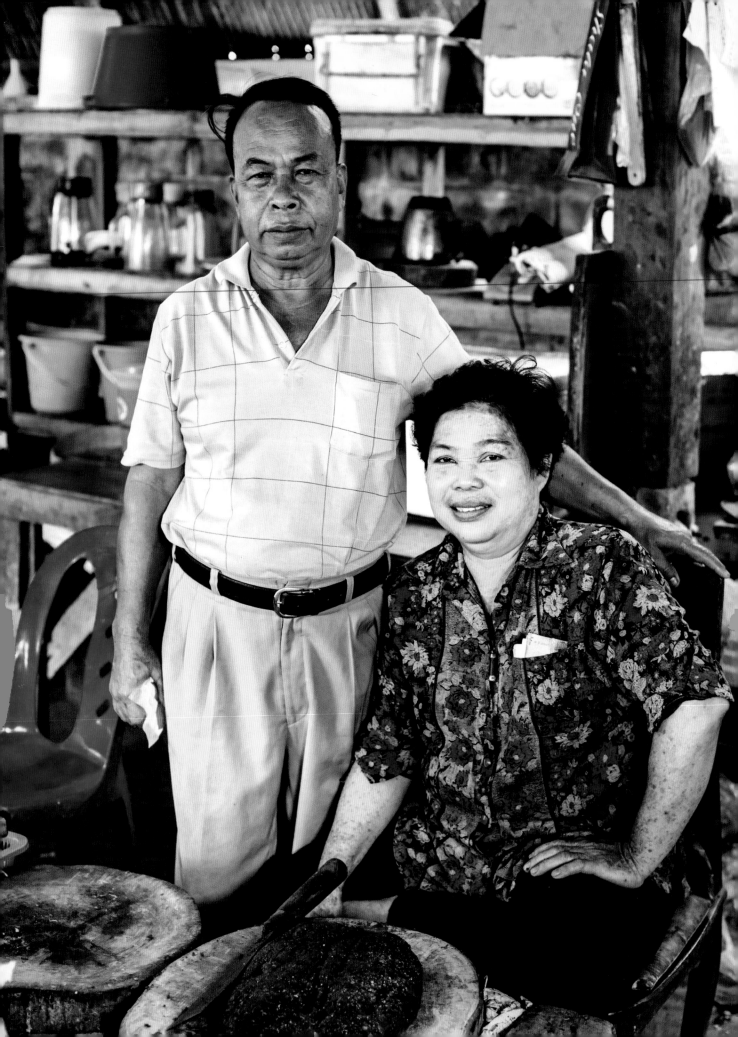

Laap Muu Khua

ลาบหมูคั่ว

PHRAE-STYLE PORK *LAAP*

SERVES 4

It was the most fortunate of circumstances. I was introduced to Decha Jankaew, chef/owner of Jaa Det, a restaurant serving local dishes in Phrae, as he was preparing for a *laap* competition.

"Our *laap* isn't like that served elsewhere," explained the native of Phrae and former soldier as he thwacked away with a mortar and pestle, honing his recipe.

If you've eaten Thai food, you've probably encountered *laap* (or *larb*, *larp*, or *lahp*), a tart, often spicy "salad" of minced meat, herbs, and seasonings that is synonymous with Thailand's northeast (the region known as Isan). But few, including many Thai, are aware of the version served in northern Thailand and closely associated with Phrae—essentially a different dish altogether.

Laap means "to mince," a reference to the vigorous chopping required to make the dish (see page 289). But minced meat is really the only similarity with the Isan version. In northern Thailand, tart lime juice and crunchy toasted rice powder—obligatory ingredients in Isan-style *laap*—are abandoned in place of an intimidating blend of blood, offal, herbs, and dried spices.

At its most basic level, Phrae-style *laap* is a combination of finely minced raw meat, blood, cooked offal, a spice paste, and fresh herbs. Those wary of eating raw meat can order their *laap* cooked—*khua* or *suk*—in which the dish, minus blood, is briefly stir-fried in a wok. Yet prod Decha enough and eventually he'll admit that what makes Phrae-style *laap* unique isn't the type of meat or whether or not it's cooked, but rather the dish's spice mixture.

"The curry paste for *laap* is very basic, just chili, garlic, and shallots," Decha tells me. "It's the combination of spices that adds a specific flavor. *Makhwaen* is fragrant, and long pepper adds a spicy flavor that's different than that of chili." (For more on the spices used in northern Thai–style *laap*, see page 291.)

Decha's recipe for cooked pork *laap* emphasizes these few but distinctive spices, a contrast with versions elsewhere in northern Thailand that might include as many as fifteen different dried spices. Like versions served elsewhere in Phrae, it's a balanced dish, featuring chili heat, dried spice fragrance, meatiness, and saltiness in equal measure. It can range from dry and almost crumbly to wet, but it always has a fine, tender consistency. And as is obligatory with *laap* anywhere in northern Thailand, it is served with sticky rice and a plate of fresh herbs (see page 277 for more on the latter).

RECIPE CONTINUES

For the Curry Paste

25 medium dried chilies (10 grams / ⅓ ounce total; see page 325)

1 tablespoon coriander seeds

2 tablespoons *makhwaen* (see page 326)

1 teaspoon *malaep* (see page 326, optional)

1 heaping tablespoon long pepper (see page 324)

10 grams / ⅓ ounce galangal, peeled and sliced thinly

50 grams / 1¾ ounces shallots, peeled and sliced

30 grams / 1 ounce Thai garlic (or 6 standard garlic cloves, peeled)

½ teaspoon table salt

For the Laap

¼ cup vegetable oil

100 grams / 3½ ounces shallots, peeled and sliced thinly

150 grams / 5¼ ounces pork small intestine

100 grams / 3½ ounces pork skin

500 grams / 18 ounces lean pork loin

12 grams / ½ ounce Thai garlic (or 2 standard garlic cloves, peeled), minced

150 grams / 5¼ ounces pork liver, ¼ × 1-inch slices

¼ cup fish sauce

1 small bunch mint (15 grams / ½ ounce total), leaves only, sliced

1 small bunch sawtooth coriander (20 grams / ⅔ ounce total), sliced

1 green onion (20 grams / ⅔ ounce), sliced

For Serving

400 to 500 grams / about 1 pound of a mixture of vegetables and herbs, such as Thai eggplant, cabbage, long bean, yu choy, Thai basil, Asian pennywort, or sawtooth coriander

THAI KITCHEN TOOLS

granite mortar and pestle

medium wok (approximately 12 inches)

large cleaver or *laap* knife

Prepare the curry paste: Heat the chilies in a wok over low heat. Dry-roast until toasted and fragrant, 3 to 5 minutes; set aside. Toast the coriander seeds, *makhwaen*, *malaep*, long pepper, galangal, shallots, and garlic separately, in the same manner.

With a mortar and pestle, pound and grind the salt and dry-roasted chilies to a coarse powder. Add the coriander seeds, *makhwaen*, *malaep*, and long pepper; pound and grind to a coarse powder. Add the galangal; pound and grind to a coarse paste. Add the shallots and garlic; pound and grind to a fine paste.

Prepare the laap: Heat the oil and half of the shallots in a wok over medium-low heat. Fry, stirring frequently, until golden, crispy, and fragrant, about 20 minutes. Remove the shallots from the oil and drain on a paper towel. Pour off and reserve the oil.

Combine the intestine and pork skin and enough water to cover by a few inches in a small saucepan over high heat. Bring to a boil, reduce the heat, and simmer until the intestines and skin are fully cooked through, about 30 minutes.

While the offal is simmering, using a heavy cleaver cut the pork loin into cubes, then mince, using a forceful chopping motion, folding the minced meat back onto itself, until very fine; this should take about 20 minutes.

Remove the skin and intestines from the water; reserve the cooking water. When cool enough to handle, cut the intestine into sections about ½ inch long and the skin into ¼ × 1-inch strips.

Heat 2 tablespoons of the reserved shallot oil in a wok over medium heat. Add the garlic and the remaining shallots and fry, stirring constantly, until the shallots and garlic are golden, about 1 minute. Add the liver, stirring, until just cooked, about 1 minute. Stir in the reserved intestine and skin. Stir in the curry paste and ½ cup of the reserved offal cooking liquid. Increase the heat to medium-high; add the minced pork and fish sauce. Cook, stirring, until the pork is cooked through and the liquid is nearly cooked off, about 10 minutes.

Taste and adjust the seasoning if necessary; the *laap muu khua* should be fragrant from the dried spices, meaty, and slightly salty, with a relatively dry texture. Remove the wok from the heat, add half of the mint, sawtooth coriander, and green onion, and stir to combine.

Remove to a large serving dish. Garnish with the remaining mint, sawtooth coriander, and green onions and the crispy shallots. Serve hot or at room temperature with sticky rice and a platter of vegetables and herbs as part of a northern Thai meal.

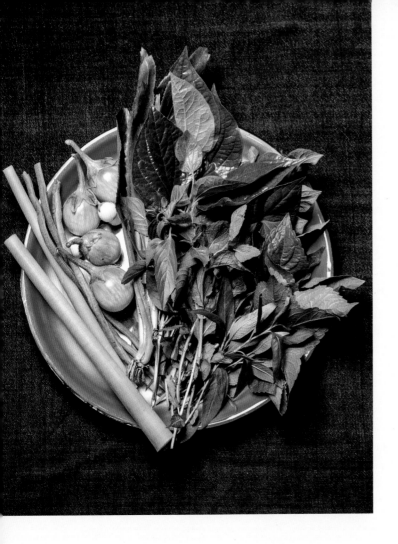

Vegetables with Laap

"If you eat just *laap* with rice, it feels like something's missing," explains Wiwat Kanka, owner of Jin Sot, a restaurant serving local dishes in Phrae. "There needs to be vegetables as well."

Northern Thai–style *laap* is an unabashedly meaty dish, and compelled by that relentless Thai desire for culinary balance, cooks couple every order with a platter of fresh vegetables and herbs known as *phak kap laap*.

At a minimum, *phak kap laap* ("vegetables with *laap*") will include a wedge of cabbage, some yu choy, a few long beans, and a sprig or two of fragrant herbs such as Asian pennywort or sawtooth coriander. There are no set rules as to what can make up *phak kap laap*, and a platter might include herbs such as *rau răm* or wild betel leaf, or even seemingly Western items like mint or dill. But when it's eaten at home or in northern Thailand's better *laap* restaurants, there's often a propensity toward the more obscure herbs that almost never have English-language names: *lep khrut*, a crispy leaf that has the color, texture, and flavor of Italian parsley; *dii plaa chawn*, a waxy leaf that mysteriously shifts in flavor from astringent to sweet as you chew it; and *khao tawng*, a purple-green leaf with a flavor that many have described as fishy.

"We like herbs that are a bit tart, a bit bitter, sometimes sweet," explains Wiwat. "Usually we use vegetables and herbs that we get from our gardens, picked from the fences around our homes."

These items function as a necessary and refreshing break from the meat, in terms of both texture and flavor, and along with sticky rice, no order of *laap* is complete without them.

A typical platter of *phak kap laap* might include any of the following items:

1. Long beans / *thua fak yaao* / ถั่วฝักยาว
2. Thai eggplants / *makhuea praw* / มะเขือเปราะ
3. Sawtooth coriander / *phak chii farang* / ผักชี฿ฝรั่ง
4. Wild betel leaf / *chaphluu* / ชะพลู
5. Fish mint / *khao tong* / ขาวตอง

6. Cumin leaf / *bai yiiraa* / ใบยี่หร่า
7. *Rau răm* / *phak phai* / ผักไผ่
8. Mint / *bai saranae* / ใบสะระแหน่
9. Elephant ear / *toon* / ตูน
10. Thai basil / *bai horaphaa* / ใบโหระพา

Manly, Meaty Ingredients

A refrigerated storage container at Paa Maa, a restaurant in Phrae, contains the essentials for making *laap* and other local meat-based dishes:

1. Raw pork blood / *lueat muu* / เลือดหมู
2. The boiled, strained liquid that is a combination of partially digested grass and bitter bile gathered from a cow's stomach / *nam phia/khii awn* / น้ำเพี๊ย/ขี๊อ่อน
3. Raw bitter bile from a cow's gall bladder / *nam dii* / น้าดี
4. Raw cow blood / *lueat nuea* / เลือดเนื๊อ
5. Uncooked minced beef / *nuea sap* / เนื๊อสับ
6. Uncooked beef tripe / *phaa khii riw* / ผ้าขี๊ริ๊ว
7. Uncooked sliced beef, beef liver and beef tripe / *nuea han, tap nuea, phaa khii riw* / เนื๊อหัน ตับเนื๊อ ผ้าขี๊ริ๊ว
8. Sliced boiled pork skin / *nang muu* / หนังหมู
9. Raw minced pork / *muu sap* / หมูสับ

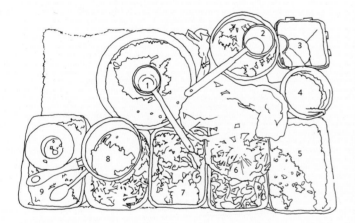

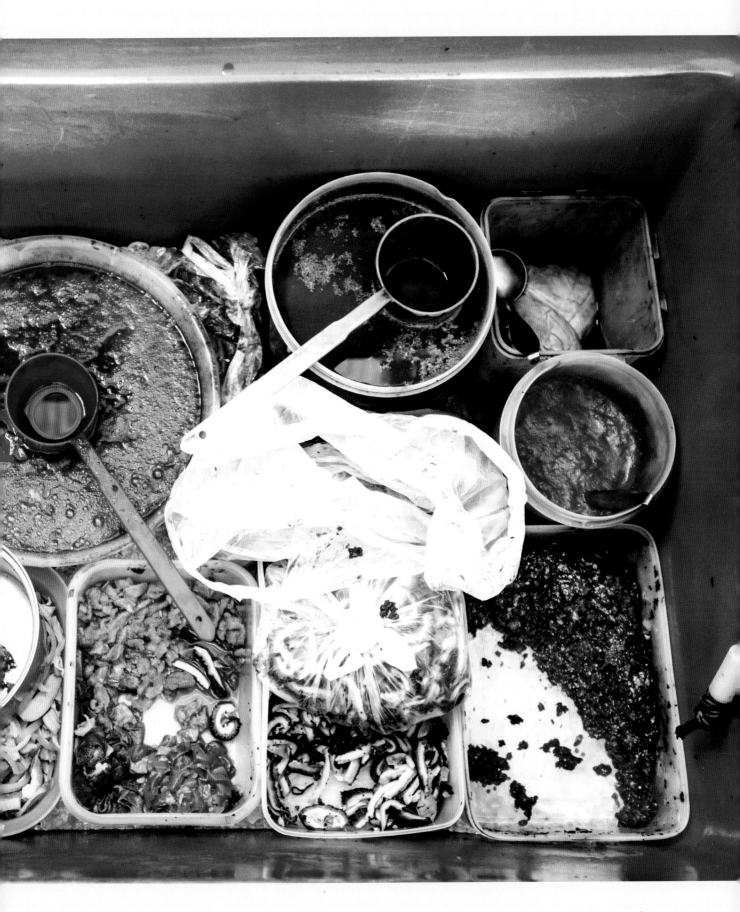

Laap Plaa

ลาบปลา

GRILLED FISH *LAAP* AS MADE IN WIANG SA

SERVES 4 TO 6

Laap means "to mince," and the word generally refers to a salad-like dish of finely chopped meat. But there is no singular *laap* in northern Thailand, and it can be made of anything from chicken to buffalo, served raw or cooked. Yet if there's one version of *laap* that strays furthest from the standard—if indeed there could be said to be one—it's that associated with the town of Wiang Sa, in Nan Province.

"Our fish *laap* is famous," explains Wijitra Momsri, a food vendor and native of the town. "People come from Bangkok and elsewhere in northern Thailand to try it."

I'm in Wijitra's tidy catering kitchen, where she's agreed to show me how to make her version of *laap plaa*, a dish she sells at the town's evening market. Outside, her husband is busy prepping small scale mud carp, a fish raised in the nearby Nan River. The flesh will subsequently be scraped off, minced finely, and seasoned with herbs and spices—dried chili, garlic, shallots, and *makhwaen*. At this point, the *laap plaa* is more or less done: most locals prefer to eat it raw, and at markets in Nan the dish is sold this way from vast pots lined with ice. But Wijitra opts to take her *laap plaa* a step further, combining the finely minced fish with its eggs and a garnish of chopped herbs, neatly wrapping these ingredients in a banana leaf, and grilling the package over coals.

"People say that the grilled version is more fragrant from the scent of the banana leaf," Wijitra tells me. "It's a bit more special; usually it's made for ceremonies."

On the surface, Wijitra's *laap plaa* is almost indistinguishable from *aep* (see page 80), another dish of minced meat and herbs grilled in a banana leaf package. But her dish is more intense in flavor and boasts a tender, almost tofu-like texture.

"It should be fragrant from the *makhwaen*, salty, and spicy—it's a strongly seasoned dish," explains Wijitra, adding that she opts to fry the dish's chilies, garlic, and shallots in oil to boost their flavor and fragrance.

Outside of northern Thailand, you're unlikely to get your hands on small scale mud carp, but any mild-tasting freshwater fish with scales should do (Wijitra also uses black sharkminnow). Similarly, Wijitra's garnish of fish eggs is a decadent yet optional element that has been omitted from this recipe.

Gut and descale the fish. Fillet the fish, discarding the skin, and scrape as much fish flesh from the bones as possible, reserving the bones and head; you should end up with around 800 grams / 1¾ pounds of fish flesh. Heat the fish bones, head, and enough water to cover by an inch or so in a stockpot over high heat. Bring to a boil, reduce the heat, and simmer for 15 minutes. Strain and reserve the broth.

While the broth is simmering, using a heavy cleaver mince the fish with a forceful chopping motion, folding the minced meat back onto itself, until very fine (this should take approximately 10 minutes).

With a mortar and pestle, pound and grind both the large and the medium dried chilies to a relatively fine powder. Add the *makhwaen* and pound and grind to a fine powder. Remove and set aside. Add the garlic and pound and grind to a coarse paste. Remove and set aside.

Heat the shallots and oil in a wok over medium-low heat. Fry, stirring frequently, until golden, crispy, and fragrant, about 20 minutes. Remove the shallots and drain on paper towels. Add the pounded garlic, frying until golden, crispy, and fragrant, about 5 minutes. Remove and drain on paper towels. Pour off all but about 3 tablespoons of the oil (saving it for another use), add the ground chilies and *makhwaen* mixture to the wok, and fry, stirring frequently, until dark and fragrant, about 5 minutes. Remove to a heatproof bowl and cool.

Combine the minced fish, fried shallots, fried garlic, fried chili powder, *rau răm*, salt, fish sauce, MSG (if using), and about 2 cups of the fish broth. Stir vigorously until combined, smooth, and somewhat sticky in texture.

Taste, adjusting the seasoning if necessary; the *laap plaa* should be salty, spicy, and fragrant from the *makhwaen*, garlic, and *rau răm*.

Prepare 20 banana leaves as described on page 80. Top each banana leaf with about ½ cup of the fish mixture, garnish with the cilantro and green onion, and fold as illustrated; you should end up with 10 banana leaf packages.

In a Thai-style charcoal grill, light the charcoal and allow the coals to reduce to low heat (approximately 250°F to 350°F, or when you can hold your palm 3 inches above the grilling level for 8 to 10 seconds). Grill the *laap plaa*, flipping occasionally, for about 25 to 30 minutes; open one package to confirm that the fish is just cooked through.

Remove to a serving dish and eat warm or at room temperature, with sticky rice and vegetable sides, as part of a northern Thai meal.

1 large (2 kilograms / 4½ pounds) freshwater fish with scales
10 large dried chilies (15 grams / ½ ounce total; see page 325)
10 medium dried chilies (5 grams total; see page 325)
2 heaping tablespoons *makhwaen* (see page 326)
40 grams / 1½ ounces Thai garlic (or 8 standard garlic cloves, peeled)
100 grams / 3½ ounces shallots, peeled and sliced finely
1 cup vegetable oil
1 small bunch *rau răm* (30 grams / 1 ounce total), leaves only, chopped
1 teaspoon table salt
2 tablespoons fish sauce
½ teaspoon MSG (optional)
20 feet of banana leaf, or as needed
a few sprigs cilantro (10 grams / ⅓ ounce total), chopped
2 green onions (40 grams / 1½ ounces total), chopped

For Serving
400 to 500 grams / about 1 pound of a mixture of vegetables and herbs such as Thai eggplant, cabbage, long bean, yu choy, Thai basil, Asian pennywort, or sawtooth coriander

THAI KITCHEN TOOLS
large cleaver or *laap* knife
granite mortar and pestle
medium wok (approximately 12 inches)
Thai-style charcoal grill or barbecue

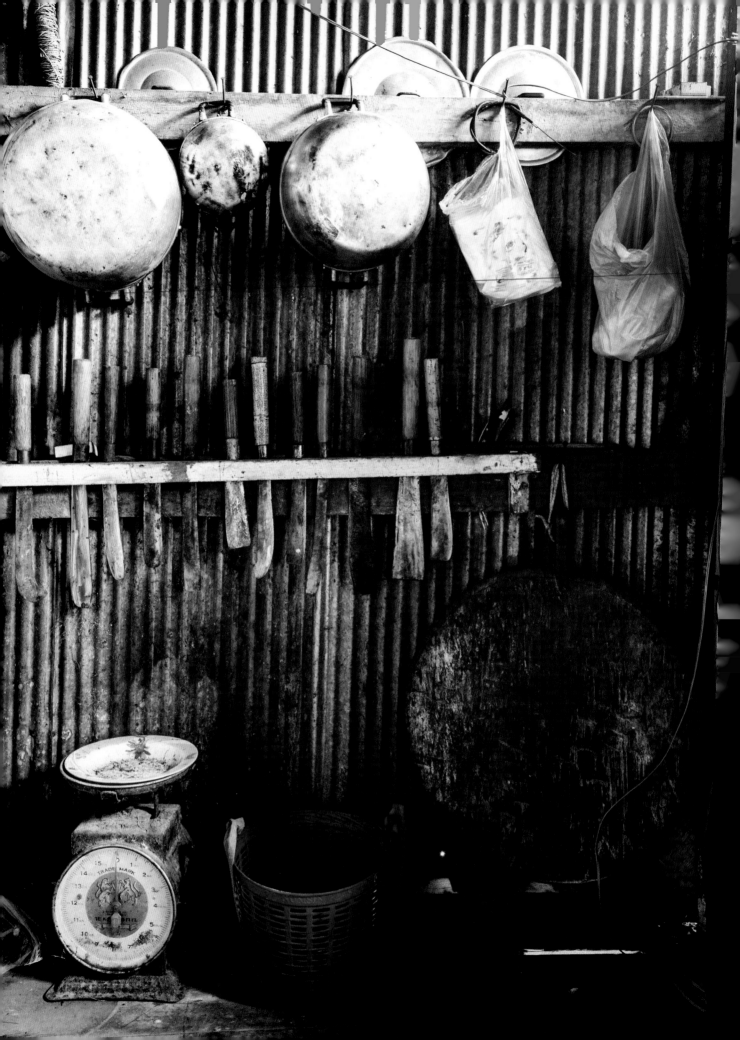

Mincing Laap

การลาบ

For a sixty-four-year-old, Samlit Wongthip has a tough job. For the last decade, he's been responsible for mincing the beef, buffalo, and pork at Paa Maa, a restaurant serving *laap* and other local dishes in Phrae.

"We tried using a meat grinder, but it ground the meat too fine," explains his daughter, Thanyaphorn Wongthip. "So he does it by hand."

An important attribute of northern-style *laap* is finely minced meat—indeed, the name of the dish can be translated as "to mince." And many claim that the ideal consistency of almost imperceptible, tender crumbs of meat can be obtained only through chopping by hand, which in northern Thailand is generally done with a *phraa to*, a type of knife traditionally made in Baan Rong Fong, a village outside of Phrae.

The knife has a wooden handle and a long, sharp wedge-shaped blade, and packs a considerable heft, which cooks use to their advantage. Yet chopping meat by hand remains a labor-intensive job.

"Mincing ten kilograms of meat takes me three hours, from 9 a.m. to noon," explains Samlit. "Pork is easy, but beef is harder; it's tougher and takes longer to chop."

Yet some clever northerners have created a way to combine the best of both knife-based chopping and automated technology. Attaching two cleavers to a motor, which powers the knives in a rapid hacking motion above a revolving chopping board, they've created a *laap* machine. And although there's something undeniably menacing about the contraption, I've eaten the *laap* prepared with it, and I couldn't help but wonder if Samlit's job may soon be obsolete.

Phrae & Nan's Meaty Dishes

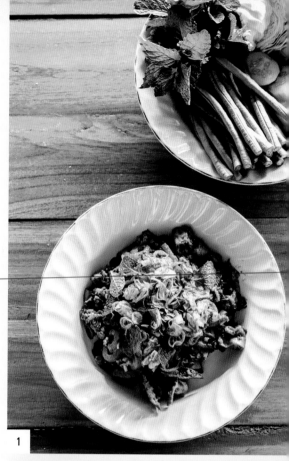

1. Cooked pork *laap* (see page 275 for recipe) / *laap muu khua/suk* / ลาบหมูคั่ว/สุก

2. "Bitter" beef *laap* consists of minced raw beef and blood seasoned with a spice paste, *nam dii* (bitter bile from a cow's gall bladder) and/or *nam phia* (the combination of undigested grass and bitter bile collected from a cow's stomach) / *laap nuea dip/laap khom* / ลาบเนื๊อดิบ/ลาบขม

3. Grilled fish *laap* (see page 280 for recipe) / *laap plaa* / ลาบปลา

4. Udigested grass and bitter bile collected from a cow's stomach (*nam phia*) supplemented with raw minced beef, liver, and tripe, seasoned with a spice mixture similar to that used in *laap*, resulting in a bitter, spicy soup / *luu phia* / หลู้เพี๊ย

5. Uncooked pork blood seasoned with a spice mixture, occasionally supplemented with cooked minced pork, served over a mixture of deep-fried crispy rice noodles, pork intestines, and pork rinds, with optional sides of the slightly sweet liquid from pickled garlic and deep-fried kaffir lime leaves / *luu muu* / หลู้หมู

6. Herb-heavy beef stew (see page 286 for recipe) / *kaeng awm nuea* / แกงอ่อมเนื๊อ

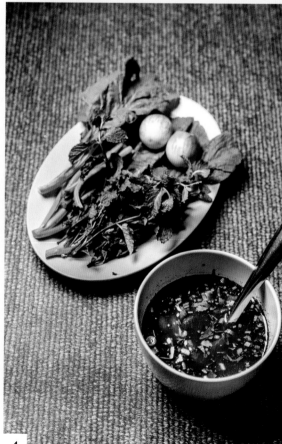

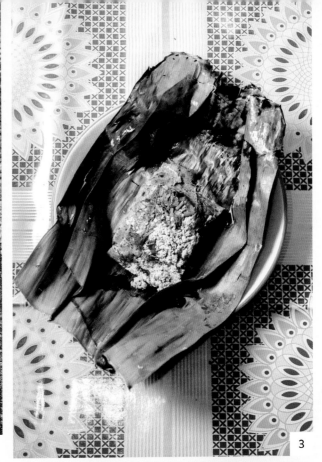

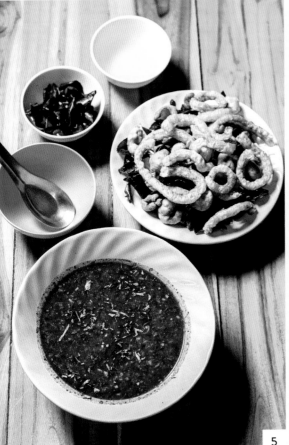

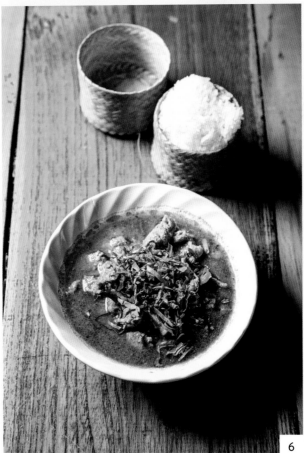

Kaeng Awm Nuea

แกงอ่อมเนื้อ

A RICH, HERBACEOUS BEEF STEW

SERVES 4

I love *kaeng awm nuea*, an assertively herbal, aggressively meaty beef stew from northern Thailand. But every time I order it, I find myself digging through throat cartilage, lung, tripe, intestines, and other bits and bobs I don't particularly care to identify for those two or three precious chunks of tender, stewed beef short ribs.

Wiwat Kanka, chef/owner of Jin Sot, an exceptionally tasty northern Thai meat shack in Phrae, appears to feel my pain.

"Some people don't like organs, offal, and innards," he offers, seemingly including himself in this description. "They just like plain meat."

With this in mind, Wiwat set out to make a *kaeng awm nuea* that appeals to guys like us. To this end, he eliminated nearly all the offal from his version of the dish, leaving chunks of fatty, tender slow-cooked boneless beef short ribs. Yet he opted to retain all the fragrant herbs that counter that beefy funk, adding to the mix kaffir lime zest, a central Thai staple that rarely appears in the northern Thai kitchen.

"It covers up any unpleasant meaty flavors," explains Wiwat, of the ingredient, which when cooked, lends the dish an almost cumin-like fragrance.

Yet this is still Phrae, and Wiwat throws in some gall bladder and a bit of bile, an effort to provide the dish with the bitter flavor so beloved by northern Thais (seasoned cow bile is available in bottled form at some Thai grocery stores). The result is delicious: a distillation of the best qualities of *kaeng awm nuea*, with none—or perhaps fewer—of the surprises.

Make the curry paste: With mortar and pestle, pound and grind the salt, medium dried chilies, and large dried chilies to a coarse powder. Add the *makhwaen*; pound and grind to a coarse powder. Add the cilantro roots and kaffir lime zest; and pound and grind to a coarse paste. Add the lemongrass and galangal; and pound and grind to a coarse paste. Add the shallots and garlic; and pound and grind to a fine paste.

Prepare the curry: Heat the beef, gall bladder (if using), and 2 quarts of water in a covered stockpot over high heat. Bring to a boil, and stir in the curry paste. Reduce the heat to a rapid simmer, and simmer until the meat is beginning to tenderize and the liquid has reduced by one-third, about 1 hour. Reduce the heat to a low simmer, add the kaffir lime leaves, season with fish sauce, MSG (if using), and beef bile (if using), and simmer until the beef is tender, another 20 to 30 minutes.

Taste, adjusting the seasoning if necessary; the *kaeng awm nuea* should taste meaty, spicy, bitter (if using bile), and salty (in that order), and should be fragrant from the kaffir lime zest and *makhwaen*.

Remove to a serving bowl, garnish with cilantro and green onion, and serve warm or at room temperature, with sticky rice, as part of a northern Thai meal.

For the Curry Paste

½ teaspoon table salt

10 medium dried chilies (5 grams total; see page 325)

6 large dried chilies (6 grams total; see page 325)

1 heaping tablespoon *makhwaen* (see page 326)

6 small cilantro roots (6 grams total), cleaned and chopped

zest of 1 medium kaffir lime , sliced thinly

3 stalks lemongrass (75 grams / 2¾ ounces), exterior layer removed, green section discarded, lower white section sliced thinly

30 grams / 1 ounce galangal, peeled and sliced thinly

70 grams / 2½ ounces shallots, peeled and sliced

35 grams / 1¼ ounces Thai garlic (or 7 standard garlic cloves, peeled)

For the Stew

600 grams / 1¼ pounds boneless short ribs, ½ × 1-inch pieces

1 beef gall bladder, ½ × 1-inch pieces (optional)

20 kaffir lime leaves, torn

2 tablespoons fish sauce

¼ teaspoon MSG (optional)

1 teaspoon bitter beef bile (optional)

a few sprigs cilantro (5 grams), chopped, for garnish

1 green onion (20 grams / ⅔ ounce), chopped, for garnish

THAI KITCHEN TOOLS

granite mortar and pestle

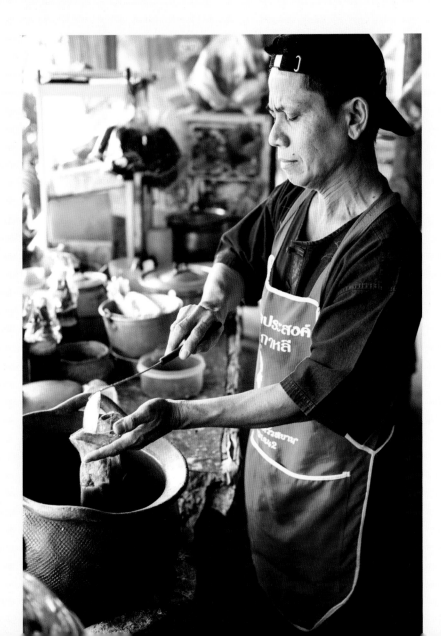

Laap Spices

For fragrance-obsessed northern Thai, cooking *laap* and other meaty dishes is regarded as a balancing act, an effort to reign in the funky odors of meat and offal. And one of the most effective ways to do this is with dried spices.

A dish of northern Thai–style *laap* can include as many as fifteen different dried herbs and spices, each playing a unique role. Pork-based dishes might emphasize sweet spices such as cinnamon or star anise, while the strong odor of beef might be countered with highly fragrant items like mace. Yet there is one spice that is always present—and indeed almost singlehandedly defines meaty northern Thai dishes, especially in Phrae and Nan: *makhwaen*.

The fruit of an evergreen shrub with no colloquial English name, *makhwaen* is a close relative of Sichuan pepper and prickly ash. Like those, *makhwaen* possesses an assertively citrusy, floral, almost pine-like fragrance and imparts a subtle numbing sensation. The fruit is most commonly dried, its husk and seed used as part of the spice paste in a variety of northern-style meat dishes, but it is also brined whole in fish sauce and used as a condiment, or used fresh in certain dishes.

To learn more about *makhwaen*, I headed to Ban Pha Lak, a remote village in northern Nan Province that is quite possibly the country's most prolific producer of the spice.

Ban Pha Lak is tiny, thirty or so houses extending along a dirt street in the shadow of an immense and singular karst outcropping. I arrive in the village during the brief window in the fall when *makhwaen* is being gathered. Basketball-sized bunches of the fruit are drying on just about every rooftop in the village, causing the air to smell like a *laap* restaurant.

The *makhwaen* trees, identifiable by their slim, pale trunks and giant, handlike, almost prehistoric-looking leaves, are located in the hilly areas surrounding the village. The fruit itself grows in bunches at the top of a trunk, up to fifty feet high, protruding with small yet sharp thorns, which makes harvesting it an intimidating and unenviable task. I watch a man wearing patched jeans and gloves shimmy up a tree and use a saw tied to the end of a length of bamboo to remove a bunch that was perhaps twenty feet away. When it tumbled to the ground, he shouted at me to taste the fresh fruit, which had an assertively citrusy flavor that left my lips and tongue feeling numb for the next half hour.

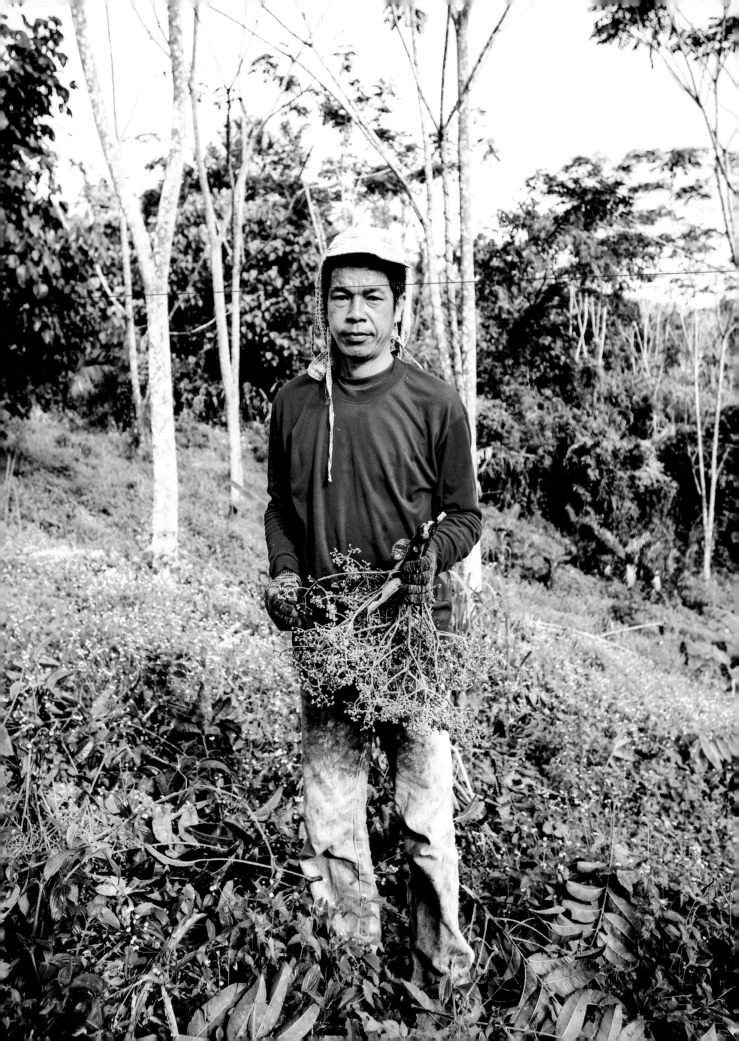

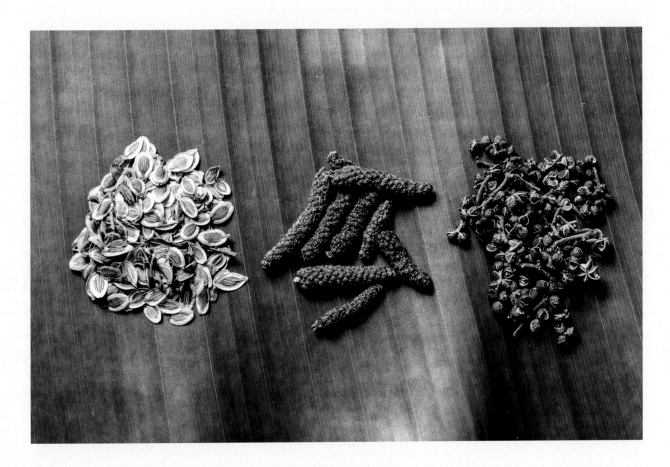

Some of the more obscure dried spices used in *laap* and other northern Thai–style meat dishes include:

1. ***Malaep*** / *Heracleum siamicum* Craib / *malaep* / มะแหลบ
 Native to northern Thailand, and without an English-language name, the dried flat, oval fruit of this plant is used in spice mixtures to lend a slightly sour flavor, a citrus-like fragrance, and a subtle numbing sensation.

2. **Balinese/Javanese long pepper** / *Piper retrofractum* / *diiplii* / ดีปลี Another essential ingredient in Phrae-style *laap* is *diiplii*, or long pepper. Related to black pepper, yet with a more fragrant, slightly sweeter flavor, long pepper comes from a flowering vine, the fruit of which is used both fresh and dried. Long pepper was known to Greeks as early as the sixth century, yet in Europe it was displaced by black pepper in the fourteenth century and is now virtually unknown in the West.

3. ***Makhwaen*** / *Zanthozylum limonella* Alston / *makhwaen*/ *makhaen*/*baakhaen* / มะแขว่น/ มะแข่น/บ่าแข่น Related to Sichuan pepper, this fragrant, numbing spice shows up in just about every meat dish in Phrae and Nan.

Kai Thawt Makhwaen

ไก่ทอดมะแขว่น

CHEF TOUN'S DEEP-FRIED CHICKEN
WITH *MAKHWAEN*

SERVES 4

Makhwaen is an ancient ingredient, a staple in northern Thai kitchens long before chilies arrived from South America. Despite this, the spice never really caught on outside of the region—few people even in Bangkok know what the stuff is. But that doesn't mean that it's not subject to innovation.

"I invented this dish in 2009," explains Toun Umpajak, chef/owner of Boklua View, a resort in Ban Bo Luang, Nan Province. We're at an open-air cooking station at his resort, and Toun is about to demonstrate how to make *kai thawt makhwaen*, chicken deep-fried with the eponymous spice. "It was created to commemorate a visit by Thailand's princess. She liked it and urged me to make it the restaurant's signature dish."

He took her advice, and today Chef Toun's creation—essentially a riff on the central Thai-Chinese staple of chicken deep-fried with black pepper—is a bona fide contemporary classic, sold at restaurants and stalls across Nan and elsewhere in northern Thailand. And it's easy to see why: the dish is assertively fragrant and satisfyingly salty, taking advantage of both Nan's most famous seasonings (*makhwaen* from the hills and salt from Ban Bo Luang) as well as the scrawny-yet-flavor-packed northern Thai chickens. As such, the goal here isn't American-style fried chicken with its crispy exterior encasing a juicy interior, but rather a dish with a relatively dry—dare I say, pleasantly leathery—texture.

As a two-pound bird is a rarity outside of Thailand, consider going with a smaller chicken, split in half lengthwise, or two pounds of chicken parts.

RECIPE CONTINUES

¼ cup *makhwaen* (see page 326)
1 kilogram / 2¼ pounds free-range chicken, butchered as shown below or chicken parts
1 heaping teaspoon table salt
oil, for deep-frying

THAI KITCHEN TOOLS
granite mortar and pestle
large heavy-bottomed wok (19 inches or larger)
large cleaver or *laap* knife

Use your fingers to pinch and rub the *makhwaen* to separate the hard black seeds and the husks. Add the husks, discarding as many of the seeds as possible, to a mortar and pestle. Pound and grind to a very coarse consistency.

Put the chicken on a flat surface, skin side up, and sprinkle with half of the salt, rubbing it into the skin, flesh, and deep into scored sections. Repeat with half of the pounded *makhwaen*. Flip the chicken over and repeat with the remaining salt and *makhwaen*.

Heat 2 inches of oil to 275°F in a wok over low heat. Add the chicken to the oil, skin side up (the chicken does not need to be entirely submerged in the oil), and deep-fry until the bottom of the chicken is orange in color and starting to crisp up, about 10 minutes. Flip the chicken over and fry until the skin side is orange and crispy, about 10 more minutes. Remove from the oil and drain. Using a cleaver, break the chicken down into parts by cutting through the joints, and chopping any larger pieces (such as the thighs and breast) in half. The *kai thawt makhwaen* should be overtly fragrant and salty, and slightly dry in texture.

Remove to a serving dish and serve warm or at room temperature, with long-grained or sticky rice, as part of a northern Thai meal.

HOW TO *Prepare a Chicken for Kai Thawt Makhwaen*

1. Using a cleaver, remove and discard the head, neck, and feet from the chicken.

2. Score the flesh to the bone with one cut in each of the breasts, thighs, legs, and wings.

3. Using your hands, break the leg and wing joints until loose but still connected to each other and to the body of the chicken.

4. Insert your fingers deep into the scores, and pull the flesh away from the bone, again being careful to leave the chicken whole.

5. Split the breastbone lengthwise, removing and discarding the heart and other organs, if still present.

6. You should end up with a limp yet fully intact chicken.

Suea Maw Hawm
เสื้อหม้อฮ่อม

Walk into any restaurant in Phrae—or anywhere in northern Thailand for that matter—and it's likely that the person wielding a knife or stirring a curry will be wearing a short-sleeved, usually faded, indigo shirt with an abundance of pockets. This is *suea maw hawm*, a garment that allegedly got its start in Ban Thung Hong, a village just outside of Phrae.

"Originally it was something people wore when working, especially when farming," explains Phanee Thongsuk. She is the third-generation owner of Paa Lueang, one of more than a dozen shops in Ban Thung Hong that still make the shirt with natural indigo. We chat, surrounded by ceramic jars filled with what looks like liquefied blue jeans. "It's made from cotton so it's cool. And it's dark, so you can't tell when it's dirty!" she adds.

These attributes (and undoubtedly all those pockets) have made *suea maw hawm* the northern Thai equivalent of overalls—or chef's whites. Yet in recent years, the utilitarian shirt has also made the transition to one of the most recognizable icons of northern Thai culture. These days, in addition to being worn by farmers, cooks, and just about everybody in Ban Thung Hong, *suea maw hawm* is required wearing for northern Thai schoolchildren and state employees on Fridays.

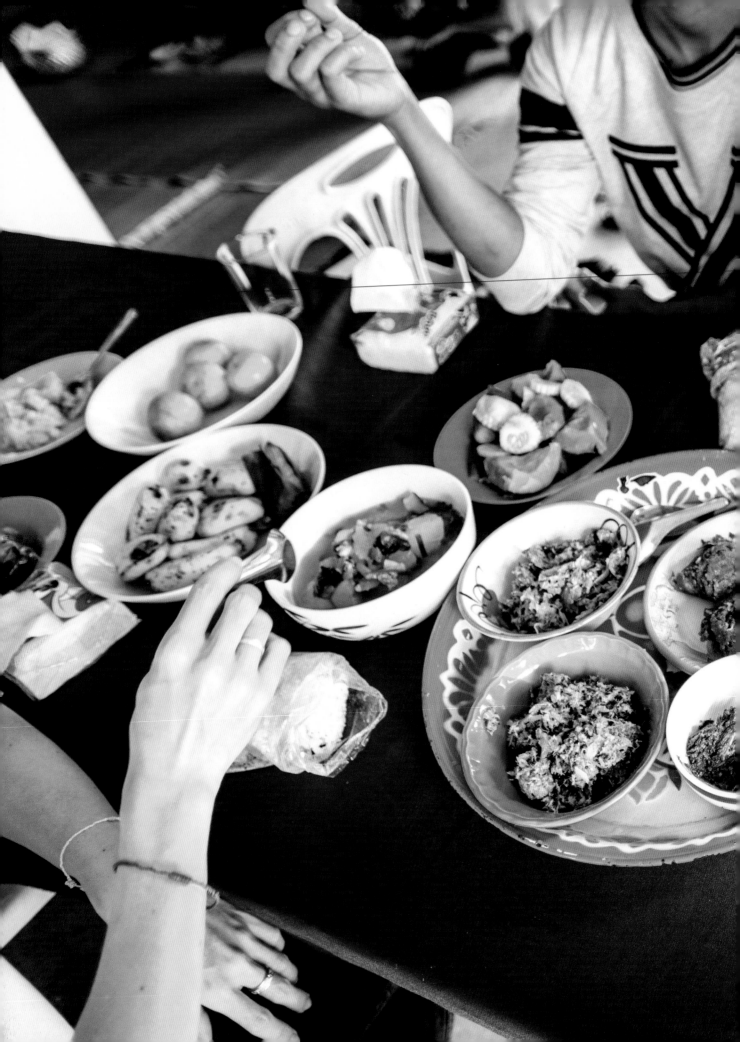

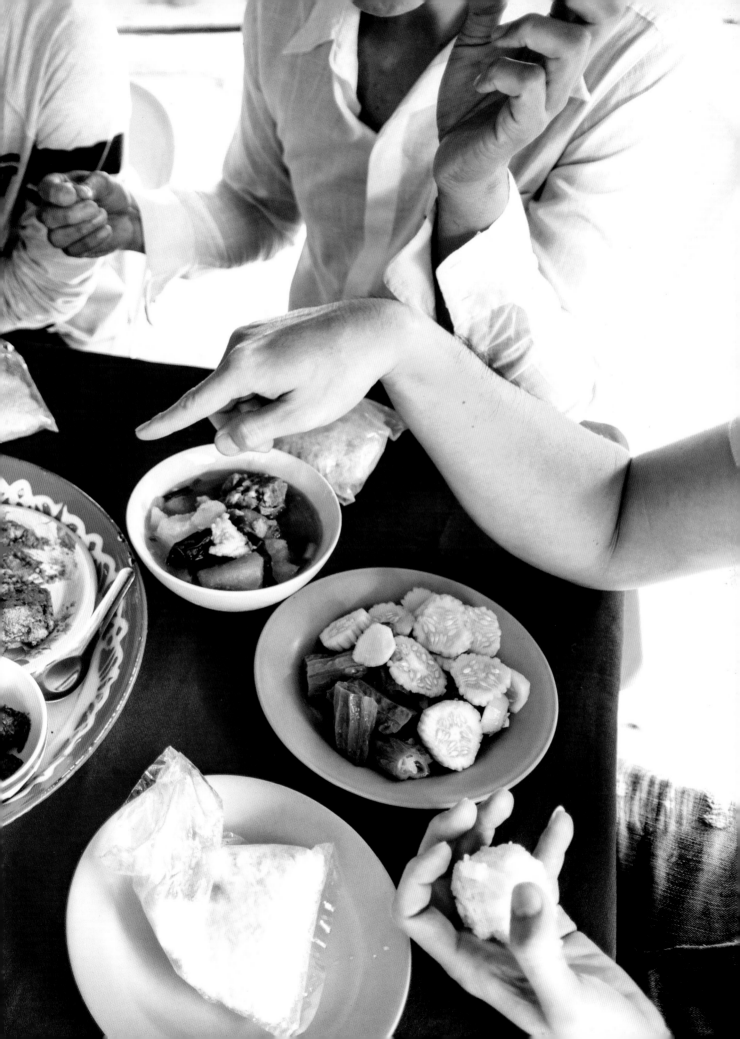

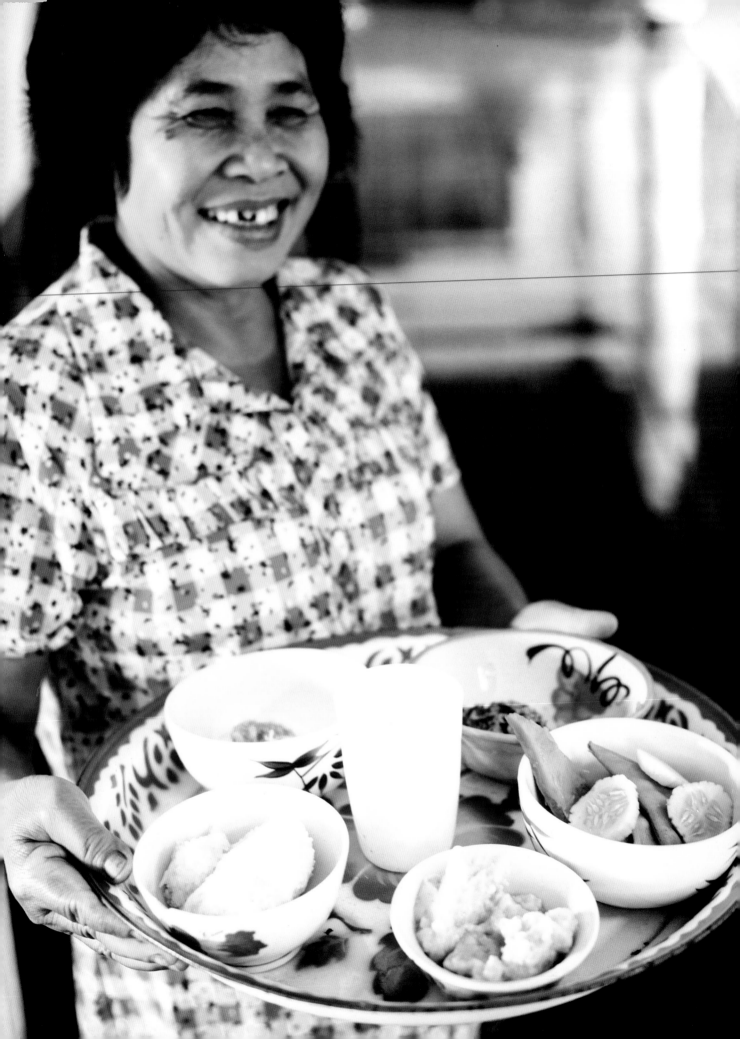

Kaeng Manoi Sai Kai

แกงมะนอยใส่ไก่

A CELEBRATORY CURRY WITH LUFFA AND CHICKEN

SERVES 4 TO 6

Spend time in northern Thailand, and eventually you'll cross paths with some sort of festival or ceremony—such as the time I made a pit stop in Song Khwae, a tiny village in the northern part of Nan Province.

I was sipping coffee at a café when I heard the sound of women chatting and granite mortar and pestles being pounded, telltale signs that a festival was afoot.

Northern Thai celebrations inevitably involve food, and there's an entire repertoire of dishes reserved for such events. These dishes tend to be regional, seasonal, and, perhaps most important, easy to prepare and serve to large amounts of people. In Phrae, family members or villagers might collaborate to make a vast platter of *laap* (see page 276); in Mae Hong Son, it might be a giant pot of *khao sen* (page 239); in Chiang Mai, a huge serving of *kaeng hang lay* (page 165). In Song Khwae, the villagers were collaborating on a massive pot of *kaeng manoi sai kai*, a curry that combines a fragrant spice paste, chicken, and luffa, a type of spongy gourd.

The occasion was the Buddhist ordination ceremony of a local man, for which several households had joined forces. In the kitchen of one home, a small army of middle-aged women peeled, chopped, pounded, and snacked.

"We chose this dish because luffa is in season now; there's lots of it," I was told by one of the cooks. Indeed, in addition to two heaping bowls of the stubby gourd, known locally as *manoi*, their curry included three whole chickens.

Yet such meals aren't all about indulgence.

"We make a big pot of the curry and it's for both the monks and the people attending the ceremony," explained the woman. "The portion for the monks is removed, and they eat first, before noon. Then we get the remainder, after the monks have eaten."

I've reduced their recipe to serve four to six people for your own impromptu northern Thai festival meal. As a two-pound bird is a rarity outside of Thailand, consider going with a smaller chicken, split in half lengthwise, or two pounds of chicken parts. And if you can't find *manoi*, it's fine to use the longer luffa available at Asian grocery stores; just be sure to peel the coarse, stringy exterior.

RECIPE CONTINUES

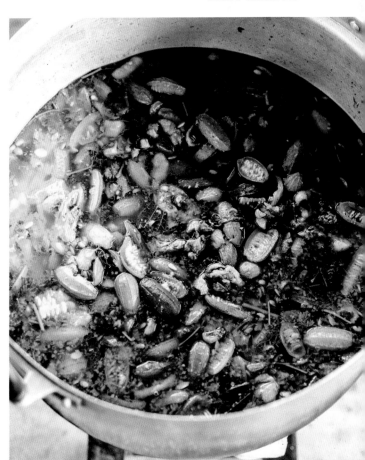

For the Curry Paste

1 tablespoon *makhwaen* (see page 326)

10 medium dried Thai chilies (5 grams total; see page 325)

1 teaspoon chicken bouillon powder

1 stalk lemongrass (25 grams / 1 ounce), exterior tough layers peeled, green section discarded, pale section sliced thinly

a few sprigs cilantro (10 grams / ⅓ ounce total), roots chopped, upper green section chopped coarsely and set aside

30 grams / 1 ounce shallots, peeled and sliced

3 garlic cloves (15 grams / ½ ounce total), peeled and coarsely chopped

15 grams / ½ ounce fresh turmeric, peeled and sliced

1 teaspoon shrimp paste

For the Soup

1 kilogram / 2¼ pounds whole chicken or parts

2 tablespoons vegetable oil

500 grams / 18 ounces small angled luffa

1 teaspoon table salt

50 grams / 1½ ounces wild betel leaves, torn

THAI KITCHEN TOOLS

granite mortar and pestle

Prepare the curry paste: Add the *makhwaen* to a wok over medium heat. Toast, stirring frequently, until fragrant, around 2 minutes. Pound and grind the *makhwaen* with a mortar and pestle to a coarse powder. Add the dried chilies and bouillon powder, pounding and grinding to a coarse powder. Add the lemongrass and cilantro roots, pounding and grinding to a coarse paste. Add the shallots, garlic, and turmeric, pounding and grinding to a coarse paste. Add the shrimp paste and pound and grind to a fine paste.

Prepare the soup: If using a whole chicken, use a knife to remove the legs and wings. Separate the drumsticks from the thighs, and using a cleaver, chop the drumsticks, thighs, and wings through the bone in sections about 1 inch wide. Halve the breast lengthwise and chop each half into sections about 1 inch wide. Halve any of the larger gizzards.

Heat the oil in a large stockpot over medium-low heat. Add the curry paste and fry, stirring occasionally, until fragrant and amalgamated and the oil begins to rise, about 5 minutes. Stir in the chicken and 2 quarts of water, raise the heat to high, and when it begins to boil, reduce the heat to medium and simmer, uncovered, for 15 minutes.

Using a vegetable peeler, remove the luffa's stringy ridges and fibrous green exterior. If using small angled luffa, halve lengthwise; if using long luffa, halve lengthwise and cut into sections around 1 inch long.

When the chicken has begun to firm up and the infused oil has risen to the top, increase the heat to medium-high and add the luffa. Reduce the heat to maintain a simmer, stirring occasionally, until the luffa is tender, around 10 minutes. Stir in the salt, wild betel leaf, and the reserved chopped cilantro. Simmer for 5 minutes.

Taste, and adjust the seasoning if necessary; the *kaeng manoi sai kai* should be salty, meaty, and fragrant (the latter from the *makwaen* and wild betel leaf).

Remove to a large serving bowl and serve warm, with sticky rice, as a northern Thai celebratory meal.

Burning Season

Anywhere else, I might have felt compelled to alert the authorities. I was driving on a rural highway in Phrae, and extending along the side of the road was an uncontrolled brush fire, spouting flames several feet high. The smoke was so thick I could barely see the bend ahead, but there were no firefighters, seemingly no effort to contain or combat the fire. Yet what may have looked like a catastrophe to me is, during a certain time of year in northern Thailand, simply the norm, a disturbing scenario I would witness several other times in the course of writing this book.

Every year between February and April, during Thailand's dry season that precedes the monsoon rains, much of the north becomes a smoky environmental nightmare known colloquially as the burning season. Ask locals why so much burning goes on in northern Thailand and the stock response is that villagers set fire to the forests to encourage the growth of *het thawp*, a valuable mushroom that is said to thrive in ashy soil. Had this question been asked a decade or two ago, the blame probably would have fallen on Thailand's hill tribes, many of whom practice swidden, or slash-and-burn agriculture. But in recent years, yet another culprit has emerged: corn.

In contemporary northern Thailand, corn has emerged as a prolific and valuable commodity, used both for animal feed and biofuel. Yet the grain's ubiquity has been exacerbated by the powerful agricultural conglomerates that both produce and purchase it. Operating under contracts with farmers, these companies provide both seed and fertilizer—for which farmers don't need to pay until after the crops have been sold—as well as a guaranteed market price for the grain. Add to this the fact that corn can be harvested after only a few months, and for struggling farmers these incentives are often too good to turn down. In 2015, Thailand produced 5.1 million tons of corn, much of which was grown on land that was cleared by burning; the crop also leaves behind a massive amount of agricultural residue that is generally discarded by burning. As a result, vast swathes of Nan and Phrae Provinces—the former once home to some of Thailand's greatest density of forest, the latter previously associated with golden teak—today resemble a hilly, hazy version of the American Midwest. But the burning doesn't impact only northern Thailand's rural areas: cases of skin and respiratory ailments among urban residents of the north are among the highest in Thailand, and in recent years, the seasonal haze has become so thick that occasional flights to and from Chiang Mai—a river basin that, unfortunately for its residents, does an excellent job of retaining smoke—must be canceled.

At the time of this writing, a decrease in the market price of corn and public dissatisfaction with the smoke are indications of potential for change. But the deeply entrenched culture of burning and the power and impunity of agricultural conglomerates mean that northern Thailand most likely has many more burning seasons to come.

Khanom Jiin

Northern Thailand is rice country, and sticky rice rules just about every meal. But if you pried deep enough, I suspect that many northern Thais might reveal a furtive allegiance to noodles. Specifically, to *khanom jiin*.

Taking the form of thin, pale, round threads, *khanom jiin* are made from a dough of long-grained rice.

"They should be fragrant, sticky, and soft," explains Thongchai Pongsakja, a producer of the noodles in Mae Lan, in rural Phrae Province, when I asked him to describe the ideal *khanom jiin*. "They should be very fine—the width of a toothpick."

The noodles were probably introduced by the Mon, an ethnic group who inhabited the area known today as northern Thailand long before the Thai arrived on the scene; *khanom jiin* is the Thai pronunciation of the Mon words that mean, approximately, "cooked threads of rice flour." "They go way back, before Chinese-style noodles," Thongchai tells me.

Making *khanom jiin* is a labor-intensive and time-consuming process, one that can span more than a week. "In the past, it took a lot of people to make the noodles, but today we can use machines to do the same job," explains Thongchai, who sells as much as three hundred pounds of *khanom jiin* a day from his home-based factory. An additional hitch is that *khanom jiin* are served fresh, never dried, meaning that they're extremely perishable and generally have to be eaten the same day they're made. Given the time and effort that goes into producing the noodles, not to mention their brief shelf life, it's hardly surprising that *khanom jiin* were formerly relegated to celebratory meals and special occasions. Today, however, they're among the cheapest and most ubiquitous dishes in the country.

Across Thailand, *khanom jiin* are served with toppings that range from watery, herbal soups to thick, rich curries. But in northern Thailand, the noodles are generally associated with one thing: *naam ngiaw* (see pages 189 and 239), a hearty soup likely of Shan origin that combines pork and tomatoes.

"It's a dish that's somewhere between a meal and a snack," says Thongchai of *khanom jiin*, perhaps honing in on what might be their most appealing aspect. "You can eat them at any time: breakfast, lunch, or dinner."

Making *khanom jiin* involves the following:

1. Uncooked long-grained rice is ground into a fine flour.
2. The flour is combined with water and allowed to ferment in airtight jars for between three days and a week.
3. The dough is bundled into cheesecloth bags, which are pressed overnight to extract water.
4. The masses of dough are then boiled in water until the exterior is soft yet the interior remains uncooked.
5. The boiled rice dough is put in an electric mixer that beats and whips it until it has a light, almost airy consistency somewhere between marshmallow creme and shortening (in the past this was done with a large wooden mortar and pestle).
6. The noodles are formed by extracting the dough through a metal plate with small holes into simmering water. After a few seconds, when the noodles are sufficiently firm and float to the surface, they're fished out of the water, drained, and rinsed several times.
7. The finished *khanom jiin* are neatly folded into handful-sized bundles known as *jap*.

3

6

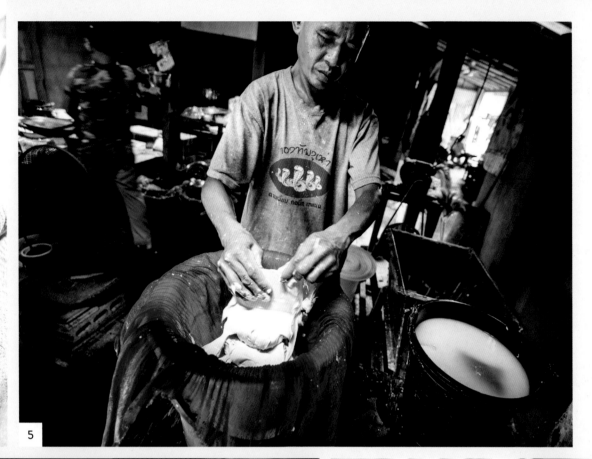

5

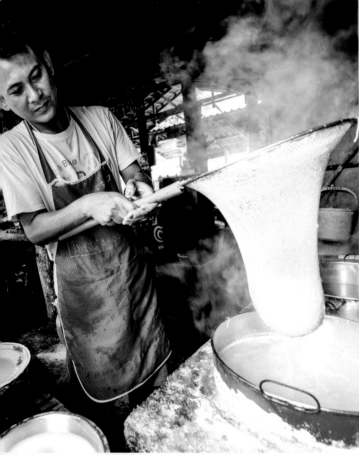

7

Khanom Jiin Naam Phrik Naam Yawy

ขนมจีนน้ำพริกน้ำย้อย

A DRY DRESSING OF CHILI, GARLIC, AND SHALLOTS FOR THIN RICE NOODLES

SERVES 4 TO 6

Thongchai Pongsakja was in the *khanom jiin* business, producing hundreds of pounds of the thin, round rice noodles daily. He sold them to markets and restaurants in and around his adopted hometown of Mae Lan, in Phrae Province.

Now, everybody in northern Thailand knows that *khanom jiin* are sold fresh, not dried, and as such are generally eaten the same day they're made. Yet as someone so close to the process, Thongchai knew that the really fresh stuff—as in, made seconds ago—was even better.

"Freshly cooked *khanom jiin* are more fragrant," explains the thirty-eight-year-old, a native of Thailand's northeast. "They have the same smell as steamed rice. And they're softer."

So Thongchai decided to loop the chain and open his own restaurant, serving his house-made *khanom jiin* with the porky, tomatoey broths that most frequently accompany the noodles in Phrae and Nan. But noting that his just-cooked noodles still held quite a bit of moisture, he was inspired to do something a bit different.

"Chili powder is a normal condiment for *khanom jiin*," explains Thongchai of the stuff found on the table of every noodle restaurant in Thailand. But he had the idea to supplement the staple with deep-fried garlic and shallots, salt, and MSG, arriving at *naam phrik naam yawy*, a dry, crumbly, savory, pleasantly oily garnish that acts as the perfect foil for his fresh, fragrant, moist noodles—essentially turning the condiment into the main course.

"You should eat it with boiled vegetables," explains Thongchai of his invention. "It's also especially good with a hard-boiled egg and deep-fried pork rinds."

Thongchai's *naam phrik naam yawy* is quite heavy on the MSG; this ingredient can be reduced or omitted, if desired. As this recipe makes more than enough topping for one large meal, any remaining can be bundled up tightly and kept in the refrigerator for as long as a couple weeks; just don't be surprised if you find yourself eating it by the spoonful or sprinkling it on plain rice. Also, note that fresh *khanom jiin* noodles are generally not available outside of Southeast Asia. If cooking in the United States, Andy Ricker of Pok Pok suggests using fine-gauge dried *bún*, Vietnamese rice noodles, following the cooking instructions on the package.

Using a mortar and pestle, pound and grind the dried chilies to a relatively fine powder. Remove and set aside. Add the garlic and pound and grind to a very coarse paste.

Heat the oil and shallots in a wok over medium-high heat. Fry for 5 minutes, stirring frequently. Add the garlic and fry, stirring frequently, until the shallots and garlic are golden, crispy, toasted, and fragrant, another 10 minutes. Turn off the heat, and while the ingredients are still hot, pour them through a sieve, saving the infused oil for another use. Return the garlic and shallots to the wok, and add the chili powder, salt, and MSG (if using), stirring to combine. The mixture should taste savory, salty, and spicy (in that order), and should be fragrant from the chili and garlic.

Top each 100- to 150-gram / 3½- to 5¼-ounce serving of *khanom jiin* noodles with a heaping tablespoon of the chili topping. Serve with the vegetables and other sides and condiments, as desired.

For the Chili Topping

40 medium dried chilies (20 grams / ⅔ ounce total; see page 325)
100 grams / 3½ ounces Thai garlic (or 20 standard garlic cloves, peeled)
1 cup vegetable oil
200 grams / 7 ounces shallots, peeled and sliced thinly
1 scant teaspoon table salt
1 scant teaspoon MSG (optional)

For Serving

600 grams / 1⅓ pounds cooked *khanom jiin* noodles
200 grams / 7 ounces long beans, cut 3 inches long, parboiled until just tender
200 grams / 7 ounces water spinach, cut 2 inches long, parboiled until just tender
3 eggs, hard-boiled and halved (optional)
160 grams / 5½ ounces deep-fried pork rinds (see page 70; optional)
fish sauce

THAI KITCHEN TOOLS

granite mortar and pestle
medium wok (approximately 12 inches)

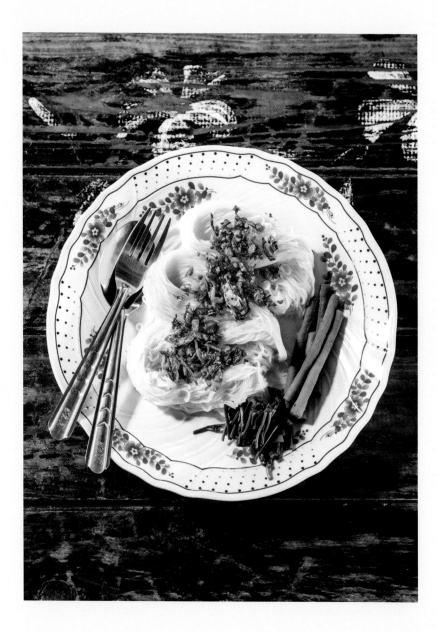

Khanom Sen Naam Muu & Khao Som

ขนมเส้นน้ำหมูกับข้าวส้ม

PHRAE-STYLE PORK BROTH SERVED
WITH THIN RICE NOODLES AND/OR
TOMATO RICE

SERVES 4 TO 6

Thai food is generally about a balance of multiple flavors, fragrances, and textures, typically stemming from a complex array of ingredients and seasonings. In this type of culinary environment, it's the simple dishes that stand out. And there might be no better example of this in northern Thailand than *khanom sen naam muu*, fresh rice noodles served in a broth of little more than pork bones, tomatoes, and a couple fragrant herbs.

"The flavor comes from the bones," explains Chanida Homkhachorn, chef/owner of Khanom Sen Paa Net, a long-standing restaurant in Phrae that serves the dish. She told me this while stationed behind two immense pots of simmering pork ribs, joint bones, and meaty neck and back bones, an oversized ladle in hand, her face intermittently obscured by clouds of steam. "Cooking them slowly brings out the flavor—it's like ramen stock."

Indeed, the broth that Chanida and her family have been making for four generations is relatively clear, lending it an almost Japanese minimalism. The dish is essentially a local take on *khanom jiin naam ngiaw* (see page 189), the tomatoey noodle soup found across the region, but the version sold here and elsewhere in Phrae and Nan eschews the richness, oiliness, spiciness, and tartness of the more famous version for an almost pure, unadulterated meatiness.

"I don't want to add too many ingredients," adds Chanida. "It's already savory and sweet from the pork bones, and fragrant from the cilantro root and garlic."

Chanida will also fish a couple of the meaty, steaming pork bones out of the stock and serve them with *khao som*, rice mixed with tomatoes and a bit of salt, a combination so understated and simple that it hardly seems Thai.

Because this recipe essentially makes two dishes, it's appropriate for a big meal. However, you can certainly choose to serve the soup with either the tomato rice or the noodles rather than both. Note that fresh *khanom jiin* noodles are generally not available outside of Southeast Asia, and if cooking in the United States, Andy Ricker of Pok Pok suggests using fine-gauge dried *bún*, Vietnamese rice noodles, following the cooking instructions on the package.

Note: When cooking rice, the ideal amount of water may vary depending on the type of rice and personal preference, generally somewhere between 1:1 rice to water to 1:1.5. Feel free to vary the amount of water in this recipe to your preference.

RECIPE CONTINUES

For the Soup

8 garlic cloves (40 grams / 1½ ounces total), peeled
1 bunch cilantro (50 grams / 1½ to 2 ounces total), stems and roots chopped coarsely (you should have 30 grams / 1 ounce of stems and roots), leaves chopped and set aside
1 tablespoon lard
1.3 kilograms / 3 pounds pork bones (an equal mix of rib, joint, neck/back bones), the larger bones cut into 3-inch sections
100 grams / 3½ ounces ground pork
250 grams / 9 ounces pork blood cake, 1-inch cubes
10 large cherry tomatoes (250 grams / 9 ounces total), halved
2 teaspoons table salt

For the Crispy Pork Fat and Garlic Garnish

50 grams / 1½ ounces Thai garlic (or 10 standard garlic cloves, peeled)
¼ cup lard
150 grams / 5¼ ounces pork back fat, 1-inch cubes

For the Tomato Rice (optional)

500 grams / 18 ounces uncooked long-grained rice
600 grams / 1⅓ pounds tomatoes, seeded and quartered
1 teaspoon table salt

For Serving

600 grams / 1⅓ pounds cooked *khanom jiin* noodles
200 grams / 7 ounces pickled mustard greens (see page 327), chopped
200 grams / 7 ounces cabbage, shredded
150 grams / 5¼ ounces mung bean sprouts
fish sauce
chili powder

THAI KITCHEN TOOLS
granite mortar and pestle
medium wok (approximately 12 inches)

Prepare the soup: Using a mortar and pestle, pound and grind the garlic and cilantro roots and stems to a coarse paste.

Heat the lard in a large stockpot over medium heat. Add the pounded aromatics and fry, stirring frequently, until fragrant, about 1 minute. Add the bones and 2 quarts of water, and increase the heat to medium-high. When the mixture begins to simmer, reduce the heat to low. Simmer, with the lid on, for 1 hour. Remove and discard any larger meatless joint bones, and add the ground pork, blood cake, cherry tomatoes, and salt. Simmer, uncovered, until the pork and tomatoes are tender, about 30 minutes.

Taste, adjusting the seasoning if necessary; the *naam muu* should be meaty, savory, and salty (in that order), and fragrant from the garlic and cilantro root.

Prepare the crispy pork fat and garlic garnish: While the soup is simmering, use a mortar and pestle to pound and grind the garlic to a coarse paste. Heat the lard in a wok over medium-low heat. Add the pork fat and fry, stirring occasionally, until the fat has rendered and the pork is just starting to turn golden, about 10 minutes. Add the pounded garlic and fry, stirring occasionally, until the mixture is golden, crispy, and fragrant, about another 20 minutes. Remove to a heatproof container and cool, reserving 1 teaspoon of lard for the tomato rice, if making.

Make the optional tomato rice: While the soup is simmering, rinse the rice well and cook in a rice cooker with 2½ cups of water. When the rice is done, allow it to rest, with the lid on, for 15 minutes. Heat the 1 teaspoon of lard from the pork fat–garlic garnish in a wok over medium-high heat. Add the tomatoes, 1 teaspoon of salt, and 1 cup of water, and bring to a boil, stirring and pressing until most of the liquid has reduced, leaving a tomato sauce–like mixture, about 5 minutes. Reduce the heat to medium-low and add the still-hot rice, stirring until the rice has absorbed the tomatoes and any residual liquid, about 3 more minutes. Return the rice to the rice cooker or a bowl, covered, to keep it warm and moist.

To serve, place 100 to 150 grams / 3½ to 5¼ ounces of cooked *khanom jiin* noodles in a bowl and top with 1 cup of the soup, garnishing with a couple cubes of the pork fat and a teaspoon or so of the pork fat–garlic garnish. Serve with sides, including the reserved chopped cilantro. Alternatively (or additionally), serve the soup alongside the tomato rice (if using), also garnished with a teaspoon or so of the crispy pork fat and garlic, accompanied by a plate of the bones.

White Gold

Ban Bo Luang, in Nan, was where I had my first taste of dog. Yet it was in the form of a curry so utterly spicy and herbaceous that I can't rightly claim to know what the meat tastes like.

The occasion was perhaps as odd as the dish. The dog had been killed as an appeasement to the spirits that are said to oversee this tiny, landlocked community's unique resource: wells that produce salty water.

In most places, unpotable water would not be a cause for celebration. But the residents of Ban Bo Luang, located approximately three hundred miles as the crow flies from the nearest sea, have turned this otherwise unfortunate circumstance into a treasure.

"They used to call it 'white gold,'" explains Sriwan Khatngangam, a native of Ban Bo Luang, of his village's unique commodity. "People came here from everywhere to buy salt."

As an ingredient, salt is so cheap and ubiquitous these days that it's often overlooked. But in landlocked northern Thailand, centuries before a journey to the sea ceased to be a major expedition, it was valuable stuff.

Mentions of Ban Bo Luang and its wells go back as far as the fifteenth century, when the village's salt was offered as a tribute to the Chiang Mai–based kings of the former Lan Na kingdom. Later, the salt wells made Ban Bo Luang a stopover on the caravan route of traders from Laos and southern China—those with even less access to the sea than the northern Thai.

The village remains home to two primary wells (the eponymous *bo luang*) from which salty water is pulled out by the bucketload and poured into vast ceramic jars. The water is then redirected into several surrounding bamboo huts, each of which is equipped with dual clay ovens topped with large woks. The salty water is poured into the woks, a fire is lit beneath, and as the water reduces and crystals form, the salt is scooped into hanging bamboo baskets to drain. As the fires need to be stoked on a regular basis, the huts are equipped with cots—not to mention radios, dishes, and girlie posters.

"When I'm making salt I have to stay overnight to add wood to the fire and to make sure the pans don't break," explains Sriwan, a salt gatherer for the last two years. He told me this while seated on a cot inside his hut, which was soot-stained, smoky, and uncomfortably hot. "It gets warm in there—too hot during the day—but during the winter I'm at an advantage!"

When I ask him if he fears that the salty water could ever run out, the sixty-three-year-old replies, "I don't think the salt will ever run out, but the people who make it might. These days, the kids here go to school, then they want to get a job somewhere else."

As old as the harvesting of salt is, so are the beliefs and traditions that surround the practice.

"The wells are owned by the spirits, not people," explains Khiaw Sonlao, eighty-three, a native of Ban Bo Luang and an authority on the village's wells and the lore and ceremonies that surround them.

Khiaw explains that chief among the spirits that look after the wells is Jao Luang Bo, for whom a ceremony, known locally as *buang suang*, is held every year. To appease Jao Luang Bo, a dog and twelve chickens are sacrificed on an annual basis—the source of my dog curry. Every second year a pig is sacrificed, and every third, a buffalo.

"The spirits who look over the well prefer different kinds of meat," explains Khiaw, laughing.

Because it's a place with such commercial and spiritual significance, Khiaw explains that there's a host of rules and protocol surrounding the wells: salt is not to be extracted during the three months of Buddhist Lent or during other important religious holidays; only local men are allowed to take water from the wells; and the water must never be removed from the village.

"The year we got electricity in the village, a man came at night and took water from the well," explains Khiaw. "Later, his bus crashed, and twenty people died!"

Today, those making the trek to Ban Bo Luang are tourists, not mule caravans. Yet they remain drawn to the village's unique commodity, buying the salt as a souvenir—a new role for an ancient resource.

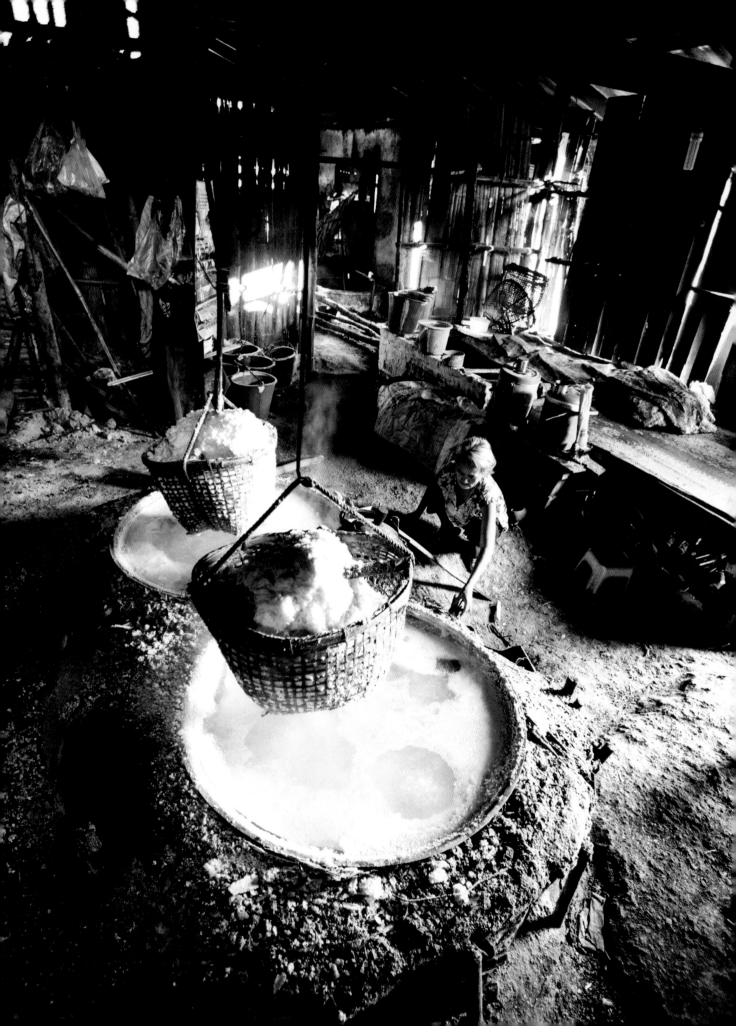

Yam Pii

ยำปี้

NORTHERN-STYLE *TOM YAM* SOUP WITH BANANA BLOSSOM AND CHICKEN

SERVES 4 TO 6

"It's like *tom yam*," offered Thongphian Pana, drawing parallels between the dish she was making and one of Thailand's most famous culinary exports. "But in central Thailand they use lots of lime juice; this dish isn't sour at all."

Thongphian, a member of a ladies' agricultural collective in the village of Ban Hat Pha Khon, in Nan Province, was seated on the floor, stripping the purple outermost leaves from a missile-like banana blossom. She was prepping for *yam pii*, a northern take on Thailand's legendary spicy/sour soup that, paradoxically, eschews the tart.

Whereas *tom yam* gets its kick from lime juice, *yam pii* relies on the distinctly northern Thai fragrance of *makhwaen*, a much-loved dried spice, and the subtle, pleasant astringency of banana blossom. And rather than the prawns that have virtually come to define *tom yam* in and around Bangkok, the northern version revolves around scrawny-but-tasty free-range chicken.

It may sound like a different dish altogether, but the soup manages to retain the essential elements of its *tom yam*–ness: the unmistakably classic Thai fragrances of lemongrass, galangal, and kaffir lime leaves; a unique fish-sauce-derived saltiness; and an overt spiciness that's rare in northern Thai cooking.

This celebratory dish is typically made with a whole chicken, but a two-pound bird is a rarity outside of Thailand, so consider going with a smaller chicken split in half lengthwise or two pounds of chicken parts.

Prepare the soup: Using a knife, separate the legs, wings, feet, and head from the chicken (discard the head and feet, if desired). Split the breast in half lengthwise, retaining the gizzards. Add the chicken, lemongrass, galangal, half of the kaffir lime leaves, and 2 quarts of water to a large stockpot over high heat. Bring to a boil, reduce the heat, and simmer for 10 minutes.

Remove and discard the exterior, purple layers of the banana blossoms until you've reached the pale core; you should end up with about 500 grams / 18 ounces of banana blossoms. Halve them lengthwise and rub with lime juice to prevent discoloring. Add the banana blossoms to the broth. Simmer until the chicken is cooked through and the banana blossoms are soft, about 20 more minutes.

Prepare the curry paste: While the soup is simmering, use your fingers to pinch and rub the *makhwaen* to separate the seeds and husks. Add the husks, discarding as many of the seeds as possible, to a mortar and pestle, along with the salt and chilies. Pound and grind the mixture to a fine powder. Add the garlic and pound and grind to a fine paste. Heat the oil in a small saucepan over low heat. Add the paste and fry, stirring constantly, until fragrant and toasted, 4 to 5 minutes.

Remove the chicken and banana blossom from the broth. When cool enough to handle, shred the meat from the chicken, discarding the skin and bones. Discard any dark or coarse banana blossom segments, halve the banana blossoms lengthwise, and shred the halves into strips about ½ inch wide. Strain the broth.

Return the chicken and banana blossom to the broth. Over medium heat, bring to a simmer and add the reserved curry paste, the remaining kaffir lime leaves, and the fish sauce.

Taste, adjusting the seasoning if necessary; the *yam pii* should taste equal parts spicy and salty, and should be fragrant from the curry paste.

Remove the soup to a serving bowl and garnish with the sawtooth cilantro. Serve warm or at room temperature, with sticky rice, as part of a northern Thai meal.

For the Soup
1 kilogram / 2¼ pounds whole free-range chicken or chicken parts
2 stalks lemongrass (50 grams / 2 ounces total), exterior tough layers peeled, green section discarded, pale section bruised
25 grams / 1 ounce galangal, peeled and sliced
10 kaffir lime leaves
2 small banana blossoms (1 kilogram / 2¼ pounds total)
juice of 1 lime
¼ cup fish sauce
1 small bunch sawtooth coriander (20 grams / ⅔ ounce total), sliced finely

For the Curry Paste
1 tablespoon *makhwaen* (see page 326)
¼ teaspoon table salt
8 medium dried chilies (4 grams total; see page 325)
12 grams / ½ ounce Thai garlic (or about 3 standard garlic cloves, peeled)
1 tablespoon vegetable oil

THAI KITCHEN TOOLS
granite mortar and pestle

Tam Makhuea

ตำมะเขือ

A POUNDED SALAD OF GRILLED EGGPLANT

SERVES 4

I watched the vendors, an aged couple at Nan's evening market, make several orders of *tam makhuea*, a savory, smoky northern Thai salad of grilled eggplant. They had a system, and it went like this: the husband worked the grill, roasting the long green eggplants over bright red coals until fragrant and charred. He would peel off the burnt exterior and toss the limp, steaming vegetable onto an adjacent cutting board. His wife would then coarsely chop the eggplant before tossing it in a large wooden mortar and bashing it up with chili, garlic, fish sauce, and MSG.

These steps are basically all that's involved in making *tam makhuea*, yet I noticed that no two orders were the same. This is because the dish, like other *tam* (Thai-style pounded salads), is seasoned to taste. In practice this usually refers to the number of chilies, but some customers may choose to omit the dish's pungent *plaa raa* (unfiltered fish sauce) or other ingredients. As such, the amounts provided in this recipe are a baseline; if you like it spicy, add another chili or two; if you don't like MSG, omit it: that's also part of the system.

4 green Japanese eggplants
(600 grams / 21 ounces total)
6 medium fresh chilies (12 grams /
½ ounce total; see page 324)
5 grams Thai garlic (or 1 standard
garlic clove, peeled)
2 teaspoons fish sauce
1 teaspoon unfiltered fish sauce
(*plaa raa*; see page 325)
¼ teaspoon MSG (optional)
a few sprigs cilantro (5 grams total),
chopped
1 small bunch mint (15 grams /
½ ounce total)

THAI KITCHEN TOOLS
Thai-style charcoal grill or barbecue
clay mortar and wood pestle

Using a Thai-style charcoal grill, light the charcoal and allow the coals to reduce to high heat (approximately 450°F to 550°F, or when you can hold your palm 3 inches above the grilling level for 2 to 4 seconds). Using a fork, poke holes in the eggplant and grill until fragrant, limp, and charred, approximately 5 minutes on each side. Remove from the grill and cool. Remove the grate; skewer and grill the chilies directly over the coals, turning frequently, until fragrant and slightly charred, about 2 minutes.

When cool enough to handle, peel the eggplant and chilies, discarding their burnt exteriors. Chop the eggplant roughly.

With a mortar and pestle, pound the chilies and garlic to a rough paste. Add the eggplant, fish sauce, unfiltered fish sauce, and MSG (if using). Pound and grind until the seasonings are distributed and the mixture has the consistency of a chunky paste.

Taste, adjusting the seasonings if necessary; the *tam makhuea* should taste equal parts spicy, salty, and smoky.

Remove to a serving dish, garnish with cilantro, and serve with a side of mint and sticky rice as part of a northern Thai meal.

Khao Tom Bo

ข้าวต้มโบ๊ะ

BANANA LEAF PARCELS OF STICKY RICE AND BANANA

SERVES 4 TO 6

One of the things I appreciate the most about northern Thai cuisine is its wariness of sugar, a trait that extends even to its sweets.

Take *khao tom mat*, sticky rice and some sort of supplement—typically banana, but also beans or peanuts—bundled up in a banana leaf and steamed or simmered in water. Eat the sweet in just about any corner of Thailand and you'll get a short tube of sticky rice that has been made rich with coconut milk and sweet with sugar. Any corner, that is, except for the north.

"The rice should have a slightly salty flavor," explains Suay Koetsap, the source of this recipe and member of an agricultural collective in Ban Hat Pha Khon, Nan Province, of the local take on *khao tom mat*. "The sugar and coconut are served on the side."

Purchase *khao tom bo*, as the sweet is known in Nan (*bo* being a dialect word meaning "divided," a reference to the fact that the sweet is sold in pairs or bundles), in the north, and the banana leaf package will be unwrapped, the sticky rice tube sliced into thick rings and garnished with sugar and freshly grated coconut meat. This undoubtedly goes back to the days when coconut milk and sugar were not always available in northern Thailand. But it also has the benefit of allowing the eater to have a say in the degree of sweetness, the grains of sugar and the coconut flesh also providing the snack with a pleasant crunchiness.

Note that Suay uses a small, fragrant variety of banana known as *kluay naam waa*. If cooking outside of Thailand, larger bananas can be used, as long as they're ripe and aromatic.

RECIPE CONTINUES

500 grams / 18 ounces uncooked sticky rice

1 teaspoon table salt

10 small, ripe Thai bananas (or 500 grams / 18 ounces of standard bananas)

10 feet of banana leaf, or as needed

1 large pandan leaf, tied into a knot (it's easier to handle this way)

150 grams / 5¼ ounces unsweetened, shredded coconut meat

¼ cup white sugar

Wash the sticky rice in several changes of water and drain. In a large bowl, add the salt to the sticky rice, stirring to combine.

Peel and halve the bananas lengthwise, and cut them into sections about 3 inches long.

Prepare the banana leaves as described opposite. To each section of banana leaf, add a scant ¼ cup of the sticky rice. Dip a section of banana in the sticky rice so that some rice clings to it, and put it on top of the rice. Fold the banana leaf as illustrated. Repeat with the remaining ingredients; you should end up with approximately 12 banana leaf bundles.

Add the banana leaf bundles, the pandan leaf, and enough water to cover by several inches to a large stockpot over high heat. Bring to a boil, reduce heat to a rapid simmer, and simmer until the sticky rice is soft, about 25 minutes. Drain and discard the water, and allow the banana leaf packages to cool.

When cool enough to handle, remove a sticky rice bundle from its banana leaf wrapper and cut, if desired, into sections ½ inch thick. Serve on a small plate, garnished with a generous pinch of the coconut meat and 1 scant teaspoon of sugar (or to taste), as breakfast or a sweet snack.

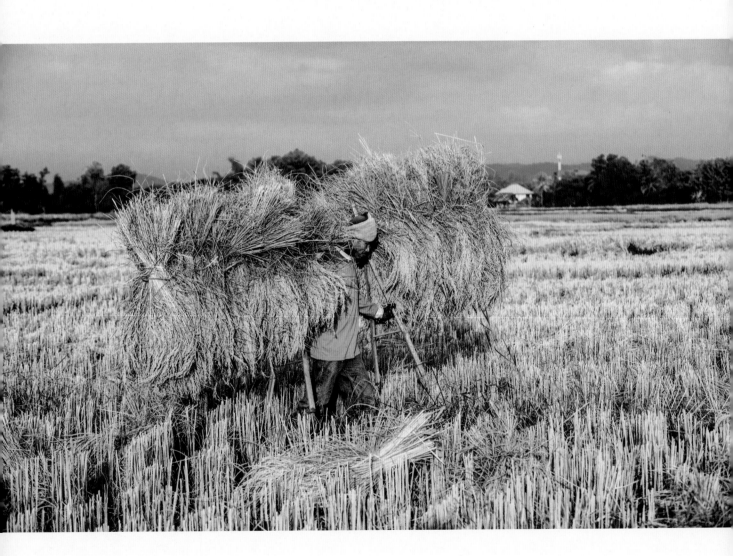

HOW TO *Fold Banana Leaf for Khao Tom Bo*

In doing this particular banana leaf fold, it's important to seal the rice and banana completely so that water doesn't enter, yet you must also avoid wrapping too tightly, as the rice will swell slightly when cooked. You will also want to avoid any tears in the banana leaf, otherwise the rice will leak out.

1. Cut the banana leaf into 12 sections approximately 8 inches wide × 10 inches long. Trim off each of the 4 corners. Holding the banana leaf in your left hand, add the rice and banana to the center.

2. Fold the left-hand side of the banana leaf over the rice.

3. Make a narrow crease at the edge of the right-hand side of the banana leaf, and lay over the first fold.

4. Pinch the banana leaf just below the rice and pull the far end toward your body, across the length of the package.

5. Hold the banana leaf package vertically to compact the rice, and fold the opposite end over the previous fold.

6. Bind the package with a thin strip of bamboo or a rubber band.

7. Combine 3 banana leaf packages, wrap a strip of banana leaf around the bundle, and bind it with a strip of bamboo or rubber bands.

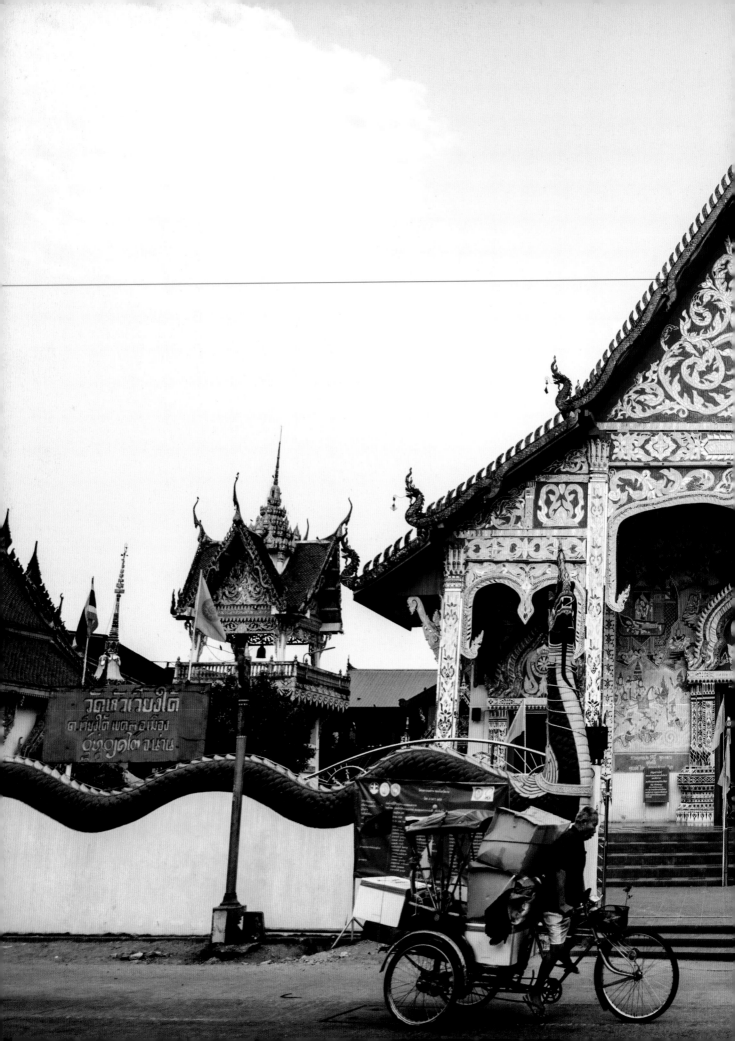

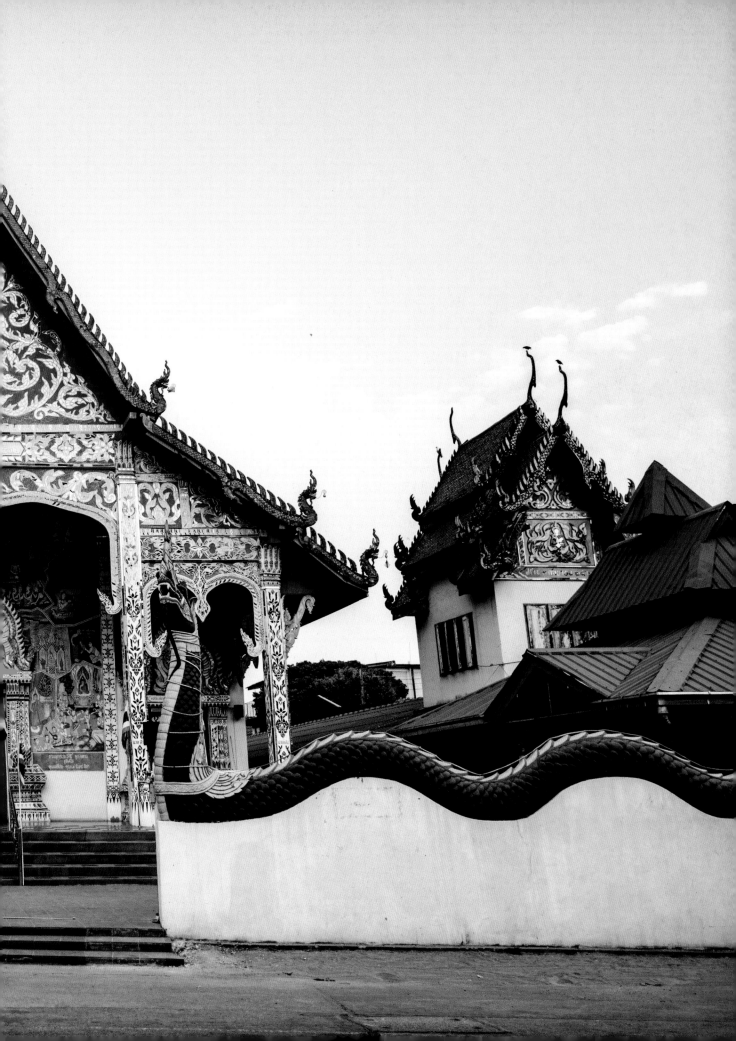

Northern Thai Ingredients: Guide and Glossary

First, the good news: many of the recipes in this book revolve around Southeast Asian staples that nowadays are generally available if you have access to a relatively well-stocked Asian grocery store or even a globally minded supermarket. If your local Asian market has fresh lemongrass and galangal, a decent selection of fresh and dried chilies, shrimp paste, turmeric powder, and non-Japanese–style soy sauce, or if you can shop online, you should have no problem in making quite a few of the dishes in this book.

That said, some of the recipes include pretty obscure ingredients that, frankly, one would struggle to source even in Bangkok. In my effort to compile an accurate snapshot of the cuisine of northern Thailand, I've made no exceptions, recording exactly the ingredients that the folks on the ground use. If there's a substitution that I feel doesn't compromise the integrity of a dish, I've mentioned it in the recipes. But for many obscure ingredients, especially northern Thailand's fresh herbs and vegetables, there simply aren't any viable alternatives, and my practical suggestion is to approach such recipes as references or perhaps even inspiration.

For ingredients both obscure and common, I've created this glossary. It's relatively exhaustive, as some staple items, such as rice or chilies, can take shapes and forms specific to northern Thailand. As other ingredients will most likely be entirely unfamiliar, I've included English-language names, scientific nomenclature, and Thai names, as well as substitutions, if available. Online sources for Thai ingredients include ImportFood.com, TempleofThai.com, ThaiGrocer.com, and even Amazon.com.

ANGLED LUFFA (*Luffa acutangula*) / *buap liam, manoi* / บวบเหลี่ยม, มะนอย The fruit of this gourd is long and dark green, with a relatively coarse exterior (the elevated, stringy ridges and the dark green skin need to be peeled before cooking) and a spongy interior that has relatively little flavor. (When dried, the interior of the loofah, as it's also known, is used as a scrubbing sponge.) Angled luffa can grow as long as eight inches, but in northern Thailand, a smaller version, as short as two inches, is common.

ASIAN PENNYWORT (*Centella asiatica*) / *bua bok, phak nawk* / บัวบก, ผักหนอก A round-leafed, green, slightly astringent-tasting herb that flourishes in wet areas, it's used as a side to *laap* or sliced thinly and used in salads in the province of Mae Hong Son.

BALINESE OR JAVANESE LONG PEPPER (*Piper retrofractum*) / *diiplii* / ดีปลี Related to black pepper yet with a more fragrant, slightly sweeter flavor, long pepper is a flowering vine, the fruit of which is used both fresh and dried.

BITTER TOMATO (*Solanum aethiopicum*) / *makhuea khom* / มะเขือขม A fruit that looks like a cross between a tomato and an eggplant, it's yellowish-green and bitter-tasting. The Akha and other hill tribes in northern Thailand eat it as a side.

BLACK SHARKMINNOW (*Labeo chrysophekadion*) / *plaa kaa* / ปลากา Not a shark but rather a relatively large freshwater fish common in northern Thailand, this is typically used to make *laap*.

BLOOD / *lueat* / เลือด Uncooked blood features in a handful of northern Thai meat-based recipes. Pork blood is the most common, but chicken and beef blood are also used. Also common are tofu-like cakes of steamed pork or chicken blood, an almost obligatory ingredient in *khanom jiin naam ngiaw*

(see page 189), a northern Thai-style noodle soup. In the United States, blood is sometimes available, frozen, at Chinese and Korean grocery stores.

BOUILLON POWDER OR CUBES / *sup kawn* / ซุปก้อน Bouillon powder, usually Knorr or RosDee brand chicken flavor, is a ubiquitous ingredient in contemporary northern Thailand, providing dishes with a touch—or more—of salt and umami.

CHA-OM (*Senegalia pennata, Acacia pennata*) / ชะอม Sometimes known in English as acacia or wattle, these are the leaves of a tropical plant with a pale green color and a pungent flavor. Generally only the youngest, most tender leaves are eaten.

CHILIES
A variety of chilies, both fresh and dried, are used in the northern Thai kitchen.

FRESH
- **Small fresh chilies** / *phrik khii nuu sot, phrik tae sot* / พริกขี้หนูสด, พริกแต้สด Known often in English as bird's eye chilies, these are short (often less than one inch long), red or green, typically very spicy chilies. In northern Thailand, they're predominately used as an optional side or in stir-fries.

- **Medium fresh chilies** / *phrik dueay kai* / พริกเดือยไก่ Common in the northern Thai kitchen are "cockspur chilies," long, thin, generally spicy, green or red chilies. In terms of size, there's some overlap with *phrik khii nuu sot*, and they can range from approximately one and a half to three inches long. They're most frequently used, raw or grilled, in northern Thai-style curry pastes.

- **Large fresh chilies** / *phrik num sot* / พริกหนุ่มสด Undoubtedly the most ubiquitous and beloved chili in the north are these long (approximately six inches), slender, relatively thick-skinned, pale green (but sometimes red) chilies. They can range in flavor from mild to hot, and are generally grilled before being included in dishes. *Phrik num sot* are unavailable outside of northern Thailand,

although Andy Ricker, in his book *Pok Pok*, writes that Hungarian wax, goat horn, and Anaheim chilies can serve as substitutes.

DRIED

-**Dried *phrik kariang* chilies** / *phrik kariang haeng* / พริกกะเหรี่ยงแห้ง So-called Karen chilies (named after an ethnic group who live in northern Thailand) are short (typically one inch or less), broad-shouldered, and are among the spiciest chilies used in Thailand. They're used more as an optional side or garnish than as an ingredient in curry pastes. If unavailable, any hot, small dried chili can be substituted. For more on this ingredient, see page 266.

-**Medium dried chilies** / *phrik haeng* / พริกแห้ง These shortish (generally less than three inches long), slender, hot chilies are typically used to provide a spicy flavor to curry pastes and dips. In the United States, chiles de árbol serve as a good substitute.

-**Large dried chilies** / *phrik num haeng* / พริกหนุ่มแห้ง These long (typically between four and six inches), relatively mild chilies, are often used to provide a red color and slightly spicy flavor to curry pastes and dips. In the United States, puya chilies are a substitute.

CHINESE ONION (*Allium chinense*) / *hawm chuu* / หอมชู The young bulbs of this variety of onion are a common ingredient in Akha cookery. The long roots, which have a spicy flavor, are pickled by the Chinese, and eaten raw, as a side, among the Shan.

CILANTRO (*Coriandrum sativum*) / *phak chii* / ผักชี The fresh leaves of the herb also known as coriander are one of the most common garnishes in northern Thailand. The roots (and sometimes the stems) also make their way into some curry pastes, as do the dried seeds, which are generally referred to as coriander seed.

COCONUT MILK/CREAM / *kathi/hua kathi* / กะทิ/หัวกะทิ This is the fatty liquid pressed from the grated flesh of mature coconuts, not the clear water found inside young, green coconuts. The richer coconut cream is obtained via the first pressing and generally is only used in sweets; coconut milk is obtained via the second pressing and is used in a variety of dishes, savory and sweet. Note that this coconut cream is very different from the cans of "cream of coconut" that come presweetened; when purchasing it for Thai cooking, make sure there is no added sugar in the ingredients.

If available, fresh coconut milk and cream are far superior to coconut milk and cream in ultra-high-temperature (UHT) processing or canned form. If you're buying processed coconut milk, ensure that it contains no emulsifiers, which can prevent the oil from separating (a desired result in some dishes).

COTTON TREE FLOWERS (*Bombax ceiba*) / *dawk ngiw* / ดอกงิ้ว The dried stamen of the cotton tree flower is a common ingredient in northern Thai soups, despite the fact that it has little, if any, flavor. The flowers are added to *khanom jiin naam ngiaw* and other soupy dishes more for their texture than their flavor. There's no substitute for *dawk ngiw*, and if you can't find them, it's fine to omit them from the recipe. If you can get them, boil them in water for fifteen minutes, or until tender, before using.

FISH SAUCE / *naam plaa* / น้ำปลา This central Thai staple is essentially the liquid extracted from salted anchovies. Despite the name, it's salty, rather than fishy, in flavor, and in northern Thailand, it's generally used in conjunction with other seasonings, often as a finishing seasoning to provide a boost of salt and umami, or as the main ingredient in certain dips.

To avoid lesser quality fish sauce, which has been produced via multiple pressings, and which can also contain food colorings and other additives, simply look for the most expensive brand you can find, which typically will still be a bargain.

FISH SAUCE, UNFILTERED / *plaa raa* / ปลาร้า A seasoning made from freshwater fish that are fermented with salt and rice or rice bran, *plaa raa* has an assertively pungent odor and a salty, fishy flavor. *Plaa raa* takes three forms: chunks of fermented fish, the liquid they're in, or a mixture of both. The latter is the most common type in northern Thailand, and although the three forms are roughly interchangeable, it's important to taste for saltiness if substituting.

If cooking in the United States, Andy Ricker, of Pok Pok, suggests the Pantainorasingh brand.

GALANGAL (*Alpinia galangal*) / *khaa* / ข่า A pale, fragrant, ginger-like rhizome native to Southeast Asia, it is less spicy than ginger and has a honey scent and a distinct flavor that some find similar to soap. The coarse, stringy mature root is pounded up in curry pastes and included in soups, while the tender young root can be julienned and added to salads or other dishes. Ginger and dried galangal slices or powder are not recommended substitutes.

GARLIC (*Allium sativum*) / *krathiam, hawm khao* / กระเทียม, หอมขาว In northern Thailand, cooks prefer tiny (generally around a half inch long) cloves of "Thai" garlic, which are fragrant and don't need to be peeled. But large cloves of so-called Chinese or standard garlic similar to those available in the United States are increasingly common. The recipes indicate which kind has been used, but in theory, if going by mass, they're more or less interchangeable. (When the recipes call for cloves of "standard" garlic, assume that a medium-sized clove weighs five grams.)

GARLIC, PICKLED / *krathiam dawng* / กระเทียมดอง Some northern Thai recipes include Thai pickled garlic, which is preserved in a sweet, tart liquid (which itself is also used to season dishes). It's generally available at Asian markets.

HANG LAY POWDER / *phong hang lay, phong masala* / ผงฮังเล, ผงมะสล่า A spice mixture, derived from Indian masala, that is common in the Shan cooking of Mae Hong Son Province; it's an obligatory ingredient in *kaeng hang lay*, a rich pork curry of Burmese/Shan

origin. For more on this ingredient, see page 216.

HOLY BASIL (*Ocimum tenuiflorum*) / *bai kaphrao* / ใบกะเพรา Not to be confused with Thai basil, the fresh leaves of this herb are thinner and paler (they can range in color from green to purple), and have a spicier flavor.

Thai or Italian basil are not substitutes for the recipes in this book, and I don't recommend using the dried leaves or powder that is sometimes sold at Asian markets outside of Thailand.

IRIDESCENT SHARK (*Pangasianodon hypophthalmus*) / *plaa sawaay* / ปลาสวาย This is not a shark at all, but rather a type of catfish native to Southeast Asia. In northern Thailand, swai or Siamese shark, as it's also known, is smoked and used in a handful of chili-based dips.

IVY GOURD LEAVES (*Coccinia grandis*) / *tamlueng* / ตำลึง The young, tender leaves of the ivy gourd can be flash-fried or parboiled and eaten with *naam phrik* (chili-based dips) or included in soups.

JACKFRUIT (*Artocarpus heterophyllus*) / *khanun, banun* / ขนุน บะหนุน When ripe, the world's largest tree-borne fruit takes the form of an immense green pod encasing yellow, waxy-looking segments with a flavor similar to that of Juicy Fruit gum. In northern Thailand, immature jackfruit (which is relatively flavorless on its own) is boiled before being used in a variety of soups and salads.

JAPANESE EGGPLANT (*Solanum melongena*) / *makhuea yaao* / มะเขือยาว The pale green version of this slender eggplant is a common ingredient in northern Thailand, typically grilled and used in salads or included in soups and curries.

KABOCHA SQUASH, JAPANESE PUMPKIN (*Cucurbita maxima*) / *fak thawng* / ฟักทอง With a green exterior, yellowish-orange flesh, and a slightly sweet flavor, this squash is used in a variety of soups and stir-fries in northern Thailand, or steamed or boiled and coupled with *naam phrik* (spicy chili-based dips).

KAFFIR LIME (*Citrus hystrix*) / *makruut* / มะกรูด This citrus has a fruit with a knobbly green exterior; the rind of the fruit is used in some northern Thai curry pastes, while the leaves of the tree are a common ingredient in soups, providing them with a fragrant, citrusy odor.

LABLAB, HYACINTH BEANS (*Lablab purpureus*) / *thua taep, thua paep* / ถั่วแตบ, ถั่วแปบ These pastel green and/or purple beans, actually the pods of a flowering plant, are parboiled before being used in local dishes in Mae Hong Son Province. They're similar in flavor and texture to green beans or long beans.

LEMON BASIL (*Ocimum × citriodorum*) / *maenglak* / แมงลัก A delicate, extremely fragrant leaf most commonly associated with central Thai cuisine, lemon basil makes a few appearances in the northern Thai kitchen.

LEMONGRASS (*Cymbopogon citratus*) / *takhrai* / ตะไคร้ This fragrant stalk, with a vivid citrusy aroma, features in a number of northern Thai dishes, most commonly as an ingredient in curry pastes. Generally the outermost layers are peeled and discarded, and only the more fragrant, white, lower part of the stalk is used.

Fresh lemongrass is relatively common in the United States nowadays, meaning that there's no reason to use the flavorless dried stuff that is sometimes sold in supermarket spice aisles.

MAGGI Actually a brand name, in northern Thailand it has become the catchall name for a family of salty, umami-heavy, wheat-based seasonings, with a flavor somewhat similar to soy sauce.

MAKHWAEN (*Zanthoxylum limonella* Alston) / *makhwaen, makhaen, baakhaen* / มะแขว่น, มะแข่น, บ่าแข่น The fruit of an evergreen shrub related to Sichuan pepper and prickly ash, *makhwaen* has no colloquial English-language name. It's typically dried and used in meat-based dishes, providing them with a strong citrusy, floral, almost pine-like fragrance and a subtle numbing sensation. You're unlikely to find *makhwaen* at your local market, but it is increasingly available online; if you can't find it by its name, you might search for "Thai Sichuan pepper powder." For more on this ingredient, see page 18.

MALAEP (*Heracleum siamicum* Craib) / *malaep* / มะแหลบ Native to northern Thailand, and without an English-language name, the dried, flat, oval-shaped fruit of this plant is used in spice mixtures to lend dishes a slightly sour flavor, citrus-like fragrance, and a slight numbing sensation. For more on this ingredient, see page 291.

MONOSODIUM GLUTAMATE (MSG) / *phong chuu rot* / ผงชูรส Ubiquitous, beloved, and frankly, to my taste, over-used in contemporary northern Thailand is this seasoning, which imparts dishes with an umami, or round, meaty flavor. The Ajinomoto brand and its flat crystals have a near monopoly in northern Thailand.

MSG can be omitted, although if you're convinced of the dangers of monosodium glutamate, I suggest reading Jeffrey Steingarten's excellent article for *Vogue*, "Why Doesn't Everyone in China Have a Headache?"

NONI LEAVES (*Morinda citrifolia*) / *bai yaw* / ใบยอ The leaves of the noni tree are often used as a seasoning in *haw nueng* (steamed banana leaf packets) to provide an earthy fragrance.

NOODLES

—**Khanom jiin noodles** / *sen khanom jiin, khaom sen, khao sen* / เส้นขนมจีน, ขนมเส้น, ข้าวเส้น These are thin, round fresh noodles made via a labor-intensive and time-consuming process of soaking grains of rice, then grinding, pounding, boiling, and extruding them; see page 304 for details on how *khanom jiin* are made.

Outside of Thailand, *khanom jiin* are generally not available, and an approximate substitute are fine-gauge dried *bún* (Vietnamese rice noodles).

—**Thin, flat rice noodles** / *sen lek* / เส้นเล็ก These thin rice-based noodles are available in dried or fresh form.

—**Wide, flat rice noodles** / *sen yai* / เส้นใหญ่ *Sen yai* can be up to one inch wide, but in these recipes, the term generally refers to those less than a half inch wide.

—**Round wheat-and-egg noodles** / *bamii* / บะหมี่ These fresh noodles are used in a variety of dishes of Chinese origin.

—**Flat wheat-and-egg noodles** / *sen khao soi* / เส้นข้าวซอย As the Thai name indicates, these fresh noodles are used almost exclusively in *khao soi* (curry noodle soup), although standard

round wheat-and-egg noodles serve as an acceptable substitute.

PALM SUGAR / *nam taan piip, nam taan buek* / น้ำตาลปี๊บ, น้ำตาลบึก A sweetener made from the sap of the sugar or nipa palm (or coconut palm) tree, which has been reduced and whipped. It's sold in the form of a soft paste (*nam taan piip*) or hard mounds (*naam taan buek*). This is yet another central Thai product that, in recent decades, has become relatively commonplace in the north.

PANDAN LEAF (*Pandanus amaryllifolius*) / *bai toei* / ใบเตย The fresh green leaves of this tropical plant, also known as screw pine, impart sweet dishes with a subtle fragrance similar to that of white bread or jasmine rice. Like bay, the leaves themselves aren't eaten and are usually removed before serving.

I don't recommend using the dried leaves, sometimes sold at Asian markets, as they have little flavor, though the frozen leaves are acceptable.

PAPAYA (*Carica papaya*) / *malakaw* / มะละกอ Unlike the fragrant ripe fruit, unripe green papaya has little flavor but an appealing crunch. Shaved into strips, it's a staple in *som tam*, a type of pounded salad, and in Mae Hong Son Province, it's combined with a seasoned batter and deep-fried.

PEA EGGPLANT (*Solanum torvum*) / *makhuea phuang* / มะเขือพวง Those pea-sized, round, slightly astringent-tasting eggplants are used in a variety of northern Thai dishes, often to accompany *naam phrik* (chili-based dips).

PHAK KHANAENG (*Brassica oleracea*) / ผักแขนง A type of young cabbage with no colloquial English name, *phak khanaeng* is typically stir-fried, or in the city of Chiang Khong, parboiled and served as a side with noodles. Outside of Thailand, Brussels sprouts can be used as an approximate substitute.

PICKLED MUSTARD GREENS / *phak kaat dawng* / ผักกาดดอง Pickled (or preserved) mustard greens are served as a side with nearly all northern Thai noodle dishes. They can range in flavor from

tart to sweet; for the purposes of this cookbook, you'll generally want the latter, available in plastic-wrapped form from Thailand. Yunnanese-style pickled mustard greens (see page 113) are generally sweet in flavor, have been seasoned with chili and/or other dried spices, and are eaten among the Chinese, Muslims, and Shan.

RAU RĂM (*Persicaria odorata*) / *phak phai* / ผักไผ่ This herb, also known as Vietnamese cilantro or mint, has small, slender green leaves and a strong, almost licorice-like taste and fragrance.

RICE

-**Sticky rice** / *khao niaw, khao nueng* / ข้าวเหนียว, ข้าวนึ่ง The staple carb of northern Thailand, these are short, stocky grains of rice that are cooked by steaming over water, not boiling. For more on sticky rice, see page 54. Outside of Thailand, sticky rice is also labeled as glutinous or sweet rice—not to be confused with Japanese sweet or glutinous rice, which is an entirely different product.

-**Long-grained rice** / *khao suay* / ข้าวสวย The staple carb of central and southern Thailand is long grains of rice that are cooked by "steaming" (really boiling) in water. There are several varieties of long-grained rice, but outside of Thailand the most commonly available is jasmine rice, a higher quality, more fragrant strain.

RICE FLOUR, STICKY RICE FLOUR / *paeng khao jao, paeng khao niaw* / แป้งข้าวเจ้า, แป้งข้าวเหนียว Flours, ground from long-grained or sticky rice, are used in different ways, typically in desserts or as batter for deep-fried dishes. When cooking with rice flours, volume can vary immensely, so it's essential to measure by weight.

SANTOL (*Sandoricum koetjape*) / *krathawn* / กระท้อน This fruit is native to Southeast Asia and has a vaguely peach-like flavor and fragrance. The unripe fruit is sometimes added to *kaeng hang lay*, a northern Thai pork curry, to provide it with a tart flavor, or it's used in pounded salads.

SAWTOOTH CORIANDER (*Eryngium foetidum*) / *phak chii farang* / ผักชี่ฝรั่ง Also known as culantro, this is a relatively coarse, fragrant herb with a flavor roughly similar to cilantro that's typically eaten whole as a side, or sliced very thinly and used as a garnish for soups or *laap*.

SHALLOTS / *hawm daeng* / หอมแดง An essential ingredient in nearly all curry pastes in northern Thailand, most cooks in the region use tiny (less than one inch in diameter), fragrant shallot bulbs. If cooking outside of northern Thailand, simply try to find the smallest shallots possible, and rely on the recipe's weight measurements, not the number of shallots.

SHRIMP PASTE / *kapi* / กะปิ A central Thai ingredient that, over the last several decades, has become a staple in northern Thailand, this pungent paste of tiny shrimp or krill is included in curry pastes to provide a savory, salty flavor. In northern Thailand, some cooks use *kapi kung*, which is off-white or pinkish in color, and is made from larger shrimp. If shopping at Asian grocery stores outside of Thailand, look for the most expensive Thai brand available; it's usually an indicator of higher quality.

SMALL SCALE MUD CARP (*Cirrhinus microlepis*) / *plaa nuanjan* / ปลานวนจันทร์ Another freshwater fish that is typically used to make *laap* in northern Thailand.

SNAKEHEAD FISH (*Channa*) / *plaa chawn* / ปลาช่อน A freshwater fish that's consumed across Thailand; in the north it's often dried and included in *naam phrik* (chili-based dips).

SOYBEAN-BASED SEASONINGS

- **Black soy sauce** / *sii iw dam* / ซีอิ๊ว ดำ This is soy sauce that has been supplemented with molasses and fermented longer, making it darker, sweeter, slightly bitter, and thicker in texture than white soy sauce.

- **Sweet soy sauce** / *sii iw waan* / ซีอิ๊วหวาน Seasoned with even more sugar and/or molasses than black soy sauce, this soy sauce has a sweeter flavor and a slightly thicker consistency.

- **White soy sauce** / *sii iw khaao* / ซีอิ๊ว ขาว Also known in English as "light" soy, this is the standard soy sauce most of us are familiar with. Yet it's worth noting that this ingredient has a substantially different flavor than the Japanese soy sauces available in the United States and elsewhere, such as Kikkoman. Instead, look for a Thai brand such as Healthy Boy or Maekrua.

- **Green cap soy sauce** / *sawt prung rot faa khiaw* / ซอสปรุงรสฝาเขียว One of the most popular all-around seasonings in contemporary northern Thailand is white soy seasoned with sugar and salt, sometimes called "seasoning sauce." Sugar and salt give it a balanced flavor, making it a go-to for stir-fries. Look for Healthy Boy or Golden Mountain brands.

- **Fermented soybeans** / *thua nao* / ถั่วเน่า Whole soybeans that have been fermented are used in a handful of Shan and Thai Lue dishes. *Natto* (Japanese-style fermented soybeans) work as an approximate substitute.

- **Fermented soybean disks, fermented soybean powder** / *thua nao khaep/thua nao phaen, thua nao phong* / ถั่วเน่า แข็บ /ถั่วเน่าแผ่น, ถั่วเน่าผง Soybeans that have been fermented, pressed into thin disks, and dried are known as *thua nao khaep*; when the disks are toasted and ground into a powder, this is *thua nao phong*. The former is included in curry pastes as a savory filler, the latter used in salads in the province of Mae Hong Son. For more on how these northern Thai staples are made, see page 227.
 Outside of northern Thailand, Thai-style fermented soybeans, bottled or in the form of a paste, can be used as an approximate substitute

for either, although their higher salt content will have an impact on seasoning.

- **Salted fermented soybeans, fermented soybean paste** / *tao jiaw* / เต้าเจี้ยว Soybeans that have been fermented, seasoned with salt, and left whole or ground to a paste are often used in stir-fries, or in northern Thailand, used in *khanom jiin naam ngiaw*, alongside or instead of fermented soybean disks.

TAMARIND PULP / *makhaam piak* / มะขาม เปียก This is the fruit—typically including the fibers and seeds—of a sour variety of tamarind that has been dried and compressed into blocks. To use, mix the dried pulp with hot water and strain it, which results in a thick liquid that provides dishes with a tart flavor.

THAI EGGPLANT (*Solanum melongena*) / *makhuea praw* / มะเขือเปราะ Golf-ball-sized eggplants, white and pale green in color, and with a slightly astringent flavor, are often eaten raw as an accompaniment to meat dishes or *naam phrik* (chili-based dips).

THAI MELON (*Cucumis melo*) / *taeng thai* / แตงไทย This particularly fragrant melon is used in Thai sweets. Its counterpart outside of Southeast Asia is the muskmelon.

TURMERIC (*Curcuma longa*) / *khamin* / ขมิ้น Turmeric is a root with a bright orange color, a slightly astringent flavor,

and a mustard-like aroma. In northern Thailand, the raw root is used in some soups and curry pastes. In the province of Mae Hong Son, dried turmeric powder features in several dishes.

WATER SPINACH (*Ipomoea aquatica*) / *phak bung* / ผักบุ้ง A crunchy, semiaquatic vegetable also known as *kangkong* or morning glory, it's an ingredient most commonly associated with central Thailand, but it does feature in a handful of northern dishes.

WILD BETEL LEAF (*Piper sarmentosum*) / *chaphluu* / ชะพลู Despite its English name, the leaves of this plant in the pepper family are not related to betel. In northern Thailand, the fragrant green leaf is often torn and used in a variety of herbal soups, including *kaeng khae* (the dialect term for the leaf is *khae*, leading some to posit that this is the origin of the dish's name).

VEGETABLE FERN / *Diplazium esculentum* / *phak kuut* / ผักกูด: A type of edible fern, abundant during the rainy season, and consumed in a variety of salad-type dishes in the province of Mae Hong Son or flash-fried elsewhere. Outside of the region, young fiddlehead ferns can serve as a substitute.

YU CHOY (*Brassica rapa* var. *parachinensis*) / *phak kaat khiaw, phak kaat kwaang tung, phak kaat jaw* / ผักกาดเขียว, ผักกาดกวางตุ้ง ผักกาดจอ This member of the Brassica family is sometimes referred to as choy sum or Chinese flowering cabbage. The plant has yellow flowers, and the leaves can be slightly spicy. In northern Thailand, yu choy is used in soups or steamed and eaten with chili-based dips.

Bibliography

Barreto, Luis Filipe. *Ploughing the Sea: The Portuguese and Asia*. Lisbon: Comissão Nacional para as Comemorações dos Descobrimentos Portugueses, 2000.

Cummings, Joe. *Chiang Mai & Northern Thailand*. Footscray, Australia: Lonely Planet, 2002.

Ehlers, Otto E. *On Horseback Through Indochina*. Volume 2, *Burma, North Thailand, the Shan States, and Yunnan*. Translated by Walter E. J. Tips. 1894. Reprint, Bangkok: White Lotus Press, 2001.

Forbes, Andrew, and David Henley. *The Haw: Traders of the Golden Triangle*. Chiang Mai, Thailand: Asia Film House, 1997.

Freeman, Michael. *Lanna: Thailand's Northern Kingdom*. London: Thames and Hudson, 2001.

Goodman, Jim. *The Akha: Guardians of the Forest*. Chiang Mai, Thailand: Teak House, 1997.

Kunstadter, Peter, E. C. Chapman, and Sangha Sabhasri, eds. *Farmers in the Forest: Economic Development and Marginal Agriculture in Northern Thailand*. Honolulu: University Press of Hawaii, 1978.

Le May, Reginald. *An Asian Arcady: The Land & Peoples of Northern Siam*. 1913. Reprint, Bangkok: White Lotus Press, 1986.

Lertchavalitsakul, Busarin. "Khao Soi: Food Transformation Reflecting Multiple Ethnic Identities in Chiang Mai City, Thailand." Chiang Mai, Thailand: Chiang Mai University.

Lewis, Paul, and Elaine Lewis. *Peoples of the Golden Triangle*. London: Thames and Hudson, 1984.

Ongsakul, Sarassawadee. *History of Lan Na*. Edited by Dolina W. Millar and Sandy Barron. Translated by Chitraporn Tanratanakul. Chiang Mai, Thailand: Silkworm Books, 2005.

Penth, Hans. *A Brief History of Lān Nā*. Chiang Mai, Thailand, Silkworm Books, 2004.

Ricker, Andy, with JJ Goode. *Pok Pok: Food and Stories from the Streets, Homes, and Roadside Restaurants of Thailand*. Emeryville, CA: Ten Speed Press, 2013.

Schliesinger, Joachim. *Tai Groups of Thailand*. Volume 1, *Introduction and Overview*. Bangkok: White Lotus Press, 2001.

Seetisarn, Manu. *Irrigated Agriculture in Northern Thailand*. Chiang Mai, Thailand: Chiang Mai University, 1974.

ก้นข้าวขันโตก ศ. สาลูมาตรา เกษมบรรณกิจ พ.ศ. 2511

เส้น วากำกิ น งานกิจกรรมวิชาการ «เชียงใหม่»: อดีตปัจจุบัน อนาคต พ.ศ. 2539

ข้าวสำรับมอญ องค์ บรรจุน สำนักพิมพ์มติชน พ.ศ. 2556

สูตรอาหารและขนมใต้ ชุมชนป๊อกตลาดเก่า พ.ศ. 2550

ผักพื้นบ้านภาคเหนือ โครงการพัฒนาตำรา สถาบัน การแพทย์แผนไทย พ.ศ. 2542

พจนานุกรมภาษาล้านนา สถาบันภาษา ศิลปะและ วัฒนธรรม มหาวิทยาลัยราชภัฏเชียงใหม่ พ.ศ. 2550

ลำปางหนา เหลียม ไพโรจน์ ไชยเมืองชื่น โรงพิมพ์ ตะวันออก พ.ศ. 2555

วัฒนธรรมการกินของคนเมือง : น้ำพริกและผักพื้น บ้านล้านนา ศูนย์ศึกษาความหลากหลายทางชีวภาพ ภูมิปัญญาท้องถิ่น พื่อการพัฒนา

สารานุกรมวัฒนธรรมไทย ภาคเหนือ รัตนา พรหม พิชัย และรังสรรค์ จันต๊ะ มูลนิธิสารานุกรม วัฒนธรรมไทย ธนาคารไทยพาณิชย์ พ.ศ. 2542

ห้องเรียนภูมิปัญญาล้านนา โฮงเฮียนสืบสาน ภูมิปัญญาล้านนา พ.ศ. 2548

อาหารพื้นเมืองจากวรรณกรรมล้านนา ฬปะ ป้ น เงิน

อาหารเหนือ ศรีสมร คงพันธุ์ สำนักพิมพ์แสงแดด

โอชะแห่งล้านนา สิริรักษ์ บางสุด เลวัฒน์ อารมณ์ สำนักพิมพ์แสงแดด พ.ศ. 2558

Acknowledgments

Thank you (in chronological order) to JJ Goode for holding my hand through the proposal process and especially for pointing me in the direction of Francis Lam and Clarkson Potter; to Kathy MacLeod for helping me put together such a stunning proposal and for making this book all the more beautiful with your support and illustrations; to Andy Ricker for his friendship, support, cooking advice, publishing advice, and the use of his kitchen(s) and home(s); to Natcha Butdee for her generous hospitality and frank recipe feedback; to Francis Lam for always pointing me in the right direction and for helping me make the book I wanted to make; to Andrea Slonecker for her excellent work on what must have been one of the most unusual recipe testing gigs she's ever tackled; to Marysarah Quinn for helping take the abstract ideas in my head and put them into book form; and to Christopher Wise for being a travel companion, for filming and photographing parts of this journey, and for lending his talented hand at the photo editing.

Thanks also to the people across Thailand who contributed recipes and information:

Achareeya Chapin, Lampang

Areerat Chowkasem, Mae Rim, Chiang Mai Province

Bualiaw Phanthong, Chiang Mai

Buatong Silamanee, Muang Pon, Mae Hong Son Province

Bunriang Jinnarat, Ban Hat Khrai, Chiang Rai Province

Bunsri Phisitsupharak, Pa Bunsri Restaurant, Lampang

Chai Kamnoetmongkhon, Ban Maneephruek, Nan

Chalada Chiwarak, Baan Sao Nak, Lampang

Chanakan Kamonthong, Ban Bua Chai, Nan Province

Chanida Homkhachorn, Khanom Sen Paa Net Restaurant, Phrae

Chanpen Boonyaoosaya, Lampang

Chuan Lolat, Ban Nong Bua, Nan Province

Chuleekorn Supana, Mae Hong Son

Decha Jankaew, Jaa Det Restaurant, Phrae

Duangporn Heepthong, Ban Mai, Chiang Mai Province

En Doenwilay, Chiang Rai

Iam Nanthanon, Pa Jang Restaurant, Mae Hong Son

Jenny Yokruji, Doi Chang, Chiang Rai Province

Assistant Professor Julispong Chularatana, Department of History, Chulalongkorn University, Bangkok

Khamhai Butdee, Ban Muang Jet Ton, Chiang Rai Province

Khampo Lueatmak, Mae Rim, Chiang Mai Province

Khemchira Arun, Ban Pha Bong, Mae Hong Son Province

Khiaw Sonlao, Ban Bo Luang, Nan Province

Kitti Leephaibun, Chiang Rai

Ladda Kangwannavakul, Chiang Rai Municipality, Chiang Rai

Lee Ayu Chuepa, Mae Chan Tai, Chiang Rai Province

Manaswat Chutima, Old Chiangmai, Chiang Mai

Manee Saelee, Ban Thoet Thai, Chiang Rai Province

Meelong Chermue, Mae Chan Tai, Chiang Rai Province

Miakhin Charoensuk, Muang Pon, Mae Hong Son Province

Nami-u Panbue, Ban Pa Miang, Chiang Rai Province

Nattapon Upama, San Pa Khoy Market, Chiang Mai Province

Nitaya Kruachinjoy, Lampang

Niwat Roykaew, Chiang Khong Mekong School of Local Knowledge, Chiang Khong, Chiang Rai Province

Nongkran Khuttiya, Pa Suk Restaurant, Chiang Rai

Pairoj Pasupe, Ban Huay Ha, Mae Hong Son Province

Pannika Tanjina, Pannika Tanjina Restaurant, Tha Ton, Chiang Mai Province

Pensri Rakwong, Ban Pa Miang Homestay, Lampang

Phairot Chaimuangchun, Lampang

Phaithoon Iamkrasin, Mae Hong Son

Phanee Thongsuk, Paa Lueang, Ban Thung Hong, Phrae Province

Phannee Khanthalak, Lampang

Phatsorn Rotklueng, Chiang Rai

Phimpha Kapchai, Mae Jaem, Chiang Mai Province

Prasert Pradit of the Tai Yai Studies Institute, Mae Hong Son

Prasit Khamsai, Laap Lung Eed Restaurant, Chiang Rai

Preecha Sirikun, Mae Hong Son

Ratchanee Kattiya, Salema Restaurant, Doi Mae Salong, Chiang Rai Province

Saeng-in Tatorngjai, Ban San Thang Luang, Chiang Rai Province

Saengduean Kamlangkla, Ban Pa Miang, Lampang Province

Saifon Khrueachinchoi, Lampang

Saiphin Suthana, Mae Suay, Chiang Rai Province

Sakul Moolkam, Senior Agronomist Researcher, Chiang Mai Rice Research Center

Samaen Kengphraiwan, Phen Restaurant, Mae Sariang, Mae Hong Son Province

Samlit Wongthip, Paa Maa Restaurant, Phrae

Sangwan Wongchai, Ban Sri Don Chai, Chiang Rai Province

Saowakhon Rattanachaichotikun, Mae Hong Son

Assistant Professor Dr. Sarawood Sungkaew, Faculty of Forestry, Kasetsart University, Bangkok

Seri Jaiya, Khun Manee, Lampang

Sira Prapa, Mae Ai, Chiang Mai Province

Siw Jern Sae Lee, Doi Mae Salong, Chiang Rai Province

Somjai Phantiboon, Pa Orn Restaurant, Chiang Khong, Chiang Rai Province

Somprattana Na Nan, Khum Ratchabut, Nan

Somphit Kaewphikun, Paew Restaurant, Lampang

Sripana Vongburi, Ban Vongburi, Phrae

Sriphin Kannika, Ban Bon Na, Chiang Mai Province

Sriwai Saengsawang, Chiang Rai

Sriwan Khatngangam, Ban Bo Luang, Nan Province

Suay Koetsap, Ban Hat Pha Khon, Nan Province

Sue Hai, Sue Hai Restaurant, Doi Mae Salong, Chiang Rai Province

Sujit Wichaisakunwan, Ban Pang Mu, Mae Hong Son Province

Sujitra Sakkaew, Rai Pian Karuna, Chiang Rai Province

Professor Suneemas Noree, Chiang Mai University

Suwaphee Tiasiriwarodom, Mae Hae Restaurant, Lampang

Surat Wangwaew, Sai Ua Mae Jan Dee Restaurant, Lampang

Surachet Trakulneungcharoen, Midnight Fried Chicken, Chiang Mai

Temsiri Wiyakaew, Khao Soi Jay Me Restaurant, Chiang Mai

Teng-u Somdet, Mae Hong Son

Thanyaphorn Wongthip, Paa Maa Restaurant, Phrae

Thawin Phimpha, Nong Ying, Ban Thoet Thai, Chiang Rai Province

Thongchai Pongsakja, Khanom Jiin Naam Yoy Restaurant, Mae Lan, Phrae Province

Thongphian Pana, Ban Hat Pha Khon, Nan Province

Thawin Phimpha, Nong Ying Restaurant, Ban Thoet Thai, Chiang Rai Province

Tim McGuire, Old Chiangmai, Chiang Mai

Toun Umpajak, Boklua View, Ban Bo Luang, Nan Province

Dr. Vithi Phanichphant, Lampang

Wanphen Jumpajan, Ton Kham Restaurant, Chiang Mai

Watcharaphong Krathomromprai, Ban Huay Ha, Mae Hong Son Province

Wichai Kamnoetmongkhon, Ban Maneephruek, Nan

Wijitra Momsri, Wiang Sa, Nan

Wimorn Penphaen, Chiang Rai

Witan Jinajul, Lampang

Wiwat Kanka, Jin Sot Restaurant, Phrae

Worakan Yuyangthai, Khao Soi Prince Restaurant, Chiang Mai

A NOTE ABOUT THE PHOTOGRAPHY: All the dish images in this book were shot on location, where they were prepared in northern Thailand, not in a studio. My primary camera was a Nikon D800, and when artificial lighting was necessary, I used an SB-900 strobe shot through a softbox.

Index

NOTE: Page references in *italics* indicate photographs.

A

Aalawaa Jong (Shan "Cake" of Toasted Wheat Flour), 254
Aep Awng Aw (Grilled Herbal Packets of Pork and Brains), 79–81, *81*
Akha tribe
 about, 95
 Akha cookery ingredients, 96
 naam phrik variations, 96
Alcohol, "white," 85–87
Aq Lul Tahq (Akha-Style Mashed Potatoes), 104
Asian pennywort
 Phak Nawk Saa (Mae Hong Son–Style Salad of Asian Pennywort), *222*, 225

B

Banana blossoms
 Khaang Pawng (Shan-Style Herbal Fritters), *242*, 243–44
 Taj Hpau Pauf (Karen Soup of Rice and Vegetables), *264*, 265–66
 Yam Pii (Northern-Style *Tom Yam* Soup with Banana Blossom and Chicken), *314*, 314–15
Bananas
 Khao Tom Bo (Banana Leaf Parcels of Sticky Rice and Banana), *318*, 319–21
Beef
 "dewdrop," about, 118
 Jin Kluea (Lampang-Style Sun-Dried "Beef"), 178–79, *179*
 Kaeng Awm Nuea (Rich, Herbaceous Beef Stew), 286–87
 Khao Soi Nuea (Muslim-Style Beef Khao Soi), *34*, 35–37
 Nuea Thup (Pounded Beef), *260*, 261
Buffalo, in Northern Thai cuisine, 89

C

Catfish, giant Mekong, about, 124
Chiang Mai Province
 buffalo markets in, 89
 "crab water" (*naam puu*) made in, 57
 deep-fried meats in, 68
 fermented meats made in, 62
 history of, 28–29
 khan toke dinners in, 61
 most famous food item, 30
Chiang Rai Province
 fishing industry in, 124
 hill tribes in, 95–100

history of, 92–93
 preserving foods in, 110
 rebel food in, 109
 Thai Lue communities in, 128
Chicken
 Haw Nueng Kai (Steamed Banana Leaf Packets of Chicken, Herbs, and Vegetables), *147*, 147–49
 Kaeng Manoi Sai Kai (Celebratory Curry with Luffa and Chicken), *299*, 299–300
 Kai Thawt Makhwaen (Chef Toun's Deep-Fried Chicken with *Makhwaen*), *292*, 293–94
 Khao Soi Yunnan ("Ancient" Khao Soi), *31*, 31–33
 Khua Khae Kai (Northern Thai–Style Stir-Fry of Chicken and Herbs), 175–76, *176*
 knees, about, 127
 Laap Kai (Prasit Khamsai's Chicken *Laap*), *125*, 125–27
 Up Kai Asii Pian (Shan-Style Aromatic Chicken Curry), 210–11, *211*
 Yam Pii (Northern-Style *Tom Yam* Soup with Banana Blossom and Chicken), *314*, 314–15
Chicken bowls, origins of, 191
Chilies
 Aq Lul Tahq (Akha-Style Mashed Potatoes), 104
 Khanom Jiin Naam Phrik Naam Yawy (Dry Dressing of Chili, Garlic, and Shallots for Thin Rice Noodles), 306–7, *307*
 Mal Qer Cael Tahq (Akha-Style Dip of Grilled Tomatoes and Chilies), 101
 Naam Phrik Awng (Northern Thai–Style Dip of Tomatoes and Ground Pork), 48–49
 Naam Phrik Khaep Muu (*Naam Phrik Num* with Pork Rinds), 44
 Naam Phrik Khing and Muu Yaang (Lahu-Style Dip of Grilled Ginger Served with Grilled Pork Belly), *102*, 102–103
 Naam Phrik Makhuea Som ("Red Eye" Chili Paste Fried with Tomatoes), 51
 Naam Phrik Num (Northern Thai–Style Dip of Grilled Chilies, Shallots, and Garlic), 42–43
 Naam Phrik Plaa Jii (*Naam Phrik Num* with Grilled Fish), 43
 Naam Phrik Taa Daeng ("Red-Eye" Chili Paste), 50–51
 Phat Muu Naam Khaang (Stir-Fry of "Dewdrop Pork" and Fresh Chili), *120*, 121

phrik kariang ("Karen"), about, 266
 in Thai naam phrik, 41
Coconut
 Khanom Paat (Celebratory Sweet of Coconut and Rice Flour), 196–97, *197*
 Khao Tom Bo (Banana Leaf Parcels of Sticky Rice and Banana), *318*, 319–21
Coconut cream
 Aalawaa Jong (Shan "Cake" of Toasted Wheat Flour), *250*, 254
 Suay Thamin (Shan-Style Sticky Rice "Cake"), *250*, 251
 thick and charred, on Shan-style sweets, 253
Cooking methods, 24
Corn production, in Northern Thailand, 303
Crab water, about, 57
Curry
 Kaeng Hang Lay (Burmese-Style Pork Curry), *164*, 165–66
 Kaeng Hang Lay Tai (Shan-Style Pork Belly Curry), *212*, 213–14
 Kaeng Ho (Stir-Fry of Glass Noodles and Leftover Curry), 167–69, *168*
 Kaeng Manoi Sai Kai (Celebratory Curry with Luffa and Chicken), *299*, 299–300
 Up Kai Asii Pian (Shan-Style Aromatic Chicken Curry), 210–11, *211*

D

Deep-frying meat, 68
Dips. *See* Naam Phrik
Doi Mae Salong cuisine, 109
Donuts
 Khao Muun Khuay (Shan "Donuts"), *255*, 255–56

E

Eggplant
 Tam Makhuea (Pounded Salad of Grilled Eggplant), 316, *317*
 Tam Som Oh (Pounded Salad of Pomelo and Crab Paste), *58*, 59–60
 Yam Makhuea Mathua (Pounded Salad of Eggplant and Long Beans), 141–42, *142*
Eggs
 Jin Som Mok Khai (Northern Thai–Style Fermented Pork Grilled with Egg), 64
 Naem Khua Kap Khai (Fermented Pork Stir-Fried with Egg), 66, *67*
 Phat Thai Muu (*Phat Thai* with Pork), 185–86, *187*

F

Fermented meats, 62
Ferns
 Phak Kuut Sanaap (Mae Hong Son–Style
 Salad of Vegetable Ferns), *222*, 224
Fish
 giant Mekong catfish, about, 124
 Laap Plaa (Grilled Fish *Laap* as Made in
 Wiang Sa), *280*, 280–81
 Naam Phrik Makhuea Som ("Red Eye"
 Chili Paste Fried with Tomatoes), 51
 Naam Phrik Plaa Jii (*Naam Phrik Num*
 with Grilled Fish), 43
 Naam Phrik Taa Daeng ("Red Eye" Chili
 Paste), 50–51
 Plaa Aep (Thai Lue–Style Herbal Grilled
 Fish), *129*, 129–30
Fritters
 Khaang Pawng (Shan-Style Herbal
 Fritters), *242*, 243–44
Frog
 Kaeng Khae Kop (Northern Thai–Style
 Soup of Mixed Vegetables and Herbs
 with Grilled Frog), 145–46, *146*

G

Garlic
 Khanom Jiin Naam Phrik Naam Yawy
 (Dry Dressing of Chili, Garlic, and
 Shallots for Thin Rice Noodles),
 306–7, *307*
 Naam Phrik Awng (Northern Thai–Style
 Dip of Tomatoes and Ground Pork),
 48–49
 Naam Phrik Khaep Muu (*Naam Phrik
 Num* with Pork Rinds), 44
 Naam Phrik Makhuea Som ("Red Eye"
 Chili Paste Fried with Tomatoes), 51
 Naam Phrik Num (Northern Thai–Style
 Dip of Grilled Chilies, Shallots, and
 Garlic), 42–43
 Naam Phrik Plaa Jii (*Naam Phrik Num*
 with Grilled Fish), 43
 Naam Phrik Taa Daeng ("Red Eye" Chili
 Paste), 50–51
Ginger
 Naam Phrik Khing and Muu Yaang
 (Lahu-Style Dip of Grilled Ginger
 Served with Grilled Pork Belly), *102*,
 102–103
Grilling favorites, 73
Grilling meats, 72

H

Hang lay powder, about, 216–17
Haw Nueng Kai (Steamed Banana Leaf
 Packets of Chicken, Herbs, and
 Vegetables), *147*, 147–49
Herbs
 Haw Nueng Kai (Steamed Banana Leaf
 Packets of Chicken, Herbs, and
 Vegetables), *147*, 147–49
 Khua Khae Kai (Northern Thai–Style
 Stir-Fry of Chicken and Herbs),
 175–76, *176*

Saq Byaev Toe Umvq (Akha-Style
 Grilled Loaf of Pork and Herbs), *106*,
 107
Het Nueng and Naam Phrik Khaa
 (Steamed Mushrooms Served with
 Galangal Dip), *152*, 153–54

I

Indigo shirts, origins of, 295
Ingredients
 glossary of, 324–28
 measuring, 23

J

Jackfruit
 Tam Khanun (Pounded Salad of Young
 Jackfruit), 138–40, *140*
Jaw Phak Kaat (Soup of Yu Choy Greens
 and Pork Ribs), 170, *171*
Jin Kluea (Lampang-Style Sun-Dried
 "Beef"), 178–79, *179*
Jin Som (Northern Thai–Style Fermented
 Pork), 63–64
Jin Som Mok Khai (Northern Thai–Style
 Fermented Pork Grilled with Egg),
 64

K

Kaeng Awm Nuea (Rich, Herbaceous Beef
 Stew), 286–87
Kaeng Hang Lay (Burmese-Style Pork
 Curry), *164*, 165–66
Kaeng Hang Lay Tai (Shan-Style Pork
 Belly Curry), *212*, 213–14
Kaeng Ho (Stir-Fry of Glass Noodles and
 Leftover Curry), 167–69, *168*
Kaeng Khae Kop (Northern Thai–Style
 Soup of Mixed Vegetables and Herbs
 with Grilled Frog), 145–46, *146*
Kaeng Manoi Sai Kai (Celebratory
 Curry with Luffa and Chicken), *299*,
 299–300
Kai Thawt Makhwaen (Chef Toun's Deep-
 Fried Chicken with *Makhwaen*), *292*,
 293–94
Karen village, 263, 266
Khaang Pawng (Shan-Style Herbal
 Fritters), *242*, 243–44
Khaep Muu (Deep-Fried Pork Rinds), *70*,
 70–71
Khanom Jiin
 how they are made, 304
 Naam Phrik Naam Yawy (Dry Dressing
 of Chili, Garlic, and Shallots for Thin
 Rice Noodles), 306–7, *307*
Khanom Bataeng (A Sweet of Fragrant
 Thai Melons), *155*, 155–57
Khanom Paat (Celebratory Sweet of
 Coconut and Rice Flour), 196–97,
 197
Khanom Sen Naam Muu & Khao Som
 (Phrae-Style Pork Broth Served with
 Thin Rice Noodles and/or Tomato
 Rice), *308*, 309–310

Khan toke dinners, 61
Khao Kan Jin (Shan-Style "Kneaded"
 Rice), *245*, 245–47
Khao Lueang and Nuea Lung (Yellow
 Sticky Rice with Shan-Style Herbal
 Pork Balls), *230*, 231–33
Khao Muun Khuay (Shan "Donuts"), *255*,
 255–56
Khao Sen (Shan-Style Noodle Soup with
 Pork and Tomato), *238*, 239–40
Khao Soi
 Naam Naa (Thai Lue–Style Rice Noodles
 in Pork Broth with a Savory Topping),
 134, 135–36
 Nuea (Muslim-Style Beef Khao Soi), *34*,
 35–37
 origins of, 30
 Yunnan ("Ancient" *Khao Soi*), *31*, 31–33
Khao Som (Shan-Style "Sour" Rice), *234*,
 234–35
Khao Taen Naam Taengmo (Deep-
 Fried Rice Cakes Seasoned with
 Watermelon Juice and Palm Sugar),
 192, 192–93
Khao Tom Bo (Banana Leaf Parcels of
 Sticky Rice and Banana), *318*, 319–21
Khua Khae Kai (Northern Thai–Style Stir-
 Fry of Chicken and Herbs), 175–76,
 177
Kitchen tools, 25
Kuaytiaw Naam Ngiaw (Rich Pork-Rib and
 Tomato Broth Served over Flat Rice
 Noodles), *189*, 189–90
Kuomintang (KMT), 109

L

Laap
 Kai (Prasit Khamsai's Chicken *Laap*),
 125, 125–27
 mincing meat for, 283
 Muu Khua (Phrae-Style Pork *Laap*),
 275–76
 phak kap (vegetables with *laap*), 277
 Plaa (Grilled Fish *Laap* as Made in
 Wiang Sa), *280*, 280–81
 spices for, 289–91
Lablab
 Thua Taep Ko (Mae Hong Son–Style
 Salad of Lablab [Hyacinth] Beans),
 222, 223
Lampang Province
 city food in, 162
 history of, 161
 miang (fermented tea leaves) made in,
 199–201
Lao khao (white alcohol), 85–87
Long beans
 Kaeng Ho (Stir-Fry of Glass Noodles
 and Leftover Curry), 167–69, *168*
 Yam Makhuea Mathua (Pounded Salad
 of Eggplant and Long Beans), 141–42,
 142
Luffa
 Kaeng Manoi Sai Kai (Celebratory
 Curry with Luffa and Chicken), *299*,
 299–300

M

Mae Hong Son Province
 fast food in, 236
 fermented dried soybean disks in,
 227–28
 history of, 205
 Karen village in, 263, 266
 local-style salads in, 222
 Shan-style food in, 206
 Shan-style staple ingredients, 208
 Shan-style sweets in, 249–50, 250
Makhwaen
 Kai Thawt Makhwaen (Chef Toun's
 Deep-Fried Chicken with
 Makhwaen), 292, 293–94
 trees, harvesting fruit from, 289
Mal Qer Cael Tahq (Akha-Style Dip of
 Grilled Tomatoes and Chilies), 101
Mangoes
 Tam Mamuang (Pounded Salad of Green
 Mangoes), 182, 183–84
Meats. *See also* Beef; Pork
 deep-fried, 68
 fermented, 62
 grilled favorites, 73
 grilling, 72
 mincing, for *laap*, 283
 preserving, Chinese-style, 110, 118
Melons
 Khanom Bataeng (Sweet of Fragrant
 Thai Melons), 155, 155–57
Miang (fermented tea leaves), how it is
 made, 199–201
Mortar and pestle, using, 47
Mushrooms
 Het Nueng and Naam Phrik Khaa
 (Steamed Mushrooms Served with
 Galangal Dip), 152, 153–54
 Khao Som (Shan-Style "Sour" Rice),
 234, 234–35
Mustard greens
 Muu Phan Pii ("Thousand-Year Pork"),
 114, 114–15
 Muu Sap Phat Kap Phak Dawng (Minced
 Pork Stir-Fried with Yunnanese-
 Style Pickled Mustard Greens), 116,
 117
 Phak Dawng (Yunnanese-Style Pickled
 Mustard Greens), 113
 preserving, Chinese-style, 110
Muu Naam Khaang ("Dewdrop Pork"), 119
Muu Phan Pii ("Thousand-Year Pork"), 114,
 114–15
Muu Sap Phat Kap Phak Dawng (Minced
 Pork Stir-Fried with Yunnanese-
 Style Pickled Mustard Greens), 116,
 117
Muu Yaang (Northern Thai-Style Grilled
 Pork), 76, 77–78

N

Naam Phrik
 in Akha tribe meals, 96
 Awng (Northern Thai-Style Dip of
 Tomatoes and Ground Pork), 48–49
 chilies used in, 41

Khaa and Het Nueng (Steamed
 Mushrooms Served with Galangal
 Dip), 152, 153–54
Khaep Muu (*Naam Phrik Num* with Pork
 Rinds), 44
Khing and Muu Yaang (Lahu-Style Dip
 of Grilled Ginger Served with Grilled
 Pork Belly), 102, 102–3
Makhuea Som ("Red Eye" Chili Paste
 Fried with Tomatoes), 51
Mal Qer Cael Tahq (Akha-Style Dip of
 Grilled Tomatoes and Chilies), 101
Naam Phak (Dip of Preserved Yu Choy
 Greens), 131–32, 133
Num (Northern Thai-Style Dip of
 Grilled Chilies, Shallots, and Garlic),
 42–43
Plaa Jii (*Naam Phrik Num* with Grilled
 Fish), 43
Taa Daeng ("Red Eye" Chili Paste),
 50–51
Naam puu, about, 57
Naem Khua Kap Khai (Fermented Pork
 Stir-Fried with Egg), 66, 67
Noodles
 Kaeng Ho (Stir-Fry of Glass Noodles
 and Leftover Curry), 167–69, 168
 khanom jiin, how they are made, 300
 Khanom Jiin Naam Phrik Naam Yawy
 (Dry Dressing of Chili, Garlic, and
 Shallots for Thin Rice Noodles),
 306–7, 307
 Khanom Sen Naam Muu & Khao Som
 (Phrae-Style Pork Broth Served with
 Thin Rice Noodles and/or Tomato
 Rice), 309, 309–10
 Khao Sen (Shan-Style Noodle Soup with
 Pork and Tomato), 238, 239–40
 Khao Soi Naam Naa (Thai Lue-Style
 Rice Noodles in Pork Broth with a
 Savory Topping), 134, 135–36
 Khao Soi Nuea (Muslim-Style Beef *Khao
 Soi*), 34, 35–37
 Khao Soi Yunnan ("Ancient" Khao Soi),
 31, 31–33
 Kuaytiaw Naam Ngiaw (Rich Pork-Rib
 and Tomato Broth Served over Flat
 Rice Noodles), 189, 189–90
 Phat Thai Muu (*Phat Thai* with Pork),
 185–86, 187
Northern Thailand. *See also specific
 provinces*
 brief history of, 15
 burning season in, 303
 chicken bowls, 191
 Chinese culinary influences, 109, 118
 cooking methods, 24
 cooking styles, 21–23
 dining tables, 143
 fermented meats in, 62
 food and flavors of, 17–20, 22
 grilled favorites in, 73
 grill shacks in, 72
 ingredients guide and glossary, 324–28
 kaeng khae variations in, 145
 kitchen tools, 25
 laap spices in, 289–91

meals, and serving sizes, 23
people of, 16–17
phak kap laap in, 277
pounded salads in, 138
preserved meats in, 118
water fountains, 174
"white alcohol" in, 85–87
Nuea Tam (Shan-Style "Pounded Meat"),
 220–21, 221
Nuea Thup (Pounded Beef), 260, 261

P

Papaya
 Khaang Pawng (Shan-Style Herbal
 Fritters), 242, 243–44
Phak Dawng (Yunnanese-Style Pickled
 Mustard Greens), 113
Phak Kuut Sanaap (Mae Hong Son-Style
 Salad of Vegetable Ferns), 222, 224
Phak Nawk Saa (Mae Hong Son-Style
 Salad of Asian Pennywort), 222, 225
Phat Muu Naam Khaang (Stir-Fry of
 "Dewdrop Pork" and Fresh Chili),
 120, 121
Phat Thai Muu (*Phat Thai* with Pork),
 185–87, 187
Phrae & Nan Provinces
 history of, 270–71
 indigo shirts from, 295
 khanom jiin (rice noodles in), 304
 makhwaen trees in, 289
 meaty dishes in, 284
 Phrae-style foods in, 273
 Phrae-style staple ingredients, 278
 salty water wells in, 312
Plaa Aep (Thai Lue-Style Herbal Grilled
 Fish), 129, 129–30
Pomelo
 Tam Som Oh (Pounded Salad of Pomelo
 and Crab Paste), 58, 59–60
Pork
 Aep Awng Aw (Grilled Herbal Packets of
 Pork and Brains), 79–80
 belly, preserved, about, 118
 "dewdrop," about, 118
 Jaw Phak Kaat (Soup of Yu Choy Greens
 and Pork Ribs), 170, 171
 Jin Som (Northern Thai-Style
 Fermented Pork), 63–64
 Jin Som Mok Khai (Northern Thai-Style
 Fermented Pork Grilled with Egg), 64
 Kaeng Hang Lay (Burmese-Style Pork
 Curry), 164, 165–66
 Kaeng Hang Lay Tai (Shan-Style Pork
 Belly Curry), 212, 213–14
 Khaep Muu (Deep-Fried Pork Rinds),
 70, 70–71
 Khanom Sen Naam Muu & Khao Som
 (Phrae-Style Pork Broth Served with
 Thin Rice Noodles and/or Tomato
 Rice), 308, 309–10
 Khao Kan Jin (Shan-Style "Kneaded"
 Rice), 245, 245–47
 Khao Lueang and Nuea Lung (Yellow
 Sticky Rice with Shan-Style Herbal
 Pork Balls), 230, 231–33

Khao Sen (Shan-Style Noodle Soup with Pork and Tomato), *238*, 239–40
Khao Soi Naam Naa (Thai Lue–Style Rice Noodles in Pork Broth with a Savory Topping), *134*, 135–36
Kuaytiaw Naam Ngiaw (Rich Pork-Rib and Tomato Broth Served over Flat Rice Noodles), *189*, 189–90
Laap Muu Khua (Phrae-Style Pork *Laap*), 275–76
Muu Naam Khaan ("Dewdrop Pork"), 119
Muu Phan Pii ("Thousand-Year Pork"), *114*, 114–15
Muu Sap Phat Kap Phak Dawng (Minced Pork Stir-Fried with Yunnanese-Style Pickled Mustard Greens), *116*, 117
Muu Yaang (Northern Thai–Style Grilled Pork), *76*, 77–78
Naam Phrik Awng (Northern Thai–Style Dip of Tomatoes and Ground Pork), 48–49
Naam Phrik Khaep Muu (*Naam Phrik Num* with Pork Rinds), 44
Naam Phrik Khing and Muu Yaang (Lahu-Style Dip of Grilled Ginger Served with Grilled Pork Belly), *102*, 102–3
Naem Khua Kap Khai (Fermented Pork Stir-Fried with Egg), *66*, 67
Nuea Tam (Shan-Style "Pounded Meat"), 220–21, *221*
Phat Muu Naam Khaang (Stir-Fry of "Dewdrop Pork" and Fresh Chili), *120*, 121
Phat Thai Muu (*Phat Thai* with Pork), 185–87, *187*
preserving, Chinese-style, 110
Sai Ua (Northern Thai–Style Herb Sausage), *74*, 74–75
Saq Byaev Toe Umvq (Akha-Style Grilled Loaf of Pork and Herbs), *106*, 107
sausage, Yunnan-style, about, 118
Taj Hpau Pauf (Karen Soup of Rice and Vegetables), *264*, 265–66
Tam Khanun (Pounded Salad of Young Jackfruit), 138–40, *140*
Potatoes
Aq Lul Tahq (Akha-Style Mashed Potatoes), 104
Preserved meats, 118
Preserving foods, Chinese-style, 110

R
Rice
Khanom Sen Naam Muu & Khao Som (Phrae-Style Pork Broth Served with Thin Rice Noodles and/or Tomato Rice), *308*, 309–10
Khao Kan Jin (Shan-Style "Kneaded" Rice), *245*, 245–47
Khao Lueang and Nuea Lung (Yellow Sticky Rice with Shan-Style Herbal Pork Balls), *230*, 231–33

Khao Som (Shan-Style "Sour" Rice), *234*, 234–35
Khao Taen Naam Taengmo (Deep-Fried Rice Cakes Seasoned with Watermelon Juice and Palm Sugar), *192*, 192–93
Khao Tom Bo (Banana Leaf Parcels of Sticky Rice and Banana), *318*, 319–20
sticky, growing and harvesting, 54–55
sticky, how to steam, 55
Suay Thamin (Shan-Style Sticky Rice "Cake"), *246*, 247
Taj Hpau Pauf (Karen Soup of Rice and Vegetables), *264*, 265–66
Rice flour
Khanom Paat (Celebratory Sweet of Coconut and Rice Flour), 196–97, *197*
Khao Muun Khuay (Shan "Donuts"), *255*, 255–56

S
Sai Ua (Northern Thai–Style Herb Sausage), *74*, 74–75
Salads. *See also* Laap
Phak Kuut Sanaap (Mae Hong Son–Style Salad of Vegetable Ferns), *222*, 224
Phak Nawk Saa (Mae Hong Son–Style Salad of Asian Pennywort), *222*, 225
pounded, about, 138
Tam Khanun (Pounded Salad of Young Jackfruit), 138–40, *140*
Tam Makhuea (Pounded Salad of Grilled Eggplant), 316, *317*
Tam Mamuang (Pounded Salad of Green Mangoes), *182*, 183–84
Tam Som Oh (Pounded Salad of Pomelo and Crab Paste), *58*, 59–60
Thua Taep Ko (Mae Hong Son–Style Salad of Lablab [Hyacinth] Beans), *222*, 223
Yam Makhuea Mathua (Pounded Salad of Eggplant and Long Beans), 141–42, *142*
Salt, harvesting, 312
Saq Byaev Toe Umvq (Akha-Style Grilled Loaf of Pork and Herbs), *106*, 107
Sausages
Sai Ua (Northern Thai–Style Herb Sausage), *74*, 74–75
Yunnan-style pork, about, 118
Serving sizes, note about, 22
Shallots
Khaang Pawng (Shan-Style Herbal Fritters), *242*, 243–44
Khanom Jiin Naam Phrik Naam Yawy (Dry Dressing of Chili, Garlic, and Shallots for Thin Rice Noodles), 306–7, *307*
Naam Phrik Khaep Muu (*Naam Phrik Num* with Pork Rinds), 44
Naam Phrik Khing and Muu Yaang (Lahu-Style Dip of Grilled Ginger Served with Grilled Pork Belly), *102*, 102–3
Naam Phrik Makhuea Som ("Red Eye" Chili Paste Fried with Tomatoes), 51

Naam Phrik Num (Northern Thai–Style Dip of Grilled Chilies, Shallots, and Garlic), 42–43
Naam Phrik Plaa Jii (*Naam Phrik Num* with Grilled Fish), 43
Naam Phrik Taa Daeng ("Red Eye" Chili Paste), 50–51
Shan-style food, 206–8
Soups
Jaw Phak Kaat (Soup of Yu Choy Greens and Pork Ribs), 170, *171*
Kaeng Khae Kop (Northern Thai–Style Soup of Mixed Vegetables and Herbs with Grilled Frog), 145–46, *146*
Kaeng Manoi Sai Kai (Celebratory Curry with Luffa and Chicken), 299, 299–300
Khanom Sen Naam Muu & Khao Som (Phrae-Style Pork Broth Served with Thin Rice Noodles and/or Tomato Rice), *308*, 309–10
Khao Sen (Shan-Style Noodle Soup with Pork and Tomato), *238*, 239–40
Kuaytiaw Naam Ngiaw (Rich Pork-Rib and Tomato Broth Served over Flat Rice Noodles), *189*, 189–90
Taj Hpau Pauf (Karen Soup of Rice and Vegetables), *264*, 265–66
Yam Pii (Northern-Style *Tom Yam* Soup with Banana Blossom and Chicken), *314*, 314–15
Soybeans, fermented, in Shan-style cookery, 227–28
Stews
Kaeng Awm Nuea (Rich, Herbaceous Beef Stew), 286–87
Suay Thamin (Shan-Style Sticky Rice "Cake"), *250*, 251

T
Taj Hpau Pauf (Karen Soup of Rice and Vegetables), *264*, 265–66
Tam Khanun (Pounded Salad of Young Jackfruit), 138–40, *140*
Tam Makhuea (Pounded Salad of Grilled Eggplant), 316, *317*
Tam Mamuang (Pounded Salad of Green Mangoes), *182*, 183–84
Tam Som Oh (Pounded Salad of Pomelo and Crab Paste), *58*, 59–60
Tea leaves, fermented (miang), how they are made, 199–201
Thai Lue communities, 128
Thua Taep Ko (Mae Hong Son–Style Salad of Lablab [Hyacinth] Beans), *222*, 223
Tomatoes
Khanom Sen Gaam Muu & Khao Som (Phrae-Style Pork Broth Served with Thin Rice Noodles and/or Tomato Rice), *308*, 309–10
Khao Sen (Shan-Style Noodle Soup with Pork and Tomato), *238*, 239–40
Khao Som (Shan-Style "Sour" Rice), *234*, 234–35

Tomatoes (*continued*)
 Kuaytiaw Naam Ngiaw (Rich Pork-Rib and Tomato Broth Served over Flat Rice Noodles), *189*, 189–90
 Mal Qer Cael Tahq (Akha-Style Dip of Grilled Tomatoes and Chilies), 101
 Naam Phrik Awng (Northern Thai–Style Dip of Tomatoes and Ground Pork), 48–49
 Naam Phrik Makhuea Som ("Red Eye" Chili Paste Fried with Tomatoes), 51
 Phak Nawk Saa (Mae Hong Son–Style Salad of Asian Pennywort), *222*, 225

ᩏ
Up Kai Asii Pian (Shan-Style Aromatic Chicken Curry), 210–11, *211*

ᩅ
Vegetable ferns
 Phak Kuut Sanaap (Mae Hong Son–Style Salad of Vegetable Ferns), *222*, 224
Vegetables
 Haw Nueng Kai (Steamed Banana Leaf Packets of Chicken, Herbs, and Vegetables), *147*, 147–49
 Kaeng Khae Kop (Northern Thai–Style Soup of Mixed Vegetables and Herbs with Grilled Frog), 145–46, *146*
 with laap (*phak kap laap*), 277
 preserving, Chinese-style, 110

ᩅ
Watermelon
 Khao Taen Naam Taengmo (Deep-Fried Rice Cakes Seasoned with Watermelon Juice and Palm Sugar), *192*, 192–93

Wheat flour
 Aalawaa Jong (Shan "Cake" of Toasted Wheat Flour), 254
"White booze," 85–87

ᩀ
Yam Makhuea Mathua (Pounded Salad of Eggplant and Long Beans), 141–42, *142*
Yam Pii (Northern-Style *Tom Yam* Soup with Banana Blossom and Chicken), *314*, 314–15
Yu choy greens
 Jaw Phak Kaat (Soup of Yu Choy Greens and Pork Ribs), *170*, *171*
 Naam Phrik Naam Phak (Dip of Preserved Yu Choy Greens), 131–32, *133*

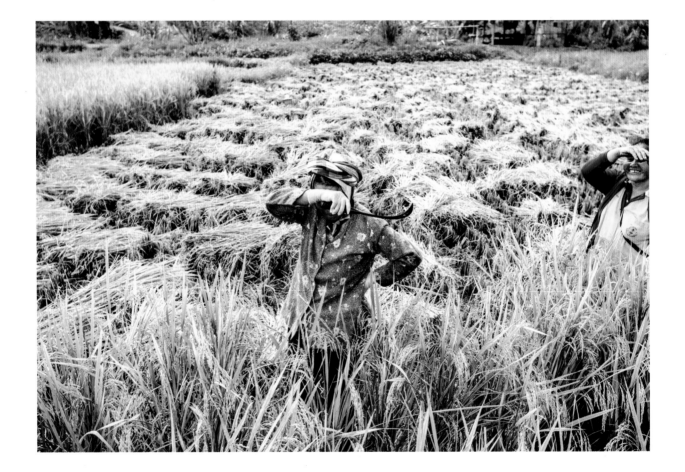